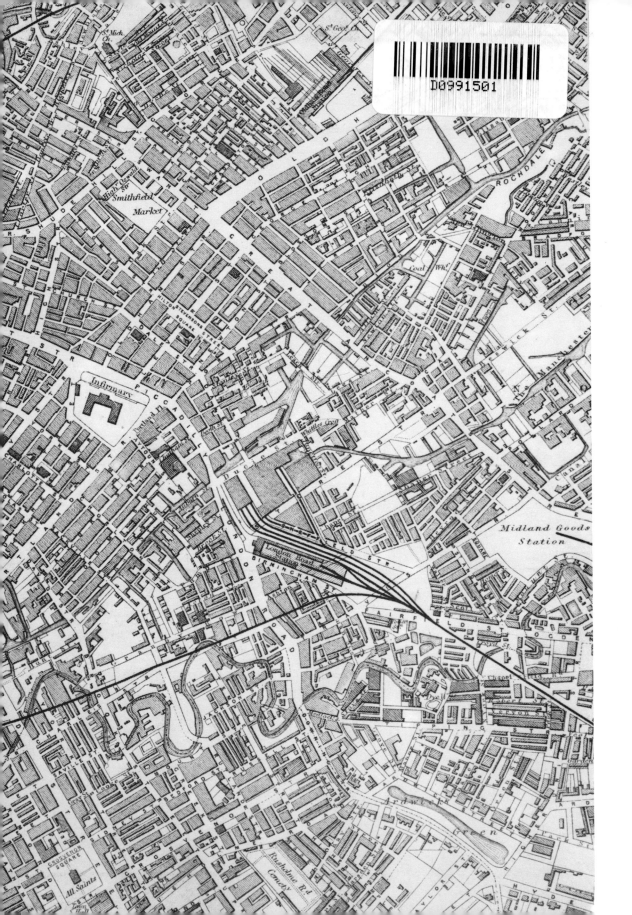

ART AND ARCHITECTURE IN VICTORIAN MANCHESTER

In the Victorian era Manchester, the first city of the industrial revolution, had the wealth and self-confidence to express itself through ambitious patronage of the arts. The prime example was the building of the new Town Hall, described as a 'classic of its age', and its subsequent decoration by the murals of Ford Madox Brown. This monument to municipal patronage has overshadowed other examples that are princely in scale, from the building of the Royal Manchester Institution in 1824 to the John Rylands Library, completed without regard to cost in 1899. All fields of artistic endeavour were encompassed and men of national reputation produced their *chef d'oeuvre* there. This book examines some of the fruits of the city's heyday, a legacy which in large measure survives.

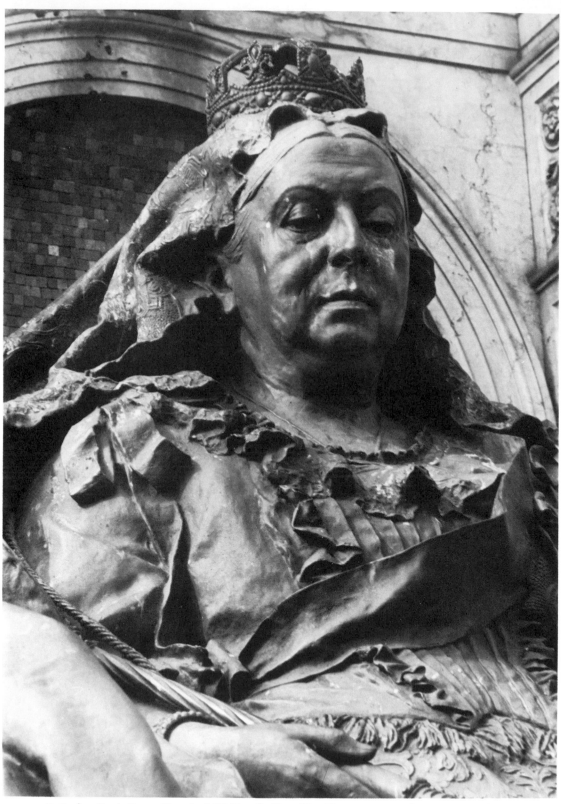

E. Onslow Ford: Queen Victoria, 1901 (detail). Piccadilly. The statue was subscribed to publicly and commemorated the Queen's diamond jubilee

edited by JOHN H. G. ARCHER

Art and architecture in Victorian Manchester

Ten illustrations of patronage and practice

You may have confidence in the interpretation of mind by the products of art.
W. M. Flinders Petrie, lecture, 1913

MANCHESTER UNIVERSITY PRESS

Published by

MANCHESTER UNIVERSITY PRESS

Oxford Road, Manchester, M13 9PL, U.K.

and 51 Washington Street, Dover N.H. 03820, U.S.A.

British Library cataloguing in publication data

Art and architecture in Victorian Manchester.
 1. Art, Victorian—England—Manchester (Greater Manchester)
 I. Archer, John H.G.
 709'.427'33 N6771.M3

Library of Congress cataloging in publication data

Main entry under title:
Art and architecture in Victorian Manchester.
 Bibliography: p. 269
 Includes index.
 1. Art, Victorian—England—Manchester (Greater
Manchester) 2. Art, English—England—Manchester
(Greater Manchester) 3. Architecture, Victorian—England
—Manchester (Greater Manchester) 4. Architecture—
England—Manchester (Greater Manchester) 5. Manchester
(Greater Manchester)—Buildings. I. Archer, John H. G.
II. Title.
N6781.M3A7 1984 709'.427'33 84–17132

ISBN 0–7190–0957–X *(cased)*

Typeset by August Filmsetting, Haydock, St. Helens

Printed in Great Britain
by Bell & Bain Limited, Glasgow

CONTENTS

LIST OF ILLUSTRATIONS

The location of Manchester subjects is given only by street and/or district. Where no attribution is given it may be assumed that the illustration is personal to the author.

ABBREVIATIONS AND REFERENCES

In several chapters numerous references occur to special collections in Manchester Central Library. Usually these are located either in the Archives Department or the Local History Library. These have been abbreviated to:

MCL Manchester Central Library
Archives Archives Department
LHL Local History Library

One other source which is cited commonly is the Library Edition of *The complete works of John Ruskin*, 39 vols., 1903–12, edited by E. T. Cook and Alexander Wedderburn, which has been abbreviated to *Works*. Some references to Ruskin's commonly available works include the sectional references (§) which he introduced in the chapters of his books. This system provides a key to all the different popular editions. In these cases page references have been omitted.

Chapters six and seven, on Manchester Town Hall and its mural paintings, rely heavily on the committee minutes retained in the Town Clerk's Department and incidentally reflect the changing pattern of administration for the project. Responsibility for this rested originally with the General Purposes Committee, which entrusted it to the New Town Hall Sub-committee, instituted on 25 November 1863. Fourteen years later, in December 1877, this was retitled the Town Hall and Audit Sub-committee, and a year later, on 9 November 1878, the Council superseded it by establishing the Town Hall Committee as a full committee 'to have charge and control of the Town Hall' (THC Proceedings, vol. 1, p. 1, 13 November 1878). The new committee incurred the troublesome responsibility of attending to the final completion of the building, which included the protracted process of the painting of the murals. Both this committee and its predecessor delegated special responsibilities to further sub-committees. The execution of the murals and the provision of furnishings were entrusted to the Decorations and Furnishings Sub-committee, whilst others similarly were responsible for obtaining the organ, bells, clocks, etc., and making the arrangements for the ceremonial opening.

In the references to these bodies and their minutes the source is given first, followed, in parentheses, by the committee and its date. The following abbreviations are used:

CP *Council Proceedings*
GPS-c General Purposes Sub-committee
NTHS-c New Town Hall Sub-committee
NTH&AS-c New Town Hall and Audit Sub-committee
THC Town Hall Committee
D&FS-c Decorations and Furnishings Sub-committee

In these two chapters frequent reference is made also to two special collections of papers from the Archives Department of Manchester Central Reference Library. These are letters from Alfred Waterhouse to Joseph Thompson, and other papers on the Town Hall collected by Thompson. Respectively they are referred to as 'Thompson letters' and 'Thompson papers'. A third collection of general correspondence within the Archives Department, known as the Autograph Collection, is cited as 'Au Collection'. Where other abbreviations are used their meaning is explained by their immediate context or within the notes when first introduced, or preliminary to the notes for the chapter.

ACKNOWLEDGEMENTS

The publication of this book
has been supported by the

GREATER MANCHESTER COUNCIL
and the MANCHESTER CITY COUNCIL

The preparation of a book of this nature leaves one indebted to many friends and colleagues for their assistance, as well as to the numerous curators and librarians whose services have been drawn upon so heavily. In the former category particular thanks are owed to Dr Paul Crossley, Mr Frank Colesby, Dr Douglas Farnie, Mrs K. M. Green, Mr Warren Marshall, Mr Julian Treuherz and Mr Geoffrey Wheeler; and, in the latter, special mention must be made of the staff of the Manchester Central Library and, in particular, of Miss Ayton, the Archivist, Mrs Canavan, the Arts Librarian, and Mr David Taylor, the Local History Librarian, as well as the staff of the British Architectural Library/RIBA Drawings Collection, Miss Matheson of the John Rylands University Library of the University of Manchester, and Sir John Summerson, formerly of the Sir John Soane Museum. I am grateful also to Messrs Bickerdike Allen Partners and Messrs Haden, who kindly provided information from their records.

Permission to publish private material has been given by Dr Michael Pegg, of the John Rylands University Library, Mr David Waterhouse, Lady Joan Worthington, and the Town Clerk of Manchester, who have allowed quotations to be made from unpublished papers, and by Mr Arthur Little, of Thomas Worthington and Sons, who sanctioned the reproduction of six drawings from the firm's collection. Mr Peter Leach and Mr David Wrightson have allowed the use of their photographs, and permission to publish reproductions of photographs, drawings and paintings within their jurisdiction has been given by the following for the plates indicated: British Architectural Library/RIBA, 6, 59, 60, 64–5, 69; City of Bristol Museum and Art Gallery, 31; City of Manchester Art Galleries, 1, 9, 10, 13–16, 20, 22, 29, 32–3, 73–4; City of Salford Mining Museum, 21; Controller of Her Majesty's Stationery Office, 75–6; Conway Library, Courtauld Institute of Art, *frontispiece*; Fogg Art Museum, Harvard University, 72; Illustrated London News Picture Library, 2; Manchester City Council, through the following officers: City Engineer and Surveyor, 68; Director of Libraries, Map 2, 11, 24, 36, 41, 52–3, 57, 62, 118–22, 124–5; Director of Recreational Services, 39, 40; Public Relations Officer, 55, 67; Town Clerk, 79–90; Metropolitan Borough of Bury Libraries and Arts Department, 18; Museum Boymans–van Beuningen, Rotterdam, 30; National Gallery of Scotland (authorised by His Grace the Duke of Sutherland), 28; National Monuments Record, 17, 26, 70, 108–9, 111, 114–16; National Trust (Wallington, Northumberland) 77–8; Trustees of the Victoria and Albert Museum, 5, 61; University of Manchester, Bursar, 112; John Rylands University Library, 19, 34; School of Architecture, 4, 7, 58, 66; Whitworth Art Gallery, 92–103.

In many cases these bodies have considerably waived reproduction fees, and in this respect the Manchester City Art Gallery, the Manchester City Library and the various other departments of the City Council have been most generous. Grants towards the cost of publication have been made by the Greater Manchester Council and the Manchester City Council Cultural Services Committee. The financial support provided, direct and indirect, has had a pronounced and beneficent effect on the decisions affecting the production of the book and is greatly appreciated.

Three persons who have been outstandingly helpful in aiding the progress and completion of the book are Mr R. H. Offord, the Manchester University Press editor, Mr Alan Rose, whose collaboration in the compiling of the index has been invaluable, and Mr Victor Tomlinson, whose extensive knowledge of Manchester's history and bibliography has always been at my disposal. I am pleased to acknowledge their guidance and practical assistance.

J.H.G.A. 1 January 1985

PREFACE

Little explanation is needed for this book. It is thought to be the first to be devoted specifically to art and architecture in Manchester, and the first to offer detailed studies of the city's Victorian architecture since the publication in 1956 of Cecil Stewart's *The stones of Manchester*. Needless to remark, it is far from exhaustive. It merely treats ten subjects that capture something of Manchester's Victorian life expressed through the visual arts. The initial criterion for their selection was that they should have gained national significance. The Town Hall and its famous murals; the Art Treasures Exhibition; the creation of the City Art Gallery and the Whitworth Art Gallery and their internationally known collections; and the architectural achievement represented by the Rylands Library immediately suggested a nucleus of six topics of the first rank, and, as it happened, at the outset there was no recently published study on any of them. The original idea has undergone some modification but is closely reflected in the list of contents. The remaining four subjects were not difficult to find. Professor Whiffen's study of Sir Charles Barry's local works, first published by the Royal Manchester Institution in 1950, provided an admirable example which could not be overlooked and patently needed reprinting. It underlined the importance of the RMI as an additional subject but led to the need for a balancing topic from the late-Victorian era. Pownall Hall, the Century Guild's one major executed commission, perfectly fitted this need and, finally, Thomas Worthington was selected as an individual Mancunian architect. Less well known than Edward Walters or Edgar Wood, his work merits wider appreciation, and this and his social, civic and professional interests appeared to make him ideally suitable for inclusion.

Fortunately the majority of the subjects were known to have potential authors possessing a personal, and in some cases a professional, interest in and knowledge of them, but the architectural chapters on the Rylands Library and the Town Hall have been researched principally for this book, although in the latter case a long-latent interest happily coincided with the opportunity presented.

The ten chapters inevitably have suggested other topics for study and it is hoped that they will stimulate their development. The abundance of Manchester's Victorian sculpture, the high abilities of designers, decorators and furniture makers, the enterprise that went into the exhibitions of arts and industries, the role of the Mechanics' Institution in promoting the arts, the organisation of the second great Manchester exhibition – that for the royal jubilee in 1887, and the activities of numerous collectors, artists, and architects all invite attention.

Victorian Manchester was an extraordinary phenomenon, and the arts reveal some of its qualities of life. Mr Michael Kennedy has illustrated some of these in his books on the city's musical enterprise.[1]. The visual arts also confirm that qualities of intellectual adventurousness and discernment were powerfully

[1] *The Hallé tradition*, 1960 and *The Hallé 1858–1983*, 1982.

evident. The ten chapters here presented further testify to Manchester's aspirations and richly varied vitality.

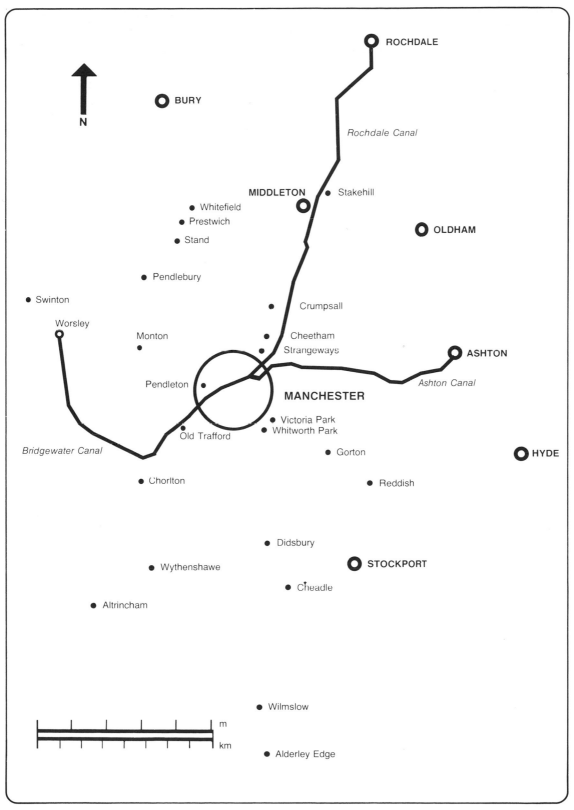

Manchester and its region, showing the location of principal subjects

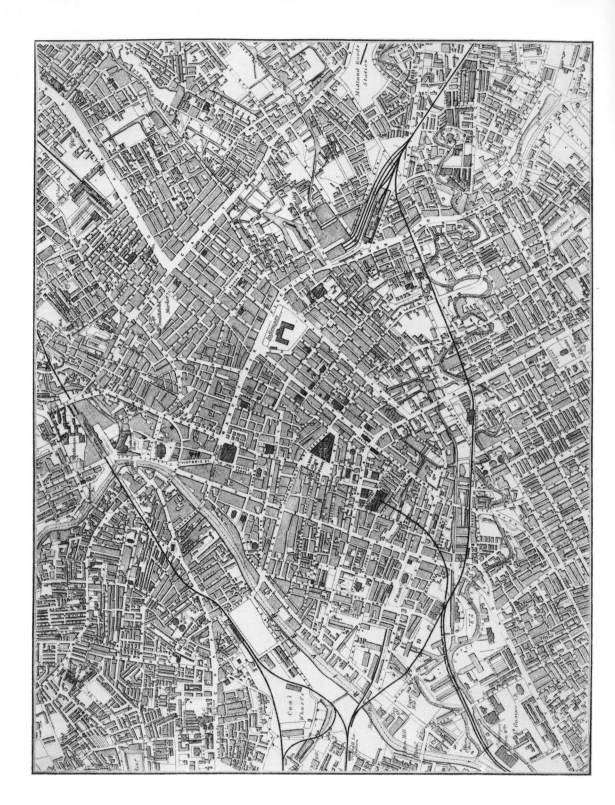

Map of Manchester c. 1870 by James E. Cornish, published 1876. Scale 1:10,560. Victorian Manchester, as depicted on Cornish's map, had extended and partly replaced the historic town which had grown southwards and eastwards from the medieval nucleus, identifiable from the position of the cathedral, formerly the collegiate church, and the road (Hanging Ditch) that curves northwards from Victoria Bridge. St Ann's Church (1709–12) and Square (from 1720) were the principal eighteenth-century developments.

The London road was a continuation of Market Street, Deansgate led to the Chester road, and the principal routes to the north served the cotton spinning towns that stretch in an arc from the north-west to the east. The commencement of Oldham Road shows its importance by its arterial scale. The river Irwell divides Manchester from the contiguous town of Salford, through which pass the roads to Liverpool, Lancaster and Scotland.

Industrial developments were generated from the Bridgewater Canal basin, south of the town and close to the junction of the winding Medlock and the Irwell. Begun in 1764, near the site of the Roman settlement, it became a centre of transport, warehousing and industry. Mills developed along the Medlock and, from the early years of the nineteenth century, along the line of the Rochdale Canal, which by various connections gave a navigable route to Hull. It terminated in Dale Street, close by the terminus of the Ashton Canal in Ducie Street. The three basins were linked by 1805 and, as can be seen, numerous branches spread from the canal that joins the two main systems. Heavy industry developed from this and penetrated the southern area of the town. Housing and factories were inextricably intermingled, and the notorious pocket of Little Ireland was in the first loop of the Medlock to the west of Oxford Road. Industry followed the canals and was concentrated in Hulme and Chorlton, around the Bridgewater basin and the Medlock respectively, and in Ancoats, where the Rochdale and Ashton canals follow parallel courses.

The location of the railway termini repeated the pattern. The earliest extant station is at Liverpool Road, slightly to the north of the Bridgewater basin. Later stations were built at London Road and Hunt's Bank, the latter close to the centre of the old town.

From about the beginning of Victoria's reign commercial development gradually transformed the centre of Manchester, and both residential and industrial areas were cleared for Manchester's staple building type, the commercial warehouse. Civic pride and the need for social and sanitary reform led to other changes, including the creation of many of those features that are now regarded as most characteristic of the Victorian city.

See endpapers for a larger reproduction of this map

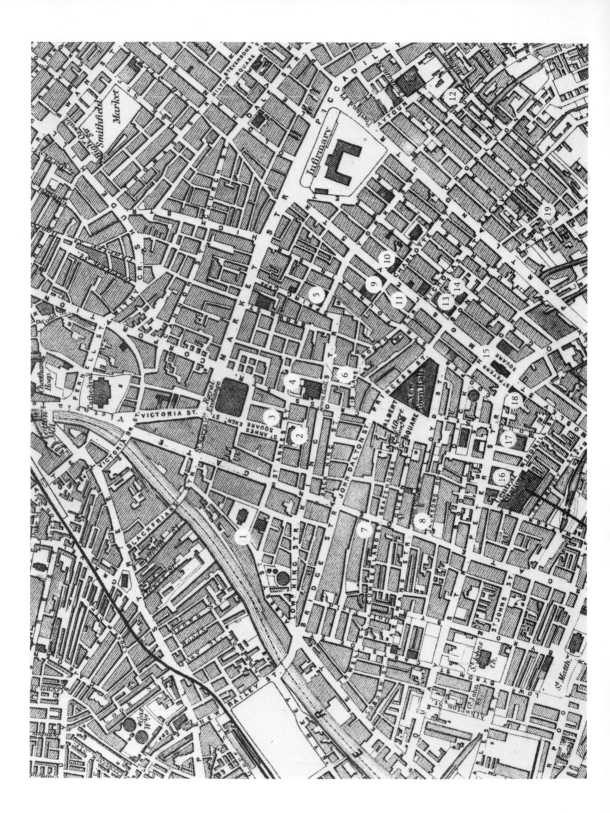

The centre of Manchester c. 1870; adapted from Cornish's map. Scale 1:10,560.

 1 St Mary's Church
 2 St Ann's Church
 3 Benjamin Heywood's Bank
 4 Cross Street Unitarian Chapel
 5 Site of Parr's Bank
 6 Bank of England
 7 Site of Rylands Library
 8 Site of Education Offices
 9 Former site of Assembly Rooms
10 Portico Library
11 Milne Building
12 Site of Magistrates' and Police Courts
13 Royal Manchester Institution
14 Athenaeum
15 St Peter's Church
16 Free Trade Hall
17 Museum of Natural History
18 Concert Hall
19 Mechanics' Institute

INTRODUCTION

Manchester has a peculiar place in the history and literature of the early nineteenth century. As an urban and industrial prodigy, a phenomenon of a new age, it caught the imagination and evoked vivid responses which have, in turn, impressed modern historians.[1] To some contemporaries it provided a visionary experience; to Carlyle it was 'sublime as a Niagara, or more so'; to Disraeli it seemed the embodiment of science and 'as great a human exploit as Athens', but there were others to whom its spectacle was less exalted. 'From this foul drain', wrote Alexis de Tocqueville on 2 July 1835, concluding one of the most lurid accounts, 'the greatest stream of human industry flows out to fertilise the whole world. From this filthy sewer pure gold flows.'[2]

It is the darker aspects of Manchester's contemporary life that have been most cited, and the best known descriptions are those by J. P. Kay (1832), de Tocqueville (1835), Léon Faucher (1844) and Friedrich Engels (1845).[3] Art and architecture are either irrelevant to or are relatively unnoticed in such accounts, although de Tocqueville observed that among the squalor from time to time 'one is astonished at the sight of fine stone buildings with Corinthian columns' (a rather uncharacteristic feature of the town's architecture), and Faucher quotes a description of 1842 by Dr W. Cooke Taylor, who cautiously observes that 'there are some very stately public buildings'.[4] However, consideration of Manchester's art and architecture reveals not only works which are intrinsically valuable, but a complementary and relatively neglected seam of contemporary life.

There is ample evidence that the face of early Victorian Manchester was more civilised than may be supposed from the often quoted sources. Surviving buildings, illustrations of others, and published descriptions show that the town's architectural endowments were considerable and included works that were advanced for their day, e.g., Thomas Harrison's Greek Revival Portico

[1] See Asa Briggs, 'Manchester, symbol of a new age', in *Victorian cities*, 1963; J. L. and Barbara Hammond, *The town labourer*, 2 vols., 1917, 1949 edn.; A. J. P. Taylor, 'The world's cities. I. Manchester', *Encounter*, vol. 8, pp. 3–13, March 1957; 'Made in Manchester', *Listener*, vol. 96, pp. 333–4, 16 September 1976; David Thompson, *England in the nineteenth century*, 1950.

[2] Thomas Carlyle, *Chartism*, 1839, Library Edition, vol. 10, 1869, p. 397; Benjamin Disraeli, *Coningsby: or the new generation*, 1844, Book IV, chapter 1, prologue; Alexis de Tocqueville, *Journeys to England and Ireland*, trans. G. Lawrence and K. P. Mayer, 1958, pp. 104–10.

[3] James Phillips Kay, *The moral and physical condition of the working classes*, 1832, rp. 1969; Alexis de Tocqueville, *op. cit.*, n. 2; Léon Faucher, *Manchester in 1844*, trans. J. P. Culverwell from *Revue des deux mondes*, 1843–45, 1844, rp. 1969; Friedrich Engels, *The condition of the working class of England*, 1845, trans. and ed. W. O. Henderson and W. H. Chaloner, 1958, 1971. See also Edwin Chadwick, *The sanitary condition of the labouring population of Great Britain*, 1842, ed. with an introduction by Michael W. Flinn, 1964.

[4] Faucher, *op. cit.*, pp. 19–21, quotes from Taylor's *Notes of a tour in the manufacturing districts of Lancashire*, 1842, pp. 10–13.

Library (1802–06) and Exchange (1806–08).[5] In addition Charles Barry's Royal Manchester Institution (1824–35) and Athenaeum (1836–39), **1, 10, 24, 25,** and buildings by Francis Goodwin (1795–1835) and Richard Lane (1795–1880), have claims to distinction, and guides and handbooks illustrate numerous other buildings showing that they belonged to an architectural corpus that was not negligible.[6] Their context and the town's aggregate character can be judged also from plates and contemporary maps. The main streets illustrated appear to have been irregular but full of architectural variety and incident, and the maps show the town still to have been relatively small, compact, and with the complex internal character typical of piecemeal growth. The most informative map, made by the Ordnance Survey at the scale of sixty inches to the mile from a survey that commenced in 1848, impartially shows the notorious pocket of Little Ireland, with its back-to-back housing and cellar dwellings, and the wealth of public buildings, educational institutions and churches that caught the eye of architectural observers.[7] It demonstrates also that industry, principally mills and foundries, followed the routes of the rivers and canals and was an integral part of the town, extending close to its centre, **56.** The visitor to early Victorian Manchester could not escape the scale of its industry, but although this and its attendant social consequences were the town's principal sights they were not the only features visitors found impressive, and some of these became the subjects of informed criticism and comparison in architectural periodicals.

In 1838 Loudon's *Architectural Magazine* published 'Fragments of a provincial tour', a record of a journey by Henry Noel Humphreys, who devoted eight pages to an appreciative account of the town and its art and architecture.[8] Humphreys was clearly an architectural enthusiast, an admirer of Welby Pugin with a zeal for Gothic architecture and antiquities that marks him as a contemporary modern. Not the least points of interest in his article lie in his first impressions and in the comparisons that he freely draws between Manchester, London and Birmingham:

> On entering Manchester by the suburb called the London road, it becomes at once evident that you are approaching a manufacturing town of the first rank. It is at a glance observable that it infinitely surpasses Birmingham in the general style and more lofty proportion of the houses, and in its noble ranges of warehouses, which are much more imposing from the superior height, than any buildings of the same

[5] The Portico Library is extant but altered internally. For a contemporary account see J. Aston, *The Manchester guide*, 1804. For the Exchange (now demolished) see J. Aston, *A descriptive account of Manchester Exchange*, 1810.

[6] E.g. Joseph Aston, *A picture of Manchester*, 1816 (the 3rd ed, 1826, includes 27 engravings of public buildings); S. Austin *et al., Lancashire illustrated*, 1829; Love and Barton, *Manchester as it is*, 1839.

[7] The OS map, scale 1:1056, consists of forty-eight sheets. The town centre is shown on sheets 23, 24, 28 and 29.

[8] Vol. 5, pp. 695–703. The article is dated 5 December 1838.

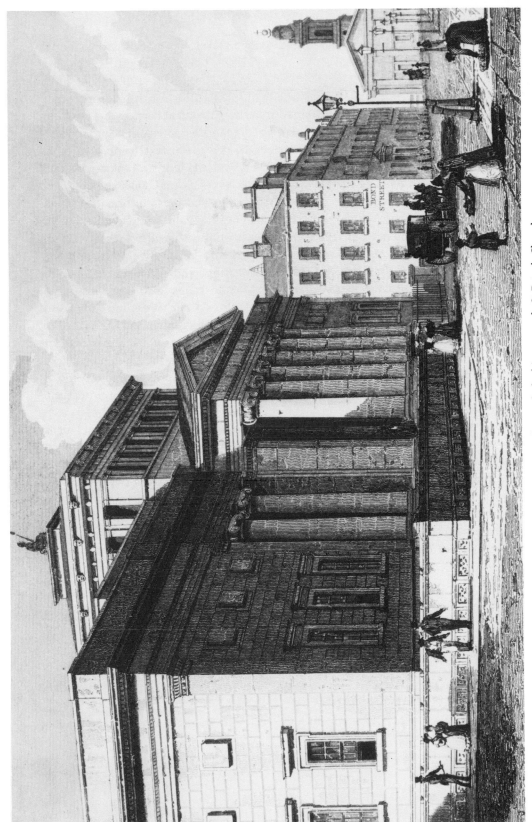

1 Charles Barry: the Royal Manchester Institution, viewed from the north, looking towards St Peter's Church

description in Birmingham. On entering Market Street, this impression of superiority in the general style of building is strengthened; many houses being five or six stories high, and in some instances a whole range is made to form one architectural design, after the manner of Regent Street, or Regent's Park.

Humphreys admits that 'these designs are in few instances very good', though maintaining that 'from their loftiness they produced a good general effect'. Deansgate, despite the associations of its name, failed to produce any antiquities, but its houses were thought 'much better than the houses of second or third-rate streets of other manufacturing towns'. The collegiate church and Chetham's College were visited: Chetham's was considered an ideal retreat 'from the busy turmoil of the cotton metropolis', and the church's screenwork and carving were rightly judged to be 'wonderfully fine' and a 'school of art' to the Gothic architects of Manchester. The public buildings were discussed individually, and the interior of Barry's Royal Manchester Institution, particularly the entrance hall, **14**, was greatly admired. Collectively the modern public buildings were thought to give Manchester 'much cause to be proud, for they are numerous, and bespeak a lavish munificence highly creditable to the place'.

Humphreys' comparisons with Nash's Regent Street may be open to question, but his observations at least have the value of placing Manchester in a perspective of normality.[9]

The growing interest in Manchester's early Victorian architecture is seen also in other periodicals. The *Civil Engineer and Architect's Journal* devoted articles to it in 1842, 1845 and 1846, and the *Builder*, then in its early days, awoke to the new Manchester in 1845: 'The progress of art in Manchester, during one or two years past, has been so prosperous, that we have made arrangements for giving a notice of several of the most important buildings in a future number,' it announced.[10] Three weeks later a long and enthusiastic article appeared, and five other notices followed in three years.[11] These also present a very different impression of the town from the stereotype of the shock city of the age. They acknowledge the visionary interpretation of the new industrial 'marvel', representing '. . . the type of one grand and new idea—MACHINERY,—. . . which belongs to our own age exclusively, . . .', but praised the high standard of buildings and the rarity of stucco and jerry-building: 'There is less bad *building* in Manchester than in London,' was the

[9] The bulk of Regent Street was built between 1817 and 1823. Sir John Summerson has described its irregular northern section as presenting a 'gay assortment of architectural ideas, like a naughty version of Oxford's venerable High Street'. (*Georgian London*, 1945, 3rd edn, 1978, p. 188.) Market Street was widened and improved following an Act of 1821. To compare its former and improved states see Ralston's or James's views (bibliography, section 2b) and those in Austin's *Lancashire illustrated*, where the text to the appropriate plates refers to Market Street as 'Manchester's Regent-street'.

[10] *CE & AJ*, vols 5, 8 and 9, pp. 27–8, 129–30, 3–5, respectively; *Builder*, vol. 3, p. 510.

[11] Vol. 3, pp. 546–8; vol. 4, p. 452; vol. 5, pp. 295, 526–7, 598–9; vol. 6, pp. 577–8, 589.

Builder's conclusion. 'Brickwork is usually very well and soundly executed there, and would put to shame much of it that has been, and is being, done in and around the metropolis.'[12] This admiration was not misplaced. A local brick of a soft golden-orange colour and of great regularity was extensively used and laid in courses with very fine joints to produce walling of an exceptionally even and pleasant character.[13] The architecture, too, was not considered inferior, and it was regarded as praiseworthy that architects were employed for the design of warehouses, 'a class of buildings in which it is not always thought that art can find a place'.[14]

The Manchester textile warehouse, 3, had civic and commercial connotations which place it in a different class from the conventional goods or carrier warehouse. This distinction still provoked comment in the *Builder* in 1858, when its notable architectural qualities were again noted and defended.[15] However, in 1847 it was regarded not as a type possessing exceptional functions but as a general model of its kind, which led to the surprising conclusion that: 'For the proof that warehouses may be designed of a character in accordance with their purpose, and yet without any absence of the graces of art, we need not now point exclusively to the commercial cities of Italy. It has been manifested in Manchester . . .'.[16]

The seamier aspects of the town were not ignored by the *Builder*, an advocate of urban and social improvement throughout the Victorian age, and reports on Manchester's notoriously bad housing were included from the first volume published, covering December 1842 and 1843;[17] however, the architectural notices confirm Humphreys' impressions: sombre Manchester was architecturally vigorous.

Although the accuracy of de Tocqueville's portrayal is dubious, in one respect he was profoundly correct: the industry of Manchester coined pure gold. Whether it fertilised the whole world is questionable, but it made architecture and the arts fruitful in Manchester. Those possessing wealth engaged in patronage on a scale that proved magnetically attractive. The opportunities did not pass unnoticed. In December 1842, at a time of depression in manufacturing industry, the *Civil Engineer* reported that 'Whilst in London we hear too many complaints of the profession being overstocked, in Manchester, where, during late years the number of architects has doubled, all

[12] Vol. 6 1848, p. 577. The reference to Manchester representing the idea of machinery, an echo of Disraeli, is quoted from an article by Hepworth Dixon, 'Manchester considered in its relation to the age and to the progress of civilisation', *People's Journal*, vol. 3, 1847, pp. 243–6.

[13] The use of this brick persisted at least up to the 1870s. Thomas Worthington used it extensively (see chapter four).

[14] Vol. 5, 1847, p. 526. See also vol. 3, 1845, pp. 548.

[15] Vol. 16, p. 97.

[16] Vol. 5, p. 526.

[17] For early notices on housing conditions and cellar dwellings, etc., see vol. 1, p, 270, vol. 2, pp, 187, 199.

seem to be full of employment'.[18] This state was attributed to the number of churches being commissioned, but is more likely to have arisen from the need for commercial warehouses, then being built in considerable numbers, as is indicated by the *Builder*.

The new wealth, of course, inevitably attracted shady dealers in tawdry ostentation and, in turn, this drew sharp satirical comment. The *Builder* in 1845 drew a brilliant sketch of a *nouveau riche* society where, through successful speculation, the 'quondam shopboy, to whom a yard-stick was the familiar instrument of success, . . . now . . . alights at the door of the stock-exchange, in all the consciousness of well-appointed horse-flesh', and the 'man of lint and bandages, whose early career was brightened only by an occasional death, now invites you to dine at his country-house, and calls for you in a carriage'.[19] Again according to the *Builder*, 'picture jockeys' seized their opportunities. It was their custom to have on sale 'works of every artist that ever painted' so that 'many "undoubted originals" were readily disposed of'. It records that a famous Reynolds was once offered 'at a price which would be cheap for the picture in the National Gallery, but was dear for any copy'.[20] Elizabeth Conran illustrates in chapter three how the taste for modern works developed partly as a reaction to this, and how Agnew's rendered art collectors and contemporary artists a signal service.

In the decades previous to Victoria's accession many of the most desirable architectural commissions had gone to non-Mancunian practitioners, which is hardly surprising, since Baines's *Lancashire* of 1825 lists only nine names under 'Architects, &c.' in the directory of professions and trades for Manchester and Salford.[21] Of these the only one now known is Richard Lane, the town's leading architect in the 1820s and 30s.[22] The promise of patronage attracted numerous architects, and all the best known of the resident early Victorian architects were newcomers. Some arrived fully fledged, as had Richard Lane, e.g. T. W. Atkinson (1799–1861), Edward Walters (1808–72), J. E. Gregan (1813–55) and Alexander Mills (1814–1905). Lane appears to have been the first of this group. All were from London except Gregan, who was from Dumfries. Others, who served their articles in Manchester offices, were J. S. Crowther (1820–93), who arrived from Coventry when his father, a decorator, set up shop in Ridgefield,

[18] Vol. 5, p. 27.

[19] Vol. 3, p. 547.

[20] Vol. 5, 1847, p. 526.

[21] Edward Baines, *History, directory, and gazetteer of the county palatine of Lancaster*, 1825 (2 vols.), vol. 2, p. 292.

[22] A short biographical article on Lane in the *Manchester Evening News* of 26 March 1898 reports that he was born in London on 3 April 1795, completed his architectural education in Paris in 1816–17 and returned to London in 1818. At about that time he received a commission for a house in Manchester. In 1825 his practice was at 11 St Ann's Street and later he took as partner Peter B. Alley. After retiring in 1859 he died on 25 May 1880 at Sunninghill. See also H. M. Colvin. *A biographical dictionary of British architects 1600–1840*, 1978.

and from less far afield, Richard Tattersall (1803–44), from Burnley, and Henry Bowman (1814–83), from Nantwich.[23] Subsequently Bowman, with Crowther, then his partner, produced several fine Gothic churches, including some notably early ones for Nonconformists, and a well known book, *The churches of the Middle Ages* (1845–53). By 1837 the profession was sufficiently established to institute, under Lane's leadership, the Manchester Architectural Society, but, although the architects were increasingly numerous, it did not survive long, perhaps because it was insufficiently professional in its aims.[24]

With few exceptions the most notable of the later generations of Manchester's Victorian architects, Thomas Worthington (1826–1909), Edward Salomons (1828–1906), Alfred Darbyshire (1839–1908), Charles Heathcote (1850–1938), Edgar Wood (1860–1935) and Percy Scott Worthington (1864–1939), had strong local family connections. Salomons may be included, since he was six when his father, a merchant, moved to Manchester from London.[25] Alfred Waterhouse (1830–1905), unquestionably the greatest Victorian architect connected with Manchester, is omitted because he came from a Liverpool family and, after serving his articles and successfully establishing himself in practice in Manchester, he won the national competition for the Manchester Assize Courts in 1864, 6, he moved to London in pursuit of the major commissions of the day (see chapter six).[26] His most important succeeding Manchester commissions, the Town Hall (1867–80) and Owens College (from 1880 the Victoria University of Manchester), were designed from London.

Waterhouse's move was an early and significant indication of the declining architectural importance of the provinces relative to London, a trend reflected also in the changing imprint of the *British Architect*, a weekly periodical first published in 1874 to give better representation to provincial architects. It first gave Manchester and London as the places of publication, but by 1878 (vol. 9) the order had been reversed, and by 1883 (vol. 20) Manchester

[23] For Atkinson and Tattersall see H. M. Colvin, *op cit.,* n. 22 for Gregan and Walters see the Architectural Publications Society *Dictionary of architecture,* 8 vols., 1849–92; for Mills *see Builder,* vol. 89, p. 626, and *RIBA Journal,* vol. 13, p. 89, for Crowther see *Builder,* vol. 64, p. 252, *Transactions of the Lancashire and Cheshire Antiquarian Society,* vol. 11, 1893, pp. 193–4, and Diane Randle, University of Manchester BA dissertation, 1974 (History of Art Department); and for Bowman see *DNB,* vol. 2, under John Eddowes Bowman.

[24] See Cecil Stewart, 'M.S.A. A brief history', in Dennis Sharp (ed.), *Manchester buildings,* 1966, pp. 4–7.

[25] For information on Thomas Worthington see chapter four; for Salomons see W. Burnett Tracy and W. T. Pike, *Manchester and Salford at the close of the nineteenth century,* 1899, and *RIBA Journal,* vol. 13, pp. 393–4; for Heathcote see Tracy, *op cit.,* and *RIBA Journal,* vol. 45, p. 410; for Darbyshire see his *An architect's experiences; professional, artistic, and theatrical,* 1897; and *RIBA Journal,* vol. 15, p. 540; for Wood see J. H. G. Archer, 'Edgar Wood: a notable Manchester architect', *Transactions of the Lancashire and Cheshire Antiquarian Society,* vols 73–4, 1963–64, pp. 153–87; for Percy S. Worthington (Sir) see *RIBA Journal,* vol. 46, pp. 950–1.

[26] See chapter six, n. 3.

had been dropped altogether, although under the editorship of T. Raffles Davison (1853–1937) the contents continued to represent northern and, particularly, Mancunian architectural activities.[27] The inexorable exodus continued, and by the Edwardian era the pattern was pronounced. Charles Heathcote, Barry Parker (1867–1947) and Raymond Unwin (1863–1940) moved south, and even Edgar Wood, whose reputation as a northern architect was then firmly established in Britain and Germany, hovered. Despite this trend, at the end of the century Manchester's architects were numerous and well organised professionally. Slater's directory of 1900 lists 164 individual architects, and of these sixty-nine were Fellows and fifty-five Associates of the Manchester Society of Architects, a body affiliated to the Royal Institute of British Architects, but the great days of provincial independence and opportunity were past.

Architecture is the major form of expression in the visual arts in Manchester. Patronage extended far beyond the resident architects, and almost all architects of national reputation are represented in the city or its region. In addition to those already mentioned, Basil Champneys (see chapter nine), Austin and Paley, George Basevi, G. F. Bodley, William Butterfield, C. R. Cockerell, J. A. Hansom, the Pugins, father and son (A. W. N. and E. W.), Scott and Moffatt, George Gilbert Scott alone, his son J. Oldrid Scott, Edmund Sharpe, Robert Smirke, Leonard Stokes, and C. F. A. Voysey are among them.[28] Mostly they are represented by handsome suburban churches, and at least four of these are outstanding works of their architect and their day. Basevi's St Thomas's, Stockport (1822–25), Scott's St Mark's, Worsley (1846), Bodley's St Augustine's, Pendlebury (1871–74), and Austin and Paley's St George's, Stockport (1896–97) are works of national importance, and there are others to rank with them, not excluding a magnificent church of Waterhouse's post-Mancunian years, St Elisabeth's, Reddish (1879–83). These widely spread buildings belong to metropolitan Manchester and reflect a patronage that denied narrow provincialism.

Unlike architecture, painting and sculpture did not have a strongly independent place in Manchester's life but were introduced principally by London artists, although not necessarily those of popular established reputation, as is shown by Julian Treuherz in his account of what became Manchester's most remarkable act of purely artistic patronage, the commissioning of the murals for the new Town Hall (chapter seven). Similarly, Elizabeth Conran and Stuart Evans in chapters three and ten, respectively, describe

[27] Davison was editor from 1878–1919. He made his professional début by winning the MSA President's Prize in 1876–77 with a group of sketches. Thomas Worthington was the president. He became an outstanding architectural illustrator. See *Raffles Davison. A record of his life and work from 1870–1926*, eds. Maurice E. Webb and Herbert Wigglesworth, 1927, and *RIBA Journal*, vol. 44, p. 753, 22 May 1937.

[28] Cecil Stewart, *The architecture of Manchester*, 1956, and *The stones of Manchester*, 1956.

notably independent acts of discerning private patronage. Of these perhaps the most surprisingly adventurous are Samuel Barlow's early purchase of the paintings of Pissarro, **32**, and C. J. Galloway's equally remarkable taste for the same artist and Degas. Galloway was an industrialist with a taste for *plein-air* paintings and Barlow was a bleacher, living and working in harsh setting of the textile towns between Manchester and the Pennines.[29]

There were no Manchester painters of major standing, although the city's art collection contains numerous works by local artists of notable talent and individuality, e.g. Isabel Dacre (1844–1933), some of whom are mentioned in chapters one and three. The Manchester school of the 1870s gained wider recognition, and the reputations of some of its members, e.g. Fred Jackson (1859–1918), are now benefiting from a renewal of interest. However, it is an expatriate French artist, Adolphe Valette (1879–1942), who made Manchester his home about the turn of the century, who has gained the widest posthumous fame as a Manchester artist, with a series of paintings which evocatively capture the atmosphere and diffused light which can miraculously transform even Manchester. Although strictly post-Victorian, they portray the late Victorian city with remarkable sensitivity.[30]

Several well known Victorian artists had strong local connections. Of these Frederic Shields (1833–1911) and Randolph Caldecott (1846–86) are the most familiar, but Alfred Darbyshire, in his *An architect's experiences*, mentions a number of artists whom he knew in Manchester before they made a wider reputation. He recalls that in the days of his pupilage, the late 1850s, he and others formed a group who used to meet regularly to practise life drawing, and that among these was Luke Fildes (1843–1927), then 'undergoing the drudgery of a school of art training at Warrington'.[31] Fildes went on to the Royal Academy schools, as did other talented students such as Clarence Whaite (1828–1912), who became a well known water-colourist. Similarly Annie Swynnerton (1844–1933) (see chapter one) moved on to London but via Paris rather than the RA schools.[32] A biographical note on Whaite observes of his career that 'throughout [it] had been associated with, though not confined to, Manchester'.[33] This was probably true of most local artists of ability, but in contrast with the numerous snubs and defeats suffered by their early Victorian *confrères*, as recounted by Stuart Macdonald (chapter one), later artists apparently enjoyed both social standing and a social life. Alfred Darbyshire describes how resident artists, migrants, and distinguished visitors used to

[29] See *F. W. Jackson (1859–1918)*, Rochdale Art Gallery catalogue, 1978. Edgar Wood came from the same seemingly unpromising locality.

[30] *Adolphe Valette*, Manchester City Art Galleries, 1976.

[31] *Op cit.*, pp. 28–9.

[32] Lawrence Haward, *Paintings by Mrs Swynnerton, ARA*, Manchester City Art Gallery, 1923.

[33] W. Burnett Tracy and W. T. Pike, *Manchester and Salford at the close of the nineteenth century*, 1899, p. 246.

meet and enjoy each other's company in the convivial respectable Bohemianism of the Brazenose Club, whose membership largely consisted of artists, actors and writers.[34] The turning point was probably the success of the Art-Treasures Exhibition in 1857, which was followed almost immediately by the establishment of the Manchester Academy of Fine Arts in the following year.

Sculpture, the most neglected of the visual arts of the Victorian age, is well represented in the city's public spaces and in and on some principal buildings.[35] Commemorative statuary predominates and there are many examples by eminent and distinguished artists, including Sir Francis Chantrey (1781–1841), Thomas Woolner (1825–92) and Alfred Gilbert (1854–1934), as well as by others whose current standing is unequal to their contemporary success, such as William Theed (1804–91) and Matthew Noble (1817–76). The subjects are mostly public figures, national and local, especially those concerned with the movement that established Manchester politically, the Anti-Corn Law League.[36] The Town Hall has a particularly extensive collection of statuary and, soon after building commenced, the principal waiting area, a vaulted hall adjacent to the main entrance, was redesignated the Sculpture Hall, and subsequently its walls were lined with commemorative busts.

Among the city's statuary historical figures are in a distinct minority, but there is a seated representation of Humphrey Chetham by Theed (1853) in the Cathedral, and elsewhere both a bust and a statue of Cromwell by Matthew Noble (1861 and 1874). The bust is in the Town Hall and the statue, which was intended for that location until it proved too large in scale, used to stand in Victoria Street close to the Cathedral but has been moved temporarily to Wythenshawe Park. Scientists are represented by Dalton and J. P. Joule, respectively by Chantrey and Alfred Gilbert (1837 and 1893), and a copy by Theed (1857) of Chantrey's seated figure of James Watt (1832) is sited in Piccadilly. Busts of Elizabeth Gaskell, Thomas Harrison, Clarence Whaite and Sir Charles Hallé appear for the arts, respectively in the University Library, the Portico Library, the Art Gallery and the Town Hall. *Mrs Gaskell* (1831) is by David Dunbar (*fl.* 1815–38); the neo-classical portrait of Harrison, dated 1839 but unsigned, shows him in the style of an Ancient; John Cassidy's vigorously modelled *Whaite* (1896) shows him palette in hand, and Hallé is expressively portrayed in a bust by E. Onslow Ford (1897).

[34] *An architect's experiences*, 1897, pp. 82–8.

[35] Benedict Read's *Victorian sculpture*, 1982, provides an invaluable introduction both to the subject and to Mancunian works. A small selection of the latter is presented also in the *Courtauld Institute Illustration Archive 4, Late 18th and 19th century sculpture in the British Isles*, Part 6, *Greater Manchester*, 1978, ed. Benedict Read and Philip Ward-Jackson. Rupert Gunnis, *Dictionary of British Sculptors 1660–1851*, 1953, rev. edn 1968, also is indispensable.

[36] Cobden, Bright and Peel are commemorated in Manchester, the two former in several versions. Salford and most towns in south-east Lancashire also pay them similar homage. Salford, unfortunately, sold some of its principal statues to 'a collector of Victoriana' when part of Peel Park was adopted for use by the new university.

The grouping of the statuary in the main public spaces is indicative of Manchester's physical and political development. The principal national figures—Queen Victoria (Onslow Ford, 1897, frontispiece), Wellington (Matthew Noble, 1856), Peel (William Calder Marshall, 1853) and the copy of James Watt—are all in Piccadilly, which was the prime public place up to the completion of the New Town Hall *c.* 1877. The creation of Albert Square in 1863, commemorating the Prince by name and symbol, gave the opportunity of siting a further set of memorials, and these, in the form of John Bright (A. Bruce Joy, 1891), Gladstone (M. Reggi, *c.* 1878) and two local benefactors, Bishop Fraser, the second Bishop of Manchester (Thomas Woolner, 1887), and Oliver Heywood (A. Bruce Joy, 1894), represent the new Manchester of Liberalism and reform.[37]

St Ann's Square, the smallest of the major public spaces, has only two sculptures, a statue of Cobden (Marshall Wood, 1867), placed near the Royal Exchange, and a heroic martial memorial to combatants in the Boer War (Hamo Thornycroft, 1907).

Of the public statuary Onslow Ford's grandiloquent memorial celebrating the Queen's diamond jubilee is the most impressive (frontispiece). The seated bronze figure, voluminously dressed and depicted with careful realism in the full panoply of state, is placed in a neo-baroque setting, a mode popular at the turn of the century. This elaborate framework, executed in limestone presumably to show off the bronze to better effect, is of such a scale that as a free-standing monument it required some feature on the rear elevation. Here a niche is formed and a second bronze figure, of a young mother carrying her children, is introduced. The symbolism is made all too explicit by an inscription: 'Let me bear your love, I'll bear your cares'. The whole concept represents an extraordinary gesture of extravagant feeling but, although the design of the architectural device is of dubious merit, the principal figure is impressive by its dignity rather than richness of detail.

Stylistically the statuary ranges from such flamboyance to the quiet neo-classicism of Chantrey's *Dalton* (1837), in the Town Hall, and E. H. Baily's *Thomas Fleming* (1851) in the Cathedral. Unintentionally this is underlined by the juxtaposition of two of the city's finest sculptures, the seated figures of Dalton and Joule on each side of the main vestibule of the Town Hall. Alfred Gilbert's *Joule* (1893), strikingly expressive of mental power and concentration, also includes touches of this artist's characteristic Art Nouveau detail.[38]

The most locally popular of the Victorian sculptors appears to have been Matthew Noble. In 1857 the *Art Journal* described him as 'the "pet" of

[37] Oliver Heywood (1825–92), a son of the banker Sir Benjamin Heywood (1793–1865), devoted himself to education and philanthropy. See *Manchester Guardian*, 18 March 1892. Bishop Fraser (1818–85) was described as 'the Lancashire people's bishop'. See John W. Diggle, *The Lancashire life of Bishop Fraser*, 1889.

[38] See Benedict Read, *Victorian sculpture*, plate 435.

Manchester, to whom go all the "commissions" by which magnates of the city
seek to honour the living or the dead'.[39] He produced the statue of the Prince
Consort for the Albert Memorial (1865), and various other statues and busts of
the Prince and the Queen for Manchester and Salford. A list of his numerous
commissions includes sixteen, public and private, from local sources.[40] Much of
his work is orthodox, but his statue of Cromwell has a vigorous individuality. It
was considered 'the most spirited work that has come from [his] chisel', but
bronze was substituted for marble 'to stand in the dense air of Manchester'.[41]

Allegorical sculpture is rare and rather weak. The two principal examples
are both by John Cassidy (1861–1939), a local artist. For the Rylands Library
he carved in sandstone *Theology directing the labours of Science and Art* (c. 1893),
a complex composition of a group of classically robed figures with distinguish-
ing emblems. His *Adrift* (1907), a composition in bronze on the south side of
Piccadilly Gardens, is of even greater complexity and represents a shipwrecked
family exposed to the elements but surviving on a rock. Somewhat inaccurately
it is described as 'An allegory of compassion . . . humanity adrift on the sea of
life', but the certain message of the wave-like lines of the flowing hair and
intertwining limbs is of the expressionism of Art Nouveau.[42]

Architectural sculpture, like the statuary, ranges from the neo-classical to
the neo-baroque. The classical tradition is seen in Barry's Royal Manchester
Institution (1824–35), now the City Art Gallery, **10**, and Edward Walters's Free
Trade Hall (1853–56), the grandest of his *palazzi*, **4**. In both the sculpture is
incorporated into the principal facade: in the former discreetly, with small
framed reliefs representing the arts and sciences by John Henning, junior
(1801–57); and in the latter, with all the prominence of mid-Victorian pomp, in a
series of lunettes within the arches of the principal arcade in which trade and
industry are variously symbolised. Whereas the neatly modelled panels on
Barry's building contrast with the spare lines of the architecture, on the *palazzo*
the greater boldness and scale of the sculptures complement an already rich and
heavily modelled High Victorian masterpiece. Walters employed John Thomas
(1813–62), of London, who carried out extensive work on the Houses of
Parliament. Individually Thomas's panels are pedestrian—indeed, some detail
degenerates to the banal—but in their context and general effect they are
successful.

Unfortunately the richest source of neo-Gothic sculpture in Manchester,
Waterhouse's Assize Courts (1859–64), was demolished *c.* 1959–60 after

[39] June 1857, pp. 187–8.
[40] Gunnis, *op. cit.*
[41] *Architect*, vol. 12, 1874, p. 6.
[42] Cassidy was born near Slane, Co. Meath, and received his training in Manchester, London and
Paris. See *Manchester faces and places*, vol. 9, pp. 189–91, and *Manchester Guardian*, 13 December
1928. In addition to the allegorical group at the Rylands Library he was responsible for the
commemorative statues of John and Enriqueta Rylands standing, respectively, at either end of the
principal reading room.

suffering war damage, and the Town Hall (1867–77) provides no equivalent. Here Waterhouse employed sculpture only to add picturesque incident and surface interest where he thought it needed (see chapter six), whereas on the Assize Courts it played a major role and underlined thematically the building's purpose. It was executed by Thomas Woolner, a fine artist and an original member of the Pre-Raphaelite Brotherhood, and the highly talented O'Shea brothers, best known for their work at and summary dismissal from Benjamin Woodward's Oxford Museum (1855–60).[43] Remnants from the Assize Courts now form a small exhibition in the High Court of Justice in Crown Square, and from these it can be seen that in his earlier building Waterhouse appears to have indulged in a little imaginative medievalising and espoused the Ruskinian ideal of granting freedom to the individual artist.[44] A pair of capitals, attributed to the O'Sheas, depict medieval punishments with an imaginative vitality that is rare in the work at the Town Hall, and in an extraordinary way they are reminiscent of authentic Gothic work, but Ruskinian vitality is not totally absent elsewhere, as may be seen from Thomas Worthington's Police and Magistrates' Courts (1867–72) on Minshull Street, where the carving, although very limited in extent, is by Thomas Earp, who was responsible for that on G. E. Street's Royal Courts of Justice in the Strand (1866–81).[45]

Various commercial and office buildings about the city employ sculpture on a relatively minor scale, e.g. the former Watts's warehouse on Portland Street (Travis and Mangnall, 1856), once the city's largest warehouse but now an hotel. The best example, the former Education Offices, now Elliot House, on Deansgate (Royle and Bennett, 1878), designed in the Queen Anne mode, has elaborately designed sculptural treatment to the windows set in the building's heavily chamfered street corners. Beautifully executed in red sandstone, garlanded amorini, foliage and a curling wisp of an entablature brilliantly frame the baroque window openings, integrating perfectly with the fabric and enhancing and uplifting the design. However, sculpture is more dominant on two other public buildings: the Fish Market (1873), (Thomas Street–Oak Street) by Speakman Son and Hickson, where the bays of the screen walls contain large lunettes filled by figures dramatically portraying fishermen at work by Henry Bonehill; and the Central Fire and Police Station (1901–06), a lavish neo-baroque building filling a large island site and facing on to London Road. Designed by Woodhouse Willoughby and Langham, and faced and detailed in terra cotta, the design incorporates an elaborate programme of decorative sculpture which is skilfully introduced into friezes and within and without arches and segmental

[43] W. H. Acland and John Ruskin, *The Oxford Museum*, 1893 edn, 'On the Irish workmen', pp. 104–9.
[44] See 'The nature of Gothic', in *The stones of Venice*, vol. 2, 1851, chapter 6, § 12–14 (*Works*,
[45] Manchester City Council, report to General Purposes Committee, GPC Letter Book 5, p. 166, 10 August 1870.

entablatures.[46] Full-bodied, handsome classically styled figures with flowing garments, billowing cloaks and flame-like hair variously symbolise the diverse functions of the building and announce also the stylistic message of the turn of the century.

This rather extended introduction to Manchester's Victorian sculpture merely outlines a rich subject that awaits a systematic study that should enrich both art history and local history. The applied arts in Manchester have been similarly neglected. It is known that there were some splendid interiors by Messrs Crace, e.g. at Abney Hall, near Cheadle, and at the Assembly Rooms at Cheetham. The work at Abney Hall was carried out from 1852 to 1857 for James Watts, the merchant, who entertained Prince Albert there when he came to open the Art-Treasures Exhibition in 1857 (see chapter five). Several of the rooms at Abney still survive, but the sumptuous Assembly Rooms built by Mills and Murgatroyd in 1857, were demolished *c.* 1966.[47] They were made memorable by their extraordinary fusion of spaciousness and lighting. The rooms were hung with crystal chandeliers, whose effect was brilliantly magnified by the ingenious and extensive use of mirrors.

The Town Hall is the only major public building with original interior designs intact, and these reveal that the principal firms of Manchester decorators employed very skilful designers, **70**. Waterhouse invited not only tenders but the submission of designs for the public rooms and the corridors (see chapter six). Some credit belongs to Waterhouse, because he collaborated with the designers, but the resulting work is of an exemplary standard and gives further evidence of the quality of the patronage that could support such a high level of attainment. In 1898 the first exhibition of the Northern Art Workers' Guild, founded two years previously by Walter Crane (1845–1915), Edgar Wood and others, again demonstrated the capabilities of local designers and craftsmen in all fields.[48]

The development of the arts in Manchester conformed generally to the national pattern, but with several exceptional forms of expression that are primarily architectural; in particular the development of the *palazzo* style and its application to the commercial warehouse, as has been mentioned already, and the adoption of the High Victorian Gothic vocabulary which largely supplanted it in the 1860s. The *palazzo* style fitted Manchester's evolving needs like a glove. The limitations of any style depending on the orders, (i.e. the classical system of capitals and columns), were all too obvious by 1840, and the

[46] The identity of the sculptor has not been traced. The terracotta is by the Burmantoft company of Leeds.

[47] Messrs Crace were closely associated with Pugin in the execution of the decorative work on the Houses of Parliament and on numerous other commissions. See Phoebe Stanton, *Pugin*, 1971, and M. H. Port (ed.), *The Houses of Parliament*, 1976. Cecil Stewart gives a short description of the Assembly Rooms in *The architecture of Manchester*, 1956, p. 20. Messrs Crace also decorated the interior for the Art-Treasures Exhibition, 1857 (see chapter five).

[48] *Northern Art Workers' Guild catalogue*, 1898. See also that for the 1903 exhibition.

2 Milne Building, Mosley Street, c. 1839 (demolished 1972): the drawing exaggerates and almost caricatures the effect of the orders

architect's difficulties can immediately be appreciated by examining the Milne Building, **2**, of about that date, which stood on Mosley Street. Land was becoming expensive, so that multi-storey buildings were required to utilise a site to its full value, and iron-framed construction became a necessity to carry the heavy loadings of cloth bales.[49] The corollary of the frame was a regular bay size on a grid of from ten to twelve feet square (3–3·6 m). The convenient height for such buildings without modern lift services was limited to four or five storeys, i.e. sixty to seventy feet (18–21 m), and good natural lighting was required for working convenience and the inspection of cloth. The Milne Building eloquently demonstrated the unsuitability and expense of imposing the orders on a structure responding to such needs. In its design the orders were extended through two floors and then superimposed to obtain the necessary height. Further, the structural grid set up a rhythm that produced a bay too narrow for the height of the columns. The design was unconventional in that the giant order used was based on the Egyptian lotus column, but no class of order could function successfully when used in such a way. A new vocabulary of design was required. Within a stone's throw of the Milne Building site is the Athenaeum, **24, 25**, by Charles Barry, erected approximately simultaneously (see chapter two). Large enough to be a warehouse, although it does not have as many floors, it presented Manchester with a highly sophisticated, urbane style without the use of orders, that of the Italian Renaissance *palazzo*. Barry's design is historicist; it maintains the deep band of walling above the upper-floor windows that in Italy serves to keep the rooms cool and shady. Manchester architects quickly realised that such features were unnecessary and that the new style was wonderfully flexible and adaptable to their needs, **3, 4**. It imposed no restrictions on size, permitted construction in brick or stone and accommodated the regular bay system of frame construction without the slightest embarrassment. The Italian Renaissance architectural vocabulary provided ample but economical means for new formal arrangements, and tactile values could be exploited by contrasting brick and stone and introducing infinitely varied textural effects through different forms of rustication and vermiculation. The *palazzo* style was used nationally for commercial archi-tecture, but it proved to be particularly suited to the requirements of the textile towns on both sides of the Pennines, and in Manchester and Bradford especially. In Manchester it was handled with particular distinction and inventiveness by Edward Walters and J. E. Gregan, who used it with excellent effect on a whole range of buildings. Gregan died relatively young in 1855, but Walters, who arrived in Manchester in 1839 on the initiative of Cobden (who commissioned him to build his first Manchester warehouse at 16 Mosley Street, a building still extant), in the following twenty years gave Manchester some of

[49] Love and Barton, *Manchester as it is*, 1839, p. 201, cite as expensive an annual rental of 14s per square yard (c. 1836) for a site on Mosley Street to be used for warehousing.

3 Edward Walters: Edmund Potter's warehouse, 12 Charlotte Street, 1857. With one exception, the succeeding buildings along the street are also former warehouses by Walters. Potter's warehouse admirably illustrate his extension of the *palazzo* vocabulary

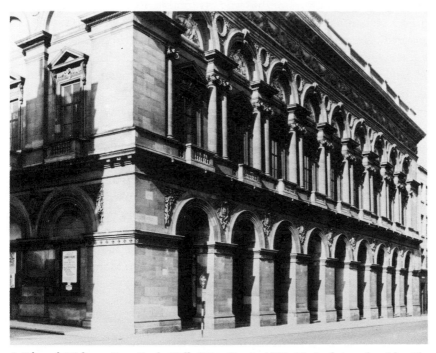

4 Edward Walters: Free Trade Hall, Peter Street, 1853–56. Sculpture by John Thomas. The interior of the hall was entirely redesigned and reconstructed after war damage

5 Alfred Waterhouse: Binyon and Fryer warehouse, Chester Street, Chorlton-on-Medlock, 1855–56 (demolished)

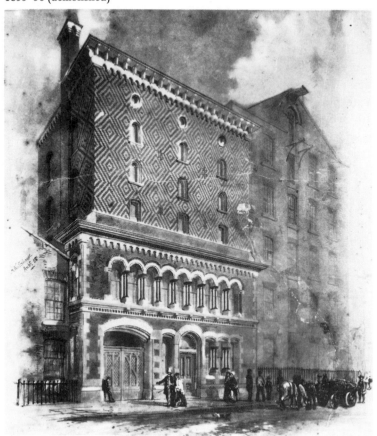

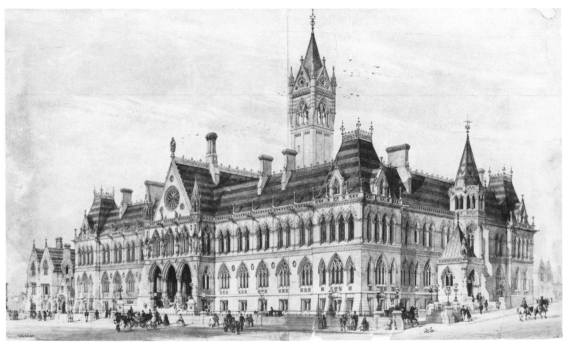

6 Alfred Waterhouse: Assize Courts, Strangeways, 1859–64 (demolished)

its best and most characteristic architecture, including the Free Trade Hall (1853–56), **4**. The south side of Charlotte Street, **3**, and the north-east facade of Portland Street still provide eloquent testimony to the architectural qualities he brought to commercial architecture through his imaginative adaptation of the *palazzo* vocabulary.[50]

Alfred Waterhouse appears to have been the principal instigator of Ruskinian Gothic architecture in Manchester. *The stones of Venice* appeared in 1851 and 1853, and Ruskin's Edinburgh lectures (*Lectures on architecture and painting*), with their telling architectural illustrations, were published in 1854, when Waterhouse was just commencing independent practice. He was a sufficiently keen Gothicist to become the local secretary for the appeal to commemorate Pugin, and embarked immediately on the architectural realisation of Puginian and Ruskinian ideals.[51] His design for his first major work in Manchester, **5**, the Binyon and Fryer building of 1855, a sugar warehouse in Chester Street, Chorlton on Medlock, now demolished, is heavily indebted to the Doge's Palace, one of Ruskin's favourite models. The Assize Courts (1859), won in an important competition, marked a further step in the evolution of High Victorian Gothic architecture nationally, **6**.[52] They drew high praise from Ruskin (see chapter six), and it can be seen from several of the designs submitted for the Town Hall competition of 1867 and 1868 that they were not without influence on other architects.[53] In the 1860s and '70s there was a proliferation of polychromatic buildings with steep Northern Gothic roofs, overhanging massing, and surfaces enriched by grotesque carvings and the colours and textures of highly polished granites, so that in 1896 the *Builder* commented that at one time 'the term "Manchester Gothic" was a kind of byword'.[54] In addition to the principal works of Waterhouse, among which the Town Hall holds prime place, there were conspicuous examples by Worthington (see chapter four, **41**, **43**), and Salomons, i.e. the Reform Club (1870) in King Street, as well as others by less distinguished firms.

The leading works in both the Renaissance and the Gothic styles are nationally important historically. The major *palazzi* are Gregan's Benjamin Heywood's Bank (1848) on St Ann's Street, and two buildings by Walters, the Free Trade Hall (1853–56) on Peter Street, **4**, and the Manchester and Salford

[50] See Henry-Russell Hitchcock, *Early Victorian architecture in Britain*, 1954, and 'Victorian monuments of commerce', *Architectural Review*, vol. 105, 1949, pp. 61–74.

[51] Waterhouse's development is outlined by Stuart Smith in 'Alfred Waterhouse: civic grandeur', in Jane Fawcett (ed.), *Seven Victorian architects*, 1976. He is listed as an honorary local secretary of the Pugin Memorial Committee in Benjamin Ferrey's *Recollections of A. W. N. Pugin . . .*, 1861, p.469 (rp. 1978).

[52] See Charles L. Eastlake, *The Gothic Revival*, 1872, rp. 1970, pp. 312–15.

[53] J. H. G. Archer, 'A civic achievement: the building of Manchester Town Hall. Part one. The commissioning', *Transactions of the Lancashire and Cheshire Antiquarian Society*, vol. 81, 1982, pp. 3–41.

[54] Vol. 71, p. 369.

Bank (1860) on Mosley Street, and, in addition, his most notable warehouses.[55] The three buildings by Waterhouse that have been mentioned already best represent the development of High Victorian Gothic. Examples from both schools received unexpected contemporary recognition in July 1861 in the parliamentary debate on the appropriate style, Gothic or Palladian, as Renaissance design was termed, for the Government and Foreign Offices to be built in Whitehall. Manchester's acceptance of secular Gothic was cited despite it being 'the city *par excellence* of Italian Renaissance'; and Palmerston referred to the Free Trade Hall as 'a splendid building in the Italian style' in answer to Lord John Manners, who in reinforcing his argument in favour of the Gothic style observed that 'No city could be more free from reactionary or mediaeval tendencies than Manchester; but in the architectural room of this year's exhibition, . . . was a plan in what might be called ultra-Gothic of a great public hall of justice now in course of erection in the city of Manchester'.[56] Clearly, Waterhouses's Assize Court design was regarded as a leading example of a new order of public architecture.

Mancunian social attitudes to the arts also generally matched those common to the age but, as might be expected, the city's peculiar circumstances are reflected in some particular local variations. In 1823, for instance, when it was proposed to establish an 'Institution for the Fine Arts' it was argued with more hopefulness than realism that the encouragement of the arts would create a community which would have 'the pleasing effect of removing prejudice, of softening the asperity of party feeling, and of fixing the public attention upon an object, with regard to which vehement differences of opinion can hardly be expected to arise'.[57] The stresses and strains of the immediate post-Peterloo years are barely concealed in such wishful utterances. Other considerations were touched upon by 'Mr Secretary Peel' in his letter of 13 January 1830 to the directors of the Institution informing them that in response to their appeal the King had agreed to present to the Institution a set of casts of the Elgin marbles. He explained that he had hardly felt himself warranted in making the request, 'But the peculiar circumstances of Manchester—its great population & importance—the close connection between the Fine Arts & the perfection of its Manufactures—their tendency to promote amongst its industrious Inhabitants the growing Taste for refined Amusement & intellectual cultivation' had emboldened him to lay the matter before the King whose 'splendid Patronage . . . has extended to every branch of Art'.[58]

The linking of manufactures and the arts appears to have occurred relatively early in Manchester. The select committee appointed 'to inquire into

[55] See Hitchcock, *op. cit.*, n. 50. The facades of the most palatial remain on the east side of Piccadilly.
[56] *Hansard's parliamentary debates*, 3rd series, vol. 164, 1861, 531, 536 and 529.
[57] Circular, 18 September 1823, included in an account of the origin of the Institution, Royal Manchester Institution Council Minutes, vol. 1, p. 19–24.
[58] *Ibid.*, pp. 281–2.

the means of extending a Knowledge of the Arts and of the Principles of Design among the people (especially the manufacturing population) of the country' was set up in 1835. Its recommendations led to the establishment in 1837 of the government sponsored School of Design at Somerset House, a step that quickly bore fruit in Manchester, as Stuart Macdonald relates in chapter one. However, in 1837 Benjamin Heywood (1793–1865), formerly a Lancashire MP, the founder and chairman of the Manchester Mechanics' Institute, inaugurated in 1825, had initiated the first of a series of exhibitions of arts and industries at the Mechanics' Institute. These were very successful: the first attracted 50,000 visitors and the second, held the following year, twice that number. The secretary at that time was William Fairbairn (1789–1874), the engineer.[59] In 1856 a sequel to these exhibitions included an exceptional collection of paintings, judged by the *Builder* to be 'a more extensive one than has ever appeared in the provinces'.[60] This was so conspicuously successful that it confirmed those planning the Art-Treasures Exhibition in their intentions (see chapter five).[61]

Some contemporary observers marvelled at the Manchester merchants' 'mania for art', but it is significant that despite the strenuous advocacy and support of Thomas Fairbairn (1823–91), who had been the chairman of the executive committee of the Art-Treasures Exhibition, Manchester did not acquire a permanent art gallery until 1882, twenty-five years after that great event, when the City Council adopted the building and art collection of the Royal Manchester Institution (see chapters one, three and four). Eight years later the opening of the Whitworth Institute, described by Francis Hawcroft in chapter eight, established Manchester's second major gallery, now highly distinguished by its collections of textiles and water-colours. The enthusiasm for the arts that produced the Art-Treasures Exhibition was accompanied also by ideas for civic improvement. In 1857 the need to provide a wide range of new and larger public buildings was seen as a means of achieving this, and there can be little doubt that the decisions taken some seven years later to site the Albert Memorial and the proposed Town Hall in the newly created Albert Square were a realisation of such concepts.[62]

Ruskinian ideals of art, architecture and society appear to have struck a particularly responsive chord in the city's artistic and intellectual conscious-ness. Ruskin lectured at Manchester in 1857, 1859 and 1864. On the first occasion he delivered his two famous lectures on 'The political economy of art' at the time of the Art-Treasures Exhibition (see chapter five); in 1859, at the annual meeting of the School of Art, he lectured on 'The unity of art' (published

[59] Leo H. Grindon, *Manchester banks and bankers*, 1878, pp. 188–9. Benjamin Heywood was made a baronet in 1837. Benjamin Arthur Heywood (1755–1828), his uncle, was the benefactor of the RMI.

[60] Vol. 14, 1856, p. 517.

[61] *Art-Treasures Examiner*, 1857, p. ii.

[62] *Builder*, vol. 15, 1857, p. 466. See also n. 53, Archer, *op. cit.*

in *The two paths*, 1859); and in 1864 he gave the two lectures that were published in 1865 as *Sesame and lilies*. On this visit he gave an address also to the Manchester Grammar School. The lectures on the 'Political economy of art' are among the most important of those on his social principles; they were later republished as *A joy for ever* (1880), and *Sesame and lilies* gained the widest currency of any of his works. By 1905 it had reached its thirteenth edition and 160,000 copies had been printed.[63] None of this, however, explains why Ruskin's views attracted such attention in Manchester as to lead in 1879 to the creation of the Ruskin Society of the Rose, which stimulated the formation of branches in London, Glasgow and elsewhere (see chapter ten). Ancoats, Manchester's most notorious industrial district, witnessed two particular developments of Ruskinian art-socialism. The first was the Manchester Art Museum and University Settlement, founded by T. C. Horsfall (1841–1932), in which Ruskin took a personal interest from 1877. The second was Charles Rowley's Ancoats Brotherhood, founded in 1889.[64] Its objects were primarily social and educational in the broadest sense, and to support them Rowley succeeded in drawing upon the services of such gifted individuals as William Morris, Bernard Shaw, Burne-Jones, Walter Crane and Prince Kropotkin. Rowley and the society are described more fully by Stuart Evans in chapter ten.

The final manifestation of the Ruskinian inspiration is seen in the translation of art and manufacture to arts and crafts through the medium of the Northern Art Workers' Guild, founded in 1896. Walter Crane (1845–1915), who was deeply involved with the London-based Arts and Crafts Exhibition Society, founded in 1887, was for a short time head of design at the Municipal School of Art and was the Guild's prime formal instigator. Exhibitors included national figures, such as Crane and Lewis F. Day, as well as distinguished northern artists, i.e. William Burton, of Pilkington's, and Edgar Wood, who was the first Master of the Guild and appears to have been its mainstay in its early years. Two major exhibitions were held, one in 1898 at the City Art Gallery, the other in 1903. A very attractively designed and printed catalogue was produced for each and, following the practice of the Arts and Crafts Exhibition Society, each contained essays on design and the crafts. A notable contribution in the 1903 catalogue is 'Cottages near a town' by Barry Parker and Raymond Unwin. This is an early illustration of their developing ideas on house design and the planning of residential areas, later expressed in the garden city movement and, ultimately, in Parker's scheme of 1927 for Wythenshawe.[65] Manchester's response to the ideal of art for society, one of the most potent of radical ideas in

[63] *Works*, vol. 18. p. 5.

[64] *Manchester Guardian*, 5 March 1889. Numerous pamphlets and cuttings on the Brotherhood are held in the Local History Library of Manchester Central Reference Library. See also Rowley's *Fifty years of work without wages*, n.d. (1911).

[65] Walter L. Creese, *The search for environment*, 1966. The Wythenshawe scheme was partly executed before 1939. Later development is of a very different character.

the late Victorian era, was by no means negligible, and in 1904, four years after his death, fitting tribute was paid to Ruskin, its great protagonist, by the presentation at the City Art Gallery of the largest exhibition of his works that had been shown up to that date. The catalogue lists 542 entries, some covering more than one item.[66]

If the building of the Royal Manchester Institution is the first signal event in the development of art and architecture in Victorian Manchester, clearly the building and decoration of the new Town Hall are their climax. As an achievement it is of a scale, significance and permanence that outstrips all others. With St George's Hall, Liverpool (1839–56), first designed by H. L. Elmes and completed by C. R. Cockerell, and Leeds Town Hall (1853–58) by Cuthbert Brodrick, it ranks as a major work of the Victorian age, produced, as Robert Kerr remarked, when the provincial cities were 'able to build quite as grandly as the Government, and much more independently of control'.[67] Although when it was finished High Victorian Gothic was outmoded and it received little critical attention, by the end of the century its architectural qualities were being perceived. In 1896 the *Builder*, then under the editorship of H. Heathcote Statham (1839–1924), drew attention to these in an extraordinary way. It acknowledged as a truism that the building was most generally regarded simply as a technical feat of planning, attributed such limited opinions to those who had never seen it, and corrected them by pointing out that 'a deliberate study of the actual structure shows that to hold such an opinion is to seriously under-estimate the merits of one of the very few really satisfactory buildings of modern times'.[68] A detailed analysis concluded with the prophetic judgement that 'In after years it will probably be accounted one of the most excellent works which the nineteenth century has bequeathed to its successors'. Nikolaus Pevsner, who quoted this in his *South Lancashire* volume of *The buildings of England*, added with characteristic authority and astringency, 'We of the later twentieth century have no hesitation in subscribing to this statement.'[69]

The attainments of its High Victorian architects still give Manchester a distinct identity. The surviving portions of the original streets are more unified than is usually appreciated. Many buildings had a common purpose, the commercial warehouse being the staple building type, with similar characteristics, a standard height of approximately sixty or seventy feet (18–21 m), a common range of materials, and a related vocabulary of well executed detail. All this made for coherence, but the influence of highly talented designers cannot

[66] J. S. Dearden, 'Ruskin exhibitions: 1869–1969', in his *Facets of Ruskin*, 1970.

[67] James Fergusson, *History of the modern styles of architecture*, 3rd edn, 1891, ed. Robert Kerr, vol. 2, p. 165.

[68] Vol. 71, 'The architecture of our large provincial towns. II. Manchester', pp. 369–80. See pp. 369–70.

[69] *Ibid.*, p. 371, and Pevsner, *op. cit.*, p. 281.

be ignored. Who could have known what excellence next to expect in the brief period when Walters, Waterhouse and Worthington were all at work? They brought both individuality and urbanity to the streets and raised the architectural standard to reflect not merely a city with wealth, self-confidence and power, but one with the ideas and ideals of an identifiable culture. In this sense the foolish-sounding allusions that liken Manchester to the cities of the Italian Renaissance are justified.

The patronage of modern artists, the key to vital health in the arts, was neither lacking nor stereotyped once collectors ceased to ape past traditions. The Art-Treasures Exhibition of 1857 appears to have been a great revelation both to Mancunians and to the art world, as is described in chapter five, and its presentation of modern painters may well have provided the spur for the collection of the Pre-Raphaelite paintings that now distinguishes the city's gallery. Forty years later Alfred Darbyshire recalled the exhibition as 'ever memorable', particularly for its presentation of Duecento and Pre-Raphaelite art. He wrote that he would 'never forget the wonder and admiration with which I contemplated "The Procession of Cimabue's Madonna" and the immortal "Autumn Leaves"'.[70] The Pre-Raphaelites were certainly popular locally, and Ford Madox Brown gained a very strong Manchester following. The catalogue to the exhibition of works by him and the Pre-Raphaelites held at the City Art Gallery in 1911 records that twenty exhibits were loaned by Henry Boddington alone. In chapter ten Stuart Evans describes how in a remarkable way Boddington (1849–1925) combined brewing, social reform and such discerning art patronage. Other chapters, too, indicate that Manchester possessed men exceptional alike in business and patronage. Among them John Edward Taylor (1830–1905), the proprietor of the *Manchester Guardian* and the *British Architect*, is outstanding not only for his remarkable art collection but for his princely gift of paintings to the Whitworth Institute. It included works of such quality that, as Francis Hawcroft observes in chapter eight, it formed 'the nucleus of its now internationally known collection of British water-colours'. The principal distinction of both of Manchester's public galleries, therefore, lies in collections of what were relatively modern paintings.

Sculptors as well as painters benefited from the extensive scale of local patronage and, as has been indicated, its informed character may be judged from the number of works that were commissioned from artists of the first rank. Only a careful survey of institutions, churches and records will reveal the full extent of what exists and what existed. St John's Church, for example, demolished in 1928, contained Flaxman memorials to the Rev. John Clowes (1819) as well as Woolner's to John Owens (1878), the merchant and founder of the college which is the present university. This memorial is now displayed in

[70] *An architect's experiences*, 1897, p. 24.

the university's principal entrance, but the Clowes memorial was lost in 1951
when St Matthew's, Campfield, was demolished.[71]

The high peak of Manchester's artistic life occurred in the High Victorian
era (c. 1850–70), but the following decades were full of vitality although it was
less concerted than in the immediately preceding period. In 1877 William
Morris summed up the contemporary architectural situation in a letter to the
Athenaeum, describing it as being 'at present in a wholly experimental
condition, as I suppose I need scarcely call on London streets to witness; . . .'[72]
The circumstances in Manchester were no different. The following year E. W.
Godwin (1833–86), Whistler's architect and a hero of the hour, lectured to the
Manchester Architectural Association on 'Some buildings I have designed'. The
lecture is of special interest because it is one of the few that Godwin gave of
which there is a reasonably adequate record.[73] Godwin dismissed the past
styles, said that the current fashion for the Queen Anne style would be
superseded 'as steam would be superseded by electricity', and advised his
young audience if asked what style their work was to reply, 'It is my own.' Such
individualism was a principal force among the swirling tides and currents of the
advanced free-style architecture of the turn of the century. Manchester has
several notable examples: Basil Champneys' Rylands Library (1890–99),
carefully interpreted by John Maddison in chapter nine, presents a complex
example of Art-for-Art's sake Gothic despite its apparent historicism, see, **109,
114, 115**; whereas Charles Heathcote's Parr's Bank (1902), on the corner of
Spring Gardens and York Street, is a curious amalgam of baroque and Art
Nouveau; and Edgar Wood's First Church of Christ, Scientist (1903–07), now
the Edgar Wood Centre, in Victoria Park, **7, 8**, proclaims stylistic agnosticism
and artistic individualism in the boldest terms. It is Manchester's leading
example of Arts and Crafts architecture, and Sir Nikolaus Pevsner considered it
a building 'that would be indispensable in a survey of the development of C20
church design in all England'.[74] These three buildings are mature examples of
the late Victorian revolution in taste, and all stand within or in close proximity
to the city, but on the southern fringe of the conurbation, at Wilmslow, is the
only major work of A. H. Mackmurdo's Century Guild, a seedbed of modern
Victorian design in what has been called English 'proto Art Nouveau', **117**.[75] It
is at Pownall Hall, **124–6**, once the home of Henry Boddington, who

[71] Nicholas Penny, *Church monuments in Romantic England*, 1977, pp. 156–7, plate 117.

[72] 7 April 1877; see May Morris, *William Morris, artist, writer, socialist*, 1936, vol. 1, p. 108.

[73] *British Architect*, vol. 10, pp. 210–12.

[74] *The Buildings of England. South Lancashire*, 1969, p. 48. See also n. 25, Archer, *op. cit.*, and Tim
Benton, 'Great Britain: Arts and Crafts and Art Nouveau', in *Art Nouveau architecture*, ed. Frank
Russell, 1979. Vandals destroyed many decorative features in 1971–72, but the main fabric has been
restored by Manchester Corporation, its present owner.

[75] S. T. Madsen, in *Sources of Art Nouveau*, 1956, and *Art Nouveau*, 1967, p. 85 and 241, n. 7,
respectively.

7 Edgar Wood: First Church of Christ, Scientist, Daisy Bank Road, Victoria Park, 1903–07. Now the Edgar Wood Centre. Front elevation

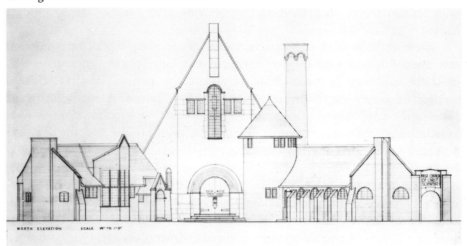

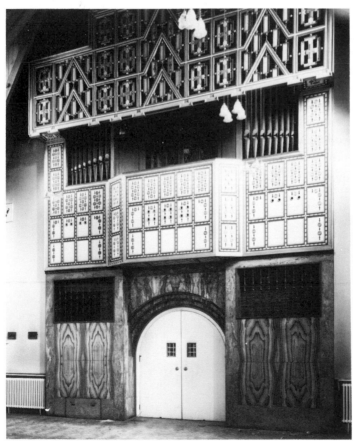

8 Edgar Wood: First Church of Christ, Scientist, Daisy Bank Road. The form of the open screen to the organ, is inspired by Arabic screens inserted into windows

commissioned the work *c.* 1886, and it is a principal subject of the concluding chapter.[76]

A revaluation of Manchester's Victorian art and architecture has long been needed. Until relatively recently it was largely ignored, and it was popularly supposed that the city's only claims to cultural distinction were through the *Manchester Guardian* and the Hallé orchestra. Old myths die hard, and even the veteran demythologiser A. J. P. Taylor, who knows the city well, has confirmed this unfortunate legend despite his perceptiveness in other matters and a declared interest in architecture.[77] In a striking essay published in *Encounter* in 1957 he writes of the city as the 'symbol of a civilisation . . .', but he presents it as 'irredeemably ugly' and architecturally indifferent. Ugly or beautiful—subjective responses—its architecture was not indifferent and its history presents a variety of appreciable and coherent aesthetic values expressed in some major achievements of the age. More recently Mr Taylor has acknowledged the Town Hall's magnificence, but in referring to the Victorian city he knew in the 1930s he sadly observes, 'Manchester was a great city. Now it has all gone; Manchester is a bright, clean city.'[78] Modern Manchester is undoubtedly cleaner and brighter, no one can regret that, but despite war, redevelopment and vandalism much remains that is eloquent of a great Victorian city in its prime. This book may incidentally dispel some historic misconceptions, but its purpose is to illustrate that art and architecture were vital elements quickening Manchester's life, and that in quality they merit attention and were commensurate with other Mancunian achievements. Both those who doubt and those who concur with these claims may here find a record for their guidance and, better still, they may yet see and judge for themselves.

[76] See also Nikolaus Pevsner and Edward Hubbard, *The buildings of England. Cheshire*, 1971, pp. 385–86. Pownall Hall is now used as a private school.

[77] A. J. P. Taylor, *A personal history*, 1983, p. 273.

[78] *Op. cit.*, n. 1, both articles, respectively pp. 3 and 4, and p. 334.

The Royal Manchester Institution

Two fine Greek Revival buildings survive in Mosley Street to remind us that in 1824 it was described as the 'handsomest street in Manchester',[1] and that in the days of George IV it was the centre of the town's intellectual activity, **9**. Of the two, the Portico Library of 1802–06, by Thomas Harrison (1744–1829), still continues as founded, but the second, of 1824–35, by Charles Barry (1795–1860), now the City Art Gallery, **10**, was originally the home of the Royal Manchester Institution, the body which initiated annual art exhibitions, public art education, and a permanent art collection in Manchester.

The idea of forming an art institution arose in the summer of 1823 during a visit to Leeds by two Manchester artists, David Parry and Frank Stone, ARA (1800–59). They were accompanied by an art-loving gentleman, William Brigham, who wrote that they 'went in Company to view the Exhibition of Painting and Works of Art in the Northern Establishment held at Leeds', and that their reaction was 'Why can we not have such an exhibition in our own Town?'[2] The three consulted Daniel and Peter Jackson, 'Carvers, Gilders, and Printsellers by Appointment to their Majesties—Looking Glass, Convex Mirror, and Picture Framers', and local artists were invited to discuss 'an annual Exhibition of Works of Art'; thus the first meeting of the Associated Society of Artists of Manchester was held on 6 August 1823 at the Jacksons' house at 1 Spring Gardens. There were present some seventeen artists, including Frank Stone, and Charles Calvert, the landscape artist, who ran a drawing school known as the Academy at 17 Lloyd Street. William Brigham and Thomas Dodd were the two 'gentlemen' present.[3]

To secure patrons it was decided that a circular be sent out to the local noblemen and gentlemen. Thomas Dodd (1771–1850), a notable print and

[1] Royal Manchester Institution, Committee Minutes, vol. 1, p. 66, 5 April 1824. An extensive collection of RMI papers is held in the Archives Department, Manchester Central Library. All RMI documents henceforth cited are from this source.

[2] Society of Associated Artists of Manchester, Minutes, 6 August 1823. An account of the founding of the society, with the early minutes, is tipped in to the front of the first volume of the RMI Committee Minutes.

[3] *Ibid.* and RMI Cash Book CI No. 107.

9 J. Fothergill: Mosley Street in 1824, viewed from the Portico Library. The farther cab stands outside Dr Henry's house

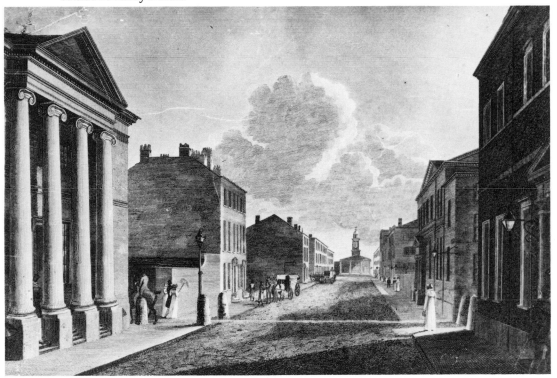

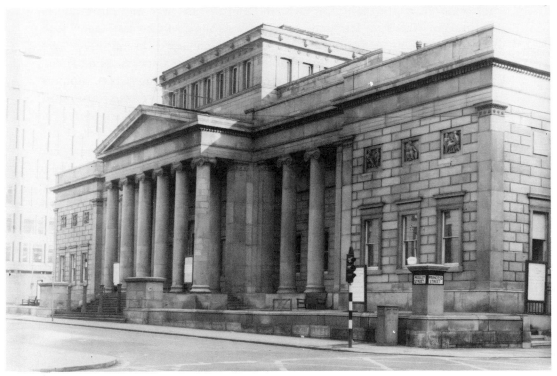

10 Charles Barry: Manchester City Art Gallery (formerly the Royal Manchester Institution), 1824–35, *c*. 1975

picture dealer, whose former auction rooms had been in St Martin's Lane, London, and who now had his rooms at 20 King Street, proposed that such noblemen and gentlemen as were interested could sign a book he would leave open there, and that further meetings should be convened at his rooms.

By the seventh meeting of the Associated Artists, on 5 September, there were sufficient gentry but no nobility. This meeting was convened to consider forming 'an Institution to promote the Fine Arts and to establish an Annual Exhibition of the works of living artists'. The modern reader may be surprised to learn that the artists now allowed the gentlemen to take over the project. The minutes state, 'The Gentlemen then constituted a Committee of the following persons with liberty to add to their number.' No artist is listed. The gentleman elected to the chair was Dr James Davenport Hulme, MD (1774–1848), a prosperous physician. It was an historic choice. Dr Hulme was to continue as their devoted chairman for nearly a quarter of a century, and establishing the Institution became his main interest. In spite of his devotion and the respect shown to him by his important contemporaries, he is now an obscure figure. E. M. Brockbank, who in 1904 wrote a detailed biography of all the other early physicians of the Manchester Infirmary, admitted that he could find out only that Dr Hulme 'enjoyed a large practice'.[4]

Arthur Perigal, speaking on behalf of the Artists, asked the gentlemen that the profits of the annual exhibitions be used for the benefit of the Artists, and for the purchase of books of prints and 'plaister casts such as were adapted to assist the artists in their labours . . .'. But he added that 'the prominent object, which the artists felt the necessity of, was the erection of a larger room with a lantern light . . . to display works of Art' and 'a smaller room adapted as a study for the Artists and fitted up with Books of Prints and Casts from the Antique for general consultation'.[5] The Artists' lowly aims may have amused the hard-headed Manchester gentlemen of the committee, who were sure plenty of funds could be raised provided there was a large institution of solid stone, brick and mortar as collateral security for share capital.

Thomas Swindells, writing some eighty years later, observed, 'The population of the town . . . was divided into two classes, the somebodies and the nobodies.'[6] A few gentlemen had become somebodies by paying £70 for owner-membership of the Assembly Rooms, also in Mosley Street, but the more serious-minded became patrons of restricted literary, philosophical, musical, artistic and scientific institutions where they could meet socially: such were the committee of gentlemen at the Artists' meeting. So certain of support were these gentlemen that seven of them, including Dr Hulme, Robert Christie, William Brigham and G. W. Wood, went ahead and purchased for £5,750 a stretch of

[4] E. M. Brockbank, *Honorary medical staff of the Manchester Infirmary*, 1904, p. 268.
[5] Associated Artists, Minutes, 5 September 1823.
[6] Thomas Swindells, *Manchester streets and Manchester men*, 1st Series, 1906, p. 193.

property, consisting of the large house in King Street in which Dodd had his rooms, a warehouse and stables in Brown Street, and a block of offices in Spring Gardens, all belonging to a Colonel Ford of Sandbach. Shares at £50 each were offered in the new venture, and on 24 September Sir Oswald Mosley wrote to G. F. Bury, the secretary to the committee of the proposed institution, taking up £250 worth. Sir Oswald, whose family had given Piccadilly to the public, still owned much of the land in the town centre. Surely Manchester merchants would follow the example of the lord of the manor? The committee replied immediately, asking him to chair a public meeting in the Exchange for the important business of establishing the project. Mosley excused himself, as he was expecting some 'friends on Tuesday or Wednesday who are coming to shoot'.[7]

The meeting, chaired by Dr Davenport Hulme, was described as a 'General Meeting of the Inhabitants of Manchester held at the Exchange Rooms on Wednesday 1st of October 1823 to take into consideration the suggestion of an Establishment in Manchester for the encouragement of the Fine Arts'.[8] The first resolution to be passed was

> That the diffusion of a taste for the Fine Arts in this populous and opulent district by establishing a collection of the best models that can be obtained in Painting and Sculpture, and by opening a channel through which the works of meritorious Artists may be brought before the public, and the encouragement of Literary and Scientific pursuits by facilitating the delivery of popular courses of public lectures, are objects highly desirable and important.

The second was 'That for these purposes a Society be now formed to be denominated The Manchester Institution for the promotion of Literature, Science and the Arts'. Thus the Institution came into being. As far as the Associated Artists were concerned it was ominous that Literature and Science were given equal prominence to 'the Arts', and that the latter were in the plural. These areas embraced all knowledge.

Manchester men, if weak on art, were strong on capital. Hereditary governorships of the new Institution were offered at forty guineas, life governorships at twenty-five, and annual governorships at two guineas per annum. Within twenty days of the meeting a hundred hereditary governors, five life governors and sixteen annual governors had enrolled and promised £4,000. By December £11,000 had been subscribed. An institution of high status was now possible, so on 28 January 1824, with Gilbert Winter, Boroughreeve of Manchester, in the chair, it was resolved 'That an application be made, through the proper channel to His Majesty the King, most humbly to request that he will be graciously pleased to confer on this Institution the high

[7] Sir Oswald Mosley, Rolleston Hall, Burton on Trent, to G. F. Bury, 24 and 28 September 1823, RMI letters, New Guard Book.

[8] RMI Minutes of First Meeting, 1 October 1823, vol. 1, p. 1.

honour of his Royal Patronage'. The rush of registered governors in the next month raised the capital to over £20,000. Then, to make the public aware of the existence and identity of those who could expend £40 apiece on culture, the Institution paid for a notice of their names in the Manchester and Stockport papers, and they became somebodies.

The nobodies most dazzled by all the golden guineas were the Associated Artists. All they wanted was a room somewhere. Frank Stone, one of the three originators of the whole scheme, had grown impatient, and George Frederick Bury, the secretary of the Institution, who was a prosperous solicitor, had obviously forgotten who this nobody was, for he reported 'that he had been applied to by Mr Stone an Artist who wishes to have the use of the room at the top of the stairs (in the King Street rooms), at present blocked off . . .'.[9] Then on 23 February 1824 the chairman of the Institution 'noted that Mr Faulkner had requested on behalf of the Artists of Manchester, that a temporary room might be provided for their work . . .'. The reply was brusque. It was ordered 'that the Chairman be requested to inform Mr Faulkner that such an arrangement cannot be made under present circumstances'. Another of the Associated Artists, by name Mather Brown, sought remuneration by submitting a design for an admission ticket for the Institution. The chairman was requested 'to state that for the present they cannot take the subject into consideration'. Yet another of the Artists bothered the Institution on 21 June, and the secretary recorded, 'The Chairman having read a letter from Mr Perigal with reference to a picture which he has painted resolved that the Secretary be requested to inform Mr Perigal that his letter has been publicly read in Committee, and that the thanks of the Committee be given to him for his obliging communication.'

Art had to wait. Uppermost in the minds of Dr Hulme and his committee was the erection of a building to accommodate art exhibitions, lecture theatres and the Museum of the Natural History Society, of which Hulme was a leading member; in the committee's words, 'combining an ample interior accommodation and chaste Architectural Design'. A large new building had been decided upon once the funds had topped £12,000, so the King Street property was sold and the quest began for a larger site in a more fashionable area.

Mosley Street was the obvious choice. At the Piccadilly end the elegant, brick Assembly Rooms (1790–92) ranged opposite the Portico, and closing the vista at the other end stood St Peter's Church (1788–94) by James Wyatt, 1, 9. A tower was being added to this church by Francis Goodwin at the time (1823–24). Some of the fine houses were owned by the doctors of the near-by Infirmary. Dr Davenport Hulme lived in this street of doctors, as did Dr William Henry, FRS (1774–1836), the brilliant chemist and friend of John Dalton.[10]

[9] *Ibid.*, vol. 1, p. 37, 6 December 1823.
[10] Brockbank, *op. cit.*, pp. 234–40; J. T. Slugg, *Reminiscences of Manchester fifty years ago*, 1881, pp. 249, 262, 265, 269.

Dr Henry's house, 26 Mosley Street, stood at the Bond (now Princess) Street corner and occupied the best site, 'standing detached from other buildings with spacious areas around it'. There was one drawback. The Henrys were in residence and did not wish to sell. However, on 11 March 1824 Robert Peel, the Home Secretary, wrote to Gilbert Winter, Boroughreeve of Manchester, informing him that he had submitted the prayer of the Institution to George IV the previous day, and 'His Majesty was graciously pleased to signify his consent'.[11] Dr Henry acquiesced rather than stand in the way of a Royal Institution, agreeing to 'let my own convenience give way to that of the public'.[12]

The Royal Institution thus acquired a plot of land 64 × 35 yards (52·425 × 32·004 m) bounded by Mosley Street, Nicholas Street, Back George Street and Bond Street, 11; and on 26 April the secretary wrote to six notable architects asking if they would submit designs in competition for the new building (see chapter two). Ultimately four designs were submitted and were judged by the committee of the Institution, which on 20 December met at twelve o'clock and unanimously decided that 'the plans with the Motto—Nihil pulchrum nisi utile—are the most eligible', 11. Barry, whose name was under a seal, had chosen his words perfectly to suit the Manchester men.[13]

The Institution now possessed the plans for 'an ornament to the town', as it was put, but the architects approached had already stated that the suggested £15,000 limit was unrealistic. The committee realised that at least another £8,400 was needed and were on the horns of a dilemma. More investments from Manchester merchants were unlikely unless some solid collateral was erected in the near future, yet the hereditary governors wished to save the rest of the £32,000 collected for a permanent capital fund which would yield interest.

To increase support it was decided to enlist the aristocracy as governors. Sir John Leicester of Tabley, Chester, was chosen as a go-between, and Barry's plans were taken to Tabley House by Dr Davenport Hulme and Gilbert Winter. Sir John (later Lord de Tabley) was a generous art lover, the patron of a gallery, and an incurable optimist. He contributed fifty guineas, and detailed a list of three dukes, two marquesses, five earls and others to whom he would write on behalf of the Institution. The response was cruel. Reform and revolution were in the air, and many aristocrats disapproved of attempts by liberal merchants to foster learning in industrial centres. Poor Sir John received abrupt replies which would have been considered rude and sarcastic in those days of polite correspondence. The royal Duke of Gloucester denied any connection with Manchester, as did Bedford and other nobles. Only a knight and two gentlemen

[11] Robert Peel, Whitehall, to the Boroughreeve of Manchester and T. Houldsworth, Esq., etc., 11 March 1824, RMI New Guard Book.

[12] Dr W. Henry, 26 Mosley Street, to G. F. Bury, April 1824.

[13] RMI Minutes, vol. 1, p. 115.

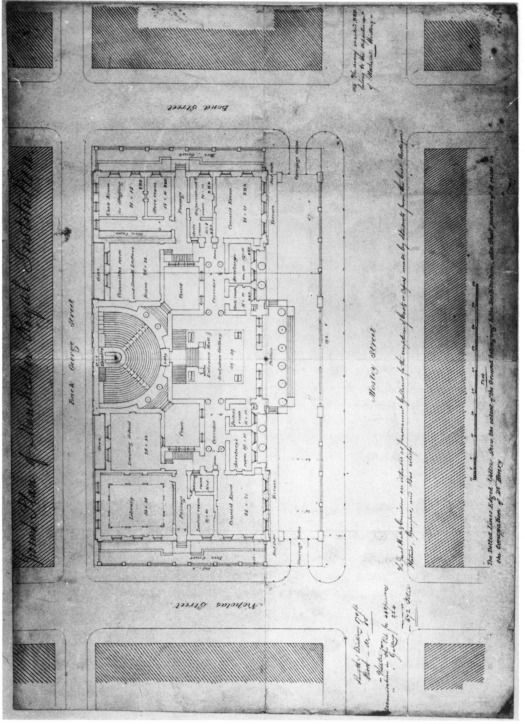

11 Charles Barry: the Royal Manchester Institution, 1824. The right-hand portion of the site (indicated by the dotted line) was owned by Dr Henry

agreed to be governors, but one of them, a Mr Fawkes, exploded with fright when he found he was expected to donate forty guineas. Sir John regretted extremely 'to observe the very narrow and parsimonious views entertained by some of them [the noblemen] in regard to the encouragement of Art'.[14]

In March 1825 the Royal Institution Apartments were established in Brown Street in the rooms of Bury, the Institution's secretary. The committee met there and in the same month engaged David Bellhouse of Manchester to erect the brickwork and masonry for the basement of Barry's building and to pave it with Yorkshire flags. Providentially, at this time of impatience, the first gift of an art collection arrived by canal and was stored in the kitchens under the Portico Library. The committee informed the papers that 'they have received magnificent presents of Casts and Antique Marbles from Jonathan Hatfield, formerly of Travis Isle, near this town, and a splendid picture of the destruction of a City by a Volcano from the artist Mr Pether'.[15] By 2 June 1826 the casts were repaired and listed, 'viz: Apollo, Apollino, Venus, Nymph with Cupid playing upon Lyre', etc., and from 9 August artists were admitted to the Portico cellars from 6.30 to 9.30 p.m. on Mondays and Tuesdays. Then in November the Institution offered ten guineas 'for the best drawing from Mr Hatfield's casts . . . to be executed in chalk to a scale of 4 inches to a foot'.[16] There was an equal prize for a design in street architecture. Sponsored art education of a sort had begun in Manchester.

The Associated Artists, delighted that at last there was some financial encouragement from the establishment they had initiated, quickly got down to work in the dim cellars. They hardly had time to square up and hatch a few inches when the Institution decreed 'That the prizes be confined to Students'. Manchester men did not intend to bestow gold upon professional nobodies. They saw themselves as merchant princes, their stated intention being to produce a young Raphael or two, despite the light in the Portico cellar not being quite Italian. The prizes were awarded in May 1827 and the results published.

The news that such large sums of money had been won by young men caused a crush in the cellar, and in March 1828, when the next awards were imminent, Henry Shepherd, secretary to the Artists, wrote in despair to the Institution: 'Gentlemen . . . We beg to intimate that we have been obliged to discontinue our attendance in consequence of the increased number of students (non-professional) being admitted to so small a room as well as having been requested to retire for their convenience . . .'[17]

[14] Sir John J. F. Leicester, Tabley House, to Dr Davenport Hulme, 7, 10, 31 January 1825, RMI New Guard Book.

[15] RMI Minutes, vol. 1, p. 133, 31 January 1825. A fine marble head of Hatfield (1793–1840) by Lorenzo Bartolini is now in the City Art Gallery's collection. Hatfield was a traveller, dilettante and art collector (M/cr C.A.G. description).

[16] RMI Minutes, vol. 1, p. 188, 13 November 1826.

[17] *Ibid.*, vol. 1, p. 243, 28 March 1828.

The Associated Artists had only themselves to blame for being ordered about and treated as nobodies by Mr Magnall, the keeper of the Institution. As far back as their fourth meeting, on 19 August 1823, Thomas Dodd had warned them that in the Institutions at Leeds and Bath, and others, 'the artists possess not an iota of power or influence . . . They are excluded from all meetings.' He had argued that the Artists should have a preponderance on the committee of the proposed institution. The Artists had ignored the warning and handed over complete power to the committee of gentlemen on the advice of the painter Arthur Perigal.

The Institution's prizes were drawn from the interest on £500 presented on 26 January 1824 by Benjamin Arthur Heywood (1755–1828), the banker, who in 1827 declined the presidency of the Institution.[18] In 1831, after his death, the Institution commissioned William Wyon of the Royal Mint to design a Heywood Medal, 12, and handsome gold or, later, silver medals were then awarded annually until the Institution's closure in 1973. A kind gesture was made by G. F. Watts, RA, when he was offered a gold for his *Mischief* in the annual exhibition of 1878. He wrote advising that it should be awarded to a young man. However, although in following years the exhibition committee awarded Heywood Medals to young artists, the recipients were artists who already had high reputations. At this time the whole ideas was to attract notable artists to exhibit in the Institution and thus bring in the paying public. Nearly half a century elapsed before the council of the Institution on 1 August 1883 resolved that all Heywood prizes would be awarded to students, quoting a precedent of 1854.

By the autumn of 1826 the hereditary governors had only the basement of their building to show for their investment, so the committee decided upon threefold action: a programme of lectures on chemistry, geology, zoology, poetry, and the art of painting; the first annual art exhibition; and a start on the building. To add to the financial worries of the governors there was at this time a serious slump in trade which was causing bankruptcies and great poverty in Manchester, so it was decided to contract for only the bare shell of the building. Lord de Tabley had written in August advising this, because of 'the beneficial effects that at this moment of distress might accrue from thus giving employment to a number of hands'. A tender of £15,566 for the shell was accepted from Trubshaw and Johnson on 27 April 1827, and the building began.

Letters about the proposed exhibition had been sent to Sir Thomas Lawrence, PRA, and to W. Linton, who gave advice and acted as contact man with London artists. Advertisements were placed in the press, and soon Bury, the secretary, was busy dealing with works arriving at the Apartments in

[18] Benjamin-Arthur Heywood, Liverpool, to Dr Davenport Hulme, 26 January 1824, RMI New Guard Book.

12 William Wyon: the Heywood Medal of the Royal Manchester Institution, 1831

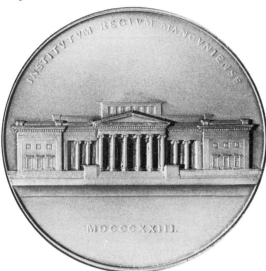

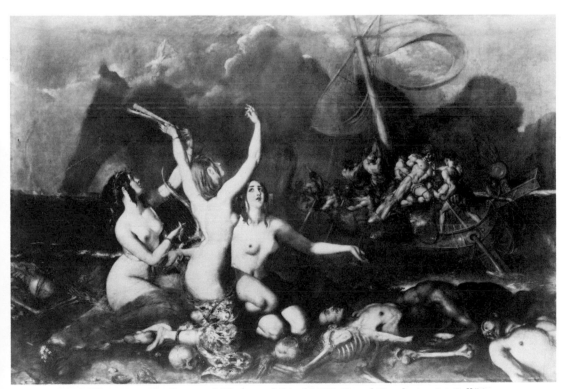

13 William Etty: *The Sirens and Ulysses*, exhibited 1837. *City of Manchester Art Galleries*

Brown Street. Unfortunately, this gentleman, who was solicitor to the Manchester Insurance Company, travelled south on the London mail on Sunday 2 March 1827. The horses bolted near Leicester and galloped three miles before the coach overturned, killing poor Mr Bury.[19]

'The First Exhibition for Paintings in Oil by Native Artists' was opened on 7 May 1827 in the exhibition rooms which Jacksons', the art dealers and decorators, had built next to their shop at 83 Market Street. On the 7th it was opened 'to the Governors and such Members of their families as are entitled to free admission, and on May 14th to the Public at large'. Admission cost 1s and the *Manchester Guardian and British Volunteer* announced 'Perpetual Tickets for the present Exhibition, five shillings each'. At a time when the average wage was below £1 a week there was no peril of any but the respectable classes attending.

Despite the rival attraction of a seventy-foot-long canvas of *Holyrood Palace by moonlight* at the Diorama in Cooper Street, the exhibition was a success. A profit accrued, and the first purchase of a major work for the collection was chosen from the exhibits, namely *Othello, or the Moor of Venice* by James Northcote, at thirty guineas. The idea was to buy at each annual exhibition an example by a famous artist to encourage others to exhibit and to serve as 'a best model' for local students. Another notable work, purchased at the exhibition of 1832, was *The storm* by William Etty, **30**. Another storm was created in 1838 when Etty's *The Sirens and Ulysses*, **13** was unloaded upon the Institution by an embarrassed Mr William Grant. Instead of being displayed, the three delectable ladies were hung face to the wall. There were a few months of constant turning for discreet inspection until it was resolved 'That the Council being of the opinion that the Picture lent to the Institution by Mr William Grant by being hung with its face to the wall will suffer injury, suggest to Mr Hindley and Mr Fraser the necessity of immediately hanging it the other way'.[20] Later the catalogue warned the susceptible that the picture conveyed 'a deep moral' in the 'certain death of the victims, who were unfortunately fascinated'.[21]

The shell of the building was completed in August 1829, and from that date until 1882 autumn exhibitions were shown by the RMI. Things went smoothly every year, save 1843, when £80 of artists' and purchasers' money was privately pocketed. The Institute had a keeper called Nabbs, but it was not his work but that of another keeper with the confidence-inspiring name of Ryder-Furniss.

Because the profits from these exhibitions were small, the collection grew

[19] *Manchester Guardian and British Volunteer*, Saturday 8 March 1827.

[20] RMI Minutes, vol. 2, p. 119, 2 May 1838.

[21] *City of Manchester Art Gallery catalogue of the permanent collection of pictures*, 2nd edn, 1895, p. 73.

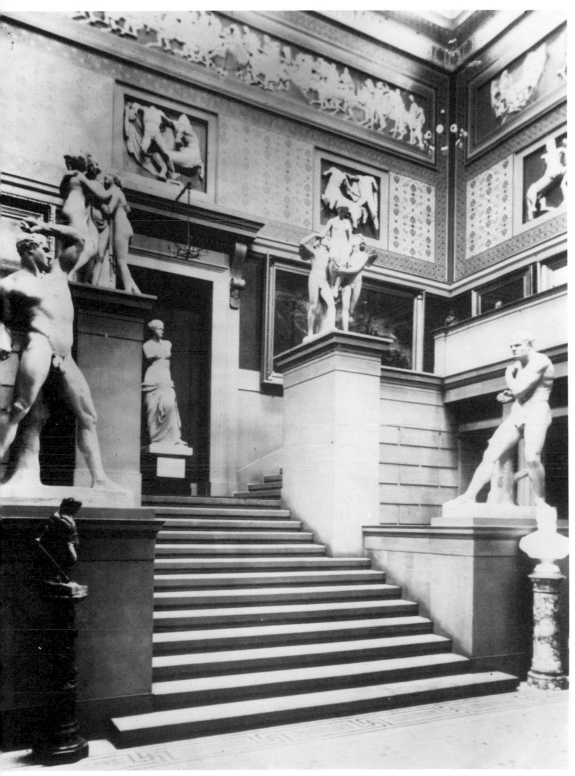

14 Charles Barry: the City Art Gallery (formerly the Royal Manchester Institution). The entrance hall, *c.* 1895, with Westmacott's casts of the Elgin marbles

very slowly. No great masterpieces were donated, and the council of the RMI, although they expressed thanks, were hardly consoled by such strange gifts as a mummy from Peru, a mammoth's tooth from Bognor, an aboriginal weapon from Bowland, etc. There were Hatfield's casts, Bury's casts, Gibson's casts, casts of the Town Hall's Ionic capitals, all dominated by Westmacott's casts of the Elgin marbles, presented by King George in 1830, **14**.[22] In that year the Institution had also been offered, at knock-down price, the huge collection of casts which Alexander Day had accumulated in the Egyptian Hall, Piccadilly (London), and which included the 13 ft (3·962 m) high *Melpomene*. Luckily the Institution could not afford the money.[23]

The RMI had to concentrate on rent as a main source of income, and rooms were let to the Choral, Madrigal, Geological, and Medical Societies. In October 1835 the Athenaeum Society moved in, but left four years later when on 23 October 1839 they opened their neighbouring *palazzo*, the Athenaeum (see chapter two and **24**). The directors of the Athenaeum such as James Heywood, Thomas Potter and G. W. Wood were also governors of the RMI, yet neither institution was economically good for the other. The profitable annual programmes of lectures and conversaziones for science, art and literature could have been held in one building. By 1849 the Athenaeum was so impoverished that its basement was being rented out as an eating-house. In the RMI the Associated Artists were allowed to study in a room of casts, but its aesthetic atmosphere was tainted by noxious fumes from a basement laboratory.

The first public art education in Manchester began at the Institution in 1838. The previous year the Board of Trade had established the Normal School of Design in Somerset House, partly because it was recognised that poor design was causing poor trade, and partly thanks to a crusade by Benjamin Robert Haydon (1786–1846). This historical painter had even tried to enlist the Prime Minister to his cause, but Melbourne replied, 'God help the Minister that meddles with Art'. In 1837 Haydon was engaged by the Institution to give lectures in paintings at £5 a time, and in June he wrote proposing a Manchester School of Design, with information on the Trustees' Academy, Edinburgh. The Manchester merchants were interested because they were paying large sums of money to Frenchmen for designs for their cotton fabrics. Thus in September the Institution set up a committee to consider appointing a drawing master, which on 4 October recommended that a School of Design be sanctioned. The main committee agreed, but could not see their way to paying for it. A separate subscription was needed, and on 19 February 1838 a 'meeting of gentlemen favourable to the establishment of a School of Design' was held in the theatre of the Institution. James Heywood, the leading patron, invited Haydon, who on his return to London noted in his diary, 'accomplished all I left town to do—the

[22] RMI Minutes, vol. 1, p. 282, 22 January 1830. Peel's letter is of 13 January.
[23] *Ibid.*, vol. 1, pp. 301, 309, 8 October 1830.

establishment of a School of Design in Manchester'.[24]

The school was given the use of the library room, the secretary's room and some cellarage at the cost of rates and the gas consumed. The first master was John Zephaniah Bell (1794–1883), portrait painter to Queen Maria of Portugal, pupil of Baron Gros of Paris, a 'High Artist' indeed, not a designer. There were classes for ornamental and pattern drawing, and visits to the Zoological Gardens at Higher Broughton to draw the animals, but Bell, like Haydon, believed that 'the naked truth' was the basis of art and put his older students to drawing in chalk from the living model. Alas, one unlucky day a governor and his lady were strolling through the Institution when they sighted something that seemed to have escaped from Etty's masterpiece, a real model in the flesh sobbing outside Bell's office. The Life Class was immediately abolished, a class for drawing casts of ornament substituted, and the frustrated students set up a live model in Mr Benson's attic in King Street, forming a fraternity called 'The Roman Bricks'.[25]

In 1842 the school received its first grant from the Board of Trade, and Bell was instructed by its inspector, William Dyce, that he must only train designers, not artists. The master decided to quit and set up studio in London. He left with a light heart. Two cartoons he had executed in the Institution had won him £200 in the competition for murals for the new Houses of Parliament. He had built up the school to ninety-eight pupils, among whom was Robert Crozier (1815–91), future president of the Manchester Academy of Fine Arts.

The next master, appointed in December 1843, was George Wallis (1811–91), who organised seminars for the discussion of his students' designs for calico prints, wallpapers and chair backs. He never allowed an exact copy. Unfortunately for Wallis, the policy directed from London had been changed in May with the appointment of Charles Heath Wilson as Director at Somerset House. Wilson insisted on exact copies of Greek and Roman ornament. Wallis was not backed up fully by the school committee, who were afraid of losing their grant from the Board of Trade, so he resigned. Wilson recommended the next master, Henry Johnstone, and attended his protégé's introductory address, given in the theatre of the Institution on 6 May 1846.[26] Johnstone condemned Wallis's original approach, stating that if 'each man had been left to his own ingenuity' art would still be primitive. He argued that the sooner Schools of Design became 'museums of art' the better. Wilson then declared that tracers were now engaged in Italy to provide them with 'accurate elevations of entire edifices . . . so that we shall bring to your habitations the walls of Pompeii'. After a fruitless year of attempting Wilson's policy, Johnstone quit

[24] B. R. Haydon, *Autobiography*, ed. P. Davies, 1926, vol. 2, p. 572, and *Corespondence and table talk*, 1876, vol. 1, p. 201, and vol. 2, p. 235.

[25] R. Crozier, Recollections', MS, and T. Letherbrow, Robert Crozier MS, Archives MCL. For information on Bell see E. Croft-Murray, *Decorative painting in England 1537–1837*, 1970, vol. 2.

[26] School of Design, *Introductory address of the new headmaster*, Manchester, 1846.

art for good. His successor, D. Davies Cooper, had an identical experience and resigned in 1848. The School of Design was now bankrupt. Unable to pay its quarterly rent, it left the Institution at Christmas and found cheap premises in Brown Street during the vacation. The council of the Institution, after shedding some crocodile tears, ordered that no furniture or casts belonging to the school be removed unless back rent was paid or a guarantee arranged.[27]

James Astbury Hammersley (1815–69), a successful landscape painter, was appointed headmaster by the Board of Trade on 1 May 1849, with an annual salary of £300. Within six years he had raised it to a thriving institution of over 700 students by playing down design and converting it to a school of art. Drawing from the nude model was reintroduced, but any student who did not immediately put away his drawing after class faced expulsion. Fee-paying young ladies with nothing to do flocked to the school, and the deprived local drawing masters protested that a school receiving a Board of Trade grant was teaching 'numbers of persons of opulent parentage' who had hitherto been instructed by them. The girls at the local art school have commonly been the best-looking bevy in town, and this was a problem for Hammersley. It was reported that continuing fees were lost 'by matrimonial engagements obtained with exceeding rapidity' and that 'plainer candidates were selected'.[28]

Throughout the country students were enrolling in such institutions provided they were allowed to study art, not ornament, and in February 1852 the Board of Trade abolished the Normal School of Design and established the Department of Practical Art. Henry Cole (1808–82), who was appointed General Superintendent, grasped the economic realities, and, following his advice, most of the Schools of Design were renamed Schools of Art, hence the title 'Manchester School of Art' was adopted. Such was Hammersley's success that his school could easily afford a rent, and in 1854 it moved back into the RMI.

Hammersley's great achievement was the foundation of the Manchester Academy of Fine Arts. In May 1857, at the time of the Manchester Art-Treasures Exhibition, he conducted Prince Albert round an exhibition at Peel Park and suggested that HRH should be patron of a local academy. Hammersley chaired some meetings of the Associated Artists in the theatre of the Institution, and it was proposed that an academy be established as a sectional department of the RMI. The Institution agreed to union with the proposed academy on 3 November 1858 on the understanding that an academician on election presented a picture to the Institution, that the academy be allowed a small room, plus an exhibition room when needed, that the academy take over the job of soliciting artists' works for the Institution's annual exhibition, and that the Institution took all receipts. The Manchester Academy of Fine Arts came into

[27] RMI Minutes, vol. 3, p. 13, 3 January 1849.

[28] Stuart Macdonald, *History and philosophy of art education*, 1970, pp. 103, 214; Cecil Stewart, 'A short history of the college', Diploma Day programme of Manchester Regional College of Art, 1953, p. 21.

existence on 15 November 1859. Eight members and four associate members were elected, Hammersley being the first president.[29] The membership was all professional and all male until 1874, when nine lady painters were admitted, including Annie Robinson (later Annie Swynnerton, ARA, the first female member of the Royal Academy since the death of Angelica Kauffman in 1807). Hammersley never managed to get 'Royal' added to the title of the Academy in spite of waiting upon the Prince Consort at Windsor.[30]

Members of the Associated Artists had arranged an annual Artists' and Amateurs' Conversazione from the early years of the RMI, and the new Academy carried on this tradition. Supporters and friends were invited and paid for tickets for this semi-private evening when the artists' work could be viewed. From 1869 proper annual exhibitions were opened with a conversazione, but it was not until 1874 that the exhibitions became public and a catalogue was printed. A reporter remarked of one conversazione, 'Everyone went, not with the intention of seeing the picture but rather to see and be seen themselves', 15.[31] The Academy ceased to be a sectional department of the RMI in 1882, when Manchester Corporation took over the Gallery, but its annual Spring Exhibition, opening with a conversazione in the Gallery, is still today the high spot of the year for local artists and their patrons.

During the 1870s the Institution could not wipe out an overdraft on its income account and the governors finally realised that a great art collection could never be purchased. On 1 March 1880 Thomas Worthington, FRIBA, and three other members of the RMI council presented a letter to the City Council suggesting the transfer of the premises and collection to Manchester Corporation if it would set up a trust yielding £2,000 a year 'to be devoted to the purchase of Works of Art of the highest character'. On 4 August the RMI council included in its scheme for the transfer the proposal that 'The Corporation shall provide an endowment of £2,000 annually to be devoted to the purchase of Works of Art, by which in time a Permanent Art Gallery for the City will be formed'. The Corporation agreed to the transfer, which was incorporated into the Manchester Corporation Act of 1882. Royal assent to the Act was received on 6 September of that year and the transfer was completed.[32] The School of Art had already left the premises on 24 June 1881, moving its hundreds of casts and students into Redmayne's Gothic palace at All Saints, their 'lordly pleasure house', in the words of the *Manchester Examiner*—in plain words, the Manchester School of Art (1878–81), designed by George Redmayne (1840–1912).

After its adoption by the Corporation the collections at Mosley Street grew

[29] RMI Minutes, vol. 3, p. 439, 1 June 1859.

[30] Hal Yates, *A short history of the Academy*, Manchester, 1959, 2nd ed., 1973, pp. 8–9.

[31] Poster, *Manchester Academy of Fine Arts 120 Years Exhibition*, 1979.

[32] RMI Minutes, vol. 4, pp. 75 and 89, 148 and 168, 1 March and 4 August 1880, 20 May and 6 September 1882.

The Manchester Academy conversazione of 1883. The secretary, H. H. Hadfield, is the central figure with arm extended

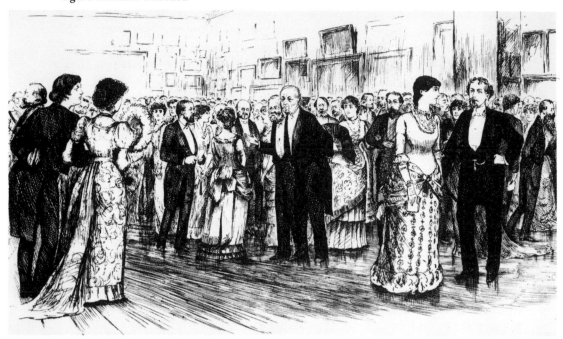

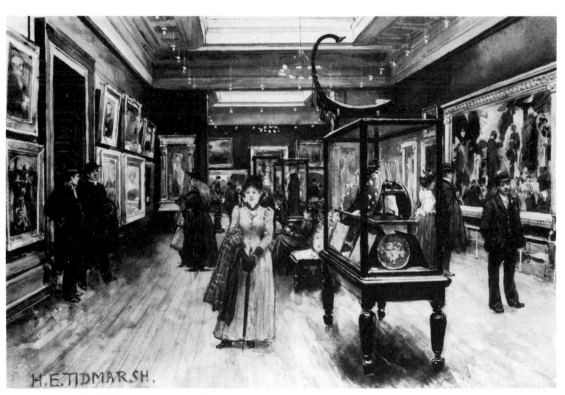

16 H. E. Tidmarsh: interior of the City Art Gallery *c.* 1894

rapidly, **16**. The Corporation provided its Art Gallery Committee with £2,000 a year as promised. There were also subscriptions and money granted by the Science and Art Department, South Kensington, to foster the textile collection. Acquisitions began to be made straight after the transfer in the autumn of 1882. The more important purchases and gifts received from 1 November 1882 to 15 September 1884 were listed by the Art Gallery Committee as: Holman Hunt, *The shadow of death*, **33**; A. Nasmyth, *Landscape*; Spencer Stanhope, *Eve tempted*; Val C. Prinsep, ARA, *At the Golden Gate*; Professor A. Legros, *Study of a head*; and A. Mengin, *Sappho*.[33]

During the first few years of Corporation ownership the works of neo-classicists such as Leighton, Poynter and Prinsep were favoured—indeed, Leighton was commissioned to paint *The last watch of Hero* (1887).[34] The works of Watts and the Pre-Raphaelites came a close second. The battle for a notable gallery, which the gentlemen of the Institution had waged gallantly for sixty years, was won.

The RMI quietly continued its work for public art education and permanent collections until December 1973, when its closure was announced. By then, through its acquisition of the Whitworth Gallery (see chapter eight), the university had joined the Corporation in the provision of art exhibitions and art education. The purposes for which the Institution was formed were thus answered on a totally different scale by corporate bodies. The Royal Manchester Institution had served its day, but its building remains, a distinctive symbol of a distinguished enterprise.

[33] *Ibid.*, report of 15 September 1884 from Art Gallery Committee of Manchester Corporation to the RMI council, pasted in vol. 4, p. 216.
[34] *City of Manchester Art Gallery catalogue*, Manchester, 1895, p. 31.

The architecture of Sir Charles Barry in Manchester and neighbourhood

⟨In 1950 the Royal Manchester Institution published as its Swinnerton Research Essay Professor Whiffen's *The architecture of Sir Charles Barry in Manchester and neighbourhood*. The original publication, of nineteen pages in a grey card cover, is now something of a rarity, but the text is reprinted here with only a few relatively minor changes. The footnotes, however, have been extended, and the editorial additions and changes are marked by enclosure in angle brackets ⟨ ⟩. Some of the original illustrations have been replaced.

Although there are numerous articles on Barry, including several others by Professor Whiffen (see the bibliography to this chapter), it is curious that an architect of his brilliance and stature remains without a major modern biography.⟩

Sir Charles Barry, architect of the Houses of Parliament, is better represented in Manchester and neighbourhood than in any other area of comparable extent outside London. Two of his buildings, the City Art Gallery (as it now is), **1, 10**, and the Athenaeum (as it may still be called), **25**, occupy conspicuous sites in the middle of the city. Less well known is the chapel in Upper Brook Street, now much altered internally, that was built for the Unitarians, **27**; and until 1951 there was the church of St Matthew, Campfield, **17**. This chapter is concerned with these four buildings in Manchester proper, together with Buile Hill, Pendleton (built as a private villa but now the Salford Museum of Mining, **21**, and the church of All Saints, Stand, near Prestwich, **18**.[1]

Barry's introduction to Manchester was almost without question due to Sir John Soane. Barry was not a pupil of Soane, and how the two became acquainted is not clear. It may be that Soane noticed the drawings that the young Barry exhibited at the Royal Academy during the years 1812–14; we have no means of telling. What we do know is that when Barry set out on his

[1] Barry also prepared designs for a concert room (1828) and a club (1833) in Manchester, neither of which was carried out. (Alfred Barry, *Life and works of Sir Charles Barry*, 1867). The former must have been for the Concert Hall in Lower Mosley Street, which was in the event built to the design of Hayley and Brown and opened in 1830; the club was doubtless the Union Club, opened in 1836 ⟨now demolished⟩, designed by Richard Lane, architect of many other buildings in and around Manchester and the first president of the Manchester Architectural Society. ⟨See H. M. Colvin's *Biographical Dictionary* and the Introduction, n. 22.⟩ Earlier, in 1823, Barry exhibited at the RA his design for rebuilding the parish church of St Mary, Oldham. A. Barry (*op. cit.*, p. 71) implies that this was built, but it was not; an engraved plan of the present Oldham church is signed by Lane. (*Victoria county history of Lancashire*, vol. 5, 1911, p. 104.) In 1911 some of Barry's drawings for the church were in the possession of the then vicar. (*Ibid.*) ⟨The Rev. Canon Edgar Stephenson, the incumbent in 1950, informed the author after a search had been made that the drawings were not to be found.⟩

foreign travels in 1817, at the age of twenty-two, he was accompanied to France by a certain Mr Conduit, who was a friend of Soane. That was on 28 June; on 30 June Soane noted in his diary that Mrs Conduit and Miss Rowsell dined with him; and this Miss Rowsell was undoubtedly Sarah Rowsell, a stationer's daughter, to whom Barry, who was a stationer's son, had shortly before become engaged to be married. Miss Rowsell makes another fifteen or more appearances in Soane's diary between that date and Barry's return to England three years and two months later. Then under the date 28 October 1820 we find the surprising entry 'Call on Mr C. Barry'—surprising because Soane was a very great man indeed in the world of architecture, and Barry (who had taken a house in Ely Place, Holborn) still a very small one.

So far Manchester had not come into the story. It did so in the April of the following year, when William Weston, of Maudesleys, Prestwich, addressed to Soane the letter from which the following extracts are taken:[2]

Manchester, April 7. 1821.

John Soane Esqre
Sir

On my arrival at home I call'd a meeting of our Rector and the principal Inhabitants who are interested in the Church intended to be built by Government at Whitefield in the Parish of Prestwich in Lancashire, free of any expense to the inhabitants except the site. I recommended you to be the Architect and told them that the nature of the Grant being to build a Church free of any expense to the inhabitants, every expense including Plans and all other contingencies was to be included in the Grant and that you would not call upon the inhabitants for any expense of Plans, alteration of Plans, rejection of Plans or any other expense whatever. On this assurance being given them they accepted my recommendation and desired I would write you on the subject which I now take the opportunity of doing, and if I am correct in what I have above stated, I should be obliged to you to produce us a plan as soon as you can of a Church that will hold 2000 persons—and you must not exceed the estimate of ten to twelve thousand pounds on any account, as I have reason to believe more will not be allow'd. I beg you will manage it so that we can have Iron Gates and a wall round the Churchyard included in the estimate and if possible the Seats to be of Oak at least below stairs. . . . We are in great hopes the Church might be built so as to be covered in before next Winter; on that account not a day should be lost, and you should send us a plan as soon as you can possibly make it to your satisfaction . . . Workmen of all descriptions are very plentifull in this Country. The Foundation I think would be very good, being as I told you a solid bed of Sand and Gravell. Labourer's Wages for cutting Foundations are about 3/- per day. Bricksetters, Masons, and Joiners about 4/6 per day. Bricks at 26/- per thousand on the ground. Stone about 10d per cubic foot. . . . As there are many Churches agreed upon to be built in the neighbourhood under the grant, if you have no objection I will mention your name to the persons interested in some of them. After I saw you I went into St

Clement's Church in the Strand, the interior of which I thought very convenient and handsome. In that church the middle aisle is rather too wide there being some free seats in it. I merely mention this as being in my opinion a handsome and convenient interior of a church.



I am Yrs.

very respectfully

Wm. Weston



The government grant referred to in this letter, with which the proposed church at Prestwich was to be built, was made under the so-called 'Million' Act of 1818. By this Act Parliament, alarmed by the spread of Deism and other near-revolutionary doctrines among the poor, had voted a million pounds for the erection of new churches. The Act was administered by Commissioners—the Commissioners for the New Churches, they were originally called—and the churches that resulted from it have been known as 'Commissioners' churches' ever since. Generally the Commissioners only made a grant *towards* the cost of the new church; it was unusual for the whole cost of the fabric to be granted as it was in this case.[3]

In asking Soane to design a church with such emphasis on the necessity for building it cheaply, Mr Weston was overoptimistic. Before the Church Building Act became law, Soane had submitted to the Board of Works a report in which he stated that the cost of a church to sit 2,000 persons should be £30,000. In spite of this the Commissioners fixed the maximum at £20,000, and here was Soane being asked to design such a church which should not cost more than £12,000. He replied as follows:



Lincoln's Inn Fields,

11 May, 1821.



Sir

In answer to your letter of the 7th of April and subsequent communications respecting plans and estimates for Churches, I must take leave to observe, that Churches to hold two thousand persons have been recently contracted for in different parts of the kingdom for even less than twelve thousand pounds, the maximum of the expense to be incurred by your letter. I have composed several designs agreeably to your instructions, and after every reduction in the extent of the building and in the quantity and quality of the materials, the estimate of the expense for building a Church to contain two thousand persons, including the Iron Gates, the enclosure of a large Church Yard and other contingencies as required, will far exceed the maximum stated in your letter. I am fully convinced, a church to contain two thousand persons, whether built in the style of the ancient English ecclesiastical structures, or according to the chaste and classical Models of Grecian and Roman Architecture, can never be completed for the sum prescribed by the Trustees for building additional Churches, consistently with

[3] ⟨See M. H. Port, *Six hundred new churches. A study of the Church Building Commission, 1818–1856, and its church building activities,* 1961.⟩

my ideas of constructive stability and characteristic appearance, and of a sufficient capacity to afford the congregation convenient accommodation and free access. Under all these circumstances the fair drawings of the design will not be made unless they are required. You will be pleased, Sir, to make my acknowledgements to the Rector and Gentlemen of the Vestry for the honor they have done me; and assure them, I should have had great pleasure in exerting my best endeavours to realize their wishes.



I am Sir

Your very obedient and truly obliged Servant

John Soane



If Soane could not himself realise the wishes of the trustees for the erection of the new church near Prestwich, it was in his power, both in his own right as a celebrated architect and also in his official capacity as one of the architects attached to the Board of Works, to recommend someone who would be glad to try. And we may take it, I think, that this is what in fact he did—that Soane recommended Barry for the Prestwich job, and that this led to Barry's being commissioned also to build St Matthew's, Campfield, to what was to all intents the same design. An additional fragment of evidence tending to the same conclusion was discovered in the shape of a crude woodcut of St Matthew's, evidently from a newspaper, among Soane's correspondence.[4] What more likely than that this was sent to Soane by the grateful Barry?

So much for the prehistory, so to speak, of Barry's two churches in and near Manchester. The foundation stone of All Saints', Stand, was laid by the Earl of Wilton, with a silver trowel presented to him by the architect (who was staying with Soane's former correspondent William Weston) on 3 August 1822.[5] Before the ceremony took place there was a little trouble with the Freemasons, who arrived in full costume behind a band, and claimed that the right of laying the foundation stone was theirs; but violence was avoided. The foundation stone of St Matthew's, Campfield, was laid by the Bishop of Chester nine days later, on 12 August 1822.[6] By July 1823, when the Commissioners issued their third report, at Stand 'the main walls and internal stone pillars' were 'to the height of the Gallery framing, namely 16 ft. above the ground line'; the Campfield church had gone ahead more quickly, and 'the whole of the Gallery framing' was 'fixed and the main walls' were 'to the height of 24 ft from the ground line'. On 24 September 1825 St Matthew's, Campfield, was consecrated; All Saints', Stand, was not consecrated until 8 September 1826. At one of the first services held in the latter church a panic was started by a man who, noticing a crack in the

[4] Reproduced in the *Architectural Review*, vol. 106, p. 202.

[5] F. E. Lowe, *Scraps of information on the parish and church of Stand*, 1910, p. 3.

[6] Each church was to hold 860 in pews and 978 in free seats. The architect's estimate for St Matthew's, including fees and incidentals, was £14,630 7s 0d; the contract was for £11,917 2s 0d. In the case of All Saints', Stand, the respective figures were £14,430 0s 0d and £11,588 1s 4d. (Commissioners for Building New Churches, *Second report*, 1822.)

Charles Barry: **17** St Matthew's, Campfield, 1822–25 (demolished 1951) and **18** All Saints', Stand, Prestwich, Lancs., 1822–26

plaster under one of the galleries, shouted out that the church was falling. This led to rumours that the church had collapsed, and local histories record admittedly richly embroidered accounts of this day's events.[7]

As already mentioned, St Matthew's, Campfield, and All Saints', Stand, were almost identical in design **17, 18**. The only noticeable difference is that St Matthew's had a spire, while Stand church has not. Barry, as his son and biographer tells us, was fond of spires; he felt that 'the vertical principle of Gothic' was not fully expressed without them. And he was proud enough of St Matthew's to send the design in to the Royal Academy in 1823, when it was exhibited.

Nothing is easier than to poke fun at the Commissioners' churches. They were designed, as Sir John Summerson has well put it, 'at a time when the mysteries of ritual were contemned and rhetoric, at least in the Church of England, had declined to platitude,[8] and a certain emptiness is hardly to be avoided in churches designed with the primary object of holding as large congregations as possible. Also, of course, the Commissioners' churches were built at a time when few architects had any profound knowledge of Gothic architecture—and Barry was not among the few. In later life Barry used to joke with Pugin about his first attempts at Gothic.[9] Nevertheless, as designs, St Matthew's, Campfield, and All Saints', Stand, have qualities we can still appreciate. The tall arches in their towers are really quite successful as scenic devices (rather in the Fonthill tradition) while we may even consider that the spire of St Matthew's is not altogether devoid of the 'light and airy elegance' that the caption to the contemporary engraving found among Soane's papers claims for it.

When all is said, though, Barry's two churches for the Commissioners in Manchester and neighbourhood are not to be taken too seriously as works of architecture. His next Manchester building, the building that in 1882 was made over to the Corporation and is now the City Art Gallery, deserves to be taken very seriously indeed.[10] It is, as it happens, the only public building in which Barry speaks the language of the Greek Revival. But what is more important is that he speaks it with an accent that is all his own. Perhaps it would not be too fanciful to call it an Egyptian accent. For Barry had been to Egypt, and as his journals show had been immensely impressed by the ancient temples. In the last analysis it may well be from them that the things that most distinguish Manchester Art Gallery from other Greek Revival buildings derive—the

[7] ⟨See Arthur Ballard, *All Saints', Stand*, 1951, and F. E. Lowe, *op. cit.*, n. 5. Mrs Conduit's letter, referred to in the original article, predates the incident.⟩

[8] *Georgian London*, 1945, p. 213.

[9] Barry, *op. cit.*, p. 69.

[10] ⟨Further references to the adoption of the building by the Corporation occur in chapters one, three and four.⟩

boldness of its modelling, and the strong contrasts of light and shade of which that is productive, **1, 10, 20**.[11]

The history of the building of the Manchester Institution for the promotion of Literature Science and the Arts, as it was titled originally (see chapter one), can be followed in great detail in the records of the Institution. In addition to council minutes and minutes of successive building committees there are more than a hundred letters from Barry.[12]

Barry won the commission for the Royal Manchester Institution building in a limited competition in which the other entrants were Francis Goodwin, J. B. Papworth and Lewis Wyatt. John Foster of Liverpool failed to submit an entry; Robert Smirke, who had already built St Philip's, Salford, was invited but declined, and so did Thomas Harrison.[13] Francis Goodwin, like Barry, was already known in Manchester, having designed the first Manchester Town Hall. The designs were submitted under mottoes, and there is no reason to suppose that the competition was not organised in as fair a way as was usual in those days; at least there were no complaints—except from Papworth, who, when extra time was given (at the request of Barry and Goodwin) for the completion of the designs, pointed out that he had already informed the Institution that his was ready.[14] On the other hand, it must be admitted that Barry had more to do with the preliminaries to the competition than would be considered proper by present-day standards. In the earliest of his letters in the RMI collection, dated 15 April 1824, he writes:

> Five persons at least out of the seven whose names you mention as having been proposed, I should think would not consider the subject worth entertaining upon the conditions prescribed; at any rate if they should, it might be only to transfer their election to one of the chief clerks in their respective offices. . . . I should

[11] ⟨In conversation it has been suggested by Sir John Summerson that designs by L. A. Dubut may have influenced Barry. There are resemblances in the character of examples in Dubut's *Architecture civile. Maisons de ville et de campagne*, 1803, and the Institution. For further discussion of the design see J. P. Estop, 'An architectural appreciation of four buildings designed by Sir Charles Barry', University of Manchester B.Arch. dissertation, 1982.⟩

[12] I must here record my indebtedness to the former honorary secretary of the Institution, Mr E. A. Entwisle, to whom the recovery and preservation of the records are due, both for his indexes to them and for the loan of a MS account of some of the early members of the RMI and the erection of the building. All letters here quoted for which no other reference is given are in the letter-books of the Institution ⟨now deposited in the Archives Department, MCL, See chapter one, n. 1⟩. ⟨Unfortunately there is no similar richness of drawn material, and very few early drawings of the design have been discovered. Two copies of plans exist, one a tracing and the other a drawing (plate 1.3). The latter is possibly a copy, to a reduced scale, of the original plan. Respectively they are located in the City Art Gallery and the Local History Library (Rare Prints Collection). Two exterior perspectives, one an engraving and the other the original prepared for Sir John Leicester (plate 2.4 *q.v.*), are similarly located; and the Art Gallery has a perspective of the entrance hall and two sheets of details. These seven items include only one original Barry drawing.⟩

[13] ⟨For information on the architects invited to compete and those who entered designs see the RMI Committee Minutes, vol. 1, pp. 71 and 122, 26 April and 29 December 1824.⟩ Another architect to prepare, or at least begin, a design, though not a competitor, was John Black. (Letter to Secretary from Black, 23 April 1824.)

[14] Letter to Secretary, 18 November 1824.

recommend them [the committee] to apply to about 4 or 5 architects of talent and reputation but whose occupations are not of such an extensive nature as to make them indifferent to success, which will be the case with most of the persons named,

and he goes on to suggest what the prizes should be, and so on.[15]

Barry's letter acknowledging 'the high honor conferred upon him' by the choice of his design is dated 29 December 1824. Other basic dates in the history of the erection of the building are 10 March 1825, when the tender of D. Bellhouse and Son for excavating the foundations at 1s 6d per cubic yard was accepted;[16] 27 April 1827, when the draft contract for the structure was signed with Trubshaw and Johnson, the price named being £15,566 0s 0d,[17] and 24 October 1829, when the final payment under this contract was made. For all practical purposes the building was completed inside and out by 1835, though the carvings on the front, by John Henning junior,[18] were not executed until 1837, and there was still a Building Committee in existence in 1841.[19] Until 1836 Barry was constantly consulted by the committee, and he advised the council of the Institution on the lighting of the entrance hall and portico as late as January 1845; his last actual attendance at a meeting of the Building Committee would seem to have been on 3 November 1832, when he 'explained his opinion regarding the Plastering of the Hall'. On a previous occasion, in August 1830, he had attended to explain the charges made in his account respecting extras and omissions. Barry held, with apparent justice, that the various modifications in the design which he had been required to make from time to time had caused him much extra work for which the 5 per cent commission upon the cost of the building would give him no remuneration, and he maintained that normal

[15] All but a few of Barry's letters in the RMI correspondence are addressed to G. F. Bury or T. W. Winstanley, successively secretaries to the Institution, but this one is to Dr Edmund Lyon. In his second letter on the subject (to Bury, 24 April 1824) Barry says: 'I shall be very happy to send them [the committee] a design but will not presume to dictate the conditions of the competition; I shall only suggest those which from experience I think most likely to conduce to the end the Committee have in view namely the production of a Design worthy of the Age and the liberal support the rising Institution has met with.'

[16] The original tender amounted to £2,109 0s 0d, which was reduced to £1,937 9s 0d. The final payment was ordered to be made 22 September 1825. (RMI Land and Building Committee Minutes.)

[17] Tenders were advertised for twice—the second time after Barry had modified the design in the interests of economy—and Trubshaw and Johnson's was the lowest each time.

[18] It was 'ordered that Mr Barry be requested to furnish a design for the Sculpture for the Six Blocks at the front of the Building' on 1 October 1829. (Land and Building Committee Minutes.) On 24 November 1829 Barry wrote that he was sending drawings prepared according to his suggestions by Richard Westmacott junior, whose price for the six tablets was £300 and for the rest of the sculpture (including 'the filling of the Pediment') £1,860. Nothing more is heard of the carving of the blocks till 1833, when (13 June) Barry sent two models by Charles Smith. On 12 July 1836 Barry sent sketches by Smith and by John Henning junior, stating that he had a 'decided preference' for Henning's, and on 30 August 1836 the council of the Institution resolved to employ Henning 'at a cost not exceeding £30 each block'. (Council Minutes). There are several letters from Henning in the RMI correspondence, including two dated in 1837 from Trentham, Staffs., where Barry was enlarging the Hall and laying out the gardens for the Duke of Sutherland.

[19] The last entry in the minute book is dated 6 August 1841.

professional practice entitled him to charge for it. There is no evidence that this account was ever settled; nor is there any evidence that the letter in which Barry offered to submit the matter to the arbitration of 'any respectable architect in London' was ever read to the committee to whose chairman it was addressed.[20]

In the early nineteenth century, when architecture was still a matter of interest to the cultivated public, it was desirable that any new building of consequence should be properly sponsored; to the members of the newly founded Royal Manchester Institution, anxious to combat the popular belief that their city was a barbarous place, it was more than desirable, it was essential, that Barry's design should find favour in the right quarters. And so, soon after the design was chosen, we find Sir John Leicester (later Lord de Tabley) writing to the secretary to make a certain proposal. It would, he thought, give

> an eclat & fashion to the Undertaking, if the Gentlemen of the Committee see no objection, to Mr Barry making me a copy (at my expense) of the Elevation of the intended Building, either in perspective or front, as he judges most advantageous, but upon the same scale as those I saw, which all the World of Taste may have an opportunity of seeing in my Gallery in Hill Street; nor am I without hope that I may have an opportunity of submitting it to his Majesty, when it would I think be highly gratifying to the Members of the Institution, as well as of incalculable importance to the Architect, to have it in their power to report that the King, whose taste is excellent, admired & approved of it.[21]

In the event it was Sir Robert Peel who showed the design to George IV, who inspected it 'with great attention and was pleased to express in very flattering terms his entire approbation', 19.[22] Among others to whom the design was shown were Sir Thomas Lawrence, Sir William Beechey and the celebrated connoisseur, friend of Constable and Worsdworth, Sir George Beaumont. Of these three, only Sir George Beaumont suggested any radical alteration,[23] this was nothing less than that the centre of the building should be surmounted by a dome. Beaumont's suggestion is recorded in the Building Committee minutes for 26 March, 1825. Then under 30 May we read: 'Mr Barry further reported that

[20] That is, to G. W. Wood; the letter is dated 23 June 1831. On 10 November 1831 Barry mentioned that Wood had replied that he would be away for a fortnight but would communicate Barry's letter to the committee on his return. Barry's letter of 10 November was read to the Building Committee on 26 January 1832, when it was ordered that he 'be informed that the Committee have seen no reason to alter' their former opinion. Barry replied on 2 February that he hoped to be able at some future date to convince the committee of the justice of his charges by personal interview. On 25 March he asked for a meeting of the committee 'on Wednesday next'. No such meeting is recorded, and that is the last we hear of his claim. If he raised the matter on 3 November there is no mention of it in the minutes.

[21] From Tabley House, 10 January 1825. ⟨Barry's drawing, now owned by the University of Manchester, is currently on loan to the City Art Gallery.⟩

[22] Robert Peel to Dr Davenport Hulme, 17 February 1825.

[23] Beechey wrote to G. F. Bury, from Harley Street, 5 May 1825, that the only material alterations he would have recommended had been anticipated by Lawrence and Barry himself.

19 and **20** Charles Barry: presentation drawing of the Royal Manchester Institution, 1824. Model by George Strutt, 1825

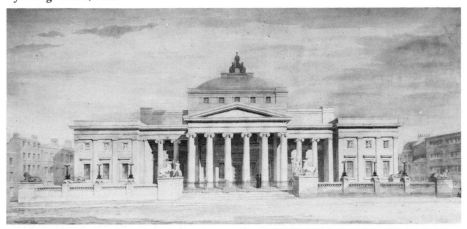

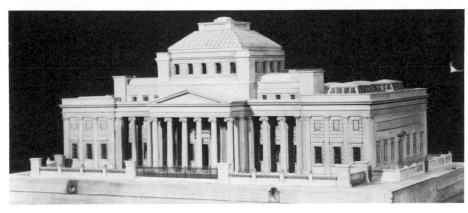

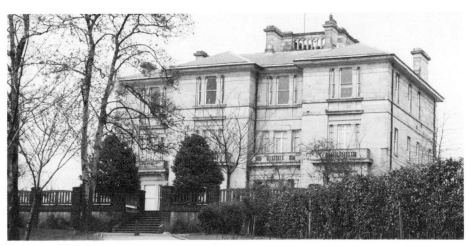

21 Charles Barry: Buile Hill, Pendleton, Salford, 1827 (now the Salford Museum of Mining). The second storey was added by Edward Walters in 1860

he had fully considered the substitution of a Dome for the Lantern light, and found it could not be done with advantage.' One might have expected that would be the end of the affair. But to do so is to reckon without the power wielded by the man of taste in Georgian times. For on 5 August 1826.

> Mr Barry produced a Perspective Drawing of the Building as exhibited by him at the Royal Academy this Season—in which he has substituted a spherical Dome in lieu of the pyramidical roof delineated in the Model, and he stated, that the spherical dome will be executed for less money provided there be no sculpture on the summit.—Resolved—That the Spherical Dome be adopted and that it is not desirable to make any provision for surmounting it with Sculpture.

Yet Barry was evidently not in love with the projected dome, and on 6 February 1828 he 'recommended that the Walls of the Hall be lowered 3 feet 9 in & that a hipped roof be substituted for the Dome—for which he has not yet made an Estimate, but which will occasion a very considerable saving as well as much improve the external and internal character of the building'. Sir George Beaumont, one must note, had died on 7 February, 1827—a year all but a day before. Barry was astute enough to avoid crossing so eminent an authority on the arts while he was alive but not the man to be unduly troubled by the risk of angering his ghost—after a 'decent interval' had elapsed.

Most of the modifications that were made in the design of the RMI between its acceptance and the completion of the building may be appreciated through a study of the fine model made by George Strutt in 1825, which was described by Barry as 'one of the most perfect and finished models I ever witnessed', **20**.[24] Among them was the lowering of the hall just mentioned; another roof-line alteration was a 12 in. (0·305 m) increase in the height of the parapet in order the more effectually to conceal the roof lights. In execution all pilasters except those at the angles of the outer parts of the main front were omitted, and the flank walls were given 'blocks', like those of the main front, instead of the long horizontal panel above the windows in the model. Also, steps were substituted for what was to have been an open space for carriages in front of the portico, and the forecourt was enclosed by iron railings instead of a low wall.[25] Internally the model shows a remarkably advanced kind of roof

[24] It was ordered that Barry 'be requested to procure a Model of the intended Building at an expense not exceeding One Hundred Pounds' on 31 March 1825. (Land and Building Committee Minutes.) Barry reported that he had agreed for the model with Strutt for sixty guineas on 30 May. Much to the annoyance of the committee, Barry was not able to send the last parts of it for fixing until 21 September. The model was illustrated, with measured drawings and photographs, in the *Architects' and Builders' Journal*, 25 October and 15 November 1916. ⟨It is now preserved in the City Art Gallery after being presented by the Manchester Society of Architects.⟩

[25] The railings (destroyed in the Second World War) were executed by Weatherhead Glover and Co., the contract price, to include painting, being £346 6s 0d. (Land and Buildings Committee Minutes, 12 February 1830.) Other contractors for the finishing of the building included G. and J. Haden (stoves), George Jackson and Sons, composition ornament manufacturers (capitals and lions' masks for lecture theatre), Hughes and Sons (plastering of entrance hall), Messrs Pattison (chimney piece of Kilkenny marble in Council Room). ⟨Small portions of the original railings survive to protect sunken areas.⟩

lighting—'top side-lighting', it has been called—in the picture gallery; this too was abandoned in execution. Other differences appear in the entrance hall, which was altered to accommodate the casts of the Elgin marbles, presented by George IV in 1830, **14**;[26] and the model also shows, of course, the lecture theatre, done away with when the building was converted to its present use.

In the minutes of the Building Committee of the RMI, under the date 5 April, 1827, we read, 'The Chairman stated that Mr Thos. Potter had informed him that he would gladly contribute one-half the expense of Mr Barry's visit as he wished to see him on the subject of the house he is building for him.' The offer was accepted, and on 28 April the Institution paid Barry nine of the eighteen guineas' expenses incurred through this visit, Potter paying the other half. This Thomas Potter was in 1838 to be elected the first Mayor of Manchester, and two years after that to be knighted. The house that Barry was building for him in 1827 was Buile Hill, Pendleton, which is now the Salford Museum of Mining, **21**.

Just as the Royal Manchester Institution is Barry's only Greek public building, so is Buile Hill his only recorded Greek villa. It has, unfortunately, been much altered since Barry finished with it, and the addition of another storey has quite destroyed its original character and proportions. Some idea of the former appearance of the garden front may be got from a water-colour in the museum—'some idea', because it is a very small picture and palpably the work of an amateur. An elevation by Barry of the entrance front was published some years ago in *Architecture*, the journal of the Society of Architects,[27] the drawing is stated to be in the collection of the Royal Institute of British Architects, but it is not to be found there now. This elevation shows a front corresponding to the eastern part of the building as it exists, though of course of two storeys and basement only, surmounted by a double hipped roof of low pitch and two

[26] It may be worth while putting on record the original colour scheme of the hall—or rather the second scheme, devised by Barry after the first had failed to satisfy the Institution authorities. Barry's specification for the work, dated 11 November 1833, is as follows: 'The ceiling to be painted a warm Stone color two shades deeper than the walls with the exception of the central pannel, which I think may with good effect be of a clear Ultramarine blue of a very light tone and slightly relieved by small fleecy clouds. The whole of the Stone work in the lower part of the Hall including the peristyle of Doric columns & parapet, the flanking pedestals of the Staircase and the spandril walls in connection therewith to be painted and grained in imitation of Grey granite similar in tone to that now executed on the Walls under the Gallery. The Dado on the Gallery, the Doorcases of the Corridor entrances, the Theatre Doors and the Spandrils of the Staircase between them to be painted and grained in imitation of granite of the tone adopted in the Dressing of the Doors under the Gallery. The Bronzing of the Doors to be made of a Darker tone and the edges of the mouldings &c. only to be relieved with the Bronze powder.'

At first the ceiling was to have been painted 'very light green bronze . . . relieved by picking out the enriched moldings and stars in the coffers or panels white, in imitation of Silver'. (Letter from Barry, 24 April 1832.)

[27] Vol. 3, new series, 1925, p. 234, by Alwyn R. Dent, 'Barry and the Greek Revival.' ⟨In addition, Manchester City Art Gallery has an unfinished perspective of the garden front and four pencil drawings of internal elevations, all from an album that was owned by Thomas Potter. None can be attributed to Barry with certainty.⟩

central chimneys joined by an arcaded motif, while to either side is a slightly
lower wing, also of two storeys, with a solid parapet hiding the roof. Today,
Barry's entrance porch is hidden behind the heavy Doric *porte-cochère*.[28]
Indoors, the walls of the entrance hall are rusticated in a manner strongly
reminiscent of the entrance hall of the Art Gallery, while on the garden front the
tripartite windows have some interesting detail. But it is probably safe to say
that no amateur of architecture would wish, today, to visit Buile Hill more than
once.[29]

In Loudon's *Architectural Magazine* for January 1838, under the heading
of 'Domestic Notices', appears a contribution dated from Manchester on 13
November of the previous year.[30] Its author writes:

> Mr Barry is making a beautiful thing of our Athenaeum. I suppose you know that
> it is in his best Italian style; it will be a fine contrast to his Royal Institution, with
> which it is in almost juxtaposition. He is also erecting a beautiful Gothic chapel for
> the Unitarians, in Upper Brook Street, Chorlton, which is expected to rival his
> church of St Matthew, the spire of which is the most elegant I ever saw.

This passage introduces for our consideration Barry's last two buildings in
Manchester, the Athenaeum and the Upper Brook Street Chapel—two
buildings which beyond their architect have on the surface little in common.

The Athenaeum, as Loudon's contributor says, is in Barry's 'best Italian
style', **24**. It follows, in fact, the Renaissance *palazzo* formula which Barry had
introduced into English street architecture with his Travellers' Club in 1829
and of which his Reform Club represents the fullest development, **23**. This
formula, which the Victorians were to employ for a very wide range of building
types (including, in Manchester and the other industrial towns of the Midlands
and North, the warehouse), was Barry's answer to the question 'Where do we
go from here?' as it presented itself to many of the more intelligent architects in
the 1830s. By then, it must be remembered, a certain dissatisfaction with the
Greek Revival, as it had hitherto manifested itself in its works, was making itself
apparent. For one thing, many Greek Revival buildings, with their 'stuck-on'
porticoes and desperate attempts to get round the unhappy necessity of having
windows, were at best successful essays in facade-making; and their detail,
copied as it often was literally line-for-line from books of engravings, was felt to
be pedantic and lacking in both richness and relief.[31] Barry's building for the
Royal Manchester Institution had avoided these faults; its portico, as one

[28] ⟨Added in 1860 when the second storey and the billiard room to the west of the main block were
built. Their design is attributed to Edward Walters.⟩

[29] ⟨Barry's work has been virtually effaced from the interior. The present staircase appears to be
coeval with the extensions.⟩

[30] Vol. 5, pp. 46–8. It is signed J. W. H. (i.e. John William Hance).

[31] ⟨See W. H. Leeds, 'An essay on the present state of architectural study and the revival of the
Italian style', in Charles Barry's *The Travellers' Club House*, 1839.⟩

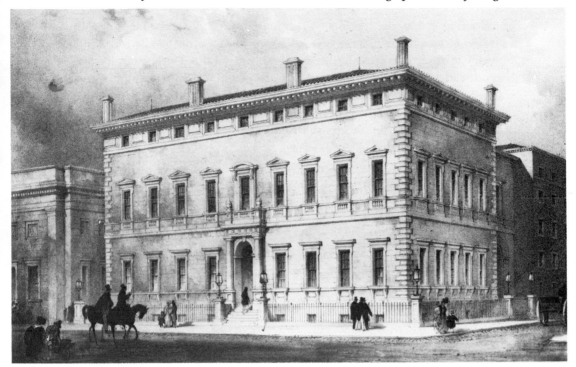

22 Charles Barry: the Athenaeum, Princess Street, 1836–39. Lithograph of an early design

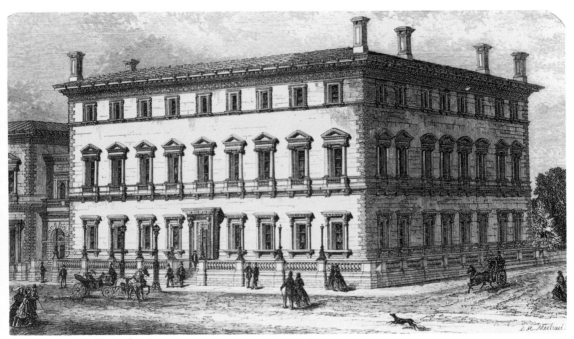

23 Charles Barry: the Reform Club, Pall Mall, London, 1837–40

Victorian critic remarked, was *used*; 'scarcely any of its details', wrote another, 'were to be found in "Stuart's Athens" and yet the building is more completely Greek than many others claiming to be so'. But Barry, although in 1830 he produced a Doric design for Birmingham Town Hall and as late as 1840 another for new Law Courts in Lincoln's Inn Fields, was not to remain a Greek.[32] It was left to Charles Robert Cockerell (represented in Manchester by the splendid Bank of England in King Street) to revivify the Greek school by means of an infusion of motifs from Rome (and more particularly the Hellenistic architecture of the Eastern Roman Empire) and also from Renaissance Italy.[33]

The Athenaeum was founded, as a venture in adult education, in 1835; Barry was first employed on the design of the building in 1836.[34] The foundation stone was laid in May 1837; and the building was opened on 28 October, 1839. Its cost is said to have been £18,000, of which £12,000 was raised by subscription and the remainder on a mortgage.[35] The early records of the Athenaeum had not, at the time of writing, come to light, so that it was not possible to trace the various changes in the design in any detail.[36] That there were changes was known from a lithograph which presumably shows the building as at some stage projected, **22**, and from the collection of tracings of Barry's office drawings made in the 1840s by his pupil John Murray, which is now preserved at the Royal Institute of British Architects.[37]

Chronologically, the Manchester Athenaeum immediately precedes the Reform Club (for which Barry produced his competition design between June and November 1837), and the early design shown in this engraving has a good deal in common with the Reform as built. In both cases the street front is of nine bays in length, with a central entrance. The general treatment of the fenestration of the two principal storeys is much the same in both, although the first-floor windows of the Athenaeum were to be, and are, framed by simple eared architraves, of very slight projection from the wall surface, while the Reform has Ionic columns supporting the pediments over them. In this early design for the Athenaeum there is a third range of windows, set in the frieze of the main entablature of the building—which is on the whole a more satisfactory arrangement than the somewhat ambiguous treatment of the uppermost

[32] The Law Courts design was published by Dent, *op. cit.*, p. 230. A reconstruction by Arthur T. Bolton of Barry's Birmingham Town Hall design was published in *Architecture*, vol. 3, 2nd series, p. 322.

[33] ⟨For C. R. Cockerell (1788–1863) see David Watkin, *The life and work of C. R. Cockerell*, 1974.⟩

[34] A. Barry, *op cit.*, 'List of architectural designs' at end of volume.

[35] Foregoing dates and figures are given in *The strangers' guide to Manchester*, Manchester, 1857.

[36] ⟨Minute Books of the Board of Directors, dating from 13 October 1835–1887 (12 vols.), are now held by the Archives Department, MCL. Reference is made to these by J. P. Estop in his study of the design, *op. cit.*⟩

[37] ⟨An earlier stage of the design than is shown by the lithograph is revealed by a sketch design, showing plans and elevations, in the Moulton-Barrett volume of drawings in the Drawings Collection of the RIBA Library. Inclusive of this, the *Catalogue of the RIBA Drawings Collection: B*, 1972, lists thirty-seven items relating to the Athenaeum, mostly showing details. Two further drawings are in the Manchester City Art Gallery collection.⟩

windows of the Reform. Another difference lies in the very much greater richness of the grand cornice, or *cornicione*, of the Reform Club. But the most striking difference of all is in the design of the main entrance. In the Reform this takes the shape of a square-headed doorway whose cornice is only a little higher than those of the windows flanking it. In the Manchester Athenaeum, both in this early design and in the completed building, the main entrance is arched and enclosed in a Doric porch, forming a much more emphatic central feature. Porches of similar type are of course not uncommon in English vernacular classicism of Georgian times, but Barry would not have adopted the motif without Italian Renaissance authority, and the Athenaeum porch may probably be regarded as a simplified version of that of the fifteenth-century Cancelleria in Rome.

In the lithographed design for the Athenaeum the balustrade over the porch is surmounted by urns, and the window above it is differentiated from its neighbours by means of a heavier frame of bolder projection and a segmental pediment supported by curved brackets. In essentials, this treatment of porch and window as a fully unified central feature is also found in the drawings at the RIBA, so that one may assume it was abandoned for reasons of cost. These drawings are far from forming a complete series, but they do throw some light on the development of the design. Besides elevations and details of the porch and the window above it there are, for instance, several drawings showing changes in the upper part of the building. One, an elevation of part of the George Street front, shows a frieze incorporating windows as in the litho-graphed design. Another shows that at one stage the plain inscribed frieze, which the building was eventually given and still has, was to have had lions' masks near the angles. The prototype of this inscribed frieze was provided by Raphael's Palazzo Pandolfini at Florence, which Barry had already followed in other respects in designing the street front of his first *palazzo*-type building, the Travellers' Club. Its substitution for a windowed frieze must have necessitated considerable alterations of the planning of the top floor, on which there were several classrooms, in addition to the lecture theatre for 800 persons.

In looking at the Manchester Athenaeum today as an example of Barry's work one must try to discount the monstrous roof added later in the nineteenth century, **24, 25**.[38] The internal arrangements have also been altered, **26**. But for all that it remains an impressive monument to Barry's genius as a classical architect, and on all counts a more important building than the former Unitarian Chapel in Upper Brook Street, with some remarks on which this chapter must close.

[38] ⟨The building was damaged by fire in 1873 and following this a crudely detailed, badly proportioned addition in inferior stone was added above the cornice. Since 1954 the building has been an annexe to the City Art Gallery, but the original name is retained.⟩

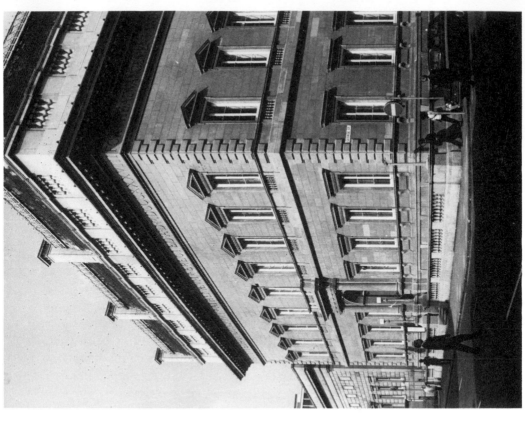

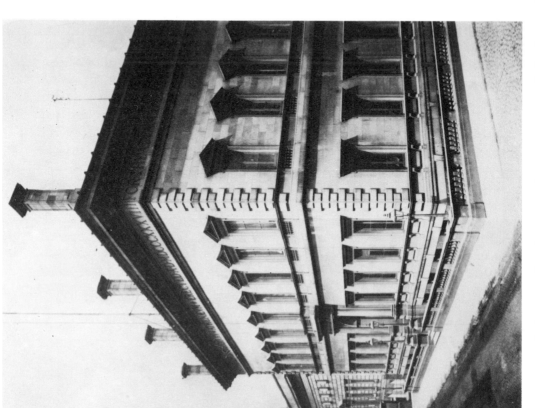

Charles Barry: the Athenaeum, Princess Street. 24 As built, photographed in 1860. 25 In 1973, showing the alterations made after the fire of 1873

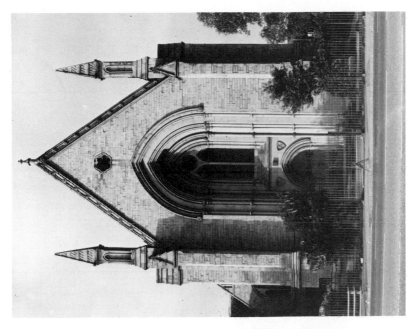

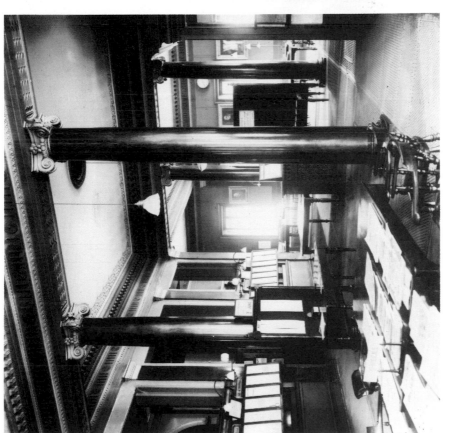

Charles Barry: **26** The Athenaeum, Princess Street, the periodicals room, c. 1918 and **27** Unitarian Chapel, Upper Brook Street, 1836–39

The Upper Brook Street Chapel, **27**, is almost exactly contemporary with the Athenaeum. In both cases Barry began work on the design in 1836, and both buildings were opened in autumn 1839—the chapel early in September. The foundation stone of the chapel was laid on 8 September, 1837, the architect being present; by that date the walls had reached the level of the floor. The builders were Messrs Bowden and Edwards, and the cost of the site and building together was between £8,000 and £9,000.[39]

The style of Upper Brook Street Chapel is Gothic, English Gothic of the thirteenth century. Barry's knowledge of Gothic had progressed considerably since he designed his Commissioners' churches fourteen years before, the chief milestone in that progress being his King Edward VI School at Birmingham of 1833. Upper Brook Street Chapel was, as it happens, the first Gothic building Barry designed during that acquaintance with Augustus Welby Pugin which was to bear such splendid fruit in their collaboration—for it was nothing less—in the design of the Houses of Parliament: Pugin's first work for Barry was on the furnishing of the Birmingham school.[40] At the same time there is no reason to imagine that Pugin had anything to do with the Brook Sreet Chapel design directly. Even if we could suppose that that fervent Roman Catholic would have lent himself to such work, there is nothing that speaks of him in the building as we see it. There is, on the other hand, much that speaks of Barry—notably an attention to general proportions that did not always go with the work of the out-and-out Gothic Revivalist, and a kind of subordination of the detail to the mass of the building which is the product of a mind trained in the classical tradition. Barry exhibited a drawing of the front of Brook Street Chapel at the Royal Academy in 1840, and the view of the critic of the *Civil Engineer and Architects' Journal*[41] on it is one from which we may not differ very much today. It is, he wrote, 'undoubtedly very far above the average, and is judiciously treated inasmuch as it is not made to look like a model for a large building executed upon a small scale. Yet while there is nothing to ensure, neither is there anything particularly to admire.'

[39] Dates, figures and names of builders as given by the *Manchester Advertiser*, quoted in the *Civil Engineer and Architect's Journal* ⟨vol. 2, p. 397, October 1839⟩.
[40] ⟨The collaboration between Barry and Pugin on both buildings is discussed at length by Phoebe Stanton in M. H. Port (ed.), *The Houses of Parliament*, 1976.⟩
[41] Vol. 3, p. 188.

Art collections

The pursuit of Manchester's nineteenth-century art collections is a pursuit of will o' th' wisps. Few of the private collections have survived and none is in Manchester. Nevertheless a tradition of local collecting grew and expanded, eventually to produce the public collections of the City Art Gallery and the Whitworth Art Gallery, and within this tradition may be discerned a pattern of taste, the spirit of which remains even though the substance of the original collections has vanished.

A poor collecting tradition historically and unstable finances during the nineteenth century may be the principal reasons for today's dearth. The old established aristocratic families, the Mosleys, de Traffords, Wiltons and Stamfords, did not own collections of outstanding merit. Dr Waagen, that much-travelled recorder of important British collections, did not visit any of their houses, and, more significantly, loans from some of these local families to the Manchester Art-Treasures Exhibition in 1857 were neither numerous nor, by today's judgement, particularly outstanding (a more detailed review of the loans follows).[1] The comparative absence of Old Master paintings from local collections may be considered a just assessment of what was in the area.

By 1900, of the old families, only the Stamfords remained in Manchester. The others had moved south. The new collectors, the industrialists and merchants, made the same journey but, with no ancestral lands to detain them, departed all the more quickly. Keeping ahead of the ever-growing pollution and population, the wealthier inhabitants moved steadily away from the city and, when the age of retirement came or the family's professional interests changed, moved from Manchester altogether.

Other factors also led to Manchester's impoverishment in this respect. The nature of business in Manchester was one. Trade was as important as manufacture, and buying and selling and speculation were central to

[1] G. F. Waagen, *Treasures of art in Great Britain*, 3 vols., 1854; *Supplement*, 1857. Only three Manchester collections are mentioned: those of Mr Cooke, Samuel Ashton (see below) and John Chapman. The last-mentioned owned three Dutch paintings. All other works listed are English. Loans to the exhibition are acknowledged in the *Catalogue of the Art-Treasures of the United Kingdom . . .*, 1857.

Manchester's business activity. Fortunes could be made and lost very quickly. Bad business judgement, bad luck or periodic slumps frequently caused the sale of collections or forced certain families to change professional interests and leave the district. Then there were, too, those who made their money in Manchester but kept their collections in more attractive places. In this context it should be remembered that two of the finest collections in England were formed with fortunes made in Manchester, although the collections were never housed there: those of Francis Egerton, third Duke of Bridgewater (1736–1803), and Sir Robert Peel, second baronet (1788–1850).[2]

The third Duke of Bridgewater, coal magnate and pioneer of canals, inherited his mother's art collection and purchased further works as a matter of social habit on the Grand Tour. However, a genuine interest was activated in 1794 by his nephew, George Gower, after which he bought in quantity. His greatest acquisition was the Italian section of the Orléans collection. The manner in which it was carried through will cause a wry smile on the subject of businessmen and art. The Orléans collection had been formed by Philippe, Duc d'Orléans (1674–1723), Regent of France, and descended in the Orléans family until 1792. After further changes of ownership it was brought to England for sale in 1798. The third duke purchased all 305 Italian paintings for £43,000. He selected ninety-four for himself and sold the remaining 211 for £41,000. Thus at a net cost of £2,000 he had acquired some of the finest works by sixteenth and seventeenth-century masters. He also purchased many Dutch cabinet paintings and patronised living artists, including the young Turner. Since he was childless, the collection passed on his death to relatives. Today some of the principal works may be seen in the National Gallery of Scotland on loan from the Duke of Sutherland, **28**. However, although the Bridgewater fortune was made in Manchester, the picture collection was kept in the Bridgewater Gallery at Cleveland House, the Duke's London residence.

Exactly the same circumstances governed the funding and housing of the Peel collection.[3] The first Sir Robert Peel (1750–1830) built up a large business by printing calico and importing and exporting cotton. Starting in Bury and Manchester, he expanded it through Lancashire, Yorkshire and eventually to Staffordshire, where he and his son, the second baronet and Prime Minister, Sir Robert Peel (1788–1850), represented Tamworth in Parliament. The younger Sir Robert collected Dutch, Flemish and English pictures which he kept in London and at Drayton Manor, the Peel home in Staffordshire. He was one of the first trustees of the National Gallery and had a deep love of art, distinct tastes (he disliked early Italian paintings as much as he loved Dutch painting) and an eye for quality. In 1871 ninety-five Dutch and Flemish paintings and drawings were

[2] B. Falk, *The Bridgewater millions*, 1942, pp. 114–15, and (for Peel) F. Herrmann, *The English as collectors*, 1972, pp. 139–42.
[3] Herrmann, *op cit.*, pp. 246–9.

Titian (Tiziano Vecellio): *Diana and Actaeon. Duke of Sutherland Collection, on loan to the National Galleries of Scotland, Edinburgh*

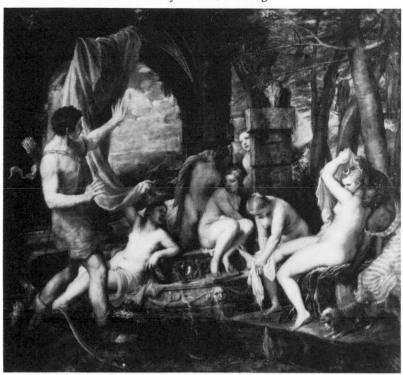

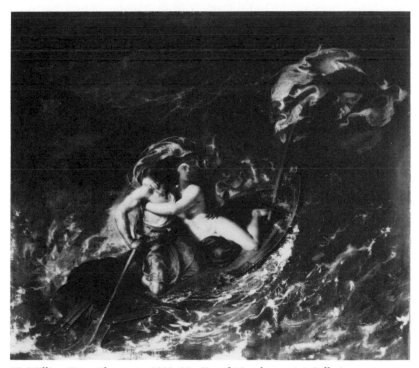

29 William Etty: *The storm*, 1829–30. *City of Manchester Art Galleries*

sold to the National Gallery by the third baronet. The National Gallery's purchases concentrated on rural landscapes and elegant genre paintings of marvellous quality.[4] These include some of today's best known and best loved images in Dutch art, e.g. Hobbema's *The avenue, Middelharnis* or de Hoogh's *The courtyard of a house in Delft*. The collection included twenty Flemish works, one of which was the beautiful and influential *Chapeau de paille* by Rubens.

Contemporary evidence of what was in collections has to be gleaned from compilers of *catalogues raisonnés* and from exhibition and sale catalogues, as well as biographies, articles and obituaries.[5] These indicate that, in general terms, a prevailing taste for Old Masters at the beginning of the nineteenth century had changed to a taste for modern art, i.e. contemporary *English* painting, by its end.

Among the most active art patrons in the first forty years of the century were the Hardman family, whose home at 21 Quay Street stood next to the present-day Byrom House, and whose name is commemorated in Hardman Street near by.[6] William Hardman (d. 1813) was a drysalter. He had two brothers, James and John, and two sons, John and Thomas (1778–1838): all were patrons of the arts. William Hardman established something of a salon in Quay Street. He built a music room where rehearsals for the Gentleman's Concert Society took place, and his home was frequented by eminent people in the fields of literature, science and the arts. The family patronised the learned and cultural organisations in the town and lent many works to Old Master exhibitions at the Royal Manchester Institution in the 1830s. It is difficult to disentangle the individual ownership of different works, but the Hardmans possessed Italian, Dutch and Flemish works, and late eighteenth-century English paintings. Italian painters whose names are given in exhibition catalogues include Andrea del Sarto, Bassano, Titian, Veronese, Guercino, Domenichino, Marieschi, Canaletto and Zuccarelli. Dutch painters include Netscher, Berghem, Adrian and Willem van de Velde, Neefs, Ruisdael, van der Neer, Cuyp and Rembrandt. The Rembrandt is *The man with the red bonnet*, now in the Boymans-van Beuningen Museum, Rotterdam, **30**.[7] Late eighteenth-century English masters include Mortimer, Gilpin, Garrard, Wilson, Smith of Chichester, de Loutherbourg, Fuseli and Wright of Derby. Probably William Hardman purchased works direct from the last two artists. He would have known that other Manchester collector of Wright's work, John Leigh Philips (1761–1814), who was also Wright's friend, correspondent and first

[4] N. MacLaren, *National Gallery catalogues. The Dutch school*, 1960.

[5] See also A. Graves, *Art sales. From early in the eighteenth century to early in the twentieth century*, 3 vols., 1918–21.

[6] For local information see the biographical index of the Local History Library, MCL; the *Palatine Notebook*, vol. 3, October 1884; J. Harland, *Chetham Society*, vol. 2, 1867; T. Swindells, *Manchester streets and Manchester men*, 1st series, 1906; and L. H. Grindon, *Manchester banks and bankers*, 1877.

[7] C. Hofstede de Groot, *A catalogue raisonné of the works of the most eminent Dutch painters of the seventeenth century*, 8 vols., 1908–27, especially vol. 6, pp. 127–8, No. 185 (Rembrandt).

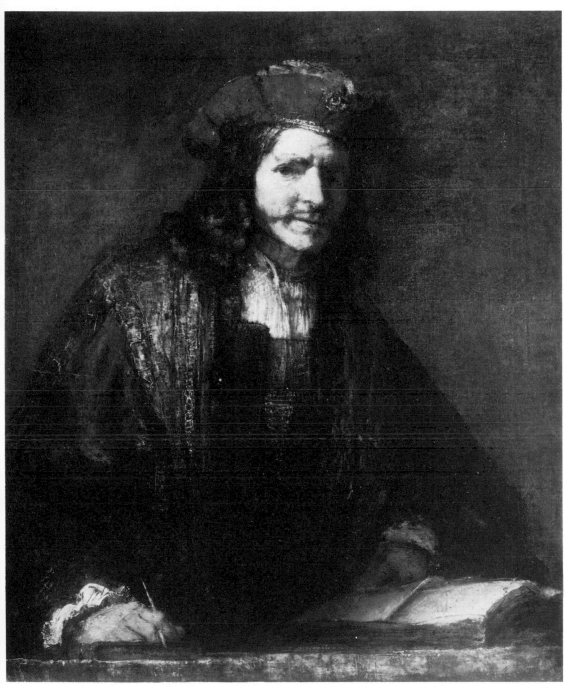

30 Rembrandt van Rijn: *The man with the red bonnet. Museum Boymans-van Beuningen, Rotterdam*

biographer.[8] The Philips sale in 1814 and the Thomas Hardman sale of 1838 were the only ones for some seventy-five years after Wright's death to include a number of his works. Thomas Hardman had died unmarried in 1838. There were two sales of his pictures. Pictures from Quay Street were sold in 1832, and those from his other residence, Richmond House, Higher Broughton, were sold with the house to James Hatton, an ironmonger, of Chapel Street, Salford, in 1838. Later generations of the Hardman family moved south.

Another collector of Old Master paintings was Edward Loyd (1780–1863) of Greenhill, a banker, and partner in Jones Loyd and Co., King Street.[9] Loyd was a keen billiards player, a member of the Broughton Archers and first treasurer of the Royal Manchester Institution. His collecting activities included books as well as pictures. Loyd concentrated his artistic interests on the Dutch school, and he owned works by Ruisdael, Hobbema, Cuyp (four), Wouwerman, Steen, Dou, de Hooch (two), Isaac van Ostade, Backhuysen (two), William van de Velde (three) and Wynants. Many of these were seen personally by John Smith, the connoisseur of Dutch paintings, who commented most favourably on their quality in several cases.[10] Smith's comments were recorded between 1834 and 1842. Clearly Loyd was collecting excellent-quality works in Manchester, but he retired to Croydon in the late 1840s.

From the collections already described it can be seen that a love of Old Master paintings did not exclude a personal liking for, and direct patronage of, living artists. The foundation of the Royal Manchester Institution in 1823 (see chapter one), whose aims included the encouragement of the visual arts, created the opportunity for exhibitions of modern art (from 1827) and Old Masters (from 1831), and sales of modern art began to grow. In addition the governors made occasional purchases to encourage more established artists to exhibit and provide examples for students. They accepted occasional gifts as well. However, they made no effort to build up a permanent collection with a cohesive character. In all probability neither funds nor space permitted such a policy. Nevertheless a small collection of works came into being, which became the nucleus of the municipal art collection in 1882 (see below).[11] In this group English eighteenth and nineteenth-century paintings were strongly represented. Works by James Northcote and William Etty, **29** were purchased from the artists through the annual exhibitions of 1827 and 1832 respectively. Other works acquired were by Richard Ansdell (1847), J. S. Lauder (1848), F. R. Pickersgill (1851), William Hilton and James Barry (both in 1856). Some collectors gave works by Etty, Watts, Morland, Hodges, Northcote, Tresham,

[8] B. Nicolson, *Joseph Wright of Derby*, 1968, text vol., pp. 22, 270, 276–7, cat. nos. 209, 279–80, 290, 294, 322.

[9] Grindon, *op. cit.*, n. 6, pp. 88–93, 150–9.

[10] J. Smith, *A catalogue raisonné of the works of the most eminent Dutch, Flemish and French painters*, 8 vols. and supplement, 1829–42.

[11] Manchester City Art Gallery, *Concise catalogue of British paintings*, 2 vols., 1976–78; and *Concise catalogue of foreign paintings*, 1979.

Wheatley and Westall. In 1832 James Bradock gifted fourteen sixteenth- and seventeenth-century works, attributed to Pietro da Cortona, Rubens, Guercino, Titian, Veronese and others. Some artists presented works—Sebastian Pether junior, John Tennant, J. A. Hammersley (first President of the Manchester Academy of Fine Art) and Ruben Sayers. Unfortunately twenty-eight works from the RMI collection were sold or written off in 1931, including thirteen from Bradock's gift, the sole survivor being a Honthorst, now reattributed to Guerrieri.

Parallel with this development, and if anything more significant, was the career of Thomas Agnew (1794–1872).[12] Agnew came to Manchester from Liverpool in 1810 to join Vittore Zanetti, a looking-glass and barometer maker and picture dealer. He rose in the firm, becoming a partner in 1817 and the principal from 1825, and his interests rapidly developed into picture dealing alone, so that by 1851, when he was Mayor of Salford, he was able to present as a personal gift a collection of 120 paintings and 400 engravings to the newly founded Salford Museum and Art Gallery. (Salford created the first municipal art gallery in England in 1849 in the wake of the Museums Act, 1845, which had been brought before Parliament by the Salford MP Joseph Brotherton.) The Agnew family business went on to advise almost every collector in Manchester until the 1920s.

It was probably the combined influence of the RMI and Agnew's that began to turn the interests of Manchester collectors away from Old Masters in the second quarter of the nineteenth century, possibly reinforced by a more negative influence. There were many spurious Old Masters circulating in the regions. At least with modern art you could be sure of a genuine article. *The Art-Journal*, in 1871, was quite positive about the extent of Thomas Agnew's influence:

> Much of the beneficial changes we have ourselves witnessed in the huge centres of manufactures must be traced to the enterprise and energy of Mr Thomas Agnew. When we knew him and Lancashire first, it was a rare event to find the purchaser of any work of modern art; cart loads of trash under the pretence of being ancient masters, were annually sold in the north of England, works with the names of 'Rubens' or 'Raphael' or 'Titian' found ready buyers; but pictures by British artists had little or no chance of sale; the 'old' must be worth money, the 'new' worth nothing. . . . It was against this delusion, Mr Agnew took arms, and Lancashire and Manchester especially, owe him a debt. . . .[13]

Agnew's continued to sell modern, especially modern English, paintings in Manchester throughout the nineteenth century. However, in 1860 they expanded their business to London, where they sold Old Master paintings of

[12] G. Agnew, *Agnew's 1817–1967*, 1967.
[13] *Op. cit.*, June 1871, p. 183, cited by C. P. Darcy, *The encouragement of the fine arts in Lancashire, 1760–1860*, 1976, p. 140.

the highest quality. For example, Edward Cecil Guinness, later first Earl of Iveagh, was buying superb works by Cuyp, Hals, Vermeer and Rembrandt from Agnew's in the 1880s and '90s (now in the Iveagh Bequest, Kenwood), as well as French and English masterpieces. There is no doubt that had Manchester collectors wished to buy genuine Old Masters through Agnew's the opportunity was there. It is difficult to say whether Agnew had merely responded to local demand or had created that demand (certainly it was a personal enthusiasm), but between 1857 and 1887 the balance swung well to the side of living (and fashionable) English artists.

Confirmation that this was beginning to happen can be found in loans to the great Art-Treasures Exhibition of 1857. (See chapter five.) The quality of works in this enormous exhibition was amazingly high. Among Manchester-based collectors there were four principal lenders of Old Master paintings. Edward Loyd lent eleven works by the Dutch school, a Claude and a Wilson. (Works by C. A. Duval were lent by Edward Loyd junior, and works by David Roberts and Turner were lent by Lewis Loyd.) Sir Humphrey de Trafford lent thirteen paintings of the Italian and Flemish schools. They included works ascribed to del Sarto, Giorgione, Carlo Dolci, Legnani and Tibaldi. George Faulkener, the textile manufacturer, lent three works by Vaccaro, van der Heyden and Teniers. The Earl of Wilton lent four by Lanfranco, Weenix and Lawrence. In contrast, modern works were lent by many local people—often the manufacturers and businessmen who were by then the principal collectors in the city. Among them were Samuel Ashton, William and Thomas Fairbairn, Henry McConnel and Sam Mendel.[14]

One of the organisers of the Art-Treasures Exhibition itself was Thomas Fairbairn (1823–91, later second baronet), eldest son of Sir William Fairbairn (1789–1874), the great engineer, who was created a baronet in 1869. His son played a leading role in the financial management of the Great Exhibition of 1851 and the International Exhibition of 1862. His loans to the Art-Treasures Exhibition included works by E. W. Cooke, F. W. Pickersgill, T. Uwins, F. Goodall, W. Wyld and two works by Holman Hunt – *The awakening conscience* (Tate Gallery), and *Valentine rescuing Sylvia from Proteus* (Birmingham City Museum and Art Gallery).[15] Hunt painted a portrait of Thomas in 1873, and a group portrait of his family in 1864. Thomas also owned works by mid-nineteenth-century French *salon* painters. Sir William lived in Ardwick but his son moved to Sussex in the early 1860s.

Another industrial dynasty was the Ashton family, from Hyde, who left farming for cotton manufacturing and printing, and finally trade. Thomas

[14] *Catalogue to the Art-Treasures Exhibition, 1857.*

[15] For Fairbairn see the biographical index, LHL, MCL; for his Holman Hunt paintings see *William Holman-Hunt*, 1969, Walker Art Gallery, Liverpool, cat. No. 49 and cross-references; also see Judith Bronkhurst, 'Fruits of a connoisseur's friendship: Sir Thomas Fairbairn and William Holman Hunt', *Burlington Magazine*, vol. 125, 1983, pp. 586–97, plates 2–14.

Ashton senior had two sons, Thomas (1818–98) and Samuel (d. 1861). Samuel collected works by English painters of the first half of the nineteenth century—Collins, Müller, Webster, Dadd, Turner, Constable, Prout and de Wint. He also owned a work by the contemporaneous French academic artist Ary Schaeffer. His collection was inherited by his brother, Thomas, of Ford Bank, Didsbury, who played a prominent role in political, cultural and educational affairs in Manchester, and whose son Thomas Gair Ashton (1855–1933) became the first Baron Ashton of Hyde in 1911.[16] His own purchases included *Claudio and Isabella* by Holman Hunt, and works by High Victorian painters such as Egg, Elmore and Leighton. Perhaps the most famous work in his collection was Constable's *Salisbury Cathedral from the meadows*. This and other works are in the possession of descendants living away from Manchester.

Henry McConnel (1801–71) and Sam Mendel (1810/11–84) were enterprising collectors who both suffered spectacular business crashes.[17] Mendel died totally ruined. McConnel recovered and formed a second collection. He was partner in one of the most famous cotton mills in Manchester, McConnel and Kennedy, Union Street, Ardwick. His Manchester home was at the Polygon, Ardwick, where Sir William Fairbairn later lived. McConnel was forced to sell his first collection, which included several fine Turners, as his fortunes fell, but formed a second as they rose again.[18] This second collection was sold at Christie's on 27 March 1886. For the Art-Treasures Exhibition McConnel lent works by Thomas Uwins and William Collins, both Academicians, and the Manchester artists and genre painters J. P. Knight, J. F. Tennant and Miss Mutrie. Eastlake's *Christ blessing little children*, which he owned, is now in Manchester City Art Gallery, as is a graceful reclining figure of Mrs McConnel by E. H. Baily.

Mendel's collection was a legend in its day, although its reputation would not be upheld now. He had specialised in transporting goods round the Cape of Good Hope more quickly than his competitors, and had built Manley Hall, Chorlton, where he lived in opulent splendour. The opening of the Suez Canal undermined his business and he was obliged to sell his possessions in 1875. The contents of the Hall were auctioned by Christie's in a twenty-one-day sale between 15 March and 24 April 1875.[19] Five days were devoted to furniture and modern sculpture, three to porcelain, metalwork, clocks and *objets d'art*. One day was given to the 'Modern Library', two days to English and Italian

[16] For Thomas Ashton (1818–98) see *Manchester faces and places*, vol. 1, pp. 79–80, and *Manchester Guardian*, 22 January 1898. For Thomas Gair Ashton see *DNB*, 1931–40, and *Manchester Guardian*, 2 May 1933.

[17] See John Wanklyn, *McConnel and Co. Ltd., a century of fine cotton spinning*, and, for Mendel, W. E. A. Axon, *The annals of Manchester*, 1886, p. 407. See also *Manley Hall, catalogue of contents*, 1875.

[18] M. Butlin and E. Joll, *The paintings of J. M. W. Turner*, 1977, text vol., Nos. 356, 360, 387, 389, 397.

[19] For an account of the sale see Agnew, *op. cit.* For the sale catalogue see n. 17.

31 Henry O'Neil: *The last moments of Raphael*, 1866. *City of Bristol Museum and Art Gallery*

engravings, Wedgwood and ivories, two to modern drawings and another two to pictures. It took five days to sell his wine, and one more for miscellaneous furnishings. The picture sales show that his collection consisted for the most part of contemporary English and Continental academic painting. The titles form a textbook of nineteenth-century subject painting in England: W. J. Webb, *The lost sheep*; J. Millais, *Jephthah* and *Chill October*; W. P. Frith, *Sterne's Maria* and *Before dinner at Boswell's*; O'Neil, *The last moments of Raphael*, **31**; E. M. Ward, *The last sleep of Argyle* and *Last scene in the life of Montrose*; H. Wallis, *The death of Chatterton*; A. Egg, *The night before Naseby*; Turner, *View on the river Maes* and *Grand Canal, Venice*. Mendel's Continental works included paintings by Gérôme, Delaroche, Frère, Ziem and Koekkoek. The sale demonstrates how by the 1880s taste had swung well to the side of modern art.

The apogee of the display of Manchester's modern collections was the Royal Jubilee Exhibition, held in 1887, at Old Trafford.[20] The theme was paintings by Gérôme, Delaroche, Frère, Ziem and Koekkoek. The sale from the whole country, but many came from Manchester. The exhibition showed the fruits of Agnew's influence, and seven members of the Agnew family between them lent fifty-two works. A feature of the exhibition was the large number of water-colour paintings, many from Manchester sources. One lender was John Edward Taylor (1830–1905), whose collection, kept in London, was one of the finest in Britain.[21] Taylor owned sixty-one water-colours by Turner, forty-nine of which were purchased through Agnew. In 1892 he gave 150 water-colours to the newly founded Whitworth Art Gallery (see pp. 220–1).

In the late Victorian decades a few more independently-minded collectors were turning to artists outside academic circles and offering direct and continuing patronage to favourite artists. Two who patronised individual artists were Charles Rickards (d. 1886) and Henry Boddington (1849–1925). In 1871 Rickards sold a collection of works by early nineteenth-century artists in order to concentrate on the paintings of G. F. Watts. In 1880 he exhibited at the Royal Manchester Institution fifty-four paintings and two sculptures by Watts, and this inspired the exhibition at the Grosvenor Gallery, London, of 1882, which changed Watts's fortunes with the public. Rickards's portrait by Watts was donated to the City Art Gallery by his executors.[22] Henry Boddington, the brewer (see also chapters seven and ten), was particularly interested in the work of Ford Madox Brown, who lived in Manchester in the 1880s.[23] By 1896 he possessed twenty-five of his oils and water-colours, including a group portrait of himself and his family. Boddington's collection has been dispersed and the group portrait lost, but several of the works are in public collections in Aberdeen, Glasgow, Carlisle and Manchester.

[20] Catalogue to the Royal Jubilee Exhibition, Manchester, 1887.
[21] Herrmann, *op. cit.*, p. 436.
[22] R. Chapman, *The laurel and the thorn*, 1945, pp. 96–9.
[23] F. M. Hueffer, *Ford Madox Brown*, 1896, pp. 432 and ff.

Perhaps the most interesting and original of these later collections were those of C. J. Galloway and Samuel Barlow. Galloway (d. 1904), whose engineering firm supplied steam engines throughout Europe, was by the 1870s showing interest in *plein-air* painting, and in commissioning works direct from the artist. He commissioned *The roll call* from Lady Butler in 1873, but ceded it to Queen Victoria in 1874 in exchange for *Quatre-Bras* (Melbourne). The fashion for patronising one artist in particular led Galloway to E. J. Gregory (1850–1909), a painter of genteel rural life. Galloway owned thirty-seven works by this artist, including his own portrait. Among British artists he owned works by academic narrative painters such as Gilbert, Pettie, Poynter and Waterhouse, as well as landscapes by Müller, Cox, Mark Fisher, Clausen and Manchester school artists (see below). This taste for a natural, freely painted style led him to purchase works by a number of French painters working in the same manner—Boudin, Corot, Daubigny, Harpignies, L'Hermitte and Troyon—but his most exciting acquisitions, from today's standpoint, are Pissarro's *Crystal Palace* (estate of Henry J. Fisher, 1967), and a pastel, *The ballet*, by 'de Gaz'. The latter hung in his own bedroom. The catalogue of Galloway's collection, privately printed in thirty-six copies in 1892, notes that it was a purchase direct from the artist.[24] The spelling of Degas's name gives it as Degas himself pronounced it, substantiating Galloway's note. Galloway's collection was sold at Christie's in 422 lots on 14, 26 and 27 June 1905.

Samuel Barlow (1825–93) lived and worked as partner in a bleachworks at Stakehill, near Middleton. His artistic and botanical interests were numerous. He was a founder member of the Manchester Arts Club, an active member of the Manchester Literary Club, with a special interest in Lancashire dialect, and as a noted horticulturalist he specialised in auriculas and apples. His art collection was extensive and concentrated on living artists, including some to whom the quality of paint was as important as the subject. A large part of it (140 oils and fifty-seven water-colours) was sold by auction at Manchester, on 20 March 1894. Another part remains with the family in North Wales. The sale catalogue lists works by English, French, Dutch and German artists, with landscape, flower and genre subjects predominating. Barlow was an early patron of the Manchester school of artists, and they were strongly represented in the collection.[25]

The Manchester school was a group of painters who were among the first British artists to be influenced by the Barbizon school. They came together around 1870, and by 1874 were producing works sufficiently comparable and original in style to be recognised as a group. They produced rather sombre grey-

[24] C. J. Galloway, *Catalogue of paintings and drawings at Thorneyholme, Cheshire, collected by Charles J. Galloway*, 1892.

[25] See *Transactions of the Manchester Literary Club*, vol. 19, 1893, pp. 459–62, and *Momus* (a Manchester periodical), 31 July 1879; and the catalogue of paintings sold by Capes, Dunn, and Pilcher, Manchester, 20 March 1894.

green paintings, worked with the palette knife as much as the brush. The public were not ready for such works, and for some time the group was abused and ridiculed. They acknowledged as the source of their inspiration a work by Corot, in all probability his *St Sebastian* (Walters Art Gallery, Baltimore), at that time in the collection of Samuel Barlow. Barlow's tastes, therefore, were advanced for an English patron of that date, and he encouraged the Manchester school by purchasing their work in quantity. The catalogue of the sale of his collection records twenty-seven oils and ten water-colours by Anderson Hague, seven water-colours by Joseph Knight, four oils and two water-colours by R. G. Somerset, twenty oils and eight water-colours by F. W. Jackson, and works by J. E. H. Partington, J. H. Davies and others. Barlow's interest in flowers led him to patronise William Rathjens, a talented local flower painter, whose work has similarities to Fantin Latour's still-life paintings. Barlow may have been instrumental in developing Rathjen's talent. Certainly two works by Fantin Latour were in Barlow's sale, and he owned at least three more.

Other mid-to-late nineteenth-century artists listed in the sale catalogue include J. B. Davis and William Huggins of the Liverpool school, a group of painters contemporary with and working in a similar manner to the Pre-Raphaelites;[26] the landscape artists Mark Fisher (two), Frederick Goodall and Atkinson Grimshaw; the figure painter Charles Leslie; the German Hans Thoma (four); the Barbizon artist Narcisse Diaz and, most exciting of all, 'C. Pissaero'. Although only one Pissarro was sold in 1894, Barlow owned four in all. His *Village Street, Louveciennes*, 32, was sold by the family to Manchester City Art Gallery in 1970. These are among the first Impressionist pictures purchased by any English collector.[27] It is possible that they were bought from the French dealer, Durand-Ruel, when he was based in London in the early 1870s, after the Franco–Prussian war had forced him to leave Paris, and that Galloway also made his purchases at much the same time. Ironically Barlow attempted to sell *Village street* at Christie's in 1882 and was obliged to buy it in at twenty-one guineas.

In the previous year, 1882, the Royal Manchester Institution transferred its building and small collection to the City of Manchester to form a municipal gallery. An important condition attached to the gift was that the Council should spend £2,000 a year for twenty years on the purchase of works of art. Thus the City Art Gallery began its life with the advantage of possessing one of the largest purchase grants available to any regional art gallery (see chapters one and four).

At that time High Victorian subject painting was on the wane, and the Arts and Crafts movement and *plein-air* naturalism were gathering momentum. The Art Gallery Committee showed they were abreast of changing taste. First of

[26] H. C. Marillier, *The Liverpool school of painters*, 1904.
[27] C. Gould, 'An early buyer of French Impressionists in England', *Burlington Magazine*, vol. 108, March 1966, pp. 141–2.

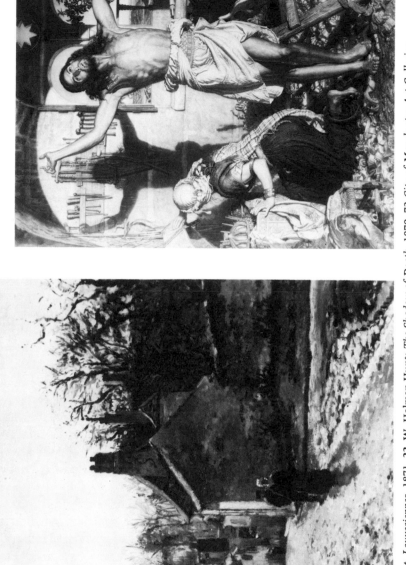

32. C. Pissarro: *Village Street, Louveciennes*, 1871. 33 W. Holman Hunt: *The Shadow of Death*, 1870–73 *City of Manchester Art Galleries*

all, they must have decided to concentrate on English art. Then they seem to have concentrated on landscapes and figure studies, on truth to nature, on aesthetics rather than anecdote, and on serious moral tone. On the whole they avoided imaginary subjects and sentimental genre paintings. Unfortunately they were just too late to acquire works by the now successful Manchester school in its important formative period.

A brief review of purchases in the first twenty years shows that the committee pursued historic works by the greatest masters of the late eighteenth and early nineteenth centuries: Reynolds, Gainsborough, Raeburn, Wilson, the Norwich school, Callcott, Cox and Müller.[28] Fairly modest sums were expended and some rather unexciting works acquired. One extraordinary bargain, however, was William Blake's eighteen *Heads of poets*, purchased for approximately £125.

On the modern front, the expenditure of fairly large sums of money did produce rewards. With such a large purchase grant they were able to secure some important works by living artists. Acquisitions included works by Randolph Caldecott, Vicat Cole, Alfred East, David and Joseph Farquharson, Luke Fildes, Herkomer, James Hook, Colin Hunter, Leighton, George Mason, Pettie, Poynter, Edward Pritchett, Rivière, James Sant, Marcus Stone and Watts. These included such famous works as *Hard times* by Herkomer, *Captive Andromache* and *The last watch of Hero* by Leighton, *The Ides of March* by Poynter. Among younger artists they secured *Christening Sunday* by James Charles and *The lighthouse* by Stanhope Forbes of the Newlyn school, and *The minister's garden* by Cecil Lawson.

Manchester is famous for the Art Gallery's extensive collection of Pre-Raphaelite paintings, but by 1900 only thirteen of these had been purchased. They include, however, some of the highest reputation, and certainly those most important in the city's ownership, namely *Work* by Ford Madox Brown, *Autumn leaves* by John Millais, *The hireling shepherd* by Holman Hunt, and *Astarte Syriaca* by D. G. Rossetti, *Sibylla Delphica* by Burne-Jones and *The pedlar* by Charles Collins.[29] These had been augmented by six gifts, *The shadow of death* by Holman Hunt, 33, donated by Thomas and William Agnew, two late works by Millais, two Spencer Stanhopes and a Prinsep. The remainder of the gallery's 117 Pre-Raphaelite works were acquired by purchase and gift after 1900.

Benefactors from this later period include Thomas Horsfall, who founded a teaching museum in the slums of Ancoats and persuaded Brett, Madox Brown, Burne-Jones, Rossetti, Leighton and others to donate small oils and drawings. The Horsfall Museum collections were incorporated into the city collection in 1918. Others were A. C. Blair, James Blair and G. B. Blair (brothers who made

[28] Manchester City Art Gallery; see sources cited at n. 11.
[29] For dates of accession see Manchester City Art Galleries, *Pre-Raphaelite paintings*, 1974.

individual presentations—in the two latter cases, splendid bequests, in 1917 and 1940), Dr Lloyd Roberts, James Gresham and John Yates (Manchester businessmen); creative artists such as Fred Jackson and Edgar Wood; and such famous Mancunians as C. P. Scott, editor of the *Manchester Guardian*, Mrs Rylands and Miss Horniman. In general the greatest period of benefactions was between 1900 and 1920.[30]

It is interesting that the taste of many of these later collectors did not move with the times into the twentieth century but stayed faithful to the collecting tradition stimulated by Agnew's in the second half of the nineteenth. The taste for what at the time was modern British art became in the twentieth century a taste for 'High Victorian' art. In the 1980s one may remark upon the constancy of Manchester's affections.

[30] Manchester City Art Gallery, *150th Anniversary Exhibition*, 1973.

Thomas Worthington

In the spring of 1848 Thomas Worthington and a travelling companion, Henry Darbishire, having recently completed their articles with Manchester architects, set out on a grand architectural tour to Italy.[1] In that year of widespread tumult, when France, Italy, Germany and Austria were plunged into revolution, their travel was more hazardous than usual. They left Paris barely twenty-four hours before rioting began; at Marseilles they heard of the flight of Louis-Napoleon; and in Italy too they saw evidence of civil war, but they were not deterred, and the great events that Worthington recalled in his memoirs were architectural.[2] One of his most vivid recollections was of the evening when they were travelling by mail coach to Rome and 'our postboy turned round and shouted, "Ecco, signori, il duomo di San Pietro," and there before us we saw the mighty dome of St Peter's, dim in the distance and we all shouted in excitement'.

Worthington sketched the great buildings of Rome and travelled unhindered through the spring and summer months. He embarked upon prodigious walking tours and in August covered 140 miles of the Tuscan roads on foot and alone, visiting Siena, Volterra and Pisa before returning to Florence, where he enjoyed a round of 'church hunting' and constant sketching. The memory of his stay in Florence was a constant inspiration to him long after the hazards and discomforts of his journeyings were forgotten. In later life he even saw Manchester as 'the Florence . . . of the nineteenth century' because it had developed a style of architecture 'which we may largely call our own and in which we may take a not unnatural pride'.[3] On examination

[1] For further information on Worthington see A. J. Pass, 'Thomas Worthington, Practical Idealist', *Architectural Review*, vol. 155, 1974, pp. 268–74, and 'Thomas Worthington, Architect', University of Manchester MA thesis, 1978. Henry A. Darbishire later practised in London and designed model housing for Miss Burdett-Coutts and the Peabody Trust. See J. N. Tarn. *Working-class housing in nineteenth-century Britain*, 1971, and R. Dixon and S. Muthesius, *Victorian architecture*, 1978.

[2] In 1898, probably from his diaries, Worthington compiled four volumes of 'Memories', which remain in private ownership. Future unreferenced quotations are all from the first volume. The MS is unpaginated.

[3] Presidential address to the Manchester Society of Architects, 1875–76, *Architect*, vol. 15, pp. 9–10, 1 January 1876.

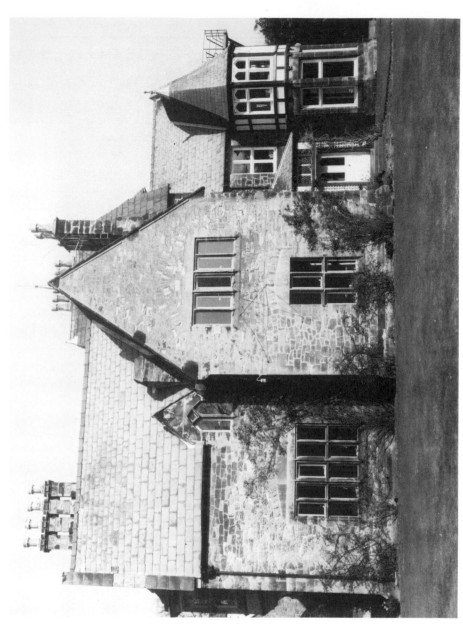

34 Thomas Worthington (1826–1909). 35 Bowman and Crowther: Bromfield, Alderley Edge, Cheshire, 1847

the parallel Worthington drew was not so far-fetched as it might first appear, nor was his use of the first person unjustified.

Thomas Worthington, **34**, born in 1826, was the fourth of six sons of Thomas and Susannah Worthington. They were members of the Cross Street Unitarian Chapel, one of the oldest dissenting congregations in the North and one respected in a town where liberal Nonconformity had deep roots. Thomas began his architectural career at the age of fourteen in the office of Henry Bowman (1814–83), learning his Gothic vocabulary by accompanying him on 'church-hunting expeditions' (see p. 7 and note). He assisted in the preparation of Bowman's *Specimens of ecclesiastical architecture of Great Britain* (1846) and in 1844 was awarded the Isis Gold Medal of the Royal Society of Arts for the design of a Gothic chancel. He recalled that the presentation ceremony, conducted by the Prince Consort, was 'rather an ordeal for a youth of 18'.

The following year Bowman entrusted him with his first complete project, Broomfield, **35**, one of the earliest of the large houses to be built on Alderley Edge, Cheshire, fourteen miles from Manchester. It is a skilful and accomplished design, much influenced by Pugin's plates of the fourteenth-century manor house at South Wraxhall, Wilts., and the Vicars' Close at Wells.[4] Much later Worthington purchased Broomfield. It became his family home for the last forty years of his life, and Edith Emma Swanwick, the daughter of the first tenant, became his second wife.

Early in 1847 Worthington completed his pupilage and, taking up an offer from Sir William Tite to 'find him a berth', joined his Carlisle office to work on the buildings for the newly completed Lancaster and Carlisle Railway.[5] After a short but enjoyable spell in the Borders Worthington set out on his nine-month European tour, during which he made a huge collection of sketches which were constantly enjoyed and used in his long architectural career. After returning he lost no time in consulting Tite about his future. He records, 'London had many attractions but there were also many reasons why I should settle in Manchester. Mr Tite had unhesitatingly advised me not to think of London where there was so much competition. He said: "You have many friends in the north, go down to Manchester and hang out a sign there."' This Worthington did, renting two small rooms in King Street early in 1849.[6]

Tite's advice proved sound. There can have been few places and periods when the prospects for a young architect were so full of promise, though Worthington was later to admit that the earliest years of his practice were 'a rather struggling time'. Prompted by youthful ambition, he entered the

[4] A. and A. W. Pugin (text by E. J. Willson), *Examples of Gothic architecture*, 3 vols., 1831–36. See vol. 3.

[5] Sir William Tite (1798–1873), an MP and twice president of the RIBA, was as much public figure as architect. His extensive practice included much railway work and the rebuilding of the Royal Exchange, London (1841–44).

[6] Worthington practised successively from 110 King Street, 54 John Dalton Street and 46 Brown Street.

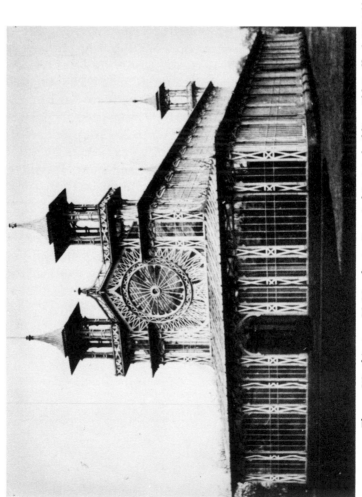

Thomas Worthington: **36** Manchester Botanical Society building, Old Trafford, 1854 (demolished) and **37** Overseers' and Churchwardens' office, 46 Fountain Street, 1852–58

competition for the buildings to be erected for the Great Exhibition of 1851 in Hyde Park. Among the 245 unsuccessful competitors his entry gained an honourable mention and attracted the praise of Decimus Burton, and through the influence of Matthew Digby Wyatt he was appointed regional organiser for northern exhibitions, working closely with Manchester industrialists, including Whitworth and Fairbairn.[7]

Paxton's Crystal Palace apparently inspired Worthington in his design for the Manchester Botanical Society's glasshouse, completed in 1854, an iron-framed extravaganza combining a variety of architectural whims and fancies, with 'here an arch or a wheel window, there a square campanile surmounted by a dwarf spire and flagstaff'.[8] An early photograph, **36**, illustrates this short-lived curiosity, which Cecil Stewart described as an 'indiscriminate sowing of wild oats'.[9]

After a series of unsuccessful competition designs Worthington was more fortunate in gaining the commission for the Overseers' and Churchwardens' Office in Fountain Street, Manchester, begun in 1852. In marked contrast with the eccentric Botanical scheme it is a happy composition, aptly described by one of his architect sons as 'a little gem of the Italian Renaissance, the first fruits of his Italian journey', **37**.[10] Occupying a narrow frontage, the first stage of the building followed the *palazzo* mode and the distinguished example of Edward Walters (1808–72) and J. E. Gregan (1813–55). Later two floors containing a magnificent boardroom and library were added. This stage took the form of an arcade surmounted by a high, pierced frieze crowned by a heavily modelled cornice projecting a full 4 ft (1·219 m). The Renaissance grandeur of the exterior was more than matched internally by the staircase and boardroom, with their fine arrangements of barrel vaults, coffers and saucer domes. In referring to it as a 'simple bit of Italian design in brick and stone' Worthington was unduly modest.[11] There is richness and vitality in the carefully contrived asymmetry and in the dramatic skyline; moreover the detail has a sharpness and distinction which a century of Manchester's grime did not efface.

Worthington's 'rather struggling time' came to an end with his appointment as architect to the Manchester and Salford Baths and Laundries Company in 1855. The concept of a philanthropic company dedicated to the advancement of social projects for a limited return on investment is difficult to grasp in our own day, with its sharp division between public and private ventures. In the mid-nineteenth century, when municipal government was in its infancy, many

[7] Sir Matthew Digby Wyatt (1820–77), a member of that famous family of architects (see John M. Robinson, *The Wyatts: An architectural dynasty*, 1979), was Secretary to the Executive Committee for the Great Exhibition.

[8] *Builder,* vol. 12, p. 328, 17 June 1854, quoting the *Manchester Courier*. Technical details are given in the same volume, p. 514, 30 September 1854.

[9] *The stones of Manchester*, 1956, p. 81.

[10] Sir J. Hubert Worthington, 'Notes on Father', 1963, unpublished MS.

[11] 'Memories', vol. 3.

38 Thomas Worthington: Collier Street Baths, Greengate, Salford, 1856. Front elevation

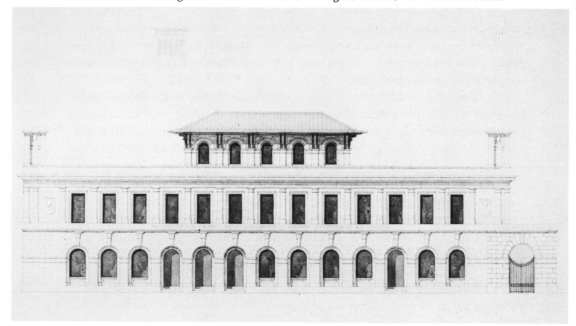

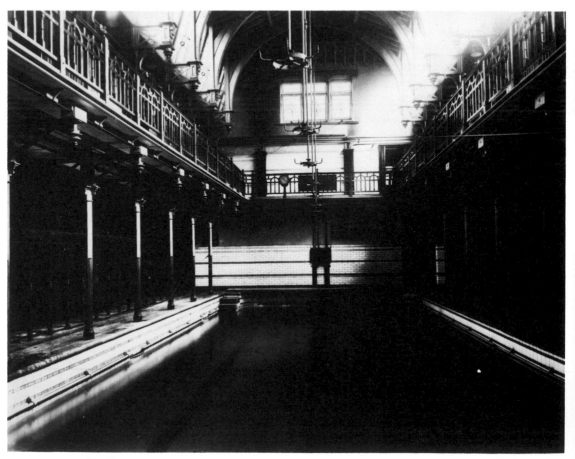

39 Thomas Worthington: Mayfield Baths, New Store Street, 1856–57 (demolished)

projects were pioneered by individuals prepared to invest in joint-stock companies devoted to specific social aims. The Manchester baths concern was formed when the Council had repeatedly deferred consideration of public baths 'to some more convenient season'.[12]

In June 1855 plans for the first pioneer block, in Greengate, Salford, were presented to the directors. The only surviving drawing shows a strong Italianate influence, with a two-storey frontage surmounted by a central attic storey intended for the manager's apartment, **38**. Behind this block were the first and second-class swimming pools, the largest then built, spanned by a complex structure of iron and laminated timber supporting a fully glazed roof. Completed on time in 1856 at a cost of £9,000, the Greengate establishment was an instant success: nearly 3,500 bathers used the building during the first fortnight. At the shareholders' meeting in December 1856 the chairman was able to report a healthy balance, commenting that 'the advantage to our fellow citizens of the working classes has been everything we anticipated'.[13] One leading shareholder, the engineer William Fairbairn, told the meeting that the Greengate baths were 'likely to be an example to other cities in the kingdom'. The London establishments he had visited were not to be compared with the venture.[14]

In this spirit, in the same year, the company embarked upon the building of a second block, in New Store Street, Mayfield, a locality between the poor and heavily industrialised districts of Ardwick and Ancoats. For this Worthington once again adopted the Italianate style, and contemporary photographs show the distinctly Roman trappings of the iron-colonnaded swimming pool, **39**, but when two years later, in 1858, he designed the third and largest of the baths, built in Hulme and completed in 1860, he ventured into a new field stylistically.

Whilst preparing the preliminary designs Worthington had made a second pilgrimage to Italy. Ruskin's *The seven lamps of architecture* (1849) and *The stones of Venice* (1851–53) had appeared since his last visit, and he was fired with enthusiasm for the medieval architecture of northern Italy, which he recorded in considerable detail. Back in Manchester, his sketches came into immediate use, and Hulme Baths were completed in a polychrome style described by the *Builder* as 'Veronese or Lombardic', **40**.[15]

An unprecedented period of civic patronage that provided Manchester's most notable High Victorian Gothic building commenced with the competition for the Assize Courts in 1858–59. Worthington's entry 'in the Rathaus style'

[12] E. T. Bellhouse, 'On baths and wash-houses for the people', a paper delivered to the Manchester Statistical Society, June 1854, *Transactions*, 1853–54, pp. 91–100.

[13] Manchester and Salford Baths and Laundries Co., unpublished report, December 1856, now in the records of Manchester Corporation's Recreational Services Department (Baths and Laundries).

[14] *Ibid.*

[15] Vol. 18, p. 414, 30 June 1860.

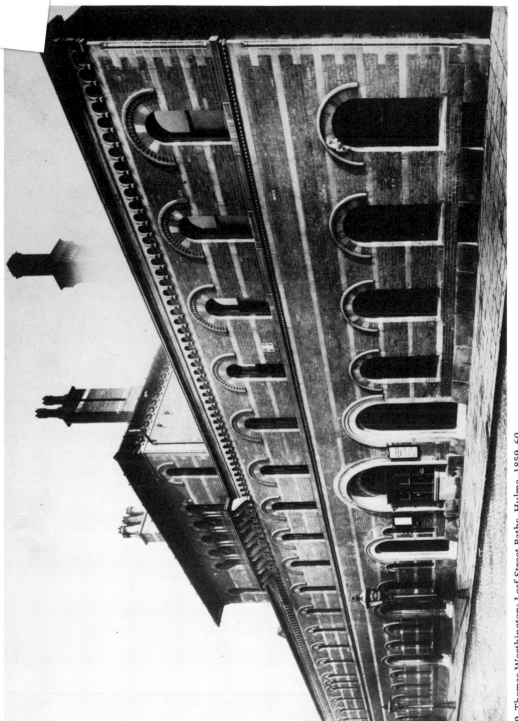

40 Thomas Worthington: Leaf Street Baths, Hulme, 1859–60

was unsuccessful,[16] and it was the death of the Prince Consort in December 1861 that gave him his first opportunity to build a major monument. A memorial fund had been set up, and the appeal committee considered no fewer than seventeen suggestions for the form of a memorial to the Prince. The mayor had already commissioned a statue from Matthew Noble (1818–76) and at length, after much wrangling, it was decided that the first object of the fund should be 'to provide a suitable receptacle to contain or cover the statue'.[17] Worthington submitted two sketches, the first for a Gothic ciborium or canopy, and an alternative based on that well tried Athenian classic, the Tower of the Winds. The committee, conforming to the contemporary taste for romantic Gothic, chose the former.

The design was unusual although not unprecedented and consisted of an open, four-sided structure 73 ft (22·250 m) high, **41**. Its derivation can be seen from a sketch by Worthington of 1848 of the tiny chapel of Sta Maria della Spina, Pisa. The memorial incorporated a lavish display of allegorical figure sculpture and royal heraldry, and was much admired for its novelty. The Bishop of Manchester suggested that Worthington's drawing should be published to establish the authorship of the idea. This proved to be timely, for the design antedates the more famous memorial in Kensington by George Gilbert Scott (1811–78), who claimed that *his* idea was 'so new, as to provoke much opposition' but that it had been produced *'con amore'* after 'long and painful . . . effort'.[18] Worthington's design appeared in the *Builder* on 27 September 1862. Work on the memorial was slow, but it was finally completed in 1867 and became the prime feature in the newly created Albert Square until the construction of the new Town Hall.

One of the earliest buildings of the new square was by Worthington. The Memorial Hall was commenced by the Unitarians in 1863 to commemorate the Great Ejection, a landmark in the history of English Dissent.[19] Worthington made the fullest use of an irregular corner site to create an arresting composition reminiscent of a Venetian palace, vivid in brick and stone polychromy. The external elements of the traditional *palazzo*, the half-basement, the jutting balconies and traceried screens, were skilfully rearranged to accommodate offices at the lower levels and a large public hall above. The influence of Ruskinian Gothicism on Worthington is seen perhaps at its greatest in this most sensitive example of street architecture.

In the winter of 1867–68 Worthington was exceptionally busy. First and foremost he was engaged in preparing a magnificent set of drawings as his entry

[16] *Manchester Guardian*, 24 May 1859, p. 10.

[17] *Ibid*. 3 March 1862, p. 9.

[18] *Personal and professional recollections*, 1879, pp. 225 and 263. Scott's design was published in the *Builder* on 23 May 1863, vol. 21, pp. 370–1. Also see Stephen Bayley, *The Albert Memorial*, 1981.

[19] On St Bartholomew's Day 1663 some 2,000 Puritan ministers were ejected from their livings as a result of the Act of Uniformity of 1662. Unitarianism grew from this dissenting body.

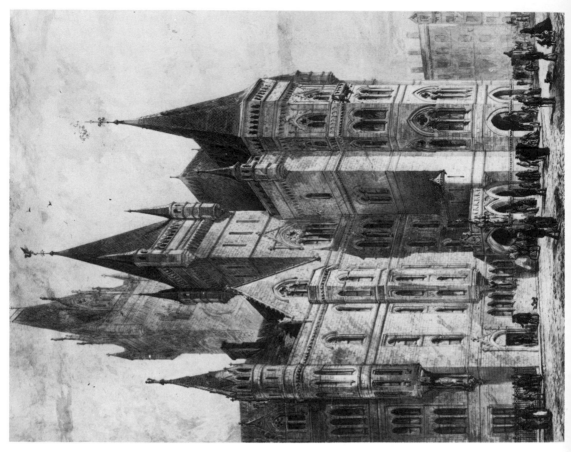

Thomas Worthington: **41** Albert Memorial, Albert Square, 1862–67 and **42** Manchester Town Hall, competition drawing for the second stage, 1868. The Princess Street–Albert Square corner

for the second stage of the Town Hall competition. His perspectives reveal his genius for drama and romanticism. The *Manchester Guardian* accurately summed up the composition as 'a Rhineland vision'.[20] The drawing of the Albert Square–Princess Street corner, in particular, expresses a truly Wagnerian fantasy in slated spires and pinnacles dominated by the misty, gaunt and unbuttressed clock tower, **42**. Though highly praised for its 'poetic feeling', his design failed to surpass Waterhouse's (see chapter six).

In the years following the Town Hall competition several commissions enabled Worthington to use the rich vocabulary of High Victorian Gothic that he had developed for secular purposes. His greatest work in Manchester and the most impressive monument of his career commenced in 1868 when he won a limited competition for the new Police Courts, a municipal project which cost £81,000 and was second only in importance in Manchester to the Town Hall. The site and the brief posed formidable physical and financial problems. Traffic noise from iron-tyred vehicles on the setts of the adjacent streets dictated that the four courts should be set in the centre of the building, flanked by ancillary rooms ranged round the frontages. Worthington achieved a masterpiece of internal planning, with separate access for the public and the justices by means of handsome portals rising from the narrow streets, **43**. Prisoners were delivered from horse-drawn wagons at half-basement level into cells which, with their plastered walls and separate lavatory facilities, were considered very advanced in the 1870s.

The heating and ventilation of this intricate building were through a boiler and heat-exchanging plant that warmed fresh air for circulation to the rooms through brick ducts. This and the provision of speaking-tubes between major departments drew admiring comments from the technical press.[21]

The architectural value of the building as a dramatic element in the town has been greatly enhanced by recent cleaning. The gridiron of streets flanking the site permitted only oblique views of the frontages, and Worthington decided upon an asymmetrical composition. The most prominent feature on the skyline, a clock tower rising sheer to a height of 188 ft (52·302 m), is sited not in the centre but at the most important corner, and a richly decorated boiler flue rises centrally over the steep slate roofs. Financial limitations had prevented the exclusive use of stone for the facades, but a most effective use was made of the contrasts between bright orange brickwork, pale golden Yorkshire stone dressings and blue slate roofs. This combination became something of a Worthingtonian hallmark and is to be seen in several other buildings that are equally demonstrative of High Victorian Gothic design.

Nicholls's Hospital, founded as a charity school to provide maintenance and education for boys from 'honest industrious and needy families', was

[20] 7 April 1868, p. 12.
[21] *Architect*, vol. 5, p. 32, 27 May 1871.

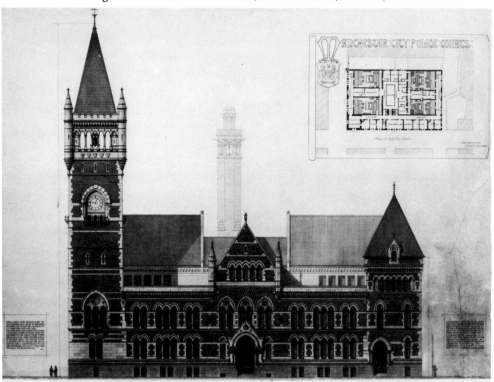

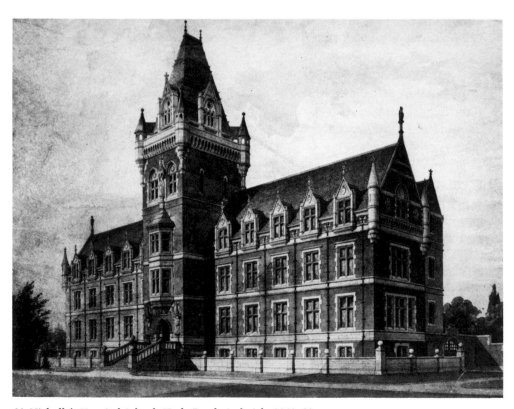

44 Nicholls's Hospital School, Hyde Road, Ardwick, 1869–80

commissioned in 1867 by Benjamin Nicholls (1798–1877), twice Mayor of Manchester, but not completed until 1880, **44**. It was a memorial to his son, John Ashton Nicholls (1823–59), a school friend of Worthington's who had devoted a short life to social welfare. Worthington conceived a lavish and romantic composition in full-blooded Franco–Italian Gothic. It is finely executed in fine orange-red brickwork with cream, stone dressings. The main frontage, to Hyde Road, is distinguished by ranges of stone-mullioned windows capped by tall dormers set in a steep, slated roof. A handsome tower, closely resembling that designed for the Town Hall competition, rises to 130 ft (39·624 m) above the entrance, and the dramatic form of the building makes a landmark on the eastern approaches to the city that is now widely visible because of extensive slum clearance.

Less prominent but in the same vein is the mansion Worthington designed in 1867–68 for John Edward Taylor (1830–1905), owner and editor of the *Manchester Guardian*. Appropriately named The Towers, it stands in pleasantly wooded grounds off Wilmslow Road, Didsbury, **45**. It was designed to make the most of the south-western aspect overlooking the Mersey valley. The arrangement of the plan makes bold use of the main elements to create a romantic Gothic composition reminiscent of the chateaux of central France. The kitchen block, capped by a high, louvred roof, acts as a foil within the turreted and high-dormered entrance front. Within, the handsome staircase and painted state rooms are the best surviving examples of Worthington's interior work. Soon after the completion of the house Taylor moved to London, and The Towers was sold to Daniel Adamson, engineer and chief promoter of the Manchester Ship Canal. It was here that the Canal Company was conceived in 1882.

Worthington has a special position among Victorian architects for his active interest in the development of buildings to serve the social needs of the time. His association with the Manchester Statistical Society brought him into contact with the great figures of medicine and social science.[22] Florence Nightingale's letters to him during the building of the hospital workhouses at Chorlton and Prestwich illustrate her campaigning style and her remarkable grasp of technical detail. On her return from the Crimea she had discovered with horror that the chaos she had found in war had its counterpart in the hospital system at home. Her *Notes on hospitals* (1859) was sent to the Queen and the Cabinet and became something of a best-seller among the public. To counter the dangers of infection she advocated improved standards of space, light and air and the principle of physical isolation between wards. A fixed volume of air was to be planned for each bed space, the size of each ward was to be determined by the most efficient nursing unit, and ward blocks were to be built in pavilions set 100 ft (30·480 m) apart.

[22] See T. S. Ashton, *Economic and social investigations in Manchester, 1833–1933*, 1934 (rp. 1977).

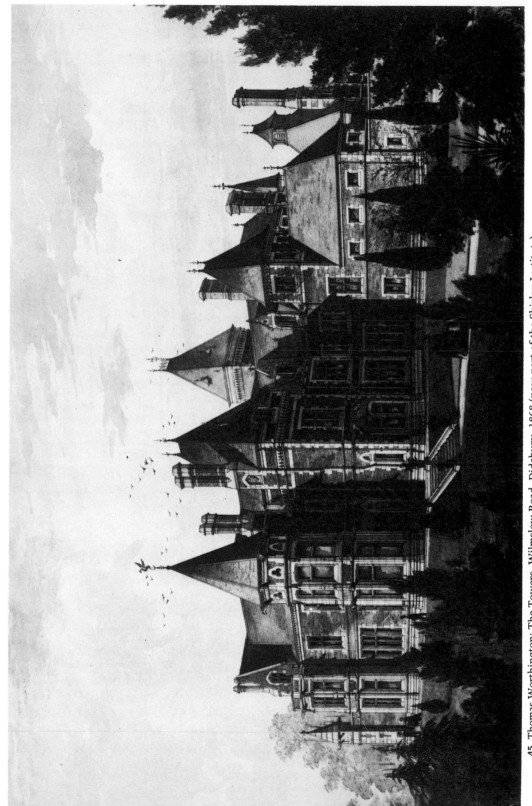

45 Thomas Worthington: The Towers, Wilmslow Road, Didsbury, 1868 (now part of the Shirley Institute)

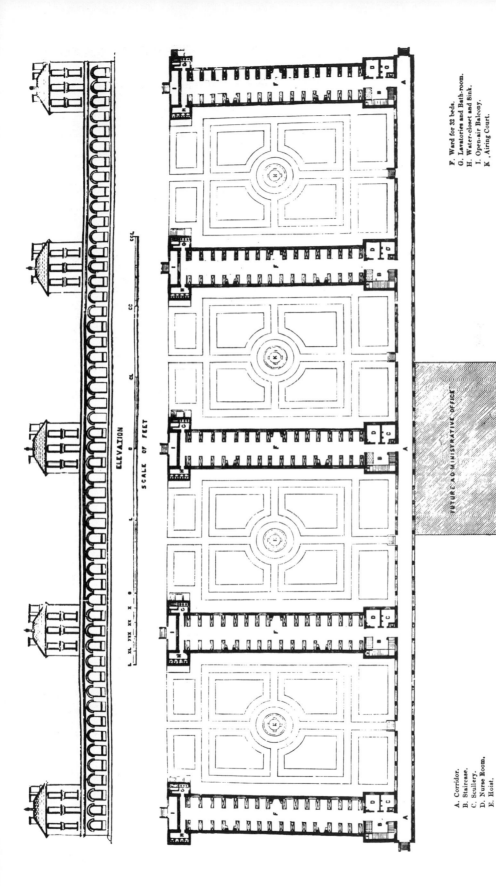

ELEVATION

SCALE OF FEET

PLAN

FUTURE ADMINISTRATIVE OFFICE

A. Corridor.
B. Staircase.
C. Scullery.
D. Nurse Room.
E. Hoist.

F. Ward for 32 beds.
G. Lavatories and Bath-room.
H. Water-closet and Sink.
I. Open-air Balcony.
K. Airing Court.

46 Thomas Worthington: Chorlton Union Hospital, Nell Lane, 1865, now part of Withington Hosital

After experiencing many delays and frustrations in her campaign, in a letter to Worthington (23 July 1865) Miss Nightingale acclaimed his designs for the proposed Chorlton Union Infirmary as the first pavilion scheme, **46**. With evident pleasure she wrote, 'If you succeed in completing the buildings for anything like the money, with due regard to the simple sanitary requirements of so great a building, you will have inaugurated a new era.'[23] The infirmary consisted of five three-storey pavilions with ground-floor entrances connected by a long arcaded corridor, open at the sides. Each ward was equipped with waterborne sanitation, coal fires and ample ventilation. Subsequently (7 November 1868) Florence Nightingale commented: 'Your hospital plan is a very good one: when completed, it will be of the best, if not the best in the country. It might be improved in some small matters of detail. . . . Still, it is capital as it is. . . .'

Worthington's Prestwich Infirmary, of 1866, was the subject of further detailed comments and encouragement, and the same year Miss Nightingale had the plans copied and distributed at home and in the colonies, and it is therefore partly to Thomas Worthington that the genesis of the Victorian infirmary, that most enduring backbone of the twentieth-century medical service, should be attributed. Worthington's hospitals are extremely plain. At Prestwich the elevations are straightforward expressions of the brief, for the architect commented, '. . . all attempt at architectural effect has been carefully avoided but the work is substantial and good, and the main sanitary objects will be attained'.[24] This would have drawn a sympathetic response from Miss Nightingale, who had asserted in her *Notes* that 'fitness is the foundation for beauty'.[25]

The success of Worthington's early hospital designs brought him several important commissions outside Manchester. Soon after the completion of the Prestwich Union Infirmary he built an extensive convalescent hospital at Woolton, near Liverpool 1868–73. It was followed by the Wigan Royal Infirmary (1870–73) and the lavishly appointed Bath Hospital at Harrogate (1885–89). However, his ideas were not followed for the modernising or resiting of the old established infirmary in the centre of Manchester. Twice, in 1875 and 1896, the Infirmary trustees called for schemes of improvement, but it was not until 1902 that the decision was taken to move the Infirmary, and six years later it was transferred to its present site on Wilmslow Road.[26]

Another expression of Worthington's practical concern with social questions was his involvement in the provision of improved dwellings at economic rents. Housing conditions in Manchester were a byword from 1832

[23] Letters from Florence Nightingale, 1865–68, John Rylands University Library, University of Manchester.
[24] *City News*, 25 April 1868.
[25] *Notes on hospitals*, 3rd ed, 1863, p. 11.
[26] William Brockbank, *Portrait of a hospital, 1752–1948*, 1952.

and the publication of Dr J. P. Kay's *Moral and physical condition of the working classes employed in the cotton manufacture in Manchester*. Worthington's interest in housing began early in his architectural career and was perhaps stimulated by his attendance at Cross Street Chapel during the ministry of the Rev. William Gaskell, the husband of Elizabeth. The most active reformers were members of the Statistical Society. Their efforts were acknowledged at the Social Science Congress held in Manchester in October 1866. There Worthington, in presenting a *résumé* and discussion of a paper, argued that the only possible remedy for dense overcrowding was the erection of blocks of dwellings in flats, although he later acknowledged 'the prejudice in the minds of the Lancashire working man against such buildings'.[27]

In 1868 the Mayor of Salford called a meeting to launch a public company to promote the construction of 'decent, well arranged habitations let at small rentals'.[28] Many leading citizens, including the Bishop of Manchester and Thomas Worthington, bought shares, but despite initial enthusiasm it proved difficult to raise more than a small part of the £25,000 capital required. Worthington, a director of the company, undertook the commission but nearly twelve months passed before he was able to begin work on the project. On a small site of half an acre at Collier Street, Greengate, opposite the first of Worthington's public baths, the company planned to build no fewer than sixty-two experimental flats and two shops. Construction started in April 1870. The scheme consisted of two parallel four-storey blocks separated by a narrow courtyard only 26 ft (7·925 m) wide, **47**. Within the severe limitations of cost and space thirty-six two-room, twenty three-room, and six four-room flats were planned, each with its own kitchen and a separate w.c., the latter accessible from an airy landing. This level of provision was considered advanced when the exclusive use of a kitchen and w.c. was not generally thought necessary for a working-class family.

The Greengate model housing scheme cost £8,600 to build, or approximately £140 per dwelling. The subsequent profitability of the company was disappointing, and the expected 5 per cent dividend did not materialise. It fell to Worthington himself, as architect and a director, to appeal in the columns of the *Manchester Guardian* of 29 November 1879 for a renewal of public support for model housing. He then stated:

> The object of the promoters was rather to set down in the midst of a populous district an example of a block of housing flats with good sanitary arrangements as a test of a principle novel in the neighbourhood, than to create a paying investment of money.

The cost of management, he argued, would be reduced if more estates were to be

[27] See the *Builder*, vol. 24, p. 770, 20 October 1866. His subsequent acknowledgement of the dislike of flats is in a letter to the *Manchester Guardian*, 29 November 1879.

[28] A long account of the project is printed in the *Salford Weekly News*, 9 April 1870.

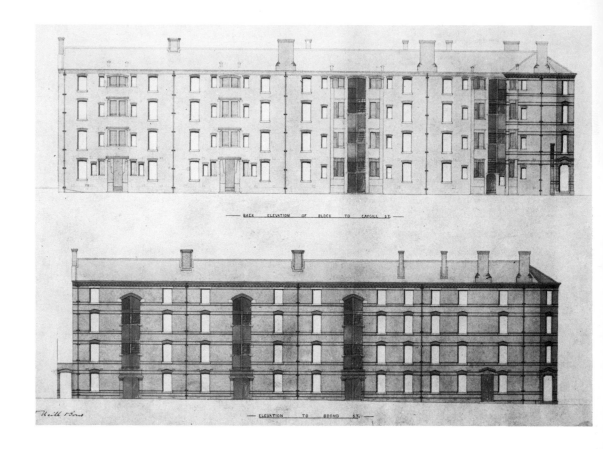

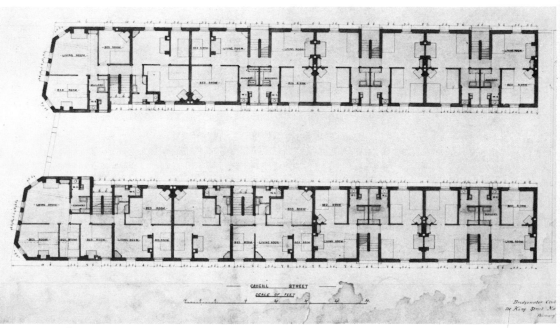

47 Thomas Worthington: model housing, Greengate, Salford, 1869 (demolished). Plans and elevation.

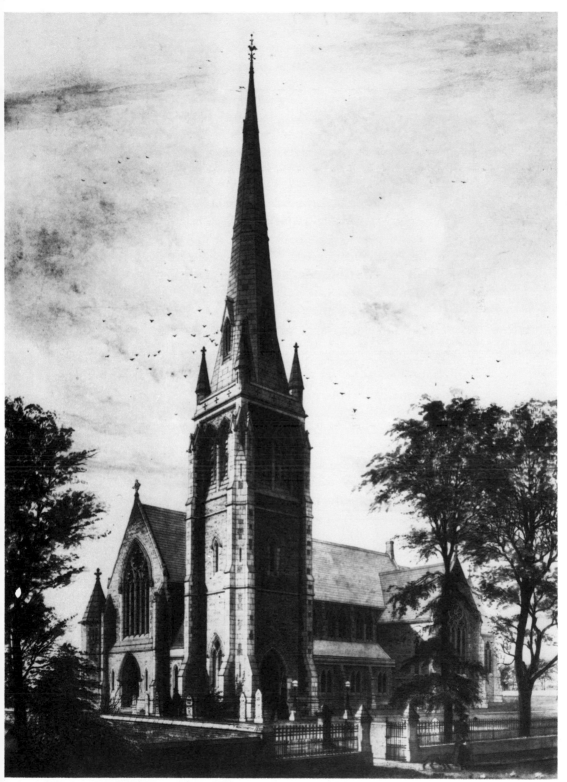

48 Thomas Worthington: Unitarian church, Monton, Salford, 1872

built. He had always believed that the company's aim of holding rents down to those of the surrounding slum property was misguided, and in his letter he pressed for a marginal increase in rents to pay for the immeasurably better standards of accommodation, the gas lighting and waterborne sanitation.

Among Worthington's associates in such social enterprises were members of many of the great liberal mercantile families of Manchester who played a major role in the city's life and government. Some have already figured as Worthington's patrons, such as J. E. Taylor and Benjamin Nicholls. Perhaps the most lavish was Richard Peacock (1820–89), the locomotive engineer, industrialist and founder and patron of the Brookfield Unitarian Church at Gorton. Then a separate township to the south-east of the city, Gorton was the home of Beyer Peacock and Co., the locomotive builders. Brookfield Church (1870) was the first of eight Unitarian chapels to be built or remodelled in the Gothic style by Thomas Worthington in the later years of his career. In these he added notably to the line of Gothic Revival Unitarian architecture established in the 1840s by Bowman and Crowther, perhaps influenced by the liberal ecumenical principles of Dr James Martineau (1810–1900), a leading Unitarian divine.

At Brookfield Worthington designed a large, handsome church in full Gothic with a most distinguished tower and spire. Internally the arrangement includes a font, communion rails, pulpit and raised chancel, yet the character is distinctly Unitarian, although restrained rather than plain. Symbolism was fully embraced, for the church is adorned with the emblems of the evangelists and representations of saints, martyrs, philosophers and scientists. In the churchyard Peacock is interred, an industrial baron in a medieval tomb, in a handsome marble vault of Worthington's design. Here a different symbolism prevails, and on each of the four corners is a carved and reverential figure representing respectively an engineer, a blacksmith, a draughtsman and the architect himself.

During the 1870s Worthington built other Unitarian chapels, at Altrincham, Pendleton, Buxton, Monton and Hyde. All were shaped by the necessary economy of their construction, but perhaps the churches at Monton Green, 1875, **48**, and Flowery Field, Hyde, 1878, are the finest, demonstrating the almost limitless flexibility of the Gothic style in the hands of an adventurous designer. At Flowery Field Worthington dispensed with nave arcading to create a wide, dignified interior with galleries at the west end and in the transepts. Here his delight in well proportioned plain surfaces, lively sprouting carved detail, and contrasts between smooth dressed ashlar and boasted stonework was expressed to the full.

As has been shown, Worthington's practice extended beyond Manchester, partly because of his professional reputation and also because of Mancunian or Unitarian connections. The commission for Manchester College, Oxford,

1889–93, a Unitarian foundation and his major work outside Manchester, can be attributed to the latter two factors. Planned around a central quadrangle, it is a complete college complex in a noble composition incorporating ecclesiastical and domestic themes of fourteenth, and fifteenth-century English building. The foundation stone of the college chapel is inscribed 'To Truth, to Liberty, to Religion', a dedication not inappropriate to the architecture.

Worthington died in 1909 after a career of sixty years. His office was never large, and despite the importance of his commissions he was rarely assisted by more than one architect and a small staff. His principal assistant for many years was John Elgood (1834–93), who later became his partner. Later in his career he was joined by his son, Percy Scott Worthington (1864–1939), who, succeeded by John Hubert (1886–1963), the youngest son of his second wife, continued the distinguished reputation of the practice.

Worthington became the life tenant of a large estate in the Midlands in 1863 as a result of his first marriage. This gave him the financial independence that left him free to devote himself to matters outside architecture, especially in his later years. Unlike Waterhouse, his friend and occasional rival, he remained in Manchester, where he became a respected elder statesman among his confrères. In 1875–77 he served as president of the Manchester Society of Architects, and he was a vice-president of the RIBA from 1885 to 1886. He was active in the city's cultural affairs and took a leading role in the transfer of the building and collection of the Royal Manchester Institution to Manchester Corporation to provide it with a city art gallery. It was Worthington who shrewdly negotiated the clause requiring the allocation of £2,000 per annum by the Council for the purchase of new works of art, a provision that was instrumental to the creation of Manchester's collection of art treasures (see chapters one and three).[29]

Despite semi-retirement from 1896, Worthington regularly attended his office in Brown Street until he was eighty. His healthy constitution was matched by a lively mind, and his youngest son, Sir Hubert, recalled that he 'entered into every detail of my architectural education, and I could hardly stop him taking a hand in student competitions'.[30] He was a striking figure, over six feet tall, with snowy white hair, a fresh complexion and a full beard. Personally and professionally he was indeed an architectural patriarch, the quality and consistency of whose work brought Manchester closer to his Florentine ideal, and whose individuality richly contributed to the identity and architectural character of Victorian architecture in his native city.

[29] 'Memories', vol. 4.
[30] Sir Hubert Worthington. 'Notes . . .', *op. cit.*

The Art-Treasures Exhibition

In his essay 'Art and socialism' Roger Fry pronounced the Manchester Art-Treasures Exhibition of 1857 an event 'destined to change ultimately the face of things' and the 'Mene Tekel of the orgy of Victorian Philistinism'.[1] Certainly the event evoked both surprise and some surprising responses. Friedrich Engels, better known for his descriptions of Manchester's social conditions, was not alone in finding it remarkable that Manchester and not London had organised an art exhibition of 16,000 works. 'Here everyone is a friend of art,' he wrote to Karl Marx. 'Moreover there are some very beautiful pictures here. You must come over this summer and see it with your wife.'[2] John Ruskin, however, when he lectured in Manchester during the exhibition period in July 1857, instead of addressing his audience on art used the occasion to beard the lions of *laissez-faire* economics by expounding his radical views on the social order in two lectures, *The political economy of art*. Many years later, when the lectures were republished (1880), he retitled them '*A joy for ever*', in ironic allusion to the popular line from Keats that was inscribed over the main entrance inside the exhibition hall.[3] By chance, a month after Ruskin's lectures, Marx created an historical parallel to them in his introduction to his *A contribution to the critique of political economy*.[4]

As Fry suggested, the Manchester exhibition is of great significance in the history of art in the nineteenth century. Although its detailed documentation still requires scholarly attention, it can be seen to illustrate the complex

[1] Roger Fry, 'Art and socialism', *Vision and design* (1st edn 1920), Phoenix edn, 1928, p. 58. This essay was reprinted with considerable alterations from 'The great State', 1912 (*op. cit.*, p. 55). See Francis Haskell, *Rediscoveries in art*, 1976, pp. 97–9.

'Mene tekel', part of the inscription that appeared at Belshazzar's feast; 'You have been weighed in the balance and found wanting' (*Daniel* 5, 25).

[2] Karl Marx and Friedrich Engels, *Works*, vol. 29, p. 135 (Engels to Marx, 20 May 1857).

[3] The lectures were reported in the *Manchester Guardian* on 13 and 14 July 1857. They were published as *The political economy of art* in December 1857 and in further editions in 1867 and 1868. For a list of contemporary reviews see *Works*, vol. 16, p. 6. See also (*a*) George Eliot's letter to Sara Hennel, cited in Raymond Williams, *Culture and society, 1750–1950*, 1958, p. 140; (*b*) J. T. Fain, *Ruskin and the economists*, 1956, pp. 31–2.

[4] The introduction was written between the end of August and mid-September 1857, but not published until 1859.

interaction of the numerous factors bearing on art in the age of industrialisation and it marks a fruitful moment in the formative phase of art history as a discipline. Finally, as Fry's reference to it with regard to Victorian philistinism reflects, it marked a watershed in the development of taste which is of considerable historical and social importance (see also chapter three).

Manchester, as is well known, experienced a profound economic and urban transformation about the middle of the nineteenth century.[5] On her first visit Queen Victoria wrote in her diary on 14 October 1851, 'In the midst of so much wealth, there seems to be nothing but chimneys, flaming furnaces, many deserted but not pulled down, with wretched cottages around them.'[6] William Wyld (1806–89), the artist who accompanied the Queen's party, produced a water-colour painting for her collection, *Manchester: from Kersal Moor*, which reveals the real Manchester beyond a romantically Arcadian foreground reproduced in the manner of Claude, **49**, but when the *Art Journal*, at the time of the Art-Treasures Exhibition, published an engraving after Wyld's painting, it mentioned *inter alia*:

> From whatever side the spectator contemplates the city, he sees long ranges of factories with innumerable chimneys, which point 'Their tapering spires to heaven;' but recalling to mind other associations than those to which the poet's line has reference – thoughts of active enterprise, industry, and accumulating wealth. Of later years, however, the city has assumed a new character – all the public buildings of recent erection are fine examples of Art, and its 'warehouses' are almost palaces.[7]

The Art-Treasures Examiner, a special publication by a local newspaper, the *Manchester Examiner and Times*, gives a good illustration of the new pride in art animating the city. After referring to Manchester's acknowledged individual enterprise and industrial pre-eminence, it asserts: 'Now she steps forward in her aggregate character to emulate the glorious example of Florence of old, under her prince-merchants the De Medici, to display to the world the richest collection of works of fine art the resources of the country afford.'[8]

The Art-Treasures Exhibition sprang from well prepared ground. The Royal Manchester Institution with its annual art exhibitions and the circle of patrons who supported it, and such other institutions as the Literary and Philosophical Society, the Portico Library and the Mechanics' Institute, had created a fertile soil for this ambitious proposal that related the arts to a major industrial society. In Manchester the process had commenced earlier. Virtually

[5] See Asa Briggs, 'Manchester, symbol of a new age', in *Victorian cities*, 1963, Pelican edn 1971, pp. 93–4, 105.

[6] Cited in W. Ames, *Prince Albert and Victorian taste*, 1968, p. 153.

[7] *Art Journal*, 1857, p. 204. Wyld's painting is reproduced in R. Davis, *Victorian watercolours at Windsor Castle*, 1937.

[8] *The Art-Treasures Examiner: A pictorial, critical, and historical record of the Art-Treasures Exhibition at Manchester in 1857*, 1857, p. i.

49 William Wyld: *Manchester: from Kersal Moor, 1857*

from its inception the Royal Manchester Institution had been concerned with education.[9] Its exhibitions always had been open to the public, and in 1838 a School of Design was instituted. Even Manchester's commercial architecture pointed to the *palazzi*, so that in the mid-nineteenth century it did not seem ridiculous to compare Manchester with a city of the Italian Renaissance.

To organise an event such as the Art-Treasures Exhibition, which enjoyed the patronage of Queen Victoria and Prince Albert, would have been inconceivable without precedents. Among these were the annual art exhibitions held by the British Institution in Pall Mall, London, from 1806, and the international industrial exhibitions held in London (1851), Dublin (1853) and Paris (1855).[10] Of these the Great Exhibition of 1851 is the best known, and it perhaps provided the best model, although, as an industrial exhibition (its full title was 'The Great Exhibition of the Works of Industry of all Nations') its content was of a different order.

The *Art-Treasures Examiner* gives a detailed account of the exhibition's inception:

> It was in the early part of the year 1856 that several of the influential merchants and manufacturers of Manchester, strongly impressed with the happy results of the Paris Exhibition of the previous summer, as well as those of the Dublin Exhibition of 1853,—forcibly struck, above all, with the important claims and uses of the fine arts, and calling to mind the remark made by Dr Waagen in his valuable work, that the art-treasures in the United Kingdom were of a character, in amount and interest, to surpass those contained in the collections upon the continent, bethought them of the grand idea of bringing the *élite* of these works into view under one roof, for the edification of their fellow-men. It was under these circumstances, and at this juncture, that Mr J. C. Deane, the commissioner of the Dublin Exhibition, . . . conjointly with Mr Peter Cunningham, issued to certain influential parties a paper, marked 'private and confidential', containing suggestions to the effect that Manchester would be a suitable locality for such an exhibition of art-treasures.[11]

Thomas Fairbairn (1823–91), the son of the engineer William Fairbairn (1789–1874), was a recipient, or *the* recipient, of this paper dated 10 February 1856.[12] He had had previous experience as a commissioner of the Great Exhibition and appears to have been the prime mover in bringing the proposed exhibition to fruition. According to the report of the executive committee, he 'lost no time in communicating with friends who concurred with him that the

[9] See chapter one; also S. D. Cleveland, *The Royal Manchester Institution*, 1931, and W. G. Sutherland, *The R.M.I.*, 1945.

[10] For a short history of the British Institution see Algernon Graves, *The British Institution 1806–1867*, 1875 (rp. 1969), and T. S. R. Boase, *English Art 1800–1870*, 1959, p. 149.

[11] *Art-Treasures Examiner*, p. i.

[12] There are slight discrepancies between the *Examiner*'s version and the account of the origins of the exhibition given in the *Report of the Executive Committee of the Exhibition of Art Treasures of the United Kingdom*, 1858 (henceforward *Report*), pp. 2–23. Cunningham and Deane's paper is reproduced in both.

project was one that ought to be entertained by the citizens of Manchester', and a circular, dated 22 March, signed by Fairbairn and six other prominent citizens, was issued convening a meeting in the Mayor's Parlour on 28 March.[13] It was unanimously resolved that '. . . it is desirable if practicable to carry out the proposal . . . for holding at Manchester, in 1857, an "Exhibition of Art Treasures of the United Kingdom".' To make it possible to commence work immediately, a guarantee fund was launched. Fairbairn and 'one or two influential friends' organised it; within a month £60,000 had been raised and soon this was increased to £74,000.[14] After satisfying themselves by obtaining estimates of the cost of providing a suitable building, an exercise that was also entrusted to Thomas Fairbairn, the promoters despatched a delegation to Buckingham Palace to present the project to Prince Albert and solicit royal patronage. The Queen gave her assent on 10 May, and on 20 May a meeting of the subscribers, after receiving reports of the progress achieved, formally decided to proceed. The subscribers then constituted themselves into a general council. They were informed that whilst in London the deputation had also waited upon and obtained the support of the Earl of Ellesmere, lord lieutenant of the county, and the Earl of Derby. The Earl of Ellesmere was chosen as president of the council, and James Watts, the Mayor of Manchester, chairman. An executive committee of seven was elected and Thomas Fairbairn became its chairman.

Designs were invited for a building of fifteen thousand square yards, capable of being constructed in six months at a cost not exceeding £25,000. Twenty-five designs were received, including one from Owen Jones, then at the height of his reputation through his contribution to the 1851 exhibition. After preliminary negotiations with Jones the committee decided against employing him and instead adopted the design submitted by the ironfounders C. D. Young and Co. of Edinburgh, from whom they had previously obtained a preliminary estimate.[15] In order to 'determine to what extent the facade and the exterior of the building should be decorated or relieved by any architectural designs' the committee turned to a local architect, Edward Salomons.[16] Five architects whose designs had been selected as being of special interest each received a letter of thanks and a draft for twenty guineas. Jones declined the payment and published the letter as 'a warning to my professional brethren'.[17]

The *Builder* exposed this petty shabbiness and scornfully described the design as 'a repetition of the three steam-boilers, side by side, with which Brompton is disfigured, with an ornamental brick "front" attached to one end',

[13] *Report*, p. 2.

[14] *Ibid.*, p. 6.

[15] An estimate had been obtained also from Messrs Fox and Henderson, of Birmingham, the contractors for the Crystal Palace, 1851. (*Report*, p. 6.) For the conditions of the competition, etc., see the *Report*, p. 14.

[16] *Art-Treasures Examiner*, p. iii.

[17] *Builder*, vol. 14, p. 374, 5 July 1856.

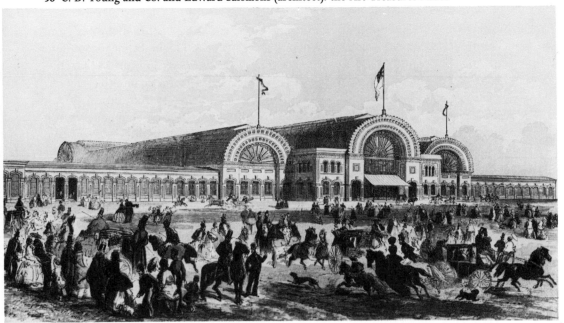

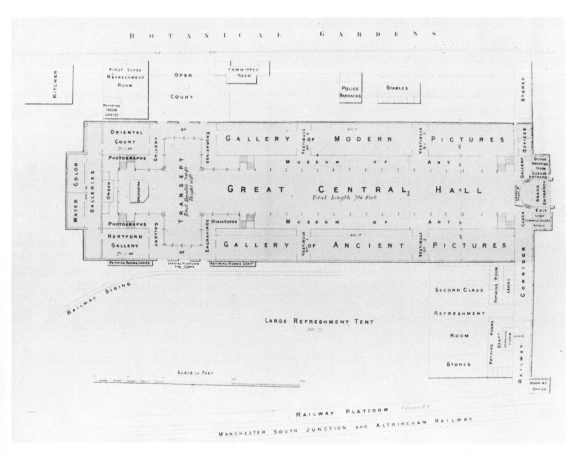

51 C. D. Young and Co. and Edward Salomons (architect): Art-Treasures Exhibition. Plan of the exhibition hall. The main axis, as shown, runs west–east

52 Art-Treasures Exhibition: central hall. The inscription above the organ reads 'To wake the soul by tender strokes of art' (Pope)

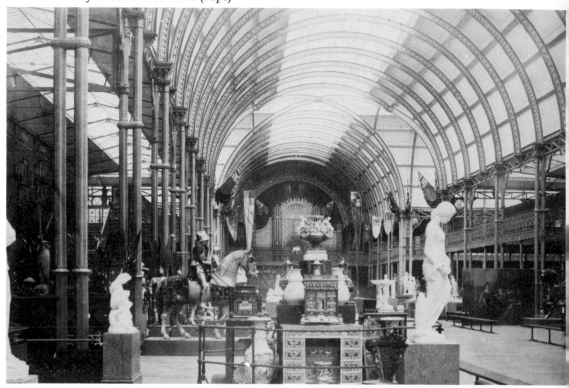

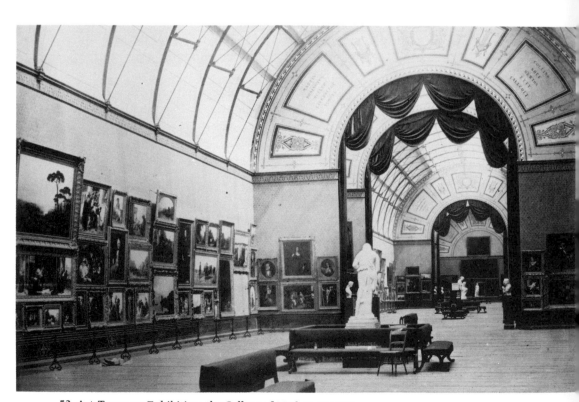

53 Art-Treasures Exhibition: the Gallery of Modern Pictures

50.[18] The reference was to the 'Brompton Boilers', the derisive epithet given to the newly finished Museum of Science and Art in South Kensington (1855–56), for which C. D. Young and Co. were also responsible. The *Builder* called them 'abominations'.[19]

The Art-Treasures Palace covered over three acres and was erected at Old Trafford and leased to the Manchester Cricket Club. It was adjacent to the gardens of the Botanical Society. A railway station was constructed specially for the exhibition and linked to it by a covered corridor. With the exception of the entrance facade, the whole building was of wrought and cast iron, timber and glass. The interior was clad in wood and lined with calico and wallpaper. John G. Crace was responsible for the interior design.[20]

The interior arrangement of the plan corresponded to that of a basilica, **51**, at whose high altar Charles Hallé conducted for edification and entertainment an orchestra assembled especially for the exhibition. The *Builder's* relatively mild observation that the building is 'not very handsome,—indeed, to speak the truth, it is squat and ugly', ignored its virtues.[21] Gustav Friedrich Waagen, to whom the whole enterprise indirectly owed its *raison d'être*, described it in different terms in the *Art Journal* and declared: 'With the exception of the Palais des Beaux Arts, in which the works of Art were exhibited in the Paris Exhibition of 1855, I have never seen a building containing such collected works of Art so advantageously lighted as this, while the rooms are airy, and of felicitous proportions', **52**, **53**.[22] The *Quarterly Review* also was impressed by 'the admirable adaptation of the building to its immediate purpose—the display of the works of art it contains . . .'. It admired the spaciousness, the 'subdued equal light, and admirable ventilation', but above all it praised the design's appropriateness, effective use of materials, and representation of 'the wants and feelings of the day'. Finally the reviewer associated it with Sidney Smirke's reading room at the British Museum, describing them as in the two last respects 'two of the most successful modern buildings with which we are acquainted . . .'.[23]

The response of those invited to lend their support was varied. The Duke of Devonshire is reported to have said, 'What in the world do you want with art in Manchester? Why can't you stick to your cotton spinning?'[24] Prince Albert however, on 3 July 1856, sent a letter to Lord Ellesmere in which he outlined in

[18] *Ibid.*, p. 398, 19 July 1856.

[19] *Ibid.*, p. 354, 28 June 1856.

[20] Detailed descriptions of the building are included in the *Art-Treasures Examiner*, pp. iv–vi; the *Builder*, vol. 15, 1857, pp. 105–6, 162, 264–5, 287; and the *Report*, pp. 39–41.

[21] Vol. 15, p. 264, 9 May 1857.

[22] 'On the Exhibition of Art-Treasures at Manchester', 1857, p. 234.

[23] 'The Manchester Art-Treasures Exhibition in 1857', vol. 102, 1857, p. 202.

[24] *Manchester Guardian*, 5 May 1857; see David Ayerst, *The Guardian omnibus 1821–1971*, 1973, p. 123. The suggestion that the Duke of Devonshire might have made this remark seems very likely, as he was one of the very few members of the nobility who adhered to his original decision not to lend art works. The duke did not visit the exhibition until just before it closed, but was so impressed with

an incisive manner his view of the function and conception of the exhibition:

> Manchester enters upon this undertaking at a certain disadvantage. It has been preceded by the Exhibition of 1851, that of Dublin in 1853, and that at Paris, during the last year. That a mere repetition of what has thus gone before would fail to attract sufficient notice and public support appears to have been felt by the Committee; and they most wisely gave a distinctive character to their scheme by making it an Exhibition of what may emphatically be called the Art-Treasures of this country. How to succeed in collecting such treasures, fondly cherished as they are by their owners, who are justly jealous of their safety, is the problem to be solved.

> . . . national usefulness might, however, be found in the educational direction which may be given to the whole scheme. No country invests a larger amount of capital in works of Art of all kinds than England; and in none almost is so little done for Art-education! If the collection you propose to form were made to illustrate the history of Art in a chronological and systematic arrangement, it would speak powerfully to the public mind, and enable, in a practical way, the most uneducated eye to gather the lessons which ages of thought and scientific research have attempted to abstract; and would present to the world for the first time a gallery such as no other country could produce, but for which, I feel convinced, the materials exist abundantly in private hands among us.[25]

These wider aims, however, were unconvincing to the French critic Théophile Thoré, who saw a connection with cotton spinning that escaped the Duke of Devonshire. He claimed that the whole exhibition had originated with an industrial aim in view: 'précisément dans un but industriel'.[26]

More than a million visitors (the exact number was 1,336,715) viewed the exhibition, which was opened on 5 May 1857 in the presence of Prince Albert. On one day alone there were 29,160. Total receipts from admissions reached £83,920. At the end of the exhibition the committee announced a clear profit of £304 14s 4d, and however insignificant this seems compared with the £50,000 achieved by the London and North Western Railway, which brought the visitors to the exhibition, it enabled the organisers to congratulate themselves on having avoided a deficit, unlike those of some similar enterprises.[27] The

what he saw that he later gave a magnificent banquet and ball at Chatsworth as a tribute to the organisers. See *Manchester Guardian*, 30 September and 5 November 1857. There were doubts among the aristocracy as to how far it would be prudent to entrust their ancestral treasures to the keeping of Manchester: some, perhaps, questioned whether they owed any great debt of gratitude to the metropolis of cotton. See 'Manchester and its exhibitions of 1857. By a Manchester man', *Fraser's Magazine*, vol. 56, October 1857, p. 384.

[25] *Report*, pp. 16–17. Prince Albert's support for the exhibition is described by T. Martin, *The life of His Royal Highness the Prince Consort*, 5 vols., 1875–80, vol. 4, pp. 34–8.

[26] Théophile Etienne Joseph Thoré (1807–69) wrote under the pseudonym of W. Bürger from *c.* 1848. For a brief biographical note see Frances Suzman Jowell, 'Thoré-Bürger and the revival of Frans Hals', *Art Bulletin*, vol. 56, 1974, pp. 101–17. For the quotation see W. Bürger, *Trésors d'art exposés à Manchester en 1857*, Paris, 1857, p. 2, and *Art-Treasures exhibited at Manchester in 1857*, London, 1857 (reviewed in the *Athenaeum*, 10 October 1857, pp. 1270–1).

[27] The statistics of the exhibition are presented in remarkable detail in the appendices to the *Report*. For information on arrangements for transport see the *Times*, 20 April 1857.

leading political and intellectual lights of Europe made their rendezvous in Manchester, events which were reported in detail by the *Times* as well as the *Manchester Guardian*. Only the murder of Miss Mary Smith in Edinburgh snatched the headlines for a while from the Manchester event. Charles Blanc, Théophile Thoré, Paul Mantz, Prosper Mérimée, Waagen and Fontane were among the well known visiting critics from abroad.[28] The exhibition left a lasting impression on Florence Nightingale, Mrs Gaskell, Nathaniel Hawthorne, Charles Dickens, Alfred Tennyson and William Morris. Prince Albert, staying at Abney Hall, the residence of the mayor, wrote to the Queen about the exhibition on 5 May 1857, remarking on 'a wonderful collection, the building very beautiful and tastefully decorated, the people very friendly'.[29]

Gustav Friedrich Waagen, an outstanding art historian and director of the Royal Picture Gallery in Berlin, was known to the readers of the *Art Journal* through his numerous previous contributions. He had first visited England in 1835 in order to acquaint his German readers with the art treasures in British collections. Johann David Passavant had prepared the way for him to some extent with his *Kunstreise durch England und Belgien* (*Art journey through England and Belgium*, 1833), followed by the two-volume edition of *Tour of a German artist in England*, 'with notices of private galleries and remarks on the state of art' (1836).[30] Waagen had returned to England in 1850 in order to bring up to date his earlier *Works of art and artists in England* (1838), which incidentally had been translated by Sir Charles Eastlake, Director of the Royal Academy in London, the translator of Goethe's *Farbenlehre (Theory of colours)* and friend of Cornelius and Overbeck, members of the German Nazarenes. His work later appeared as *Treasures of art in Great Britain* (3 vols, 1854, suppl. vol. 1857).[31]

One of the great issues of debate in the 1850s was the inadequate provision for the growing collection of the National Gallery, which contained only 380 pictures, including the Vernon collection. 'In a city containing nearly 400,000 houses, the Government of this country can find *four rooms* only which they can devote exclusively to the keeping and exhibition of the nation's gallery of pictures,' the *Art Journal* tartly observed on the occasion of the Great

[28] See Charles Blanc, *Les trésors de l'art à Manchester*, Paris, 1857; Thoré (W. Bürger), *op. cit.*, n. 26; A. Darcel, 'Excursions artistiques en Angleterre', *Revue Française*, 1858, pp. 98–114; P. Mantz, in *Revue Française*, 1857, 357–75; P. Mérimée, 'Les Beaux-arts en Angleterre', *Revue des Deux Mondes*, 1857; T. Silvestre, *L'art, les artistes, etc., en Angleterre*, London, 1857; G. F. Waagen, 'On the exhibition of art-treasures at Manchester', *Art Journal*, 1857, pp. 233–6; and 'Über die Kunstausstellung in Manchester', *Deutsches Kunstablatt*, vol. 7, 1857, Nos. 22, 24, 25, 32, 33. Theodor Fontane, author of *Effie Briest*, went with Waagen to see the Manchester exhibition and recorded his impressions in *Briefe aus Manchester*, 1857. See his *Aufsätze zur bildenden Kunst*, Munich, 1970, pp. 49–161; and Peter-Klaus Schuster, *Theodor Fontane: Effie Briest. Ein Leben nach christlichen Bildern*, Tübingen, 1978, pp. 29 ff, 46 ff.

[29] Martin, *op. cit.*, n. 25, vol. 4, p. 38. For a reference to the exhibition as a social attraction see L. M. Hayes, *Reminiscences of Manchester . . . from 1840*, 1905.

[30] Published in Germany in 1833 and in translation in London in 1836.

[31] Reviewed in the *Art Journal*, 1854, pp. 193–7, and the *Athenaeum*, 1854, pp. 517–18, 551–2.

Exhibition of 1851.[32] Shortly afterwards an article entitled 'Proposed Exhi-
bition of the Chef-d'oeuvres of the English School of Painting' referred to the
exhibitions held by the British Institution since 1806 in the gallery which
Boydell had built for his Shakespeare Gallery. It proposed this as a possible
location in case the directors were in a position 'to waive their proposed
exhibition of the Old Masters, this year, in its favour, and close that which is
now on view a few weeks earlier than usual'.[33] The plan remained unfulfilled.

Waagen, who had travelled throughout England on behalf of the
Parliamentary Commission on Matters of Art, in 1853 published his 'Thoughts
on the new building to be erected for the National Gallery of England, and on
the arrangement, preservation and enlargement of the collection' in a further
article in the *Art Journal* (pp. 101–3). His ideas on the hanging of the pictures
are extremely interesting, not only because they reflect the experience of a great
enthusiast for museums, but because they were in many ways decisive for the
Manchester exhibition. The ideas of Prince Albert and Waagen concerning an
illustrated history of art were taken up by the organisers in Manchester, so that
both the Italian Primitives as well as the early North European schools were
included as complementary works of one epoch. The Art-Treasures Exhibition
was therefore of great significance for its comprehensiveness; also because for
the first time the art treasures of Great Britain were presented to the public in a
'palace of art', even though that palace was only a temporary building; and,
fortuitously, because it provided a splendid example to those campaigning to
raise the standard of the National Gallery. The *Art Journal*, for instance, in an
article reviewing the Future of the National Gallery made a direct connection
between it and the Manchester exhibition when it wrote, 'let the present
unparalleled display at Manchester suggest some notion of the matchless wealth
which under such conditions might one day make up the sum of the national
treasure'. Around a scheme of similar comprehensiveness, it believed, 'a
collection would in time group itself which would throw every other Art-
museum in Europe into shade'. It reinforced this by citing Waagen's view, 'that
the true method of proceeding towards the formation of such a collection is, to
lay the nucleus at the highest point of development, and gather round it on all
sides: — to begin, that is, with the masters of the age of Raffaelle, and add to this
centre in both directions, —'. It expanded on this to argue for comprehensive-
ness, because 'the history of one art is not completely illustrated without the
light thrown on it from the others'.[34]

The Manchester exhibition was also seen as a precedent for an expanded
National Gallery by the *Quarterly Review*. A long article in the July number of
1857 begins with a tribute to those who had brought the exhibition together

[32] 1851, p. 37.
[33] 1851, p. 97.
[34] 'The National Gallery', 1857, pp. 236–8, at pp. 237–8, 1857.

and embarks on a careful review of the various schools as represented at Manchester, but always with the wider end in view of advocating a suitably housed national collection on the modern principle (attributed to Waagen) of explaining 'the history of the origin and development of the art under different conditions and in different localities' . . . 'tracing the steps which mark the gradual progress of human skill and thought towards the attainment of the highest perfection'. The existing state of the National Gallery was considered to be in 'the ancient hopeless confusion of schools and periods', whereas the Art-Treasures Exhibition represented 'the attempt made for the first time in this country to place before the public pictures . . . arranged upon the system we have described'.[35]

The exhibition was divided into ten major sections that ranged in subject from Old Masters to photography. Smaller sections were devoted to tapestry, furniture, ivories, armour, architectural drawings, etc. Several major historic collections of various kinds were included as special features, 54. Among the main sections were:

Ancient Masters. Examples from Byzantine art, the Trecento and the early Quattrocento were to illustrate the beginning of European painting. Among the latter were many works which demanded of the observer a new attitude towards the Italian Primitives. The Wilton diptych, together with the portrait of Richard II, were also counted among the highlights of early painting. Although the death of Lord Ellesmere prevented the dispatch of his collection of Raphaels from Bridgewater House, nevertheless, the importance of the Italian Renaissance was underlined by the inclusion of Raphael's *Three graces*, Titian's *Likeness of Ariosto* and examples from the Florentine school.

The Spaniards were represented by Velasquez and Murillo, the Flemish by Rubens and van Dyck, the Dutch by Rembrandt and Hals; and the 'German schools' included both old German and old Dutch works. Whenever it was impossible to obtain originals to illustrate a definite point in the development of the history of European art, old copies were chosen. Works from the Trecento, for example from the collections of Prince Albert, W. Y. Ottley and Roscoe, could be seen by the public for the first time. Pictures by Hals, Rembrandt and Velasquez found a new appreciation or were, so to speak, rediscovered. Although European painting of the eighteenth century was still undervalued, the Hertford collection, later donated to the nation by Lady Wallace in her will, revealed some important French paintings. George Scharf was responsible for this part of the exhibition.

Modern Masters. Devoted to the English school, this section was conceived by August Egg also as a comprehensive representation of contemporary art production. Gainsborough's *Blue boy* introduced this section, which was completed by Maclise's *Macbeth* and Leighton's *Procession of Cimabue.*

[35] Vol. 102, 1857, pp. 168–9.

Art-Treasures Exhibition.

THE EXHIBITION
OF THE
ART-TREASURES OF THE UNITED KINGDOM,
OPENED ON TUESDAY, 5TH MAY,
AT MANCHESTER.

UNDER THE IMMEDIATE PATRONAGE OF HER MOST GRACIOUS MAJESTY THE QUEEN AND H.R.H. PRINCE ALBERT,
Who has graciously consented to preside at the Grand Inaugural Ceremony.

This PALACE, covering a space of 18,000 Square Yards, contains the LARGEST and most VALUABLE

COLLECTION OF WORKS OF ART,

Ancient and Modern, ever collected, and which, there are many reasons for supposing, can never be brought together again.
THE EXHIBITION ALSO INCLUDES

A NATIONAL GALLERY OF PORTRAITS OF BRITISH CELEBRITIES;

ALSO, A HISTORY OF MINIATURE ART.

A SEPARATE GALLERY OF THE CHOICEST WATER-COLOUR DRAWINGS, FROM THE TIME OF SANDBY.

THE CELEBRATED

MEYRICK COLLECTION OF ARMOUR, FROM GOODRICH COURT.

ENGRAVINGS,

From Wood, Copper, and Steel, showing the history of the engraver's art, from Maso Finiguerra to the present time.

SCULPTURE.

In Marble and Bronze, Ancient and Modern.

FINE SPECIMENS OF PHOTOGRAPHY.

CURIOUS ANTIQUE FURNITURE. RICH DISPLAYS OF GOLD AND SILVER PLATE.

Mediæval Works.

RARE SPECIMENS OF CHINA AND BRONZES.

Along with the far-famed and hitherto comparatively unknown Continental Collection of

M. SOULAGES.

These gems of art have all been most graciously lent for the purpose by Her Majesty the Queen, Prince Albert, and the leading nobility and gentry of the United Kingdom.

MUSICAL ARRANGEMENTS.—A LARGE ORGAN has been built purposely for the occasion, and kindly lent by Messrs. Kirtland and Jardine, and throughout the season there will be DAILY MUSICAL PERFORMANCES, by a large Orchestra, under the superintendence of Mr. CHARLES HALLE', who will conduct in person each Thursday.

BOTANICAL GARDENS.—A communication is opened from the Palace to the Gardens, thus adding to the interest and variety of the Promenade. The charge for admission will be entirely under the control of the Council of the Botanical Society.

REFRESHMENTS are provided on an extensive scale, at moderate charges. A tariff of prices for dinners and lighter refreshments, approved by the committee, will be fixed in conspicuous parts of the Palace. The refreshment rooms communicate with the Palace, and adjoin the Botanical Gardens and the railway station. No refreshments will be allowed to be carried into the Palace, as the arrangements are adapted for the suitable supply of the wants of all classes.

GENERAL ARRANGEMENTS.

The Executive Committee give notice of the following GENERAL ARRANGEMENTS for the information of visitors:—

The EXHIBITION will be OPENED on Tuesday the 5th May, on which day none but the proprietors of £2. 2s. season tickets will be admitted.—Season tickets may be had at the Building on the day of opening. All season tickets presented for the first time, must bear the signature of the owner.

PRICES OF ADMISSION.—From the 6th to 16th May (both days inclusive), 2s. 6d. for each person. On and after Monday the 18th May, 1s. for each person, except on Thursday in each week, when the charge will be 2s. 6d. for each person.

N.B.—There will be also certain days (not exceeding eight in all) specially reserved for proprietors of £2. 2s. season tickets, of which due notice will be given by public advertisement at least seven days beforehand.

SEASON TICKETS, at £2. 2s., entitle the proprietors to admission on all occasions when the Exhibition is open to the public; tickets at £1.1s. entitle to admission on all but the "reserved days." These Tickets may be procured at the Exhibition Building; or at the offices, 100, Mosley-street.

Season Tickets are not transferable, and must be signed by the proprietor before being presented at the entrance of the Palace, where a book will be kept in which the proprietor will be required to write his or her name whenever requested to do so by the officers of the committee.

HOURS OF EXHIBITION.—The doors will be open daily at ten o'clock, and will be closed at sunset. A bell will be rung half an hour before closing.

CATALOGUES.—A General Catalogue, price 1s., will be sold in the Palace. A more full and explanatory catalogue will be subsequently published, at an advanced price.

BATH CHAIRS will be provided at a moderate charge for the use of ladies and invalids.

OPERA GLASSES will be on Sale or Hire in the Palace.

SMOKING in any part of the Palace is strictly prohibited.

NO PARCELS, STICKS, OR UMBRELLAS will be allowed to pass beyond the entrance, where they may be left in charge of a proper officer, at a charge of one penny.

NO CHANGE will be given at the doors.

NO RETURN TICKETS will be given to anyone leaving the Palace, and passing out beyond the barriers where the turnstiles are fixed. N.B.—These limits include the Refreshment Rooms, but not the Botanical Gardens.

CARRIAGES.—All drivers will be required to obey the directions given to them by the police on duty at the approaches.

VISITORS ON FOOT are requested to keep the path to the north side of the carriage drive.

Arrangements are being made with the various railway companies to enable visitors to come direct from any part of the country to the Building. The London and North-Western Railway Company have arranged to convey passengers from London by the 6 15 a.m. train, returning to London in the evening, allowing four or five hours in the Exhibition.

THOMAS HAMILTON, Secretary.

Offices, 100, Mosley-street.

54 An advertisement of the Art-Treasures Exhibition

Gainsborough's *Mrs Graham*, Reynolds's *Nelly o'Brien* and various paintings by Hogarth, Wilson, Barry, Fuseli, Romney, West and Lawrence then led into the nineteenth century, represented by the numerous works of Turner, Constable (*The white horse* and *Salisbury Cathedral*), Wilkie, Haydon, Etty, Frith, Egg, Goodall, Landseer and many others. The Pre-Raphaelites showed Millais's *Autumn leaves*, Holman Hunt's *Claudio and Isabella*, *The hireling shepherd*, *Awakening conscience* and finally Brown's *Christ washing Peter's feet*.

British Portrait Gallery. Anticipating the function of the National Portrait Gallery, which was founded by an Act of Parliament in 1856 but had remained ·without a home, this section was arranged by Peter Cunningham. Strict chronology was disregarded, and although the portrait of Richard II from Westminster Abbey was the earliest exhibit, the section began with a court portrait of Henry VIII by Holbein; it then proceeded to the court art of van Dyck under Charles I, and ended with a portrait of Keats, whose *Endymion* had provided the inscription later borrowed by Ruskin. The portraits were to illustrate the glorious history of Britain, so that not only works of great artists such as Hogarth or Reynolds were included but also those of less well known masters in order to present great personalities of the past. The Historical Miniatures were, so to speak, a culmination of the Portrait Gallery.

Sculpture. Although some masterpieces of the past were available, the exhibits were mainly a collection of works of living Victorian sculptors. In contrast to the 1851 exhibition, where casts were included, only originals were shown.

Ornamental Art. This section of the exhibition, for which J. B. Waring was responsible, confirmed that exhibits made of glass, enamel, metal, clay, porcelain and other materials were no longer inferor to the fine arts. It awakened in the viewer a feeling for the potential beauty of industrial art, and its clear aim was to encourage this in contemporary production.

Watercolour Gallery. By the presentation of many examples, this section demonstrated how the history of water-colour painting originated with the illumination of manuscripts in the Middle Ages and extended through the Renaissance and Baroque periods to the high point of English art, that of Cozens, Girtin, Constable and Turner.

Drawings. Chronologically this section began with the Italian Quattrocento and proceeded via the Renaissance and Baroque to the English school of around 1800.

Engravings. In the catalogue Edward Holmes claimed in the introduction to this section, 'This is the first time in the history of the Art of Engraving at which an attempt has been made to show to the public generally at one view, a complete chronological series of prints from the commencement of the art up to the present time.'[36]

[36] The executive committee published the catalogue in two parts. The first, *Catalogue of the art*

One of the spectacular acquisitions for the exhibition, and ultimately for the nation, was the Soulages collection. In Italy in the 1830s and '40s Jules Soulages, a lawyer, of Toulouse, had gathered a collection of decorative utilitarian objects and the smaller productions of important artists. His collection of 749 items, initially located in Paris and then in Toulouse, rapidly acquired a reputation and was the subject of several offers of purchase, which were, however, declined because Soulages wished to sell his collection only as a whole. Henry Cole, one of the organisers of the Great Exhibition, who was later appointed Director of the South Kensington Museum, i.e. the present Victoria and Albert Museum, inspected the collection after seeing photographs of its contents at the World Exhibition in Paris in 1855. He concluded that 'it was my duty to effect the purchase if possible for the nation, and that it would be of great use to manufacturers'.[37] In England he gained the support of Prince Albert, who guaranteed £1,000, and within a short time Cole had received further promises to the amount of £24,800. The collection was valued at £11,782 and Soulages agreed to a negotiated price of £11,000. The collection arrived in London in October 1856; it was catalogued and set up in Marlborough House, then in temporary use for exhibition purposes before the South Kensington Museum opened in December the same year. Palmerston and the Treasury refused, however, to sanction its purchase. Under the terms of the trust deed the collection had to be offered for resale. The executive committee of the Manchester exhibition thereupon put in a request that it should be made available, on loan, to the public. Cole refused, declaring that the collection would have to be sold, whereupon the individual members of the committee raised the necessary £13,500 and bought it. However, it did not remain in Manchester, as Cole made further attempts to secure it for the nation. Finally he succeeded in leasing the whole collection on behalf of the Practical Art Department of the South Kensington Museum and acquired the exhibits individually over a fairly lengthy period. It was only through the generosity of the organisers of the Manchester Art-Treasures Exhibition, therefore, that the collection was retained for the nation.

The Hertford collection, now part of the Wallace collection, undoubtedly represented another highlight of the exhibition.[38] With an annual income of £240,000, Richard, fourth Marquess of Hertford, could afford to spend £40,000 yearly on the purchase of works of art in the 1850s. He rarely went to an auction

treasures of the United Kingdom collected at Manchester, in 1857 (price 1s), covered the ancient and modern Masters, the British Portrait Gallery, the sculpture, the Museum of Ornamental Art, the water-colours and miniatures. A supplementary volume (price 6d) listed the drawings, engravings and photographs. Special collections were catalogued individually.

[37] A brief history of the collection is given in the exhibition's *Catalogue of the Soulages Collection*, 1857, prepared by J. C. Robinson, described as 'The Curator of the Museum of Ornamental Art'. For an account of its acquisition see Frank Davis, *Victorian patrons of the arts*, 1963, pp. 15–17. For the quotation Davis cites Henry Cole, *Fifty years of public work*, 1884.

[38] See T. Cox, *A short history of the Wallace Collection and its founders*, 1936.

himself but had in Sir M. Mawson a devoted agent who was responsible for the loan of forty-four paintings to Manchester, among them works by De Champaignes, van Dyck, Gainsborough, Greuze, Poussin, Rembrandt, Reynolds, Rubens, Velasquez and Watteau. How captivated people were by masterpieces of the French Rococo is revealed by Ottley's reluctant praise of Watteau and the dislike of Boucher he expressed in the *Art-Treasure Examiner* (pp. 262–3). A slow reappraisal of French painting had begun in the '40s. In 1854 Charles Blanc published *Les peintres des fêtes galantes*, and Edmond and Jules de Goncourt's 'La philosophie de Watteau' appeared in *L'Artiste* (7 September 1856) and, with small variations, in *L'art du dix-huitième siècle* in 1860.[39] It was against this background that the pictures by Lancret, Boucher, Pater and Watteau appeared at Manchester as a manifestation of a modern attitude which was reflected also in the reproduction of three pictures in the *Art-Treasures Examiner*.

George Scharf junior (1820–95), who was responsible for the selection, hanging and cataloguing of the Old Masters, wanted to produce a complete survey of the history of art from the Byzantine era up to the Baroque, just as had been done already at the re-erected Crystal Palace at Sydenham.[40] After the exhibition, in a lecture at Liverpool 'On the Manchester Art-Treasures Exhibition, 1857', describing his section he said, 'I had already formed an *ideal* gallery on paper, taking the choicest specimens of every master in the history of art, as far as I remembered their existence in this country. This plan, I found, corresponded very satisfactorily with the scheme recommended by His Royal Highness, . . .' Concerning their arrangement, he explained:

> It will be borne in mind that I adopted one leading principle . . . I desired not only to arrange them in chronological order, but to mark as far as possible the contemporaneous existence of opposite schools.
>
> The long southern wall as far as the middle of saloon C, where the termination of the series was noted both in the catalogue and on the wall, was therefore devoted *exclusively* to Italian art; and on the opposite wall were ranged the paintings of the *foreign* nations to correspond as nearly as possible, in point of time, with the dates of the Italian ones facing them.[41]

It is in this way that presentation by analogy and 'correspondence' began, with the altarpiece of Cimabue, representing the Southern school, and the old copy

[39] Edmond and Jules de Goncourt, *L'art du dix-huitième siècle*. The chapters first appeared in various periodicals and then in twelve parts, 1859–75. There are several modern translations.

[40] The reconstructed Crystal Palace opened on 10 June 1854 and may be seen as a further major precursor of the Art-Treasures Exhibition. Its educational object embraced 'a complete historical illustration of the arts of sculpture and architecture' from the earliest works of Egypt and Assyria down to modern times, . . .' (*Builder*, vol. 12, 1854, p. 318). Specially designed courts were designed for each epoch, and others were devoted to the natural sciences and industrial subjects. A series of handbooks was published (considered excellent by the *Builder*) but a proposed court on the fine arts was abandoned. (Ed.)

[41] Scharf's informative lecture appears in the *Transactions of the Historic Society of Lancashire and Cheshire*, vol. 10, 1857–58, pp. 269–331. See pp. 274 and 279–80.

after Jan van Eyck's altarpiece in Ghent, the Northern. The achievement of this 'ideal gallery', however, was hindered by insufficient resources through the lack of paintings from Blenheim, Hamilton Palace, the Bridgewater Gallery, Dulwich, the Fitzwilliam Museum and the National Gallery.

Theophile Thoré, one of the founders of the scientific methods of the new history of art, published the results of his visit to the Manchester exhibition in book form under the title *Trésors d'art exposés à Manchester en 1857*, which included a detailed discussion of the English school. He admired Scharf's arrangement as an 'innovation excellente' illustrating in a concrete manner his own idea of a universal history of art with its analogies and harmonies.[42] The complementary contrasting of schools and their representatives, expressly rejected by Waagen,[43] is demonstrated, for example, in Wackenroder's dream of a meeting between Raphael and Dürer in his *Herzensergiessungen eines kunstliebenden Klosterbruders* (*Outpourings of an art-loving monk*) (1796), i.e. in that early written programme of German romanticism; or in Overbeck's picture *Italia and Germania*.[44] Much later Heinrich Wölfflin converted such contrasts into a comparative method in art history in his book *Italien und das deutsche Formgefühl* (1931). However, the contrastive method had triggered off ideas and polarities in Thoré's mind. On each occasion when he thought of Rembrandt and the Dutch, Raphael and the Italians appeared simultaneously before him as a contrast with the northern artists. On the occasion of the Manchester exhibition he realised that the time had come when the cohesive and binding tradition of Italian art had expired. It was not the imagination but rather uniformity, imitation and the tradition beginning with Raphael which had destroyed art. For Thoré perception came first, then reflection. Dutch painting inspired him with a vision of a modern art—'l'art pour l'homme', which followed the principle of painting only what the artist saw and felt.[45] When he brought Raphael and Rembrandt together in a Janus-like manner[46] he had already discovered Frans Hals's work, and in his *Nouvelles tendances de l'art* (1857) had related Dutch naturalism to the art of his own time. Nothing, he argued, could be less real in painting than *reality*, since this was completely dependent on the individual's way of seeing things. He rejected realism, in the manner of the Düsseldorf school or the Pre-Raphaelites, as degenerate detail painting or bourgeois realism because it lacked the 'unité d'effet', but, although with some reservations, he admired Courbet.[47] Thoré's enthusiasm for Turner's

[42] *Op. cit.*, p. 17, see n. 26. See also Frances Suzman Jowell, *Thoré-Bürger and the art of the past*, 1977, pp. 214–42.

[43] G. F. Waagen, 'Thoughts on the new building to be erected for the National Gallery of England, etc.', *Art Journal*, 1853, pp. 101–3.

[44] See K. Andrews, *The Nazarenes*, 1964.

[45] *Musées de la Hollande*, 1860, vols. 9–11, cited by F. S. Jowell, 'Thoré-Bürger and the revival of Frans Hals', *Art Bulletin*, vol. 56, 1974, p. 116.

[46] *Ibid.*

[47] Discussed by Philippe Rebeyrol in 'Art Historians and Art Critics: Théophile Thoré', *Burlington Magazine*, vol. 94, 1952, pp. 196–200, at p. 198. See also Jowell, *op. cit.*, n. 42, *ibid.*

'light painting', on view at the exhibition, anticipated his admiration of about ten years later for Monet and Renoir. He ignored, however, the metaphorical content of Turner's pictures which had been interpreted by Ruskin in a brilliant fashion by analogy, association and metaphor in the first volume of *Modern painters* (1843).

Early Italian painting, although incompletely represented, was felt to be an important contribution to the exhibition. Many articles were written about the 'Primitives', although their tenor was generally romantic and anecdotal. Scharf commences his *Handbook to the paintings by Ancient Masters* (1857) by pointing out that 'The taste for studying the history of early Italian art is not a recent development in our country alone; it is a novelty even in Italy itself', and he surveys its development, accrediting those who were principally responsible. Among others he mentions Lasinio, the *conservatore* of the Campo Santo, Pisa, who had saved it from destruction during the revolution and publicised its great frescoes; Ottley, an English friend of Lasinio, who had drawn and published a series of engravings of Trecento works; and Roscoe, the translator of Lanzi's *The history of painting in Italy*.[48] A telling point he makes is that Vasari's *Lives of the painters* had been available in English translation for only seven years; Mrs Foster's version had been published in Bohn's series only in 1850, an event considered to be 'of noteworthy importance, and the more remarkable, as Vasari had for many years been translated into almost every other European language'. A. H. Layard, one of the most interesting art historians of the nineteenth century, who must have particularly impressed Scharf, showed in the *Quarterly Review* (1857) that he too had been similarly impressed by the qualities of the 'Primitives', which he likewise found in the contemporary art productions of 'realism'.[49] In his Liverpool lecture Scharf claimed with some satisfaction:

> At the period of the Manchester Exhibition, not one of the following masters, although great and important in their way, was to be found in our National Gallery Catalogue:—Van der Weyden, Meister Stephan [i.e. Lochner], Grünewald, Memling, Wohlgemuth, Mabuse, Quentin Matsys, Martin Schön [i.e. Schongauer], Cranach, Lucas Van Leyden, Bernard Van Orley, Burgkmayer, Herri de Bles, Patenier, Horenbout, Van Cleef, Pourbus, Sir Antonio More, and Janet.[50]

It was through the Nazarenes and Pre-Raphaelites that an artistic and historical interest grew in the northern masters of the early Renaissance.

[48] Luigi Lanzi, *The history of painting in Italy*, 'from the period of the revival of the fine arts to the end of the eighteenth century', trans. in 6 vols. by Thomas Roscoe, London, 1828. The original, *Storia pittorica della Italia*, 6 vols., was published at Pisa, 1815–17.

[49] (Sir) Austen Henry Layard (1817–94), the excavator of Ninevah, see *DNB*, vol. 22, and Frank Davis, *Victorian patrons of the arts*, 1963, pp. 26–34. Scharf notes of Layard's *Ninevah and Babylon*, 1853, 'one of the great features of the year', (31 December 1853), Sketch Book no. 27, National Portrait Gallery London. For Layard's unsigned review see *Quarterly Review*, vol. 102, 1857, pp. 165–204.

[50] *Op. cit.*, p. 285, n. 41.

The timing of the Manchester exhibition also marked the beginnings of the history of art as a scientific discipline in which two streams were already prominent: empirical positivism, the demonstration of true facts by means of historical research, and the subjective method of interpretation, in which Baudelaire, Ruskin and Pater excelled, instead of mere description. Thoré's discovery of Hals on the occasion of the Manchester exhibition was also of great importance for contemporary painting, and he regarded as modern the Dutchman whose virtuosity of bold brushwork diffused material phenomena into a coloured world of appearances.

The liberal attitude of the organisers made it possible for a broad and almost complete spectrum of contemporary British art to be presented. Officially recognised academic painters such as Eastlake, Wilkie and Landseer were to be seen alongside Holman Hunt and Millais. Although an attempt was made to avoid popularity as a criterion of selection, popular artists such as Lawrence or Eastlake were the subject of great admiration. Turner was admired, yet there was agreement with Ruskin that his later pictures were of lesser value, because the artist's sight and mind had deteriorated. Constable's large pictures such as *The white horse* or *Salisbury Cathedral* were criticised as 'ploshy, willowy, weedy, rain-clouded . . .', and for their apparent monotony and limited nature. The Pre-Raphaelites met with a mixed reception, and Millais's *Autumn leaves* was the only one to escape criticism of any kind. Holman Hunt was both liked and disliked; *The awakening conscience*, loaned by Thomas Fairbairn, aroused great controversy. It is well known that Hunt's picture, together with his *Light of the world*, had given rise to an exchange between Ruskin and Waagen in the columns of the *Times*.[51] In his memoir *Pre-Raphaelitism and the Pre-Raphaelite Brotherhood* (1905) Holman Hunt wrote:

> My good friend Mr Thomas Fairbairn was one of the Council of the Manchester Loan Exhibition, and a guarantor. The collection was partly hung by my true defender, Augustus L. Egg, who had placed all my picturew well . . . The works of our school were received so favourably by the Manchester potentates that I assumed they had become converted to our views. Once when talking to my host about modern art I did not hesitate to refer to our school as Pre-Rephaelite in contradistinction to others. He stopped the conversation with a serious countenance and said: 'Let me advise you, when talking to Manchester people about the works of your school, not to use that term; they are disposed to admire individual examples, but the *term* has to them become one of such confirmed ridicule that they cannot accept it calmly.'[52]

When Alfred Tennyson visited the exhibition on 30 July 1857 he spent most of his time looking at Holman Hunt's pictures, Turner's sketches,

[51] *Times*, 5, 13, 25, 30 may and 13 July 1854. For Ruskin's views see also R. L. Herbert, *The art criticism of John Ruskin*, 1958. Part of Waagen's correspondence is reproduced in the catalogue *Holman Hunt*. Walker Art Gallery, Liverpool, 1969.

[52] *Op. cit.*, vol. 2, pp. 159, 162.

Mulready's drawings and various pictures such as Gainsborough's *The blue boy* and *Mrs Graham*.[53] Charles Dickens, in Manchester for a literary evening, found the English pictures wonderful. He remarked of the explanation, 'the care for the common people, in the provision made for their comfort, and refreshment, is also admirable and worthy of all commendation. But they want more amusement, and particularly something in motion, though it were only a twisting fountain. The thing is too still after their lives of machinery; the art flows over their heads in consequence.'[54] William Morris visited the exhibition in October. According to his biographer, J. W. Mackail, it was on this visit that he produced his only accredited painting in water-colour:

> he was on a visit to Dixon at Manchester to see the famous Art Treasures Exhibition of 1857. While staying there he painted a water-colour of 'The Soldan's Daughter in the Palace of Glass' . . . To the pictures in the Manchester Exhibition he seemed to pay little attention, but studied the collection of carved ivories minutely. . . . It was during this visit to Manchester that he wrote the 'Praise of My Lady', with the lovely Latin burden, which is one of the jewels of the volume of Poems of 1858.[55]

In one of his later lectures, 'At a picture show, 1884', he recalled this and other exhibitions, which had made a reawakening of interest in popular art possible, but he added:

> So here you see we are back at the point we began at, that the public does its art, as it does its religion—by deputy: pays a certain number of what I should call art-parsons to perform certain mysteries of civilisation which it is pleased to call the fine arts, and stands on one side while they go through their mumbo-jumbo with grievous results to their morals in most cases, and with still more grievous results to the fine arts; which depend on all life being carried on with art; that is the very sustenance and well-spring of them, the beauty and manliness of daily life.[56]

In his *English notebooks* Nathaniel Hawthorne offered an interesting description of the exhibition and the circumstances surrounding it. He disliked art exhibitions generally but appreciated their social value: 'Nothing is more depressive to me than the sight of a great many pictures together. . . . Galleries of pictures are surely the greatest absurdities that ever were contrived, there being no excuse for them, except that it is the only way in which pictures can be made generally available and accessible.[57]

Various press notices amply confirm that the importance of the exhibition was appreciated, although widely different conclusions were drawn regarding its success. On its opening the *Times* and the *Manchester Guardian* emphasised

[53] C. Tennyson, *Alfred Tennyson*, 1949, p. 305.
[54] *The letters of Charles Dickens*, 1880, vol. 2 (1857–1870), p. 23 (3 August 1857).
[55] J. W. Mackail, *The life of William Morris*, 1899; see 1907 edn, vol. 1, p. 115.
[56] May Morris, *William Morris, artist, writer, socialist*, 1936, vol. 2, pp. 417–18.
[57] N. Hawthorne, *Our old home, and English note-books*, (1863–64), 1895 edn, vol. 2, pp. 517–45.

its significance and envisaged success. Both papers maintained their interest in the enterprise and printed regular reports and letters. On 6 May 1857 the *Times* commented, 'Manchester was yesterday the scene of an event almost unique in the history of art in England or perhaps the world. An exhibition of art treasures, never before equalled for extent and importance opened with an éclat to which nothing but the presence of the Sovereign herself could have added.' Letters of 16 and 18 September were directed towards the social problem of how art should be communicated to the working class, and the paper's final report (16 and 17 October 1857) makes it only too evident that Manchester had taken a leaf out of London's book, had introduced partisanship into the affair and that a certain degree of envy could not be concealed. The *Manchester Guardian*, on the other hand, was intensely and actively involved in the venture. In May, June and July it published detailed, critical and highly interesting reports on the various sections of the exhibition, republished later as a notable series of handbooks (see below). Information about the visits of the political and intellectual élite of Europe appeared in its columns alone.

The *Art Journal* printed copious notes on the exhibition and, in a final article in December 1857 (pp. 361–2), critically examined its success. It gave credit for the magnificence of the achievement, although not without a touch of bitter condescension: 'That Manchester should propose such an exhibition was surprising enough; but how much greater was the marvel that such an exhibition as was actually formed, should have established itself at Manchester!' The mere creation of the exhibition was not considered a sufficient purpose, and it questioned 'will Art be better understood at Manchester in 1858, and more duly appreciated, than it was in 1856? In years to come will Manchester manufacture show, in their fairer aspect, that the sunshine of Art has been diffusing its invigorating influence in the midst of them?' The organisers were taken to task for failing to provide adequate educational means for the interpretation of the riches on display: 'How deplorable, therefore, the result, that, because there were none at Manchester . . . who could deal with these "Treasures" of Art as Teachers of Art, they should have so signally failed to do what they possessed the power to have done so thoroughly!'

The *Athenaeum* viewed it differently. A long report, placing its emphasis on progress, opened with idealistic, verbose and exaggerated praise of the concept of the exhibition:

> Before we can become creators we must educate a race of appreciators who will admire – and buy . . . Nineteenth-century Art has broken from the patron's drawing-room, and appeals to the crowd, who do not patronize, but purchase.
> The Manchester Exhibition is a vast epitome of Art, ancient and modern—the best of its kind ever attempted. Everything is to see, and nothing to sell.[58]

[58] 1857, p. 564.

Furthermore, the article drew attention to the other social aspects of the exhibition; the education of the working classes and the relations between art and commerce which were shown there for the first time. In a subsequent contribution the *Athenaeum* specifically praised the use of photography for the production of the lavish two-volume *Gems of the Art-Treasures Exhibition* (1857), and the organisers' idea of putting it on the market as a permanent record of their enterprise and an illustrated textbook of the history of art.[59] The *Athenaeum* concluded its reports with a wish that the exhibition should go on to London. 'Manchester has done well, let London do better.'[60]

The previously discussed article in the *Quarterly Review* provides the best report on the event.[61] Well researched and constructive, it concludes by reverting to the subject of the National Gallery, reiterating that the exhibition and its building provided an object lesson, 'an experiment from which solid instruction may be derived, and which is of the greatest value at this time as a guide to those who may be intrusted with the erection of a building to contain the art treasures belonging to the nation and with the arrangement of its contents'.[62]

The success of the Art-Treasures Exhibition should not be underestimated in so far as its social, popular scientific and general effect is concerned. A great deal of idealism was devoted to it as a means of helping working people towards moral improvement by organised visits. An Alpha Fund was instituted through which children from poor districts were sent to the exhibition. The exhibition fulfilled one of its aims, namely that of presenting to the public the art treasures in British private collections, and of making it aware of the existence of its own school of painting.

Guides, brochures and descriptions of the exhibition proliferated, and among them is the valuable set of handbooks on the different sections reproduced from the 'Critical notes' in the *Manchester Guardian, e.g.* George Scharf's *A handbook to the paintings by Ancient Masters*. Whilst the exhibition catalogue printed the attributions supplied by the owners, the notes, written by the person responsible for the subject in the exhibition, included factual criticisms of the attributions.[63] At a more popular level, another type of publication inspired by visits to the exhibition is seen in several descriptions humorously written in dialect. Between these two rather special forms of literature is the ephemera of the various *Guides, Works* and *Companions* which illustrate that as an event the exhibition was of most value to the informed visitor, and, as has already been observed with reference to Thoré and others, in

[59] *Op. cit.*, pp. 1270–1. *Gems*, by Caldesi and Montecchi, was published jointly by Messrs Colnaghi and Messrs Agnew.
[60] *Op. cit.*, p. 1327.
[61] Vol. 102, 1857, pp. 165–204.
[62] *Op. cit.*, p. 204.
[63] For other handbooks see the bibliography for this chapter.

this respect it proved to be an experience which led to new fields in the literature of art criticism.

The financial success of the exhibition was extremely limited; on an expenditure of £110,588 it produced a clear profit of only £304 14s 4d.[64] Although so small, the surplus was not unimportant to those sponsors whose *laissez-faire* view of economics had been criticised so sharply by Ruskin. The exhibition provided an example of 'cultural politics' without subsidies.

The principal credit for the Art-Treasures Exhibition belong to Thomas Fairbairn. He was the real driving force behind the idea and its execution, and can be regarded as representative of the other industrial and mercantile sponsors whose liberality made the enterprises possible. He declined the knighthood which he was offered in official recognition of his services and continued his patronage of the arts nationally and locally. In 1860 he was chosen as a member of the Royal Commission for the International Exhibition held in London in 1862, and in the same year he published a pamphlet on the building of a new art gallery and museum for Manchester. The *Art Journal* reported on it and quoted an extract in which Fairbairn stated that it 'must be no puny and purely local affair, but must attain a national importance . . .'. He envisaged its advantage 'if it were possible, to carry out the scheme in connection with some much-needed improvement in the main thoroughfares of the city . . .'. In a clear reference to the Art-Treasures Exhibition he explained, 'We now possess the experience of what well-lighted and properly decorated picture and sculpture galleries should be . . .', and proposed that extensive galleries should be provided that would permit 'if desired, a chronological and historial arrangement of the works . . .'.[65] He outlined the idea again at a civic occasion when he and other members of the executive committee received testimonials, and in pledging his support towards its attainment he promised, 'I, for one, . . . will willingly give my time, money, and whatever energies or influence I possess.' He added that he would view the scheme's accomplishment as 'the most appropriate and enduring monument which Manchester could raise to the unbounded liberality and confidence which were extended to its representatives by the contributors to the Art-Treasures Exhibition'.[66] It was not until 1882 that his vision was partially realised with the establishment of the City Art Gallery.

The Manchester Art-Treasures Exhibition had set itself the aim of improving historical knowledge, taste and, through direct emulation, the

[64] *Report*, appendix 3.

[65] A brief note on Thomas Fairbairn is included in William Fairbairn, ed. William Pole, *The life of Sir William Fairbairn, Bart.*, 1877 (rp. 1970), p. 449; see also, 'Art-gallery and museum for Manchester', *Art Journal*, 1860, p. 72; and Judith Bronkhurst, 'Fruits of a connoisseur's friendship: Sir Thomas Fairbairn and William Holman Hunt', *Burlington Magazine*, vol. 125, 1983, pp. 586–97 (see plate 13, Robert Phillips, 'The Manchester Art Treasures Exhibition memorial trowel').

[66] *Art Journal*, 1860, p. 54.

quality of industrial design, but the *Art Journal* adopted a severely critical attitude towards the actual educational success of the exhibition. Although acknowledging its beneficial potentialities it was repeatedly dismissive in its strictures on this subject. 'Had it been definitively arranged that the collections should teach as little as possible, they could not have taught much less to the mass of the visitors,' it acrimoniously declared its closing review.[67] Efforts were indeed made to bring working people into the exhibition by reducing the entrance fees on Saturday afternoons to 6*d*. But, as Nathaniel Hawthorne observed, 'after 2.00, the Exhibition was thronged with a class of people who did not usually come in such large numbers. It was touching to see how earnestly some of them sought to get instruction from what they beheld.'[68] Scharf observed that much was expected of the voluntary visits of the working class in the industrial areas during the long annual holidays:

> but the people whose duties keep them under mill-roofs day after day, naturally preferred the fresh air; . . . The lower and uneducated classes did not go to the Art Treasures willingly. Many went because they were told they ought to go, . . . Had *educational* information been at the same time afforded to these helpless children and factory people, a more direct benefit might have resulted. Had the promoters of the Exhibition taken more time over it, and during three years instead of one, *disseminated preparatory instruction* among the lower classes, they would have afforded far more gratification.[69]

Scharf's well-intentioned proposals would only have scratched the surface of the problem. Even John Ruskin, who from 1854–1858 (and later) voluntarily and regularly taught at the Working Men's College in London, resigned in face of the sheer enormity of the task. In a letter to F. D. Maurice of 2 November 1867 asking to be relieved of his teaching duties he explained: 'But I ascertained beyond all question that the faculty which my own method of teaching chiefly regarded was necessarily absent in men trained to mechanical toil, that my words and thoughts respecting beautiful things were unintelligible when the eye had been accustomed to the frightfulness of modern city life.'[70]

The progressive pedagogic idea of reinforcing the possible beneficial effects of art objects by titling the pictures, providing pamphlets and organising free lectures had been advanced to the committee by Scharf but had come to grief on their objection that sales of the catalogue would be adversely affected. Those sales ran to 154,668 general catalogues and 13,250 supplementary catalogues of the drawings, sketches and photographs.[71] Visitors were forbidden to make notes or pencil sketches, but they were allowed to touch the pictures!

[67] *Ibid.*, 1857, p. 362.
[68] Hawthorne, *op. cit.* (n. 57), vol. 2, p. 535 (9 August 1857).
[69] Scharf, *op. cit.*, n. 41, pp. 313–14.
[70] Quoted from D. Leon, *Ruskin, the great Victorian*, 1949, pp. 230–1.
[71] *Report*, p. 44.

On the occasion of the centenary of the Art-Treasures Exhibition it was stated in the annual report of the National Art Collections Fund: 'The centenary is significant as a reminder, not only of a great exhibition of artistic wealth but also, more forcibly, of the impoverishment and irreplaceable losses to collectors overseas which have taken place in the last 100 years.'[72]

The Manchester exhibition now belongs totally to history. It led to no permanent memorial, nothing from it was retained for posterity; the art works were dispersed and the building was demolished and sold immediately after the exhibition ended. Its magnificence survives only in three sumptuous volumes, the two of photographs, *The Gems . . .*, published by Messrs Colnagni and Messrs Agnew, and J. B. Waring's *Art of the United Kingdom* (1858), a book with splendid chromolithographs by Messrs Day and Sons.[73] The exhibition can be reconstructed historically only from the contemporary reports, faded photographs, catalogues and emphemera of library and archive collections, but the works of art, its very essence, still exert their vital potency, and its principal object, the organisation of a great and comprehensive art collection open to the nation, continues to challenge each new generation.

[72] Quoted in an introductory leaflet inserted in *Art Treasures centenary. European Old Masters*, Manchester City Art Galleries, 1957.

[73] Both books were expensive. *Gems of the Art-Treasures Exhibition* cost £42, *Art of the United Kingdom* £20. A further lasting souvenir of the exhibition is an architectural medal. See Jeremy Taylor, *The architectural medal*, 1979, p. 148.

JOHN H. G. ARCHER

A classic of its age

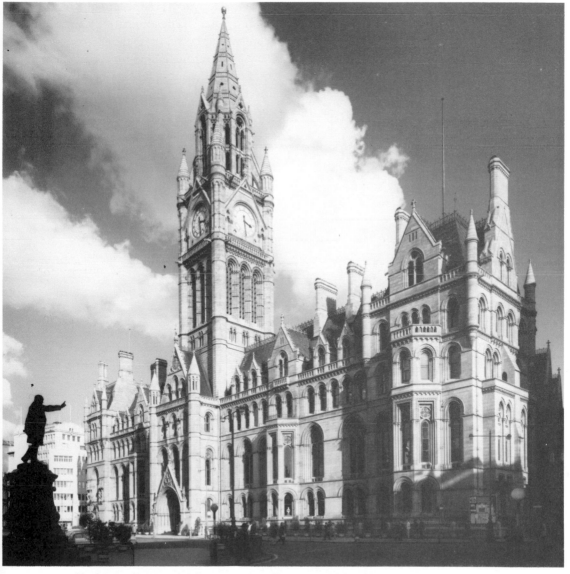

55 Alfred Waterhouse: Manchester Town Hall, 1867–77, from the south-west. The silhouetted sculpture is of William Ewart Gladstone, *c.* 1878, by Mario Raggi

Civic ambition found its most dramatic expression in the building of the Town Hall, **55**.[1] As a major city Manchester possessed the obvious means to engage in such a lavish project, but also was doubly fortunate in the qualities of its civic leadership and professional officers.[2] Their informed, intelligent patronage led to the appointment of one of the most able of Victorian architects, Alfred Waterhouse (1830–1905), who rose to the occasion with what is probably his major work, aptly described as 'a classic of its age'.[3]

Waterhouse gained the commission after a two-stage competition held in 1867–68 that attracted 137 entries. George Godwin (1815–88), the editor of the *Builder*, assessed these, and eight architects entered the second stage, which was adjudicated by Professor T. L. Donaldson (1795–1885) and George Edmund Street (1824–81), equally eminent architects with complementary backgrounds.[4] Whilst Donaldson, a founding father of the professional institute and former Professor of Architecture and Construction at University College, London, was a classicist, Street, a very able and distinguished practitioner, was a Gothicist of the most thoroughgoing kind. With Waterhouse the finalists were Cuthbert Brodrick (1822–1905), of London and Leeds, the architect of Leeds Town Hall (1853–58); William Lee, of London; Edward Salomons (1828–1906), of Manchester; John Oldrid Scott (1841–1913), of London, a son of Sir George Gilbert Scott; Speakman and Charlesworth, of Manchester (the partner responsible was John Charlesworth (1832–81); Thomas Worthington (1826–1909), of Manchester; and T. H. Wyatt (1807–80), of London, who was assisted by his brother, Sir Matthew Digby Wyatt (1820–77).[5] Local architects, therefore, had no cause for complaint and the Council had the assurance of knowing that the contestants included young aspiring entrants, such as Scott,

[1] For contemporary descriptions of the Town Hall see W. E. A. Axon (ed.), *An architectural and general description of the Town Hall, Manchester,* 1878 (henceforward Axon, *Description*), J. McLeod, *Manchester Town Hall,* 1877 (henceforward McLeod), and A. Waterhouse, *Description of the New Town Hall at Manchester, RIBA Transactions,* 1876–77, pp. 117–36. For recent descriptions and commentaries see Cunningham, Dellheim, Jenkins and Pevsner in the bibliography to this chapter.

[2] Notably Abel Heywood (1810–93), who guided the project throughout, Joseph Heron (later knighted), the Town Clerk, and J. G. Lynde, the City Surveyor.

[3] H. S. Goodhart-Rendel, *English architecture since the Regency,* 1953, see frontispiece caption. For information on Waterhouse see M. Girouard, *Alfred Waterhouse and the Natural History Museum,* 1981; S. Maltby, S. MacDonald and C. Cunningham, *Alfred Waterhouse 1830–1905,* 1983; S. Smith, 'Alfred Waterhouse', unpublished doctoral thesis (1970–71), Courtauld Institute, University of London; also his 'Alfred Waterhouse; civic grandeur', in Jane Fawcett (ed.), *Seven Victorian architects,* 1976, pp. 92–121. See also *RIBA Journal,* 30 September 1905, pp. 609–18 and *DNB,* Supp. 1901–11, and references.

[4] For Godwin see *DNB,* vol. 22; *Builder,* vol. 54, 1888, pp. 75–8, and Anthony D. King's introduction to Godwin's *Town swamps and social bridges* (1859), rp. 1972: for Donaldson see E. A. Gruning, 'Memoir of the late Professor Donaldson', *RIBA Transactions,* 1886, pp. 89–95: for Street see A. E. Street, *Memoir of George Edmund Street, RA,* 1888, and *DNB,* vol. 55.

[5] Charlesworth was named by the *Builder,* vol. 26, p. 261 (11 April 1868). Matthew Digby Wyatt corresponded with the City Surveyor about the competition conditions. See Proceedings of the General Purposes Sub-committee, vol. 2, pp. 506–14 (henceforward GPS-c). For notes on abbreviations and the organisation of the committees, see p. xii.

who was making his début in a national competition, and experienced professionals of wide reputation.

Waterhouse had opened his practice in Manchester in 1854 after completing his articles with Richard Lane (1795–1880), Manchester's leading architect of the 1820s and '30s.[6] Five years later Waterhouse had won the important competition for the Manchester Assize Courts and subsequently made a great success of the building, 6. It gained the unusual distinction not only of having satisfied the legal profession but of having won the praise of John Ruskin, who thought it 'a very beautiful and noble building indeed . . .' and 'much beyond everything yet done in England on my principles'.[7] Soon after its completion in 1864 Waterhouse had moved to London and was appointed in 1865 to advise on the provision of accommodation for the Royal Courts of Justice, to be built in the Strand, but had promptly resigned when informed that this would exclude him from competing for the commission.[8] Perhaps as a measure of compensation he was entrusted with the building of the Natural History Museum following the death of its architect, Captain Francis Fowke, RE, (1823–65), and the following year, 1866, he was one of the eleven architects selected to compete for the Law Courts.[9] He later confessed that at the time of the first stage of the Manchester competition, from March to August 1867, he was 'much pressed for time'.[10]

The Gothic Revival, the radical movement of the 1840s, inspired Waterhouse's early allegiances. Pugin's theories were formative upon him, and Ruskin's enriched his vocabulary and literally coloured his early architecture.[11] Unlike these mentors, Waterhouse was an admirer of the Crystal Palace and a frequent visitor to Sydenham. He might be described best as a 'modern Goth', that is, an architect who developed the principle of Gothic fitness rather than adhering to medieval precedents, and during the decade when the Town Hall was built he became increasingly eclectic, adopting and adapting whatever seemed most suitable for his purposes.[12] The Town Hall, although often described as thirteenth-century Gothic, nevertheless illustrates stylistic freedom.

[6] See Introduction, n. 22.

[7] Lecture on 'Traffic' delivered in the Town Hall, Bradford, 21 April 1864, *Works*, vol. 18, lxxv: and letter to his father, 9 December 1863, *Works, loc. cit.*

[8] M. Girouard, *Alfred Waterhouse and the Natural History Museum*, 1981, pp. 17–18.

[9] John Summerson, 'A Victorian competition: the Royal Courts of Justice', *Victorian architecture: four studies in evaluation*, 1970.

[10] Letter to Joseph Thompson, 13 August 1867 (file of letters from Waterhouse to Joseph Thompson, 1862–1902 (henceforward 'Thompson letters'), Archives, MCL).

Joseph Thompson (1833–1909), a councillor, Ancoats mill owner and a prominent Manchester Congregationalist, knew Waterhouse from at least 1862, when Waterhouse had designed the Ancoats Congregational Chapel. Thompson supported Waterhouse in committee during and after the building of the Town Hall and actively participated in the planning of the decorative programme. See also his volume of reports, etc., henceforward 'Thompson papers', Archives, MCL.

[11] Stuart Smith describes Waterhouse's early allegiances in *Seven Victorian Architects*, see above, n. 3.

[12] For Waterhouse's views on style see S. Smith, *op. cit.*

Architectural competitions in the nineteenth century were so generally subject to jobbery and interference that by 1867 they were received sceptically. The organisers of the Manchester competition set out with the creditable intention of obtaining a fair result with the minimum of loss to unsuccessful entrants. They introduced the two-stage procedure, limiting the first entry to five drawings that excluded the seductive blandishments of colour and perspectives, and stated the Council's intention of obtaining professional advice for the assessment. The winner was to receive the commission and other competitors completing the second stage £300 each.[13] The *Builder* hailed the conditions as 'for the age and the country, an immense innovatory stride'.[14] No stylistic preference was expressed, but the detailed requirements for the different functions, with their areas, locations and interrelationships, were carefully defined.

The site selected, the former Town Yard, faced the newly designated Albert Square and the memorial to the Prince Consort, **56, 41**, and furthered civic improvements that removed a central area of small factories, seedy courts and back-to-back houses. Its shape, an irregular triangle with one corner cut off, **57**, posed some taxing architectural difficulties, especially at the angles. It was not essential to follow the building line, which could be crossed only by the main entrance and steps, but the full frontage to Cooper Street, the shortest face, had to be filled. Some latitude was permitted in determining where the building line was set back from the boundary. The building had to consist of four floors and a basement, and it was stated that the amount of accommodation provided would be a criterion in the assessment. It was suggested that the 'grand front and entrance' should be in Albert Square and that the main rooms should be at first-floor level. Convenient access was required for the different functions; in particular the mayoral reception rooms and apartments had to have independent access, and the importance of good internal circulation was stressed. Ashlar was required for the exterior walls and all the elevations were to be of a similar character, a stipulation indicating that consistent quality was desired.

Of the eight finalists, Brodrick, Lee, Scott, Speakman and Charlesworth, Waterhouse and Worthington submitted Gothic designs, while Salomons's and Wyatt's were in grandiloquent versions of the Italian Renaissance. Compared with the other Gothic schemes, Waterhouse's final entry has a rather ponderous character, typified by the tower and its squat spire, and is strikingly plain in colour and decorative detail. Other designs were soaringly dramatic and colourful, but Waterhouse had produced a plan that was masterly in its efficiency, apparent simplicity and inherent architectural qualities.[15]

[13] Manchester Corporation, *New Town Hall: instructions to architects*, 1867, 8 pp + 1 plan.
[14] Vol. 25, p. 223, 30 March 1867.
[15] The reports of the finalists and illustrations of all of the designs except Lee's are in the Local History Library, MCL. Principal references to the entries appear in the *Builder*, vol. 26 (1868), pp. 259–62, and 317, 336 and 394; and in the *Building News*, vol. 15 (1868), pp. 237, 254, 317, 344, 360, 414, 468 and 634. Scott's design appears in vol. 16 (1869), p. 204.

56 The site of Albert Square and the Town Hall in 1849. Ordnance Survey map, 1:1056 (60 in.: one mile), 1851, Manchester, sheet 28

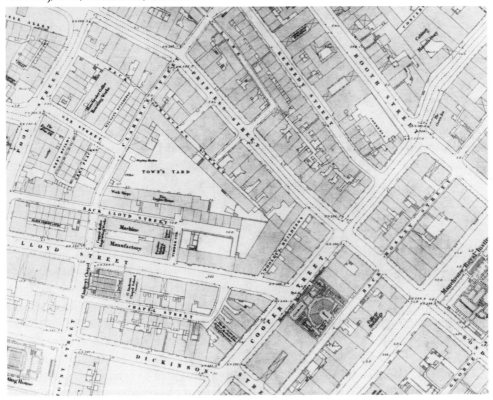

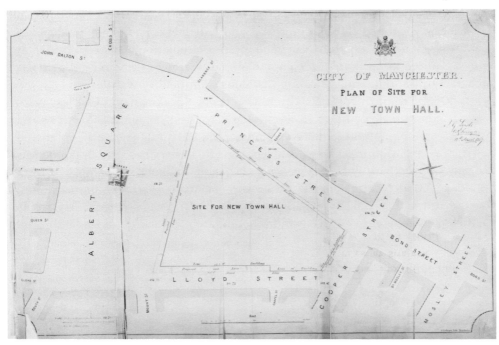

57 Manchester Town Hall, site plan published with the conditions for the Town Hall competition, 1867

Donaldson and Street were carefully briefed by letter and asked to give their views under six headings that can be summarised as external and contextual issues, internal arrangement, the provision of natural light, accommodation for heating and ventilation, the acoustic properties of the hall and council chamber (a point which they declined to answer), and the probable accuracy of the estimates.[16] After spending two days examining the 161 drawings, which at this stage included perspectives, Waterhouse was placed fourth under the first heading, first on the next three, and first overall 'on the grounds of Architectural merit, Construction, Excellence of plan and arrangement, Light, Cost, and provision of spare room, . . .'. Some aspects of the external form and detail of his design, the main entrance, the clock tower and the angles towards Albert Square, were thought to require 'additional study and modification . . .', but this plan was considered so good that it was considered 'thoroughly entitled to first place'.[17]

The wrangling that so frequently accompanied competitions broke out when the report was published. The first heading had asked the assessors to consider '. . . the comparative merits of the designs in an architectural point of view' having regard to the form of the site, the lines of the adjacent streets, the local climate and the building's purpose. All these are strictly architectural points, but Donaldson and Street introduced a gloss that unleashed a hoary Victorian bogey, the art–function dichotomy, by stating that the schemes by Speakman and Charlesworth, Scott, Worthington and Waterhouse were 'as works of art, the finest of the whole series', and that 'with regard to relative merit' they stood in the order given. By a neat transposition their critics asked why the scheme placed fourth in architectural merit was placed first overall.[18] Asked to clarify their report, Donaldson and Street presented a second absolutely confirming Waterhouse's primacy, and on 1 April 1868 he was appointed.[19]

The design of the Town Hall passed through three distinct stages and then evolved further as the construction proceeded. For the first competition, under the *nom-de-plume* 'Time Tryeth Truth', Waterhouse presented a relatively undeveloped entry that suggests haste. Admitting this in a letter, he wrote that he would 'think himself fortunate if he be among the 12 . . .', i.e. of those selected for the second stage.[20] A hybrid stylistically, the predominant character of the design is Gothic, although the main tower is capped by a pointed dome, **58**. The plan form closely follows the building line, and the accommodation is arranged in a continuous band following the site's periphery,

[16] GPS-c, vol. 2, pp. 539–40, and *Proceedings of the Council* (henceforward *CP*) 1867–68, pp. 141–2 (1 April 1868).
[17] Ms report in the Archives, MCL. It was printed in the *Builder*, vol. 26, p. 190, 14 March 1868.
[18] For one example of such criticism see the *Builder*, vol. 26, p. 190, 14 March 1868.
[19] *CP*, 1867–68, pp. 119 and 145–47.
[20] Letter to Joseph Thompson, 13 August 1867. See n. 10.

58 Alfred Waterhouse: Manchester Town Hall, 1867 scheme. Front elevation

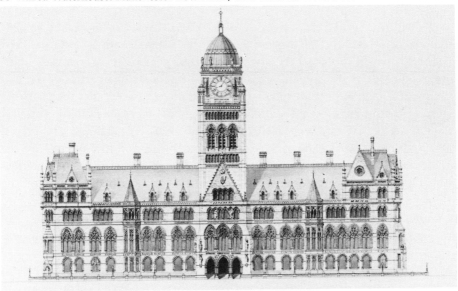

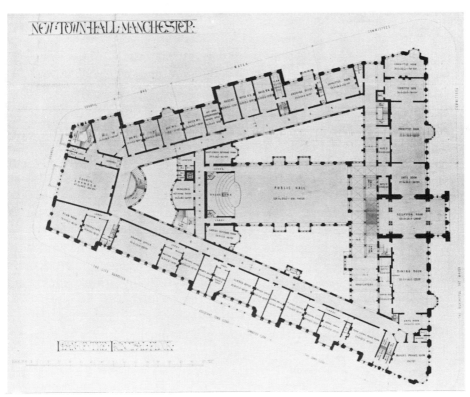

59 Alfred Waterhouse: Manchester Town Hall, 1867 scheme. First-floor plan. The main frontage faces west

60 Alfred Waterhouse: Manchester Town Hall, 1868 scheme. Perspective showing the Princess Street elevation

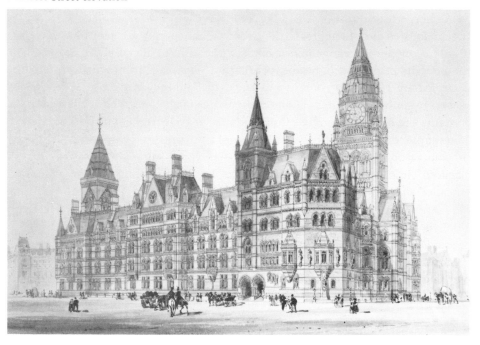

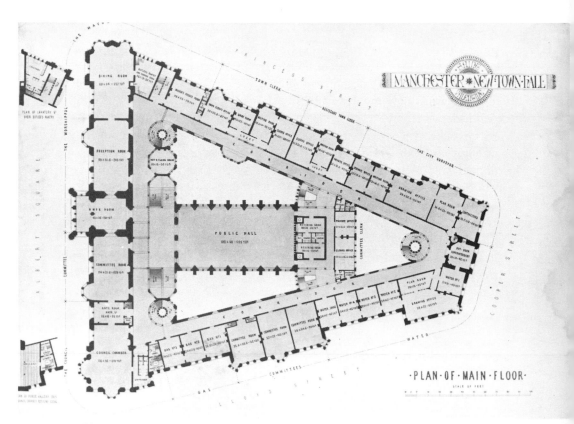

61 Alfred Waterhouse: Manchester Town Hall, 1868 scheme. First-floor plan. The top corner of the plan approximately points north

59. Concentrically within it is a corridor, and within this is a central void in which, located at right angles to the Albert Square range, is the public hall. This highly economical arrangement promised the offices, the corridor and the hall the benefits of natural light and ventilation. The main frontage is principally occupied by reception rooms, and the two flanking arms consist of offices served by public entrances at the main angles of the site. The truncated apex contains the council chamber, conveniently central to the main departments. The simple, direct and effective strategy of this concept, grasped so early, was the source of Waterhouse's ultimate success. From this point onwards it was clarified, improved and enriched. Only in the handling of the principal entrance and the tower did he vacillate.

The 'St Valentine' design, submitted for the second stage on 14 February 1868, is in every respect superior to its predecessor. The planning of the accommodation is different, partly because the Council decided that the council chamber should be in the front half of the building, but all the other changes were architectural developments, **60, 61**.[21] The most significant is the relocation of the staircases. Waterhouse complemented the logic of the horizontal circulation and the siting of the entrances by placing a circular staircase in the three internal angles of the plan. That in the Cooper Street angle, which serves more offices than the others, is largest. In addition, an intermediate staircase is sited towards the centre of each administrative wing, greatly facilitating movement between offices. A private stair links the mayoral apartments direct to Princess Street, and the reception suite and public hall are cleverly linked to the main entrance by a foyer and a flanking pair of ceremonial semi-octagonal staircases. The positioning of the various staircases serves the building's several functions, permitting concurrent uses, public, private and administrative, to proceed independently.

Stylistically the second design is more consistent than the first, although the attempt to complete a Gothic form with a Renaissance dome was not abandoned quickly, and the corner stairs, **62**, were inspired by the courtyard stair by François I at Blois (1515–24).[22] In the submission the dome is replaced by a short spire of heavy proportions, **60**, and the whole external design shows vigorous revision.

An amendment to the conditions permitted the absorption of small portions of the external areas between the boundary and the building line 'for the purpose of constructing towers or other architectural features' at the principal angles.[23] Waterhouse exploited this to full advantage. In the first

[21] The revised instructions were issued on 17 September (GPS-c, vol. 2, pp. 44–6). They appeared in the *Building News*, vol. 14, p. 648, 20 September 1867.

[22] A perspective study illustrates the revised design still with a dome (University of Manchester Drawings Collection). For a reference to Blois see Waterhouse, *Manchester New Town Hall; short description*, n.d., 3 pp., the description is of the 1868 design. A signed copy is in the Archives, MCL.

[23] Revised instructions, see n. 21 above.

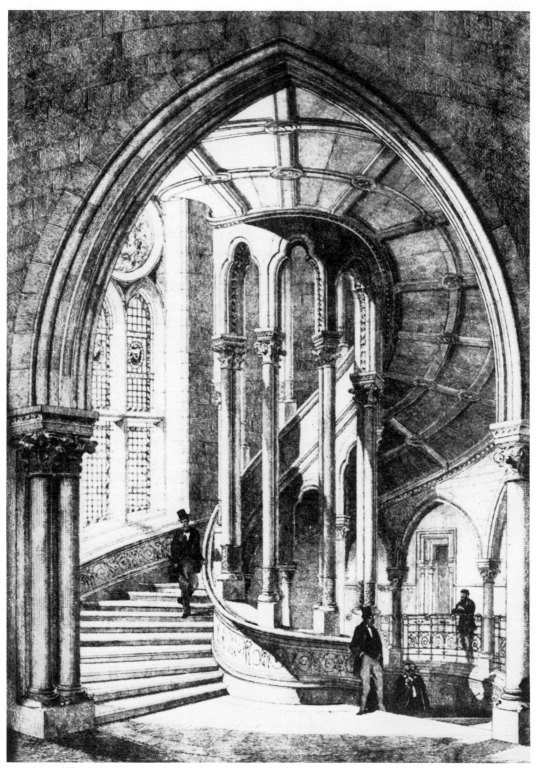

62 Alfred Waterhouse: Manchester Town Hall, 1868 scheme. Corner stair adjacent to the Princess Street entrance

design the corners are emphasised by a superstructure of pavilions above the main building, but now projecting pavilions were introduced whose modelling turns the awkward angles and resolves their inherent formal weakness. They boldly terminate each elevation and allow a transition of scale between the grandeur of the three-storeyed front and the necessarily smaller-scaled flanks of office accommodation that consist of four storeys but rise to five in a central block in each long side.

The main features of the exterior form were thus established. Each elevation has a central feature, and in the cases of the shortest, that facing Cooper Street, this is a tower and spire located approximately centrally above an entrance, thus echoing the Albert Square frontage. Each external angle has its pavilion, and each contains a principal entrance, marked like the major entrance by a tower. On analysis, therefore, the overall picturesque effect is far from arbitrary.

Symmetry played an important part in the ordering of the design, not the rigid symmetry of convention but an expression of Ruskin's dynamic interpretation of the principle. He observed that in nature symmetry is subject to the infinite variations of natural forces and that similar radical variations constitute one of the characteristics of vital architecture, so he argued that convenience need never be subordinate to symmetry.[24] Such freedom was exploited by Waterhouse with increasing adroitness and artistry as the design proceeded. Strict symmetry occurs only in component parts and details, and these are controlled by a whole series of axes generated by practical needs. In the front elevation of the 1867 design, for instance, **58**, the paired windows flanking the centre bay are unequally divided, but each bay containing them has its own axis. The classic demonstration of this principle is seen in the plans of 1868 and 1869 designs, **61**, **63**.

The design strategy required the great hall to be approximately central in the hollow triangle; however, formal reasons led Waterhouse to place the main entrance and its tower similarly centrally in the front elevation. Two major axes, parallel but about twenty feet (6 m) apart, each representing a dominant element in the design, were therefore created. Waterhouse related them through a co-ordinating system of structural bays that extends through the two superimposed foyers, their adjacent corridors and the ground-floor sculpture hall. Its basis is the division of the width of the hall into four equal bays. The axis of the hall divides these symmetrically, whereas that of the main entrance and tower occurs centrally in the northernmost bay of the four. The staggered axes are linked not only by structure but also by function through the planning of the ceremonial route from the main entrance. The foyers are closed at each end by the grand staircases, and one of these, therefore, is immediately adjacent

[24] See *The seven lamps of architecture*, 1849, chapter 5, § 7–20, and 'The nature of Gothic', *The stones of Venice*, 1851–53, vol. 2, chapter 6, § 38 and 39.

to the bay containing the entrance axis. The ceremonial route leads to it direct. At first-floor level a cross-axis links the stairs and is intersected almost immediately by the axis from the entrance vestibule to the reception suite, i.e. the axis of the tower, and again by the subsidiary axes from the entrances to the main hall. In either case a simple, unmistakable and effective route is provided despite the required changes of direction. The key to this notably adept solution, of course, is the play upon symmetry and asymmetry through controlling axes. It is one of the most significant developments of the 1868 design and illustrates a planning technique which Waterhouse fully mastered, perhaps through the study of medieval planning.[25]

On 1 April 1868, when the City Council appointed Waterhouse it also instructed that steps should be taken 'to secure the prosecution, without delay, of the necessary works'.[26] A sense of urgency led to the constructional work being divided into separate contracts, a policy that gave a rapid start but made it impossible to estimate the final cost until the last major contract was placed, a point which later assumed unfortunate significance.[27]

Whilst the first contracts for foundations, etc., progressed, Waterhouse had time to reconsider his design and the suggestions made by the assessors. Later he dryly remarked that some of the defects were 'too patent to have escaped even their author',[28] but he had cause to be grateful, because Donaldson and Street had pointed out that the internal courtyards merited full architectural treatment, and in a timely homily to the Council they concluded that 'The character of the whole building as a work of art depends very much upon its being uniformly good throughout'.[29] The Council thus permitted Waterhouse to make the courtyards consistent with the rest of the exterior. A further suggestion, attributed to Street and also accepted, was to link the main hall to the corridors with bridges.[30] Waterhouse's spirited response was to design two charming romantic structures that became the principal features of the courtyards, **69**.

The revised design was presented on 3 November 1868.[31] A comparison of the new plan with that of 1868 reveals the extent of the revision, **63, 60**. All aspects of the design were refined and enriched. Weaknesses, such as where the

[25] See, for instance, the cathedral plans of Lincoln, Wells or York Minster or, in domestic architecture, the plans of Haddon Hall, Derbyshire, or Hatfield House, Herts.

[26] *CP* 1867–68, pp. 147–8.

[27] The contracts covered, respectively, the excavations and foundations; the basement structure to ground floor level; the carcase except the tower; and the main tower, spire and finishing trades. That for the carcase alone (August 1870) amounted to £192,574 (GPS-c, vol. 3, p. 215).

[28] Paper to the RIBA, 19 February 1877, 'Description of the new town hall at Manchester', *RIBA Transactions*, 1876–77, p. 118.

[29] Assessors' report, see n. 17 above.

[30] The bridges span the north and south courtyards. Regrettably the northern bridge has been absorbed in a modern extension that seriously detracts from the courtyard and the natural lighting of the adjacent corridors.

[31] GPS-c, vol. 3, p. 148.

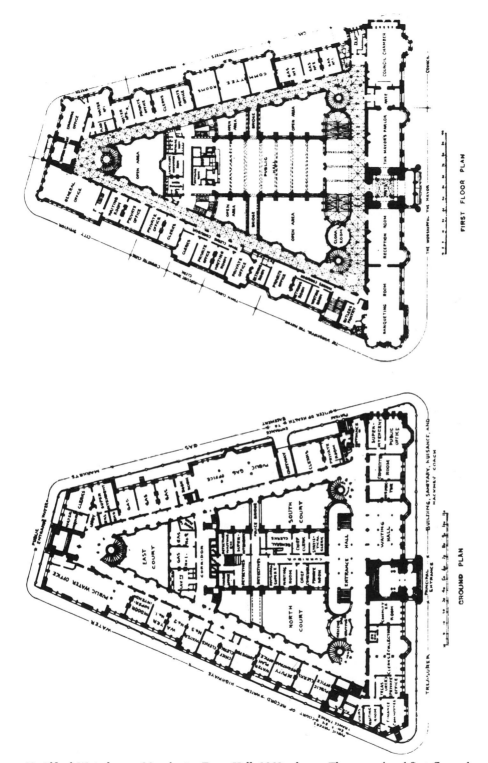

63 Alfred Waterhouse: Manchester Town Hall, 1869 scheme. The ground and first-floor plans

64 Alfred Waterhouse: Manchester Town Hall. Section through the waiting hall, showing the Dennett vaults, 1871

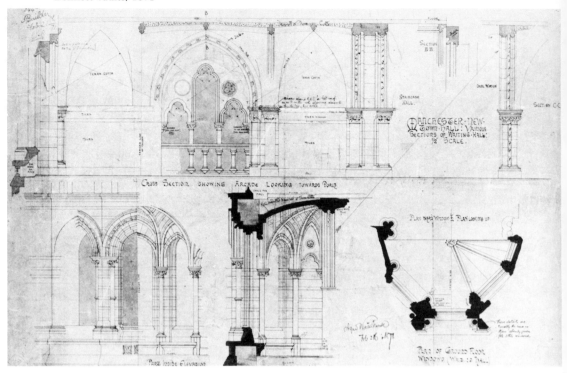

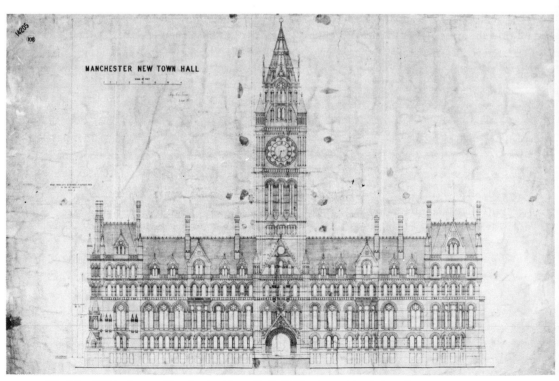

65 Alfred Waterhouse: Manchester Town Hall, 1869 scheme. Front elevation

structure and fenestration imperfectly corresponded, were removed and the awkwardness of the internal angles was resolved by the ingenious creation of vaulted spaces. Spatial relationships generally were strengthened and, above all, the plan benefited from the development of the structure.

A proprietary 'fireproof' method of construction, the Dennett system, which adapted an historic principle to modern use, was adopted throughout the building.[32] It consists of segmental or groined vaults formed in concrete and filled to the floor level, **64**. Exposed vaults could be ribbed in stone or terracotta, and the system provides an extremely durable fire-resistant structure. Large spaces, e.g. to the public rooms and offices, were divided by wrought-iron beams and then filled with segmental vaults that spring between them. Waterhouse used the system to great architectural advantage. A series of ribbed or groined vaults is carried through all the public circulation spaces and, in the internal angles, it rises to a *tour-de-force*. The long, formerly uniform corridors are given spatial variety and rhythm by the vaults, and these qualities are reinforced by the introduction of piers dividing the bays and the conversion of every alternate window into an oriel. Presumably these were intended to provide waiting or consultation spaces outside the offices, but they serve as yet a further means of enriching the interior and the courtyards.

The revision of the main elevation followed inevitably after the assessors' criticisms. Waterhouse made changes far beyond these and extensively recast its design on the principle of organic symmetry previously discussed. The treatment of the main floor windows differs on each side of the tower, **65**. On the Princess Street side the windows are divided by heavily moulded piers, whereas their counterparts are simply recessed into the wall plane. This variation produced a similar pattern of identical windows in different wall lengths, but a further departure from symmetry was introduced in the bays adjoining the pavilions, where the number of windows in each varies. The plan explains the arrangement: the accommodation on each side of the tower is different, and by departing from conventional symmetry a free arrangement, responsive to need, became possible. The fenestration admirably fits the plan.

No radical change was made to the pavilions, but the main entrance and, particularly, the tower apparently gave Waterhouse considerable trouble. The entrance, which had been conspicuously underscaled, is magnified architecturally by the enlargement of a superimposed traceried screen that is raised to the level of the springing line of the arches of the principal windows, and the tower itself is of a totally different character from its immediate predecessor, **60**, **65**, **66**. Taller and more elongated in the proportions of its stages, it is crowned with an airy, openwork octagonal lantern and spire whose design is reminiscent of both Freibourg cathedral and Scott's design for the Law Courts, exhibited in

[32] 'Dennett's Fire Proof Construction', patented by Robert Dennett & Co., Nottingham. See the *Building News*, vol. 13, pp. 582 and 626, 31 August and 21 September 1866.

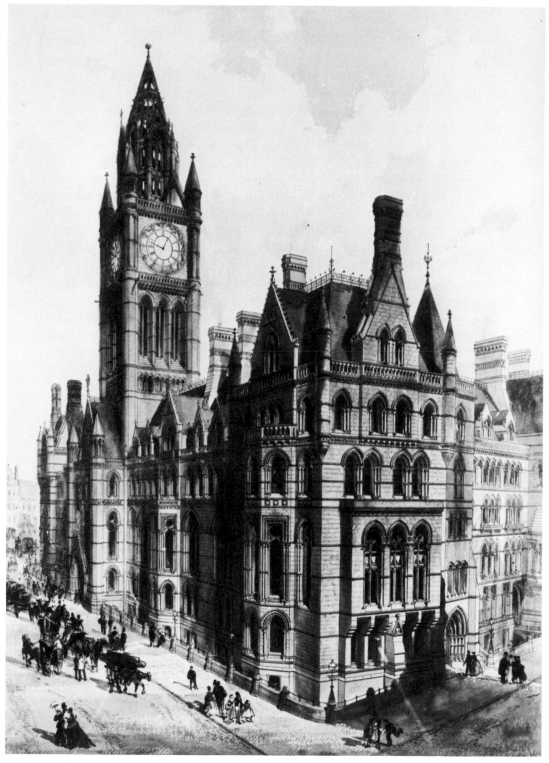

66 Alfred Waterhouse: Manchester Town Hall, 1869 scheme. Perspective of the Albert Square–Lloyd Street corner

January 1867, but an altogether different source is possible. The form is strangely similar to a distincive landmark of the port of Liverpool which Waterhouse must have known from boyhood, the tower and spire of the pierhead church of Our Lady and St Nicholas, as rebuilt by Thomas Harrison from 1811–14.[33] The committee minutes record that besides presenting the working drawings Waterhouse showed 'a modified plan of the Tower', and the drawing of the main elevation indicates by glue dabs that a further drawing has been superimposed over a section of it, **65**.[34] The precise nature of the modification presented remains uncertain, but, as will appear, the tower continued to haunt Waterhouse.

The design at this stage expresses a relaxed ease and freedom that is both impressive and deceptive. The simplicity of the concept and the logical clarity of the plan are made to look inevitable and easy, as is the free combination of symmetry and asymmetry, but Waterhouse was a master of the art that conceals art, and his handling of the practical freedom of the Gothic principle shows an understanding that goes far beyond stylism.

The revised design was approved and the long task of detailed development began. The major construction work, divided into three main contracts arranged sequentially, lasted for twelve years, 1868–80, although the last three were mainly devoted to the completion of details and decoration. Various changes were made to the design as the work progressed. Sometimes the Council asked for further accommodation or services, and Waterhouse, too, developed or modified his ideas. In July 1871, for instance, he proposed that the ground and main floor corridors should be lined with terracotta instead of plaster, a change that provided a permanent, cleanable decorative finish, an aim he was developing for the interior and exterior finishes of his buildings.[35] The most dramatic alteration came in July 1875 when he took the extraordinary step of suspending work on the main tower because he was dissatisfied with the proportions of the spire. He proposed, and it was agreed, that the spire should be made 16 ft (4·876 m) higher at a cost of £450–500, ostensibly to make it more distinct from the smaller one above the Cooper Street entrance.[36]

It is evident that Waterhouse took great personal care over the building. Altogether 1,373 drawings were produced, and many are in his hand or bear his annotations.[37] Careful attention was paid to three-dimensional details and in

[33] For Scott's design see the *Building News*, vol. 14, p. 41, 5 April 1867. The similarity between St Nicholas's church and the executed design was pointed out to me by E. V. Walters, an American visitor. In the 1869 design it is still more marked.

[34] As n. 31 above.

[35] The change was estimated to cost an extra £175. (GPS-c, vol. 3, p. 318, NTHS-c 18 July 1871). Waterhouse's ideas on the use of materials are given in the *British Architect*, vol. 10, 97–8, 6 September 1878.

[36] GPS-c, vol. 4, p. 341, NTHS-c, 20 July 1875.

[37] Stated by Waterhouse in 'Architecture' in *Unwritten laws and ideals of active careers*, ed. Edith H. Pitcairn, 1899, pp. 342–58.

some cases the contractor was required to produce models of them for approval.[38] By such means Waterhouse maintained close personal control of the development and execution of the design, and his letters and reports show that he was often on site.

From the time of Pugin, Gothicist architects had dreamed of uniting the arts and crafts in one sublime architectural harmony, and Waterhouse went to great lengths to realise this ideal in the Town Hall.[39] From 1875 he was concerned with the design of innumerable fittings and furnishings: lettering for the individual departments, lamp standards for the surrounding streets, and even china for the dinner service.[40] The decoration of the public rooms presented a special opportunity, and collaboration with other artists and designers was proposed.

Reality, another peculiarly Victorian value, led to the introduction of permanent forms of colour and decoration whenever possible.[41] The finishes in the main spaces were determined accordingly, and painted decoration was confined to strictly limited areas—ceilings, friezes and walls above the dado. Mural paintings fitted perfectly into such an architectural framework, and it is significant that at least four of the six Gothic designs submitted in 1868 included them in the public hall.[42] Waterhouse had ambitious hopes for an elaborate series of murals extending through the reception suite to the great hall. He first offered to prepare this in January 1876 when the decoration of the ceiling of the great hall was being considered, but no decision was taken. By April he had prepared a list of artists and an estimate of the cost, amounting to £9,000.[43] Again a decision was deferred, but Waterhouse was sufficiently confident of the result to include panels for the murals in his designs for the different rooms.

The two themes chosen for the decorative work generally were Manchester's history and commerce. The figurative sculpture on the exterior, for example, represents persons known or believed to have local associations. They range from Agricola (over the main entrance) to Charles Worsley of Platt, a Civil War general (on the north-west pavilion). In the interior more emphasis was laid on symbols of industry and commerce, which, of course, mainly

[38] Information from a working drawing of the inner porch of the principal entrance. (British Architectural Library/RIBA Collection, ref. E47.)

[39] See the frontispiece to A. W. N. Pugin's *Glossary of ecclesiastical ornament*, 1844.

[40] References to such details appear in the proceedings of the New Town Hall Sub-committee, which entrusted to sub-committees responsibility for special items, e.g. the organ, bells, decorations and furnishings. Drawings of many items are in the British Architectural Library/RIBA Collection.

[41] Reality: '. . . *the kitchens alone* are real', A. W. N. Pugin, condemning meretricious 'abbey style' domestic architecture and furnishings, *The true principles of pointed or Christian architecture*, 1841, p. 50. 'The first great canon . . . in Church-building is this: LET EVERY MATERIAL EMPLOYED BE REAL,' *Few words to church builders*, 3rd edn, 1844 p. 5 (published by the Ecclesiological Society). 'Only by being intensely real can we get back wonder into building once more,' W. R. Lethaby, *Architecture*, 1911, p. 243.

[42] Those by Lee, Scott, Waterhouse and Worthington.

[43] GPS-c, vol. 4, pp. 403 and 454. NTHS-c, 19 January and 19 April 1876.

signified cotton. Heraldry, too, provided a rich vein for civic display, and the widespread nature of Manchester's commerce is represented by the coats of arms and emblems that decorate some principal rooms.[44]

The cost of decoration, other than by murals, was covered by the final contract, and for this work Waterhouse invited firms to submit both tenders and designs. Heaton Butler and Bayne, of London, and two local firms, Best and Lea and Pollitt and Coleman, were selected.[45] Waterhouse selected and supervised the designs and ensured that the character from room to room is coherent.

Chapter seven tells how Ford Madox Brown was commissioned to paint his great series of murals to complete the main hall, **67**. In this long, lonely and arduous task he was consistently supported by Waterhouse, who intervened and obtained better terms for him but completely failed to persuade the Town Hall Committee to commission the other murals, although he pursued this virtually to the end of his professional career.[46]

If, after the opening, the Council was tardy in its dealings with Brown and unresponsive to Waterhouse, the cause requires little imagination. The whole project had cost almost a million pounds, exclusive of interest charges. The construction ran to some £522,000; fees, furniture and the purchase of land brought the total to £859,000. The new Police Courts, **43**, chargeable to the same fund, added a further £93,000.[47] Joseph Thompson, a councillor and a firm supporter of Waterhouse, later commented that the murals were deferred because the Council experienced 'a cold sweat . . . and one ever to be regretted'.[48] Of the five principal public rooms only two, the council chamber and the great hall, are completed as Waterhouse intended, although the principal vestibules, entrances, foyers and corridors are magnificently finished.

The ceremonial opening on 13 September 1877 was accompanied by great civic rejoicings that culminated in a banquet. John Bright, who made the speech of the evening, spoke of the building as 'truly a municipal palace', and the Bishop of Manchester proposed the health of 'The Architect'.[49] Waterhouse was nearing the peak of his career. Earlier in 1877 he had delivered a paper describing the new Town Hall to a well attended meeting of the RIBA.[50] The

[44] The decorative work and its significance is described in detail by Axon in his *Description*. For interpretations of its symbolism see E. V. Walters, 'The civic imagery of Manchester', 1976, an unpublished paper deposited in the John Rylands University Library, University of Manchester, and C. Dellheim, *The face of the past'*, 1982.

[45] GPS-c, vol. 4, pp. 455–6, 19 April 1876.

[46] On 16 January 1895 Waterhouse wrote to the Lord Mayor renewing the proposals for the decoration of the reception rooms. (Thompson papers, item 15).

[47] By November 1879 the Town Hall Committee knew that a loan of £200,000 was needed 'to meet obligations already incurred'. (THC, vol. 1, p. 160, 19 November 1879.) Previous loans had been granted for £495,000 (1866), £200,000 (1869) and £100,000 (1875). (THC. vol. 1, p. 199.) Waterhouse submitted the final account of £521,357 12s 1d, on 19 October 1880 (*ibid.*, pp. 290–2).

[48] Notes by Joseph Thompson, 12 December 1906, on item 468 in the Thompson letters.

[49] Axon, *Description*, 'A report of the inaugural proceedings'.

[50] See n. 28. *Op. cit.*, p. 134.

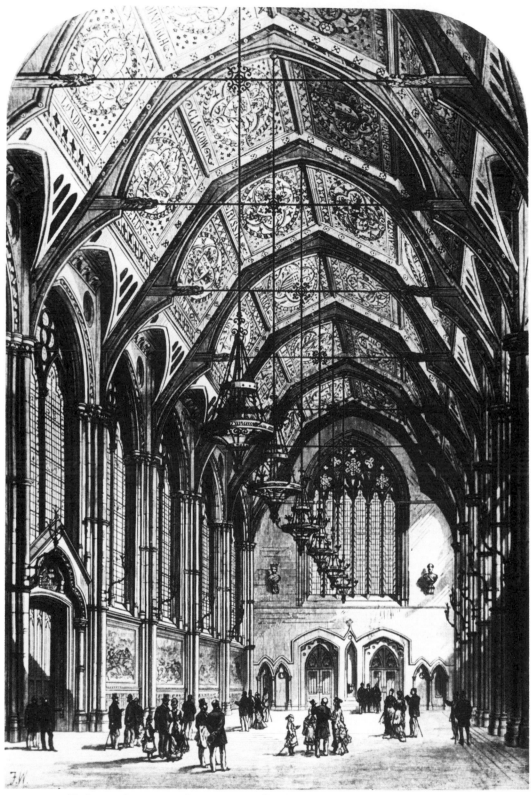

67 Alfred Waterhouse: Manchester Town Hall. The public hall

design was widely complimented and Charles Barry (1823–1900), the president (the eldest son of Sir Charles Barry), advised students that the study of the building 'will yield as much profit . . . as the study of the buildings of antiquity'. Both Donaldson and Street were present to congratulate Waterhouse, and Street remarked that 'the building generally was about as scientifically and well planned as it was possible to be'.[51] The following year Waterhouse was awarded the Royal Gold Medal for Architecture and elected president of the Institute.

Despite the praise of his *confrères*, the completed building received little attention in the architectural press. It seems that it was no longer architecturally newsworthy, no doubt because much space already had been given to it, and perhaps because by 1877 enthusiasm for the Gothic Revival had evaporated.[52]

Waterhouse was well aware of the trap of historicism and was clearly anxious to avoid stylistic labelling. After he had delivered his RIBA paper in 1877 he was congratulated on the design by Professor Donaldson, who referred to it as 'Mediaeval'. Waterhouse was quick to demur, replying, as was reported by the *Builder*, 'The learned professor spoke . . . as if the Manchester Townhall were a Medieval building. On the contrary, the architecture of the building was essentially nineteenth-century, and was fitted to the wants of the present day.'[53] The building justifies Waterhouse's claim. The Gothic style is used simply as a vehicle, a starting point, for a highly original design, and in certain respects the detail suggests he was deliberately distancing himself from the inventive, variable character of the truly medieval. Only occasionally does anything like authentic Gothic detail appear.

Waterhouse's reputation, contemporary and posthumous, has depended on his ability as a planner.[54] This is entirely fitting provided that the term is not limited to mean only the competent devising of convenient arrangements. In this respect he was obviously a master, but he possessed the larger and infinitely rarer gift of being able to make a highly efficient and ingenious arrangement expressive and ordered in external form and interior space. In the Town Hall this is achieved economically and unostentatiously in a fine concept in which logic, economy and imagination are well matched. The true hallmark of Waterhouse is not merely competent planning but a command of space and structure that places him in the first rank of Victorian architects. As Goodhart-Rendel observed, 'in the general shaping of a complex building he has had few

[51] See the *Builder*, vol. 35, p. 175, 24 February 1877.

[52] A watershed in architectural taste occurred *c*. 1870. Among numerous indications two are the publication in 1872 of C. L. Eastlake's *A history of the Gothic Revival* and, in 1873, of T. G. Jackson's *Modern Gothic architecture*.

[53] Vol. 35, p. 176.

[54] See *Manchester Guardian* obituary, 23 August 1905, 'His *forte* was planning'. H. S. Goodhart-Rendel paid tribute to 'his large grasp of planning', *English architecture since the Regency*, 1953, p. 158. Also see the Introduction, p.23.

superiors in his own country before or since'.[55] Moreover, in the Town Hall Waterhouse demonstrated his architectural mastery both of mass and of detail and produced a building of remarkable integrity. Examine it anywhere and this is revealed. Although the experience may not always soothe aesthetic sensibilities it will constrain admiration.

The plan is extremely efficient. Entrances are located strategically in relation to the streets and, as has been indicated, the disposition of the accommodation is well suited to the needs and the site. The detailed organisation is effective, and four discrete circulation systems were provided. The ceremonial route does not cross the corridors serving the administration; an individual entrance and staircase ensures the mayor's privacy from the street to his apartments, and equal care was taken to isolate a police station, now removed, from the other functions. It was located under the public hall and entered from a courtyard. Communication between the offices is easy and direct. The corner staircases, supplemented by the intermediate ones and the cross-corridors, ensure that the maximum distance between any office and a staircase never exceeds approximately sixty feet (18m).

The construction is a model of contemporary technology. The arcuated principle of the Dennett system is followed consistently and is made expressive not only in the vaulted corridors but in the offices, where shallow segmental vaults form bays dividing the ceiling. Overt structural expression occurs also in the cranked and curved wrought iron beams of the intermediate staircases. The Puginian principle of making the mechanism a vehicle for art was clearly a central tenet of Waterhouse's architectural beliefs.[56] It is seen in the pattern of the external masonry, where alternating deep and narrow courses express the bonding of the stone casing with the internal brickwork. In the great hall, however, the main roof, a timber structure consisting of pairs of opposed trussed rafters, is not exposed. The room has a waggon-roof ceiling carried by a secondary truss of unusual design, **67**. It parodies a hammer-beam roof, rising in two unequal arcs to the ridge. Where the arcs intersect, the 'hammer beams', carved as winged grotesque beasts, project, but their true function is revealed by the wrought iron tie rods which stretch between them, tying the foliated blades and also, incidentally, the feet of the invisible main trusses. The function of the inner truss is perfectly clear. It is obviously much too light to be carrying anything other than the ceiling. Its design illustrates Waterhouse's attitude to historic precedent: the suggestion of the hammer beam is merely an allusion.

The services throughout the building are skilfully integrated architectur-ally. The roof void above the hall, for example, serves as a ventilating chamber. Vitiated air rises through star-patterned grilles in the soffits above the windows and is drawn to a large ventilating stack at the Cooper Street end. The corner

[55] *Op. cit.*, p. 158.
[56] A. W. N. Pugin, *The true principles* . . ., 1841, p. 2.

staircases also serve a hidden function. At the centre of each is a hollow shaft, arcaded spirally to correspond with the staircase, **62**, **71**, and at basement level each contains a large heating coil from which warm air circulates up and through the building. The offices, too, are warmed and ventilated unobtrusively by air that is drawn through patterned ventilators located beneath the windows and warmed by a coil before passing into the room. Waterhouse did not design the heating system but, as on other works, collaborated with the well known engineer, G. N. Haden (1817–92).[57]

The final form of the Town Hall, **55**, is very close to that shown in the 1869 design. The most conspicuous changes were to the tower and spire. The attractive, lacy openwork shown in Waterhouse's perspective was discarded, **66**, perhaps wisely in view of the heavy pollution from which it would have suffered. The lantern remains octagonal and open but the spire is banded and panelled in masonry. Waterhouse was probably correct in deciding to increase its height, not because of any comparison with the secondary one over Cooper Street but because of its relationship with the lantern, a powerful element in the design, and the inevitable foreshortening that occurs when the spire is viewed from street level.

Such difficulties in visualising the intended result do not appear to have affected the design elsewhere, and the three-dimensional nature of the concept is unmistakable. It was intended to be seen from any angle. The main tower dominates the frontage, the pavilions masterfully resolve the difficulties of the corners, and the character of the form is typically Ruskinian and High Victorian, with the wall faces, in Ruskin's phrase, nodding 'Jupiter like' and ponderously overhanging the streets, an effect achieved through oriels and corbelled bays projecting from first-floor level. Finally, the crowning feature of the high-pitched Northern Gothic roof firmly unites the variety and complexity of the main fabric.[58]

The most important aspect of the building is not the main front, as might be imagined from the elevations, but the Albert Square/Princess Street corner, where four principal streets meet. The design was carefully studied from this angle, **60**, and the pavilion forming the corner far surpasses the main entrance in richness of effect. Its significance is reflected in its sculptural enrichment. Six canopied niches, each containing an historic Mancunian, are distributed on the two more public faces. Each figure is in appropriate contemporary dress because Waterhouse wanted 'figures of as picturesque a character as possible . . .'.[59]

[57] I am indebted to my colleagues M. R. Maidens and G. R. Winch for guidance on some technical matters, and to Messrs Haden for biographical information.

[58] For these forms see, respectively, 'The lamp of power' (*Seven lamps* 1849), § 7, and *Lectures on architecture and painting*, 1854, Lecture 1, § 17 and 18.

[59] From a report (n.d.) by Waterhouse in the Thompson papers, item 8. A list of the proposed sculptures was presented on 19 November 1873. (GPS-c, vol. 4, p. 48.)

The pavilion is decisively modelled, with two faces parallel to and projecting from the lines of the adjacent sides and a splayed face linking them across the corner, **60**. Scaled to match the main elevation, it is a storey higher and effectively terminates the neighbouring elevations. The splayed face is gabled, and a large half-hexagonal oriel, flanked by niches, and, purely as a gesture of structural vitality, supported by a short but massively robust flying buttress, forms its centrepiece and a striking focal point to the corner.[60] The finale to this spectacular town hall in miniature is a tower and broached spire that rise above the mayor's entrance and complete the Princess Street face. This pavilion speaks as a model for the others; the external angles, for example, are either right-angled or boldly obtuse, and difficult changes of plane occur only at the internal angles, so that at no point does the design falter in turning the corners.

The integration of the differently scaled elevations can also be observed where the pavilion meets the office facade. The principal horizontal lines of the major-scaled frontage and pavilion, immediately distinguishable by their depth and mouldings, are carefully related to others in the adjacent elevation and form bonding lines establishing continuity throughout. Where the pavilion actually abuts the office elevation its corner is filled by a staircase, an element that creates a natural break and, as this northern face of the pavilion is a consummate example of functionally expressive asymmetrical design, the junction is made with unstrained ease. A similar means is used on the Lloyd Street pavilion, only the staircase here is within the office wing. At Cooper Street the problem does not arise because the pavilion maintains the smaller scale.

The lively freedom of design of the two western pavilions was probably inspired by the widely known example of Jaques Coeur's house at Bourges (1442–53), but inventive variety occurs throughout the building and usually relates to a practical purpose.[61] The ground-floor windows, for instance, except on the main front, are rectangular, **60**, no doubt to admit more light to rooms most overshadowed, but a further reference to arcuated structure is seen in the relieving arches above the lintels of the pavilion windows. Like the monstrous flying buttress, this is more an expressive symbol of structure than a practical necessity.

The exterior masonry is entirely monochromatic in a dun-coloured

[60] Structurally redundant buttresses were commonly used as expressive symbols in High Victorian architecture. This practice can be attributed to W. Butterfield (1814–1900), R. C. Carpenter (1812–55) and G. E. Street and is illustrated in *Instrumenta ecclesiastica*, 1847 and 1856, published by the Ecclesiological Society to illustrate model designs by favoured architects. See second series, 1856, plates 43–7, and 63–4, respectively by Carpenter and Street.

[61] The parallel with Jacques Coeur's house can be seen most clearly from plate 13 in R. N. Shaw's, *Architectural sketches from the Continent*, 1858 (henceforward *Sketches*). Dr Colin Cunningham informs me that Waterhouse's annotated copy is extant. Shaw's book was published shortly after Waterhouse had made an extensive Continental study tour.

Spinkwell stone, a durable, close-textured Yorkshire standstone.[62] After seeing
the walls of his Assize Courts blackened in a few years Waterhouse largely
abandoned external polychromy. On the Town Hall it was confined to a
variegated pattern in the roof slating, but by now time, weather and pollution
have rendered even the washed slate surfaces uniform. In place of colour,
surface interest is created through the more traditional means of modelled
detail, the ordered recession of the windows, their tracery, the canopied niches
for the sculptures, and the carved patterning that enriches salient features. The
latter is hard in character and no attempt appears to have been made to make it
individually expressive. It is treated mechanically and is thus totally anony-
mous and opposed to the Ruskinian principle for such work.[63] All the carving
and sculpture was supplied by Farmer and Brindley of London, a well known
firm of architectural masons, and on the exterior it is highly competent but
mostly uninspired, one exception being an imaginatively conceived roundel on
the Princess Street elevation depicting weaving.[64] As mechanical detail is
common to other comparable Waterhouse buildings it must be assumed to be
deliberate, in which case it can be viewed simply as textural enrichment,
secondary in importance to the general vigour of the exterior.[65]

The principal entrances are deeply inset in heavily moulded Gothic
doorways. The most impressive, inevitably, is the ceremonial entrance from
Albert Square. It leads to a vestibule where the richest effects in the building are
displayed. The space, which is the ground-floor stage of the tower, is rib-
vaulted and glitters with flashes of gilt from the patterned mosaic that lines the
vault panels. The floor, too, is mosaic, except for a central motif in marble and
porphyry, an example of *Opus Alexandrium* which Waterhouse presented to the
Corporation.[66] The vault springs from free-standing polished granite shafts, the
outer ones being paired. Their capitals represent grotesque beasts with a
vitality lacking in much similar work. The main vault is flanked by tunnel
vaults closed by arcades. That to the south is open and reveals a vaulted hall
that was designed as a waiting area but was redesignated the Sculpture Hall
and adopted to house the city's increasing collection of busts and statues,
principally of notable Mancunians.

From the main entrance the visitor is led without the slightest indecision
through the complex architectural manoeuvre described to emerge at the first-
floor foyer, the centre of a great spatial complex, **68**. The foyer's significance is
immediately obvious. It is flanked by the ceremonial stairs whose leading

[62] See I. M. Simpson and F. M. Broadhurst, *A building stones guide to central Manchester*, Manchester, 1975.

[63] See 'The nature of Gothic', § 13–25, *op. cit.*, n. 24.

[64] A similar roundel illustrating spinning has been removed from the Lloyd Street elevation and is now on view in the sculpture hall.

[65] See, for instance, his extensive works (1869–97–8) at the University of Manchester.

[66] GPS-c, vol. 4, p. 468, NTHS-c, 17 May 1876.

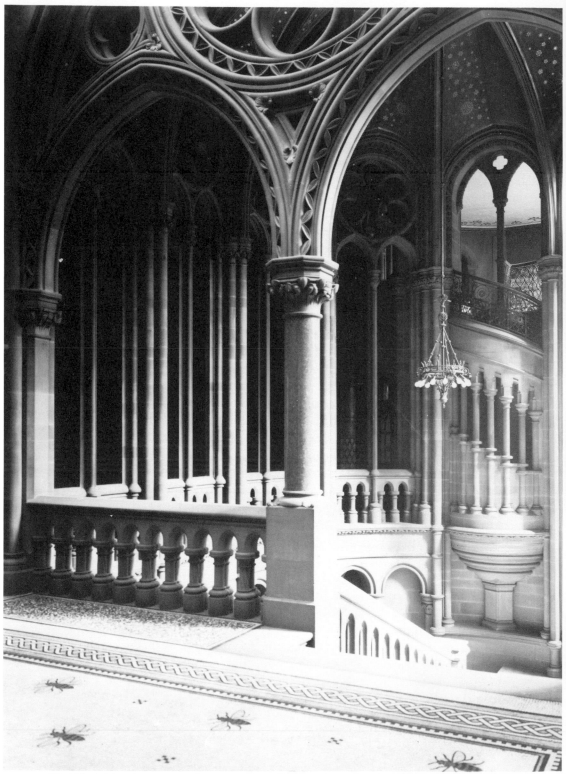

68 Alfred Waterhouse: Manchester Town Hall. View through a foyer arcade across a grand staircase

flights, lit by impressive ranges of traceried windows, fall majestically, each within a vaulted, arcaded semi-circular apse, but the importance of the principal stair, serving the main entrance, is distinguishable by an unusual feature introduced above the landing, a miniature 'oriel' staircase, arcaded and cage-like, rising centrally within the apse. It is a surprising touch. Provided nominally to serve an additional retiring room, its actual purpose is primarily architectural, and in this respect it presents a virtuoso performance.[67] This entire complex of spaces is governed by a cross-axis linking the two front, corner staircases, the foyer, the grand staircases, a circular cloakroom and the miniature stair described, **63, 68**. The vaulted corridors and the adjacent spaces are divided by arcades that define each volume individually whilst yielding views across the interconnected spaces. All requirements, practical and ceremonial, and the possibilities of the structural system are exploited in this solution that exemplifies Waterhouse's outstanding power of spatial imagination.

Dramatic lighting heightens the effect of this splendid complex. The observer can move from cavernous darkness in the internal angles to the brilliantly lit ceremonial staircases and, in passing, catch glimpses into yet another architectural world, intricate and richly detailed, that of the internal courtyards. Veiled when seen from the main windows, any open casement reveals a scene surprisingly rich in pattern and texture. Traceried windows, the network of leading and glittering glass, geometrically carved stonework, spirally moulded downpipes, and a floor of granite setts, all ordered, contrasted and in their appropriate place, arrest the eye, caught by the immediateness of such a rich concentration, and where longer views are possible, a fancifully conceived bridge may close the scene, **69**. The transformation of the originally plain courtyards was perhaps inspired by those of the fifteenth-century Continental town houses already mentioned, but practicability and contemporary needs were not forgotten.[68] The spandrels above the window-head mouldings are patterned in an attractive trellis of grey on white tiling, and each main angle is emblazoned with a radiant red sun. This colourful innovation illustrates the concern to provide permanent decorative and self-cleansing surfaces that had a profound influence on Waterhouse's subsequent work. In this instance his invention greatly enhanced the lightness and attractiveness of the courtyards and corridors.

The principal civic apartments, the former council chamber and the reception suite, consist of an interconnecting chain of first-floor rooms conforming to a further axis and filling the Albert Square frontage, **63**. The principal ceremonial entrance is through a richly decorated ante-room located

[67] Waterhouse introduced a similar device above the staircase to the council chamber at Manchester University. (1883–87). The idea may be derived from the stair from the porch beneath the chapel in the Hotel de Cluny, Paris (1485–98). See Shaw's *Sketches*, plate 31.

[68] See Shaw, *Sketches*, plates 14 and 30.

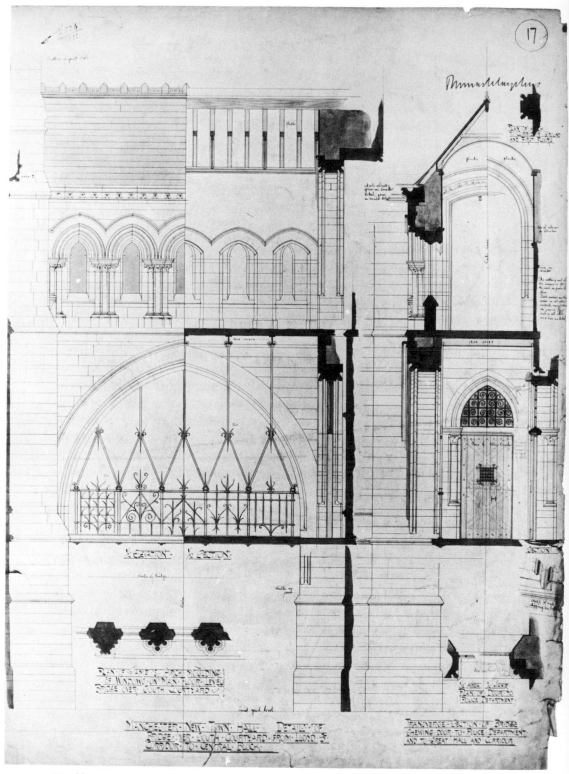

69 Alfred Waterhouse: Manchester Town Hall. Working drawing showing the bridge over the south (Lloyd Street) courtyard

within the tower and above the main entrance vestibule. The relationship between the main axis and the northern ceremonial staircase is therefore again underlined. Two apartments, the reception and banqueting rooms, extend to the north of the vestibule, and on the other side, spatially mirroring the reception room, is the mayor's parlour or committee room. Beyond this, and separated by a further vestibule, is the former council chamber. All the rooms are made individually asymmetrical by the addition of generously proportioned bays.

The rooms and their fittings have been described in detail elsewhere and, as one might expect, they are rich and varied, but their most striking architectural characteristic is their spatial quality.[69] The most complex in this respect are the banqueting room and the council chamber. In the former the main space is diversified by a large bay formed by the pavilion, a musicians' gallery opposite to and echoing the bay, and twin bays, symmetrically placed at the north end where two faces of the pavilion form a wide obtuse angle. A perfect correlation between the exterior and the interior is achieved. The council chamber, in the corresponding pavilion, is similarly complex spatially, with two bays and a public gallery opening off the major volume.

The reception apartments are individually decorated within a uniform architectural framework of an oak dado, wall panels and frieze that extends through the suite. Decorations and furnishings designed by artists from several firms form a remarkably unified ensemble and complement each other so harmoniously that their different authorship is indiscernible. The ceilings of the reception room, **70**, and mayor's parlour, by Best and Lea and Pollitt and Coleman respectively, are painted and patterned with the stylised flower-head motifs that are typical of the Aesthetic movement, the current mode of the 1870s and '80s, in light and delicate colours, vellum, orange and sage green.[70] The banqueting room ceiling, panelled in oak and decorated by gilded suns, is more orthodox.

Chimneypieces in the different rooms are carefully placed. All are by Farmer and Brindley, and their various decorations and fittings create the richest concentrations of craft work in the building. Like the detailing generally, they illustrate the transition in design from the mid to the late Victorian decades. Their tiling, for example, includes neo-medieval encaustic tiles with heraldic beasts for motifs, and others decorated with *à la mode* figures in flowing Aesthetic robes. The most unusual chimneypiece decoration is in the reception room: an embroidered panel of bees, a Mancunian emblem, on Brunswick green velvet. Although dulled it is still striking, but the use of so vulnerable a material in such a place is hardly characteristic of Waterhouse.

The furniture of the reception rooms was made to Waterhouse's design by

[69] For furnishings, etc., see Axon's *Description*, 1878, and *McLeod* (see n. 1).
[70] See Elizabeth Aslin, *The Aesthetic Movement*, 1969.

Doveston Bird and Hull, of Manchester.[71] Like the titles, it illustrates the emancipation of Victorian design from historicism. Some pieces are distinctly spare in their emphasis on the lines of their framing, whilst others are closer to the turned, upholstered furniture illustrated in C. L. Eastlake's *Hints on household taste* (1867), but one particular item, the banqueting room curtains, has an unquestionable place in the history of contemporary design. Their authorship is attributed to HRH Princess Louise, and they were embroidered at the Royal School of Art Needlework in South Kensington. They are memorable for richness of colour and texture and a clarity and boldness of pattern that are heightened through strong and expressive stitching and appliqué work. The panel of bees, already mentioned, is presumably from the same school. Other curtains of exceptional design, now removed, feature in Axon's *Description*.[72]

The great omission in these rooms is, of course, the murals that were to have filled the panels above the oak dado. Temporarily they were filled with figured tapestry, but the missed opportunity is now painfully regrettable.

The only major room in this suite that was completed in accordance with Waterhouse's intentions is the council chamber. Above the dado the wall face is of ashlar and above it is a frieze, by Best and Lea, filled with an elegant swinging pattern of intertwining cotton-plant tendrils with white bolls bursting amongst the leaves. Superimposed are shields bearing the arms of the neighbouring cotton towns. Again the lightness of touch and delicate colours show that Waterhouse's taste was that of a modern Victorian.

The great hall, **67**, the building's principal chamber, is a relatively simple space seven bays long. At the east end, beyond a high arch, is a vaulted apse which houses the organ and a platform for public occasions. The west end contains the entrances and a large six-light traceried window. The glazing here and throughout the building is delicate in colour. Very light grey tints predominate, maintaining a neutral tone to avoid detracting from the murals but admitting ample light, a matter of appreciable importance in any Victorian city.[73] The bays are divided by clustered shafts of piers and, except where the doorways to the bridges occur, each bay is filled by an oak dado and a mural panel 10 ft 5 in (3·18 m) long and 4 ft 10 in (1·47 m) high. Above is a deep cill and then a two-light window. The lower part of the hall, therefore, provides a quiet background for the murals, but in the decoration of the ceiling, by Heaton Butler and Bayne, civic pageantry reigns. The waggon roof is made up of four canted panels within each lateral bay defined by the ceiling trusses. Each is

[71] GPS-c, vol. 4, p. 385, NTHS-c, 15 December 1875.

[72] *Description*, 1878, p. 21. See also McLeod. Barbara Morris, in *Victorian embroidery*, 1962, and Elizabeth Aslin, in the *Aesthetic Movement*, 1969, illustrate the banqueting room curtains and attribute them to HRH Princess Louise, who was actively concerned with the Royal School of Art Needlework and artistic developments generally.

[73] In his RIBA paper (1877) Waterhouse referred to the special need for adequate light for the murals. *RIBA Transactions*, 1876–77, p. 125.

70 Alfred Waterhouse: Manchester Town Hall. Ceiling decoration in the reception room (Best and Lea)

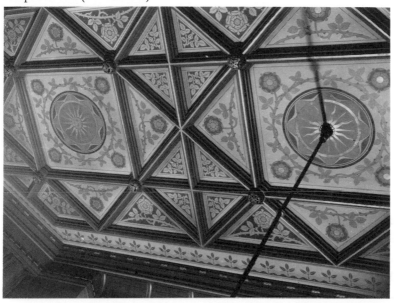

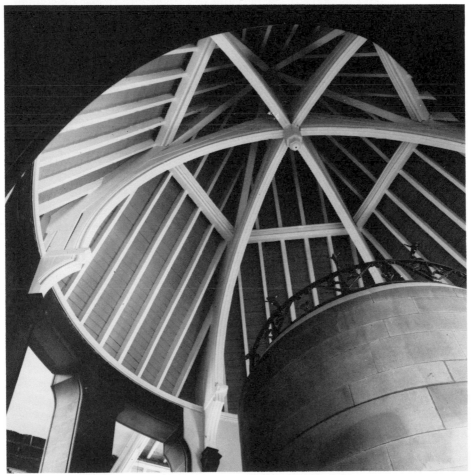

71 Alfred Waterhouse: Manchester Town Hall. 'Umbrello' above a corner staircase

decorated with symbols and insignia representing States and cities prominent
in Manchester's commercial life, but among the civic panoply Mancunian
allusions can be found: bees decorate the coloured backgrounds and bands of
crossed shuttles line the panel heads. Before the murals were finished there
were complaints that the ceiling decoration was too heavy, but such criticism
was premature, and rich and impressive though the hall may be for the glitter of
public occasions, in its design the architect respected the painter who
responded so admirably to his architectural task.[74]

The permanance of architectural finish that Waterhouse desired is realised
most closely in the corridors and public areas of the lower floors. Mosaic
paving, tiled dados, terracotta wall linings, patterned and banded in buff and
blue-grey, and polychromatic stone vaults combine to make the principle
formidably durable. It exhibits one of the hardest aspects of Waterhouse's
architectural personality and is seen at its indestructible best in the sculpture
hall, yet the severity is not unrelieved. The mosaic is light and variegated, and
focal areas are attractively and symbolically patterned with bees or the red rose
of Lancaster; cable patterns, perhaps signifying cotton ropes, are worked into
borders, **68**. Everywhere the hardness of finish is sensitively and quietly
tempered by inventively designed patterns. One memorably effective example,
a novel variation in black and white mosaic on the elementary chequer pattern,
is reserved for the main entrance. Waterhouse liked it sufficiently to repeat it in
the Natural History Museum (1868–81).

Hardness and thoroughness characterise the corridors, but they are
meither dull nor uniform. The floors are panelled, picking up the rhythm of the
bays, and the tiled dados are different on each floor and give identity to each
through variations in colour and pattern. The vaulting provides the only
surface left vulnerable to decorators, but great diversity is achieved through
them by a rich variety of stencilled patterns carried out by Best and Lea (first
floor) and Pollitt and Coleman (ground floor). Their character is widely
different, and the most successful is a pattern of barbaric splendour zigzagging
in vivid red and green. It is used on the first floor, and it is reported that
Waterhouse was personally responsible for its design.[75] It is one of the most
outstanding examples of the use of colour and pattern in the building and, with
the ceiling patterns in the reception rooms, it illustrates the originality and
appropriateness that Waterhouse and his co-designers brought to the interior
decoration. Its standard is equal to the best contemporary practice, and in the
1870s this was high indeed.[76] Waterhouse selected sketch studies of patterns
and supervised their development, which, presumably, is how he obtained
such a high degree of cohesion. The only striking disparities of character occur

[74] The criticism appeared in the *Builder*, vol. 34, p. 941, 30 September 1876.
[75] *Builder*, vol. 34, p. 942, 30 September 1876.
[76] See Elizabeth Aslin, *op. cit.*, n. 70, and Lewis F. Day's contributions to the *British Architect* in 1878
on the various entries in the Paris Exhibition of that year. Also see his *Instances of accessory art*, 1880.

in the corridors, and it is possible that these were made deliberately bold to make them readily appreciable by moving persons.

The quality of detail on any building is an index of the care taken in its development. At the Town Hall it is exceptional. Mouldings are meticulously handled and each is returned and stopped precisely and decisively. This is especially noteworthy on the staircases because of their complex geometry. Their soffits are as carefully finished as their leading features. Every angle and line, it seems, was thought out thoroughly and three-dimensionally.

Consistency of imaginative thought, another hallmark of architectural distinction, is strongly maintained, and the areas for day-to-day use are designed as thoughtfully as those for ceremony. The corner stairs, for instance, are subsidiary but not secondary in architectural quality. As the design developed they shed any superficial associations with their lavish precursor at Blois and gained a character of their own—lean, compact, efficient and visually powerful. The head of the Cooper Street stair, the largest of the three, is finished with a fine imaginative touch. Umbrella-like in structure, a lantern of openwork carpentry lights the well head and, though relatively modest, this further illustrates the spatial quality that is characteristic of this building at all scales.

The highest standards of workmanship prevail everywhere, but individuality in craftsmanship is relatively rare. This has been discussed already with regard to stone carving, but it applies equally to the joinery. It may be that Waterhouse preferred reliable uniformity to the possibility of idiosyncratic excellence when such a scale of production was required. If so, he appears to have been moving towards a machine aesthetic, but one trade, the metalwork, retained the vigorous execution that is in the best tradition of Gothic craftsmanship. It is by Hart Son and Peard, of Birmingham, but though its spirit may express Gothic vitality its design included wholly modern features. The prominent motif on the Cooper Street gate, for example, is the sunflower, as radiant in its Mancunian Gothic environment as on any contemporary Queen Anne mansion. As a designer Waterhouse's taste was catholic and his inventiveness fertile, even on occasions playful. Innumerable variations, for instance, in both pattern and colour are worked into the narrow borders of the windows. Some are produced by the simplest means in delicate tones of claret and grey. Such detail reveals not only care but a quiet creative exuberance that is a converse of the mechanical character noted previously.

As with any major creative work, the design of Manchester Town Hall invites responses at many levels of appreciation. It is impressively rational in its plan and structure and equally so in imaginative spatial character, but the ordered effects do not deprive it of a capacity to surprise. The great bulk of the Cooper Street tower, seen from the west end of Lloyd Street, is an example. It is set back from and appears at an acute angle to the facade, creating a sudden and highly dramatic impact as it rises pivotally above its pavilion. Did Waterhouse

foresee this? The sheer complexity of the geometry and foreshortening makes it unlikely, at least in precise form, but his drawings show that he appreciated the less dramatic view of the same tower seen in relation to the Princess Street elevation, **60**.[77] Foreseen precisely or not, the effect will not have been unwelcome to an architect who usually seems to have enjoyed such confidence in handling the weight of his architectural masses.

The architectural qualities of the Town Hall are memorable. Its union of plan, space and structure in a brilliant imaginative concept is so exceptional that it merits comparison both within and outside its age as a structure on Gothic principles.[78] It demonstrates that Waterhouse's range extended from firm control over powerfully expressive forms to the nuances of the most delicately modulated tones, yet it is not successful in every aspect. Ironically the points of weakness singled out by Donaldson and Street in 1868 continued to dog Waterhouse. The main entrance remains slightly underscaled and the device by which it is enlarged, the open superimposed screen, unfortunately detracts from the principal first-floor ante-room. The design here suffers from an expedient rather than a fundamental solution to a problem. The tower, also, though impressive, is disappointing from some angles, particularly where the flying buttresses, introduced in 1869, confuse the form. Such flaws, however, are incidental in so large a work.

Robert Kerr (1823–1904), one of the most astute of Victorian architectural critics, was probably correct in regarding the Town Hall as Waterhouse's *chef d'oeuvre*.[79] It is among what Waterhouse described as 'my three great works'.[80] One of these, Eaton Hall, near Chester, is largely demolished; the second, the Natural History Museum, is in many respects the logical sequel to the Town Hall. It is comparable in consistency of structure, use of materials, spatial qualities and decorative treatment, but the design problems it posed were less taxing and did not require an imaginative leap of such magnitude. Impressive though it is, and the design of its twin towers and spires is certainly more successful, it is a less complex architectural work.[81]

As a work of secular Gothic architecture the Town Hall merits comparison with two major contemporary buildings, G. G. Scott's St Pancras hotel (1866–76) and G. E. Street's Royal Courts of Justice (1866–82), but they require

[77] See the Princess Street elevation (1868).

[78] My late colleague Dr R. B. Wood-Jones, one of whose specialisms was Gothic architecture, saw similarities, both in the interior vaulting and the mechanical nature of the carved stone detail, between Waterhouse's work and German Gothic architecture. Among Waterhouse's contemporaries, the one most notable for the use of vaulting is J. L. Pearson (1817–97). His church of St Augustine, Kilburn, 1870–72, is admired for its vaulting and interior spatial effects. See A. Quiney, *John Loughborough Pearson*, 1979.

[79] James Fergusson, *History of the modern styles of architecture*, 3rd edn, 1891, revised by Robert Kerr, vol. 2, p. 165.

[80] Letter to Joseph Boult, 5 July 1872. Archives, MCL.

[81] For descriptions see Mark Girouard, *op. cit.*, n.8, and *Survey of London. The museums area of South Kensington and Westminster*, vol. 38, 1975, chapter 13.

further detailed critical analysis before strict comparisons can be drawn.[82] Regardless of such relationships, it remains incontrovertible that the Town Hall is an exceptional work, expressive not only of enlightened civic power but of an architect of powerful and original mind and large imagination who allied his great gifts with the diverse talents of other outstanding artists and designers to reward Manchester's patronage with a memorable and enduring civic symbol—a classic of its age.

[82] Both buildings are discussed by Sir John Summerson in his *Victorian architecture, four studies in evaluation*, 1970. See chapters 2 and 4.

Ford Madox Brown and the Manchester murals

'The only bit of fresco fit to look at is by Ford Brown, **72**. It is a figure of Justice and exquisite as far as that figure goes,'[1] pronounced the artist and proponent of British history painting Benjamin Robert Haydon after seeing Brown's *The Spirit of Justice*, **73** in the 1845 exhibition of the competition to find artists to decorate the new Houses of Parliament with murals. In one of the earlier exhibitions Brown had shown *The body of Harold brought before William the Conqueror*, **74**. Both were powerful designs, making much use of emphatic and angular line: they did not win a commission for the twenty-four-year-old artist, perhaps because they were not mellifluous enough for contemporary taste. Nevertheless, Haydon's enthusiasm was prophetic, for Brown was to gain his opportunity over thirty years later in the twelve historical murals he painted for Manchester Town Hall.

The Westminster competitions had been the result of royal initiative and State patronage. Prince Albert's Royal Commission to promote the fine arts saw that monumental wall paintings could make the new Houses of Parliament into a shrine of national history and tradition, **75, 76**. Thereafter, throughout the Victorian period, mural paintings in public buildings were thought to be highly desirable. This was linked with the Gothic Revival and admiration of the way in which the decoration of medieval buildings embodied their history and purpose. In 'The lamp of memory' Ruskin recommended that 'There should not be a single ornament put upon great civic buildings, without some intellectual intention'.[2] He was here writing of sculpture, but he also approved of murals, and encouraged Rossetti and his Pre-Raphaelite friends to paint the walls of the Oxford Union. G. F. Watts, who won a prize at Westminster and painted a fresco at Lincoln's Inn, was convinced of the educational value of murals over easel paintings and claimed, 'It would be highly important . . . to decorate the public buildings of England as much as possible. It is the only way of making the Fine Arts general.'[3] In this spirit the art educationalist Sir Henry Cole

[1] Tom Taylor (ed.), *The autobiography and memoirs of Benjamin Robert Haydon*, 1926, vol. 2, p. 790.
[2] *The seven lamps of architecture*, 1849, chapter 6, vii; *Works*, vol. 8, p. 230.
[3] M. S. Watts, *G. F. Watts*, 1912, vol. 3, p. 116.

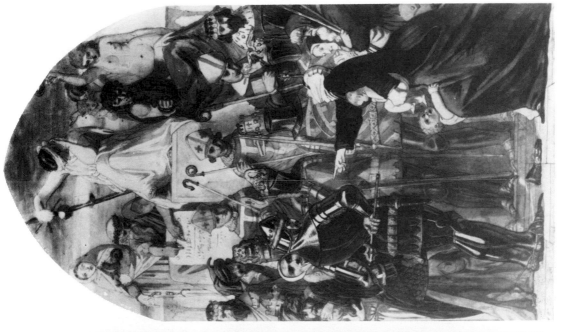

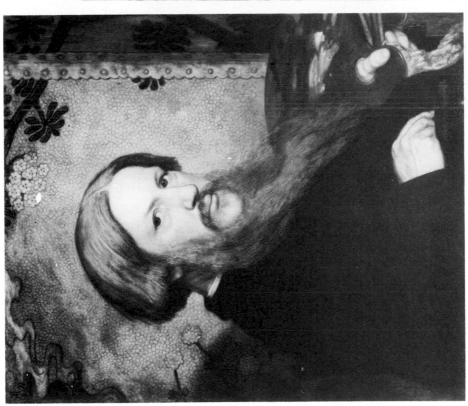

Ford Madox Brown:
72 *Self-portrait*, oil, 1877, *Fogg Art Museum, Harvard University*, and 73 *The spirit of Justice*, water-colour, 1845, *City of Manchester Art Galleries*

74 Ford Madox Brown: *The body of Harold brought before William the Conqueror*, 1844–61
City of Manchester Art Galleries

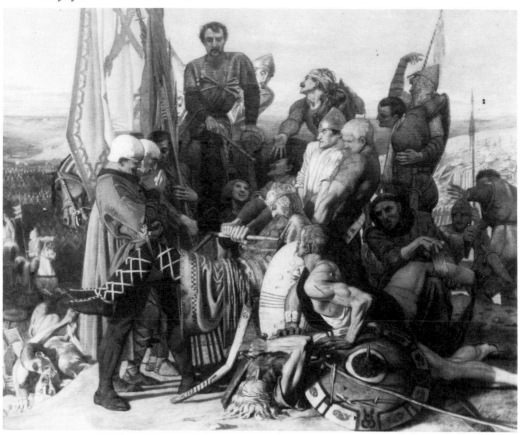

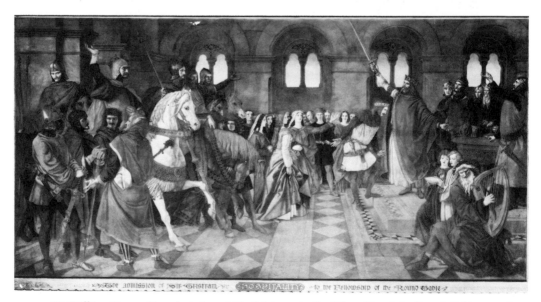

75 William Dyce: *The admission of Sir Tristram to the fellowship of the Round Table*, mural,
1848–64, Houses of Parliament, House of Lords, the Queen's robing room

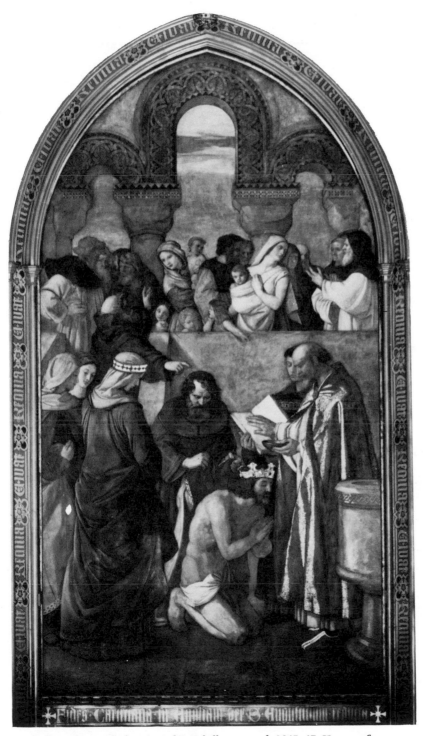

76 William Dyce: *The baptism of St Ethelbert*, mural, 1845–47, Houses of
Parliament, House of Lords

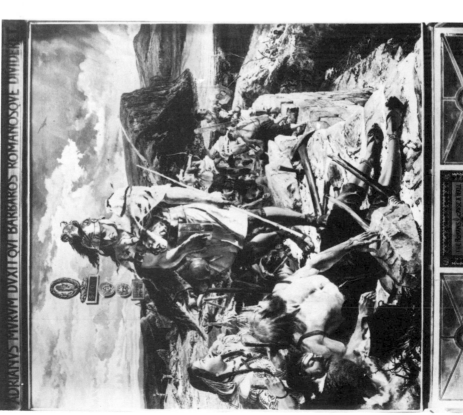

Willaim Bell Scott: **77** *The building of the Roman wall,* mural at Wallington Hall, Northumberland, 1856–61. **78** *Iron and coal – the industry of the Tyne,* mural at Wallington Hall, Northumberland, 1856–61

commissioned murals for the new buildings at the South Kensington museum.

Despite such influential advocacy, most contemporary English murals were failures. The wall spaces were generally filled with empty rhetoric and lifeless academic posturings; the paint cracked, darkened and faded away through damp, or incompetent application, or both. British artists lacked the training available in European academies to cope with composition on the grand scale and were ignorant of the demanding and specialised techniques needed. Even William Bell Scott (1811–90), who painted two successful mural schemes, wrote, 'my pictures . . . impress me with the conviction of which Sir Henry Cole was convinced, that any wall painting in this climate is a mistake'.[4] Nevertheless, Alfred Waterhouse, in his winning design for Manchester Town Hall, introduced spaces for murals, as did Thomas Worthington and at least two other competitors in theirs (see p.144).

One of Bell Scott's mural schemes forms the nearest precedent in Victorian art for the Manchester series of historical murals. Between 1856 and 1861 he painted eight scenes of Northumbrian history in the central court at Wallington Hall, Northumberland, for Pauline, Lady Trevelyan, the friend of Ruskin and the Pre-Raphaelites, **77, 78**. Though in a private house and not a public building, the Scott murals may have influenced Waterhouse, particularly as Scott lectured to the RIBA on his pictures in 1867, the year of the Town Hall competition. They certainly influenced Ford Madox Brown, an occasional visitor at Wallington, for he reused some of Scott's motifs.[5]

Already in his Manchester Assize Courts of 1859 Waterhouse had included decorations in sculpture and stained glass on the theme of law and punishment, and spaces meant for frescoes had been left in the main courtroom.[6] They were never filled. In the Town Hall he planned six panels along each side of the great hall, **67**, and a large panel at one end. Further spaces intended for mural paintings were left in all the chief state rooms and, as the Town Hall had a greater ceremonial function than the Courts it was given a far more lavish decorative programme. The centrepiece was to be the murals, but it included exterior sculpture of historical figures, a vaulted waiting hall, adopted at the design stage to house portrait sculpture of local worthies, and emblematic and heraldic devices throughout the principal public areas; there was also a profusion of decoration relating to trade and cotton (see also p.144).

It was Waterhouse's idea to commission mural paintings as the high point of the decorative scheme, and he made himself responsible for its implementation. Early in 1876, when the building work was approaching completion, he

[4] W. Minto (ed.), *Autobiographical notes of the life of William Bell Scott*, 1892, vol. 2, p. 116.

[5] W. B. Scott, 'Mural decorations at the mansion of Sir Walter Trevelyan . . .', *RIBA Transactions*, 1867–68, pp. 31–46; R. Ironside, 'Pre-Raphaelite paintings at Wallington', *Architectural Review*, vol. 92, 1942, p. 147; R. Trevelyan, *A Pre-Raphaelite circle*, 1978, pp. 123, 151.

[6] *RIBA Transactions*, 12 June 1863, pp. 31–40.

offered to prepare a scheme for the murals.[7] However, no firm arrangements had been made even when the Town Hall was open and in use, but he persistently promoted the idea, which was evidently something of a personal enthusiasm for which, he stated, he did not expect payment.[8] He energetically sought advice in many quarters, visiting artists and experts and making regular recommendations and reports to the Town Hall Sub-committee.

Waterhouse had an ally on the City Council in Councillor (later Alderman) Joseph Thompson (1833–1909), who was an Ancoats mill owner, a man of some learning, a bibliophile, educationalist and prominent Congregationalist. He had a long association with Waterhouse, who in 1862–63 had designed the Ancoats Congregational Chapel, where Thompson was a trustee. From 1869 Waterhouse was architect to Owens College, where Thompson was a member of the council.[9]

Thompson was elected a town councillor in 1865 and took a keen interest in the Town Hall competition, becoming a member of the New Town Hall Sub-committee and most of its sub-groups. He was a member of the small Decorations Sub-committee set up in January 1876 to deal with the murals and other matters.[10] He took a leading role in corresponding with artists and the architect, and from his extensive knowledge of local history and customs compiled a list of 250 suggestions for subjects.[11] Much later, in 1901, in annotating his correspondence, he wrote, 'My ambition was . . . to have a series of picture galleries in the rooms illustrative of the literature, legends and poetry of the district.'[12] How much of this was original and how much is owed to Waterhouse is uncertain.

The ambition was realised in only one of the rooms, and even this took far longer than had been expected. The artist did not start until 1879 and did not finish until 1893. Easel paintings would have been simple to commission and to execute: one had only to visit the Royal Academy to see examples of what could be done. But mural painting was a daring and uncertain venture in the light of its recent history in England. Thompson and Waterhouse had a general idea of what they wanted. Their threefold problem was: choosing the artists, the subjects, and the painting technique.

Waterhouse began by suggesting suitable artists to the committee, but the response was hesitant. The first artists to be approached had close connections either with Waterhouse himself or with Manchester. Henry Stacy Marks (1829–98), who was painting murals at Eaton Hall, Cheshire, where Waterhouse was also architect, agreed to help in January 1876 but withdrew when not

[7] GPS-c, vol 4, p. 403, (NTHS-c, 19 January 1876). For abbreviations see p. xii.

[8] GPS-c, vol. 5, pp. 44ff. (NTHS-c, 18 July 1877).

[9] *Manchester faces and places*, 1892, p. 26; obituaries in *Manchester City News*, 9 October 1909, and *Manchester Guardian*, 27 September 1909. See also chapter 6, note 10.

[10] GPS-c, vol. 4, p. 406 (NTHS-c, 19 January 1876).

[11] List in Brown family papers, private collection.

[12] 12 December 1901, on a letter to Waterhouse of 6 January 1875, Thompson letters.

definitely accepted.[13] In the following April the committee was told of four artists willing to share the work: E. J. Gregory (1850–1909), J. D. Watson (1832–92), Frederic J. Shields (1833–1911) and Ford Madox Brown (1821–93).[14] Gregory was a young London painter who had recently won a prize at the Royal Manchester Institution, Watson and Shields were Manchester artists and illustrators who were seeking to make their names in London, but Brown, more experienced than the others, had no real connection with Manchester.

How did Brown become involved? He was not a safe choice: his style was staunchly idiosyncratic and out of the mainstream, he worked slowly and painstakingly and made no concessions to popular or financial success. In the 1840s his clear, hard and bright Pre-Raphaelite style had been ahead of its time, and in the late 1850s he had acquired some following among northern industrialists. His epic *Work*, shown in 1865, had brought him further recognition, but he was never very prosperous or fashionable, and by the mid-1870s, lacking buyers, his fortunes were at a low ebb. Through the influence of Rossetti and his experience of designing stained glass for Morris Marshall Faulkner and Co., his style had become broader, more decorative and linear but this had brought out a tendency towards mannered positions and exaggerated expression which many found coarse and grotesque. Moreover the death of his beloved son Oliver in 1874, a great personal tragedy, had affected him deeply.

Brown was brought in by Frederic Shields, who had long been acquainted with Waterhouse in Manchester, and who was later to design mosaics and stained glass for him.[15] Shields was a follower of Brown's old friend and first pupil, Rossetti, and had been trying to help Brown obtain work in Manchester. Brown exhibited there from 1869, when, despite Shields's promotion, he failed to win the Heywood medal at the Royal Manchester Institution exhibition.[16] Nevertheless, he lectured at the Institution in 1874,[17] and his pictures were acquired by such Manchester collectors as Frederick Craven, Charles J. Pooley and Charles Rowley, a frame maker, educationalist and city councillor, who became a close friend.[18]

Unlike the other three artists recommended by Waterhouse in April 1876, Brown had some claim to knowledge of mural painting, but the samples of mural technique he had shown with his cartoons at Westminster did not amount to real experience. Waterhouse had second thoughts; he visited

[13] H. S. Marks, *Pen and pencil sketches*, 1894, vol. 1, p. 212; GPS-c, vol. 4, pp. 403, 454 (NTHS-c, 19 January, 19 April 1876).

[14] GPS-c, vol. 4, p. 454 (NTHS-c, 19 April 1876).

[15] A. Darbyshire, *An architect's experiences*, 1897, p. 32; E. Mills, *The life and letters of Frederic Shields*, 1912, pp. 208, 225.

[16] *Manchester Examiner and Times*, 21 December 1869; the painting was *Elijah and the widow's son*.

[17] 'The latest phase of painting in Europe' and 'Style in art', reported in *Manchester Evening News*, 13 December 1874.

[18] F. M. Hueffer, *Ford Madox Brown*, 1896, pp. 207, 302; Charles Rowley, *Fifty years of work without wages*, n.d. [1911]., pp. 93–110; letters from Shields to Charles J. Pooley, 1875–76, Archives, MCL.

Belgium 'to have another look at the Town Halls there and their decoration'.[19]
There he met the Belgian artists Godfried Guffens (1833–1901) and Jan Sweerts
(1820–79) and secured their agreement to work at Manchester.[20] Guffens and
Sweerts were partners who specialised in historical murals and had decorated
the Antwerp stock exchange, churches in Antwerp, and the town halls of Ypres
and Courtrai.[21] Since Waterhouse wrote of taking 'another look' at the Belgian
town halls, it is possible that all along he had been modelling his ideas on the
Belgian town hall murals. Now, worried at the inexperience of English painters,
he asked the Belgians to participate. 'Let us remember that the works of Guffens
and Swertz are there to look at, those of our English artists which may be going
to be—and I hope *will* be—far superior—have to be painted as yet, as these
wall pictures must have a very different treatment to easel pictures,' he wrote to
Thompson.[22]

Some of the committee visited Belgium to see for themselves, but Shields
and Rowley were outraged and campaigned against the Belgians. 'I am amazed
to hear that the idea of committing the decoration of your Town Hall to foreign
artists is still seriously entertained,' wrote Shields to Thompson as late as
October 1876.

> You did not cross the channel for a foreign architect:—You will answer—'No,
> because we were able to obtain the services of a man of proved capacity'. But his
> capacity had been proved beforehand, because he had been trusted with a great
> building when comparatively unknown, and as a consequence astonished
> England with the Assize Courts—
> But we English painters, your own children, are dogs, neither to be tried nor
> trusted . . .'[23]

'The more I talk to the painters, the more confused I become,' wrote
Waterhouse to Thompson in December as public and press debate continued.
'Those were palmy days when . . . we had only to get the money and then set
Guffens and Swerts to work!'[24] A new plan did not arise until June 1877, when
the committee heard that Brown and Shields were still willing to decorate the
Great Hall.[25] Each agreed to paint one side. A scheme was also proposed for the
other rooms, which were to be painted by W. F. Yeames (1835–1918), P. H.
Calderon (1833–1908), W. B. Richmond (1842–1921) and Walter Crane
(1845–1915). The first two were painters of popular academic costume pictures,
and the second two, who had tried their hand at murals, were painters and

[19] Waterhouse to Thompson, 14 May 1876, Thompson letters.
[20] GPS-c, vol. 4, p. 483 (NTHS-c, 21 June 1876).
[21] J. Helbig, 'G. E. Guffens', *Revue de l'Art Chrétien*, vol. 12, 1901, p. 455; H. Riegel, *Geschichte der Wandmalerei in Belgien seit 1856*, Berlin, 1882.
[22] 1 August 1876, Thompson letters.
[23] 11 October 1876, Au. collection, Archives, MCL.
[24] 15 December 1876, Thompson letters.
[25] GPS-c, vol. 5, p. 30 (NTHS-c, 20 June 1877).

decorative designers within the currently fashionable Aesthetic movement.[26]

But now another storm of protest was loosed, this time from the Manchester Academy of Fine Arts, whose members wanted to paint in the lesser rooms. They put their views before the August committee and in the press.[27] The committee, uncertain of its financial obligations and preoccupied with planning the ceremonial opening of the Town Hall in September, postponed its decision. Waterhouse considered the Academy's interference 'rude and uncalled for'[28] and Brown almost lost patience. 'It was one thing for us to work in company with some of the finest artists in the country, and another to form part of the group of nobodies such as there was talk of giving the rest to,' he wrote in December after a visit from Waterhouse. 'Waterhouse agreed to state to the committee that should they insist on giving the other rooms to these Manchester beginners it was likely I would refuse to co-operate.'[29]

At last the December committee agreed that Brown and Shields should proceed with the great hall, each painting one side of six panels.[30] Nothing was said about the other rooms, and these were never completed, despite a scheme of 1880 involving Watts, Poynter, Richmond, Legros and Burne-Jones.[31] Brown received the news from Rowley on Christmas Day 1877, and it was officially confirmed on 16 January after the full City Council had met.[32] Matters still dragged on, with discussions about the medium and the subjects; it was not until the summer that Brown started his first design and not until April 1879 that he began to paint on the wall.

Choosing the subjects was as protracted as choosing the artists. At the beginning, in January 1876, it was possible for Stacy Marks to suggest 'The games and pastimes of England', a theme without local relevance.[33] The idea of Manchester subjects was first mentioned in May 1876, when Waterhouse wrote to Thompson with a scheme of different themes for each room.[34] This was the first of such plans made by Waterhouse, Thompson and the various artists: suggestions included some connected with particular rooms, such as festive subjects for the banqueting hall, some themes of general interest from poetry or literature, 'not necessarily connected with Manchester, so as to take people's thoughts entirely away from Cotton and all its works', and many local subjects such as Manchester legends, history, great men, old halls, or representations of

[26] W. Crane, *An artist's reminiscences*, 1907, p. 201; A. M. W. Stirling, *The Richmond papers*, 1926, p. 257.

[27] *Manchester City News*, 21 July 1877; GPS-c, vol. 5, p. 81 (NTHS-c, 15 August 1877, received report of D&FS-c, 2 August 1877).

[28] 17 August 1877, Thompson letters.

[29] Mills, *op. cit.*, p. 222.

[30] GPS-c, vol. 5, p. 143 (NTHAS-c, 19 December 1877).

[31] Report of Sir Coutts Lindsay, 12 May 1880, Thompson papers; Hueffer, *op. cit.*, p. 344; *cf.* THC, vol. 1, p. 237 (D&FS-c, 2 June 1880; THC, 16 June 1880).

[32] Hueffer, *op. cit.*, pp. 322–3. CP 1877–78, p. 95.

[33] See n. 13.

[34] 22 May 1876, Thompson letters.

commerce, manufacture and cotton-growing.[35]

Eventually attention was concentrated on the great hall, and the various artists were asked to choose from the long list of subjects prepared by Thompson. The list appears to have included most, though not all, of those finally painted, but some indication of its scope is given by Waterhouse's statement that the Belgian artists chose twelve which embraced 'the entire history of Manchester, real and legendary'.[36] Many of Thompson's subjects were of fanciful origin and picturesque appeal, such as 'An annual fair granted by Henry III', 'The pageant of Robin Hood removed from the churchyard' and 'Manchester's warriors sent against the Spanish Armada'.[37]

In June 1877 Brown and Shields chose 'the most comprehensive epitome of the rise and progress of Manchester that can be compressed into 12 pictures'.[38] But it was not until August 1878 that the following list was agreed with the committee.[39]

1 A.D. 79. Building of a Roman fort by Agricola. (Representative of the Roman Dominion in Britain and the foundation of Mancunium.)

2 A.D. 620. The Baptism of Eadwine. (The Saxon period and its great event, the establishment of Christianity in England.)

3 A.D. 870. The Danes seize Manchester after an obstinate resistance from the Anglo-Saxon inhabitants. (Danish invasion.)

4 A.D. 1330. Edward III establishes Flemish Weavers in Manchester. (Origin of the commercial industries of Manchester under the Norman sway now identified with English interests.)

5 A.D. 1337. John of Gaunt supports Wyckliffe before the consistory court at St Paul's Cathedral. The populace defend Wyckliffe. (Lancashire as represented by its great Duke in connection with the earliest movement of the Reformation in Europe.)

6 A.D. 1566. The Court Leet try and stamp all Weights and Measures. (Subject illustrative of commercial integrity.)

7 A.D. 1639. Humphrey Cheetham, a Manchester merchant, founds a school for 40 healthy boys. (Humphrey Cheetham is selected in preference to Bishop Oldham to exemplify the subject of education because the first named is a layman.)

8 A.D. 1639. William Crabtree discovers the Sun's parallax by observation of the transit of Venus on Kersall Moor.

9 A.D. 1642. Lord Strange beaten back by Bradshaw at the fight on Salford Old Bridge. (First blood drawn in the Civil War.)

10 A.D. 1745. Prince Charles Edward reviews the Manchester Regiment in the Collegiate Churchyard. (Jacobite rising in the Georgian period.)

[35] Mills, *op. cit.*, p. 198; Thompson letters, 1 August 1876; GPS-c, vol. 5, pp. 30–2 (NTHS-c, 18 June 1877).

[36] Waterhouse to Brown, 12 June 1877, THC, vol. 1, pp. 421–2 (15 June 1883).

[37] List in Brown family papers.

[38] Brown to Waterhouse, 15 June 1877, THC, vol. 1, pp. 423–4 (15 June 1881).

[39] Thomas Wrigley (Committee Clerk) to Brown, 22 August 1878, THC, vol. 1, pp. 427–8 (15 June 1881).

11 A.D. 1753. John Kay, inventor of the fly shuttle, saved by being carried off in
a wool sheet as the mob are breaking into his house at Bury. (Machinery in
great part the cause of Manchester's prosperity.)

12 [Left blank.]

Most of the subjects on the list were eventually painted, but certain changes were made, in part the result of public discussion. The debate stimulated by the list is important because it highlights the intention behind the entire scheme. The list itself makes it clear that subjects were selected to represent ideas corresponding to the values of mid-Victorian and Mancunian civic and commercial pride: Christianity, Nonconformity, commercial integrity, education, science, the textile industry and mechanical invention. These ideas are more prominent than the uneven attempt to portray each of the main periods of history. The sequence starts in textbook manner with the Romans, the Saxons and the Danes, but after that there are several subjects very close in date, two from the mid-fourteenth century and three from the mid-seventeenth. Criticism of the choice of subjects from a historical point of view gave Brown the opportunity to reply with an important statement of his artistic aims.

The debate began in September 1878 when a lengthy letter of criticism was addressed to the committee by William E. A. Axon (1846–1913), a distinguished local antiquarian, author and former city librarian.[40] Firstly he corrected factual errors, pointing out, for instance, that though Agricola's army had been at Manchester the presence of the Roman general himself was purely conjectural. More important were questions of historical interpretation, for example subjects which gave artificial importance to the scenes shown. 'Without denying the influence of Flemings, we may say that Textile Manufacturing was known in Manchester 100 years previously to 1330,' he wrote, adding in similar vein, 'I object to the assumption that Manchester['s] commercial integrity was invented in 1566 by the Municipal testing of Weights and Measures.' Thirdly, and most seriously, some subjects had 'a vague and forced connection with Manchester': Edwin was baptised at York, Wycliffe was tried in London, the John Kay incident was at Bury.

Despite the justice of some of Axon's views, Brown resented the interference and considered their viewpoints opposed. He saw Axon as a captious antiquarian, and himself as an artist. Axon, he felt, had fallen 'too much into the error, so common in this century, of expecting Art to be *documentary*, instead of as it should be *typical*—and calculated to arouse our sympathies for certain great ideas and beautiful phases of nature'.[41]

To Brown the importance of 'typical' art lay not in the accuracy of detail but in its timeless imaginative significance. In a lecture of 1879 he claimed, 'the

[40] Axon to Abel Heywood, 23 September 1878, Thompson papers, item 9.
[41] Brown to Waterhouse, 1 October 1878, Au. collection, archives, MCL.

fact that historic doubts were sometimes cast on the incidents represented did not invalidate the idea, for it was not the province of art to supply documents'.[42] So pictorial equivalents had to be found for the 'great ideas' such as Christianity, commercial integrity or education. Even if Edwin was baptised at York, Brown argued, his inclusion was justified because 'we cannot do without Christianity in such a series',[43] and he regarded the historical argument that Manchester was part of Edwin's kingdom as subsidiary.

Similarly, to 'arouse our sympathies' effective communication was more important than historical considerations. When selecting subjects Brown had borne in mind that 'the work must be for the instruction of the people'[44] and in dismissing some of Axon's own suggestions he wrote, 'Subjects for Art have to be *"self explanatory"*.'[45] Thus he at first dismissed the idea of John Dalton inventing atomic theory, saying that 'it could never be anything pictorially but one man thinking, unless one might represent him shaking up his atoms like grated Parmesan in a bottle'[46]. On the other hand, 'The costumes of the Duke, the Bishop, the Knights, the poor parish priest Wyckliffe who went barefoot, would be eminently picturesque and instructive to the people of Manchester'[47], **83**.

The word 'picturesque' introduces Brown's third idea, the 'beautiful phases of nature'. Certain subjects were full of possibilities, others were judged not to make an attractive picture and were scornfully dismissed. 'One subject they would have wished me to paint at Manchester was the opening of the Town Hall itself, with the portraits of eighty members of the council, and with a procession of 40,000 people,' said Brown later.[48] The series is full of passages of great beauty, such as the sunlight and shade in the *Flemish weavers*, **82**, the charming group of Mrs Crabtree and her children, **85**, and the pageantry of the Bridgewater Canal scene, **89**. All these impress through pictorial rather than historical effects.

In August 1878 the last subject had still not been agreed. The artists wanted *The Peterloo massacre*, to represent the nineteenth century and reform, but it was left off the list, as they all knew it would be controversial. Despite the fact that it had happened in 1819, the issue was still politically live almost sixty years later and it caused a heated debate in Council. Thompson, Axon and the artists all suggested alternatives: the spirit of resignation during the Cotton Famine, the election of Manchester's first MP, packhorses on the Bridgewater Canal, the opening of the Liverpool and Manchester Railway, the reception of

[42] *Manchester Courier*, 23 May 1879.
[43] See n. 41.
[44] Brown to Waterhouse, 7 August 1876, Au. collection, Archives, MCL.
[45] Brown to Thompson, October 1878, Au collection, Archives, MCL.
[46] Brown, letter in *Manchester Guardian*, 11 February 1882.
[47] See n. 45.
[48] F. M. Brown, 'Mural painting and coloured decoration: the Gambier Parry process', *RIBA Sessional Papers*, vol. 21, 1880–81, p. 276.

Walker and Richardson on their triumphant return from London after the repeal of the fustian tax, or a modern scientist such as Joule or Dalton.[49]

Late in 1878 the committee suggested *The opening of the Bridgewater Canal*.[50] Brown had misgivings, as he felt it lacked human interest, a surprising reaction in view of what he finally made of the subject. He accepted it after Thompson had jokingly argued that 'a quarter share in the same canal had recently fetched £8,000 in the market at Liverpool. This was unanswerable!'[51] A final change of programme came in 1886, when the Prince Charles Edward subject was dropped and *John Dalton discovering atomic theory* substituted, **90**. Despite his first doubts about Dalton, Brown requested the change on the grounds that the Jacobite subject had 'no claim to be connected with the aggrandizement of Manchester morally or physically. Dalton on the contrary represents its highest intellectual development.'[52] Thus the series closed with the *Bridgewater Canal*, **89** and *John Dalton*, **90**. Ironically, both originated in suggestions made by Axon.

Even though there was now a subject to represent the nineteenth century, it is a pity that the painter of *Work*, the epic painting of mid-Victorian urban life and labour, was not given an opportunity truly to represent Manchester's recent industrial or commercial life. Bell Scott had concluded his series with *Iron and coal*, a wholly modern view of engineering workers seen against a background which included merchants, shipping, a photographer, the railway, the telegraph, the Davy lamp and the Armstrong shell, **78**. Brown had to be content with historical scenes of textile manufacture, trade and machinery before the nineteenth century.

The choice of a medium for painting on the walls was also a difficult problem. Waterhouse had already made provision for the murals in the design of the building. To avoid coloured light falling on the panels, a defect complained of by the Westminster mural painters, he had largely excluded stained glass in the Great Hall, and to avoid any dampness he ran the ducts for the warm-air heating system vertically within the walls behind the murals. In the autumn of 1876 he consulted as many artists as he could find who knew anything about mural painting in order to consider all available methods.[53]

True fresco, painted on wet plaster, was regarded as out of the question: it was ruined by damp and smoky air, was difficult to manipulate, and English attempts had failed. Waterglass, a watercolour process fixed to the wall with silica, was in widespread use in Europe. It was the method of Guffens and

[49] *Art-Journal*, vol. 40, 1878, p. 205; Brown to Thompson, 2 March 1878 (Au. collection); Shields to Thompson, 7 March 1878, (Au. collection); Thompson to Chairman, 8 October 1878, (Thompson papers.); all in Archives, MCL; Brown to Wrigley, 25 August 1878, THC, vol. 1, p. 429 (15 June 1881).

[50] THC, vol. 1. p. 430 (D&FS-c, 17 December 1878. See also 22 April 1879).

[51] Mills, *op. cit.*, p. 239.

[52] Brown to Abel Heywood, 18 May 1886, THC, vol. 3, p. 88 (23 June 1886).

[53] Willey (Waterhouse's secretary) to Thompson, 11 October 1876, Waterhouse to Thompson, 27 November 1876, both in Thompson letters.

Sweerts, and of Maclise's later work at Westminster, but Waterhouse found English artists suspicious of it.[54] The wax encaustic method, which Brown had used for the sample accompanying the cartoon he showed at Westminster in 1845, was suggested by Richmond, but at this time Brown 'proposed the use of oil colour as much more permanent in our country in such an atmosphere as Manchester'.[55] Oil, however, was unacceptable. Its glossy surface caused reflections unless viewed from the front, whilst murals had to be seen from all angles. In any case, oil would have to be painted on canvas and then set into the wall. For a man of true Gothic principle this would have been cheating: Waterhouse was intent on truly architectural decoration as an integral part of the building – 'mural pictures, i.e., painted on the walls and not on canvas', as he explained in his lecture to the RIBA in 1877.[56]

When Brown and Shields were finally given the commission, waterglass was suggested, subject to the artists visiting Antwerp to see Baron Leys's work in the medium. On his return from Antwerp Brown was unconvinced, but in the summer of 1878 he visited Highnam Church, Gloucester, to see the method invented by Thomas Gambier Parry, the church decorator and collector of Italian primitives.[57] It was this method which was finally chosen. The colours were mixed with a medium of copal varnish, wax and gum elemi, and when applied to the correctly prepared wall surface the painting became incorporated into the substance of the wall, like fresco applied to wet plaster. It was more resistant to damp than fresco, it could be retouched exactly like oil, and combined 'the richness and resources of oil with the absence of shine, which is so valuable in fresco'.[58]

Gambier Parry had invented it for ornamental decorations, but Leighton had used it in 1863 at Lyndhurst Church, Hampshire, for a mural of *The wise and foolish virgins*. 'The effect is excellent—nearly as fine as real fresco,' he wrote. 'I find it (for mere manipulation *bien entendu*) absurdly easy.'[59] But the committee at Manchester was undecided, and considered mosaic, and oil on copper before approving the Gambier Parry method in March 1879.[60]

At last, in April 1879, Brown started work. With the Gambier Parry method the painting had to be done *in situ*, but preparatory work could be done in the studio in London. The agreed fee for each mural was £275, half to be paid after the cartoon had been approved by Waterhouse and half on completion of the mural. All cartoons, working drawings, studies and replicas remained the

[54] A. Waterhouse, 'Description of the new Town Hall at Manchester', *RIBA Transactions*, 1876–77, p. 135.

[55] Shields to Thompson, 21 October 1876, Au. collection, Archives, MCL.

[56] See n. 54.

[57] Brown to Thompson, 14 July 1878, Au. collection, Archives, MCL.

[58] Report from Waterhouse, 18 February 1879, THC, vol. 1, pp. 50–2 (19 February 1879). Copy in Thompson papers, see also n. 48.

[59] Mrs R. Barrington, *The life, letters and work of Frederic Leighton*, vol. 2, 1906, p. 108.

[60] THC, vol. 1, pp. 63–4 (D&FS-c, 4 March 1879; THC, 19 March 1879).

property of the artist. The Corporation was to pay for colours and materials.[61]

The artist began not with the first subject, the *Romans*, but with the second, *The baptism of Edwin*, **80**. After finishing the full-scale cartoon he came up to Manchester to start work on the wall. The great hall was in constant use for meetings, and to enable him to work in privacy a canvas booth with a movable wooden platform was erected around the panel on which he was working.

> I find it very comfortable; the only thing about my box (for it's like a box at the opera) being that it is far too comfortable, and, I fear, not to be abandoned often eough to see the effect of one's work at a distance. At night, when I'm all alone, with an excellent gas stand, it is perfectly delightful, and by daylight I feel charmingly free from household worries.[62]

One night, life was less delightful. Brown slipped down between the front of the platform and the wall, and the caretaker, thinking he had left, turned out the lights, leaving him to feel his way to his room down long corridors and staircases.[63] Later, when painting the *Danes*, **81**, he had a live pig in his booth as a model for the animal shown escaping in the tumult. During an organ recital the pig disturbed the music by squealing loudly, causing what Rossetti called 'a pigmentary predicament'.[64]

Brown originally intended to work on the designs in London and then to come up to Manchester for short periods to paint on the wall. But the painting took longer than he had supposed. The Gambier Parry process was troublesome. He wrote to Shields, 'I find it keeps on drying and getting paler for three or four weeks, which makes it difficult to know what one's work will look like.' Working in the hall was a problem. 'There are difficulties, such as shadows cast at certain hours by the projecting piers on either side, and sunshine at certain hours . . . the result is that time is wasted and the difficulty of obtaining the desired effect increased. . . . I consider I am much behind.'[65] When using models he used a screen of oiled paper to diffuse the light, in order to obtain an evenly lit outdoor effect of 'light all round'.[66] His painstaking approach meant that he sometimes sat persistently for two or even three stretches of five hours each in one day.[67]

Preparatory research also took up much time. He visited libraries and copied details of architecture and costume from engraved sources. Rowley and Thompson helped him with books and problems such as the colour of stone

[61] Brown to Waterhouse, 15 June 1877, THC, vol, 1, pp. 423–4 (15 June 1881). 20 July 1881 (Report of Deputy Town Clerk).

[62] Hueffer, *op. cit.*, p. 334.

[63] *Ibid.*, p. 347.

[64] *Ibid.*, pp. 346–7.

[65] *Ibid.*, pp. 336–7.

[66] *Ibid.*, p. 340.

[67] *Ibid.*, p. 339; Rowley, p. 107.

used by the Romans, or the appearance of old St Paul's, where Wycliffe was tried.[68] 'To hear him vivify our "Court Leet records" which he had been reading up for one of his works [*Weights and measures*] was a dramatic experience which you could get on no stage,' wrote Rowley.[69]

In November 1880 he addressed a report to the committee, asking for more money for the murals.

> It is quite impossible for me to carry them out in the time I had originally reckoned on. . . . This result I attribute partly to the nature of the subjects selected, which being historic require so much research and care in composing them and partly to the elongated shapes and positions (so near to the eye of the spectator) of the panels themselves requiring them to be filled up from bottom to top with figures executed with all the finish of easel works.[70]

By the time the third panel was done he would have received only £825 for twenty-seven months' work.

His request was refused. In January 1881 he wrote to Rowley from his London house in Fitzroy Square, expressing his intention to 'make a new start in life'. 'Things look so gloomy that I have come to the determination to get rid of this expensive house and take a small one at Marple or Hayfield, and there, if possible, live within my means.'[71]

A new start was made. At the age of sixty, Brown and his family moved to Manchester, first to lodgings, then to Rowley's cottage at Chapel en le Frith.[72] In August his London house was sold. 'In most frightful confusion and muddle; we have got a little house in Manchester,' he wrote to Shields, and the next day Shields recorded in his diary, 'To see Brown at Fitzroy Square; all dismantled—a sad sight.'[73] The Browns settled in Higher Crumpsall at 33 Cleveland Road, and in August 1883 moved to 3 Addison Terrace, Daisy Bank, Victoria Park; both were respectable residential suburbs.

Meanwhile Shields was showing no signs of beginning his part of the scheme. Brown reminded him of his obligations in July 1879, when finishing *Edwin*, but Shields still did nothing, and by April 1880 he was considering withdrawing on grounds of nervous ill health.[74] This he did in May 1881, claiming that 'the varied distractions and noises of the Great Hall . . . would be so constantly provocative of intense suffering to my nervous system that I should break down'.[75] Shields did suffer in this way, but the motives for his withdrawal are not clear. It is possible that he stood down to help his friend,

[68] Hueffer, *op. cit.*, p. 337; Brown to Thompson, 10 April 1884, Au. collection, Archives, MCL.
[69] Odds & ends by As & Bs (MSS of St Paul's Literary and Educational Society), vol. 41, p. 135, Archives Dept, MCL.
[70] 2 November 1880, THC, vol. 1, pp. 304, 325 (17 November 1880).
[71] Hueffer, *op. cit.*, p. 341.
[72] *Ibid.*, p. 342.
[73] Mills, *op. cit.*, p. 266.
[74] *Ibid.*, pp. 244, 252.
[75] Shields to Sir J. Heron, 10 May 1881, THC, vol. 1, pp. 434–5 (15 June 1881).

whose financial state was not good.[76] It is also possible that he felt himself outclassed. Even so, it was not until January 1884 that, following Waterhouse's intercession, the committee formally asked Brown to paint the last six panels. At the same time it was agreed that he should receive £375 for each of the last six pictures, £100 more for each than before.[77] Brown accepted only on condition that he receive the increased sum retrospectively for the completed panels. The committee had to agree. Brown still considered himself underpaid, but acquiesced, resigning himself to 'only five years more exile in this place'.[78]

A final and momentous change of plan occurred in August 1885. The Gambier Parry method was abandoned.[79] Despite his initial enthusiasm, Brown found working on the wall strained his health. The first mural took four months, but the fifth, *Crabtree*, **85**, begun in May 1882, was not finished until September 1883, Brown having been interrupted by a serious attack of gout. In February 1885 he wrote to Shields, 'When I begin Wycliffe I mean to do it in oil for a change, so as to avoid the difficulties of working from models on the walls and have the luxury of working in my nice studio.'[80] But Wycliffe, the seventh to be painted, was still in Gambier Parry, begun on the wall in June 1885 but left incomplete at the end of August before the cold weather set in, **83**. Then the committee approved the change in medium and, abandoning architectural purism, Brown painted *Chetham* in the warmth of the studio, using oil on canvas. *Wycliffe* was resumed in the spring, but the last five murals were all painted in oil on canvas, which was then glued to the wall by the French process of *marouflage*.

Brown never seems to have fully enjoyed Manchester life. 'This place certainly does *not* improve by length of acquaintance,'[81] he wrote in 1881, and two years later he resolved to 'get some place in London to come to, for otherwise it would be unendurable'.[82] He took little part in Manchester society, though he lectured at Rowley's Ancoats Brotherhood and accepted honorary membership of the Manchester Academy of Fine Arts and of the artistic Brasenose Club. For the Royal Jubilee Exhibition of 1887 he decorated the spandrels of the domed hall with eight figures, representing Coal, Corn, Wool, Spinning, Weaving, Shipping, Iron and Commerce, each with an angelic companion. The figure of *Weaving* is similar to the man at the loom in the *Flemish weavers*, **82**.[83] Through Thompson and Rowley he formed a small circle of friends, including the Lancashire dialect writers Edwin Waugh and Ben Brierley; the Town Hall organist, Dr Kendrick Pyne; Alexander Ireland, editor

[76] Hueffer, *op. cit.*, p. 363; Mills, *op. cit.*, p. 252.
[77] THC, vol. 2, pp. 154–5 (2 January 1884).
[78] Hueffer, *op. cit.*, p. 365.
[79] THC, vol. 3, p. 27 (D&FS-c, 29 July 1885; 19 August 1885).
[80] Hueffer, *op. cit.*, p. 368.
[81] *Ibid.*, p. 350.
[82] *Ibid.*, p. 365.
[83] Canvases at Manchester City Art Gallery; drawings at Whitworth Art Gallery.

of the *Manchester Examiner and Times*; C. P. Scott, editor of the *Manchester Guardian*; and Henry Boddington junior, the brewer. Many of them modelled for figures in the murals, as did members of his family and visiting friends.

But once he began to work on canvas there was no real reason for him to stay. In the autumn of 1887 he returned to London, to 1 St Edmund's Terrace, Regent's Park.[84] Despite illness and bereavement, these years were happier than those at Manchester. He was surrounded by his friends and family. His daughter Lucy (Mrs William Michael Rossetti) lived close by, and Shields not far away in St John's Wood. It was at St Edmund's Terrace that the last three scenes were painted before being sent up to Manchester.

However, the shadows were lengthening. Serious attacks of gout held up the painting of *John Kay*. His son-in-law, Dr Franz Hueffer (married to his daughter Cathy), died in January 1889, and Brown's beloved wife Emma died in October 1890 after a long illness. His own health was not improved by further bitterness with Manchester Corporation, for when the *Bridgewater Canal*, **89**, was sent up in 1892 the committee declared they were not satisfied and requested him to submit a preliminary drawing of the next and final panel.[85] This affront caused some public controversy, and following a 'disagreeable little discussion'[86] in full council there was much criticism of this philistine interference with the veteran artist.

A later note by Thompson, not dated, refers to Brown putting off painting the *Canal* subject till last, by which time he had had a stroke and lost the use of his right side,[87] but the last panel to be painted was *Bradshaw's defence of Manchester*, **87**. It was done partly with the right hand, after the stroke, and shows much more obvious signs of weak execution than the canal picture. When *Bradshaw* was ready there was further wrangling, as Brown refused to have it inspected, had it sent back to London and threatened to sell it. When at last he relinquished it he was at pains to be paid 'before there has been time for a fresh meeting of the council and fresh insults to be heaped on my head'.[88]

The sad history of Brown's most ambitious undertaking was played out to the end. A group of admirers got up a scheme to buy a replica of *Wycliffe* for presentation to the National Gallery.[89] Characteristically Brown repudiated the

[84] Hueffer, *op. cit.*, p. 383.

[85] *Ibid.*, p. 394; F. M. Hueffer, *Ancient lights and certain new reflections*, 1911, p. 117.

[86] *Manchester Guardian*, 5, 6 May 1982.

[87] Hueffer, *op. cit.*, p. 396–7; id., *Ancient lights*, p. 203; note by Thompson on letter, Waterhouse to Chairman, 18 February 1878, Thompson papers.

[88] Brown to Thompson, 29 July 1893, and undated letter, Au. collection, Archives, MCL. Thompson considered that F. M. Hueffer's biography of Brown misrepresented the committee. On the back of a copy of one of Waterhouse's reports on the murals (see n. 87) he wrote, 'It is only due to the Committee to say they had *no knowledge whatever* of Mr. Brown's illness, nor of his having painted the picture with his left hand; if they had been aware of his serious illness and his great dislike of the subject they would have changed it . . . It was a very painful conclusion to a happy connection with the artist.' (Thompson papers, item 12.)

[89] Now in Birmingham City Art Gallery.

idea at first but was persuaded to accept it as the honour intended. Ironically the replica was never finished, for he died on 6 October 1893.

The history of the scheme lends weight to Brown's despairing comment, 'What chance remains of a Common Council deciding reasonably on matters of art?'[90] But once completed the murals were recognised as a success. Lord Leighton, President of the Royal Academy, visited them and pronounced his admiration, though their forceful and idiosyncratic manner was very different from his own suave and controlled style.[91] At the opposite end of the art world, W. R. Lethaby, exponent of the Arts and Crafts movement, also ranked them high in his nineteenth-century pantheon, declaring, 'It cannot be genius that is lacking to us. An age that can produce Watts' Physical Energy, Madox Brown's Manchester paintings, and the Forth Bridge, should be able to produce anything. . . .'[92]

Lethaby was not too wide of the mark: if not works of absolute genius, their spirited animation and gusto put them in a class far beyond most Victorian history painting. Brown's story-telling is perhaps not as clear as it should be, and relies excessively on long verbal explanations. His figures sometimes grimace and posture, his humour is sometimes forced, and there are passages of weak drawing and execution. But his designs are always agreeably fresh, full of unexpected beauty and expressive character, combining narrative ingenuity with something rare in Victorian academic history painting, a strong sense of design. *'When did you last see your father?'* and *The boyhood of Raleigh* became better known, but they are dull and unadventurous in dramatic conception, form and colour.[93] Brown's story is less obvious at first glance, but it is told with wit and inventiveness, without a hint of sentimentality, and with a sensitive mind and eye.

His originality in combining narrative with formal sophistication was recognised abroad. Between 1884 and 1893 a Brussels group of *avant-garde* artists, including Ensor, Tooroop and Van de Velde, organised a series of exhibitions of modern Belgian art. Among the non-Belgian artists invited to show were Cezanne, Gauguin, Monet, Redon, Rodin, Whistler, van Gogh and Ford Madox Brown, who sent *Cordelia's portion* (City of Manchester Art Galleries), a work similar in character to the murals. The only other British artists so honoured were younger men like Crane, Sickert and Steer, working in more advanced styles without the interest in historical narrative which marked Brown out as one of an older generation. Les Vingt recognised that behind his narrative and didactic intent lay a refined appreciation of aesthetic values.[94]

[90] Mills, *op. cit.*, p. 223.

[91] Rowley, *op. cit.*, p. 93.

[92] W. R. Lethaby, *Architecture*, 1911, p. 251.

[93] W. F. Yeames, *'When did you last see your father?'*, Walker Art Gallery, Liverpool; Millais, *The boyhood of Raleigh*, Tate Gallery, London.

[94] Bruce Laughton, 'The British and American contribution to less XX', *Apollo*, November 1967, p. 375–9.

In the design of the murals Brown experimented with various formal motifs. The later ones are particularly bold in their use of extreme foreshortening, especially remarkable considering his age. Some compositions are dominated by animated groupings of figures and the sweeping lines of draperies, others by clearly organised architectural elements. Busy passages are balanced against plainer areas; spatial effects are carefully controlled, with the large figures often contained in a shallow foreground space and contrasted with tiny figures in the background; distant views stretching into the pictures and foreshortened figures reaching out of them are balanced against linear patterns which emphasise the picture surface. Brown claimed that 'The very essence of the wall picture is its solidity, or at least its not appearing to be a hole in the wall.'[95] He understood that he was contributing to a total architectural scheme. He wrote of his ambition to paint the end walls of the room because 'the idea of pictures round a room would then be done away with, and the mural decoration of the Hall perfected'.[96]

The happy coexistence of the murals with the architecture is not evident in reproduction, which tends to exaggerate the theatricality of Brown's compositions. Yet, just as the historical ideas expressed in them must be judged not by modern standards but from the Victorian point of view, emphasising Victorian values, so the murals must be seen in their Victorian architectural setting, 67. When viewed in the Town Hall they spring to life, especially when illuminated by the many points of light glittering from Waterhouse's Gothic chandeliers. Then the colourful but warm tonality of the paintings glows from the walls and is set off perfectly by the stone colour of the clustered shafts separating each panel, and by the sumptuous roof with its gilded coats of arms. *In situ* it is evident that the murals relate in scale, colour and design to the hall, neither dominating nor being dominated by it. They provide just that amount of richness and movement necessary to make the architecture complete.

It is this which gives the murals their wider significance: they may not rank with the greatest works of history painting, but they do mark an important step in the history of the collaborative ideal of architecture and the arts. They were initially a product of the Gothic Revival, with its idea of unifying architecture, painting, sculpture and the decorative arts in one design. By the time they were finished this idea had been adopted by the Arts and Crafts movement, then at its height. The Manchester murals set an example for other public commissions, such as the tempera murals at Birmingham Town Hall, painted by artists from the school of art there, and the murals by Frank Brangwyn, Gerald Moira and other Edwardian artist-decorators. Collectively and in their context the Manchester murals rank as an outstandingly successful example of a Victorian ideal, the enrichment of architecture through painting.

[95] Ford Madox Brown, 'Of mural painting', in *Arts and Crafts essays*, Arts and Crafts Exhibition Society, 1893, pp. 157–8.
[96] See n. 48.

Acknowledgements. I should like to acknowledge the generosity of Mary Bennett, of the Walker Art Gallery, Liverpool, who kindly let me examine her material on the murals. I would also like to thank the Committee Clerks' Section, Town Clerk's Department, Manchester Town Hall, and Jean Ayton, Elizabeth Leach and Jeanette Canavan of the Manchester Central Library. John Archer and Elizabeth Conran have also given advice and encouragement.

THE MURALS (*Following pages*)

The descriptions of the incidents and details are based on Ford Madox Brown's lengthy commentaries given in *Particulars relating to the Manchester Town Hall and description of the mural paintings in the Great Hall* (Manchester, n.d.) Unattributed with minor alterations, in a pamphlet, *Ford Madox Brown. Mural paintings in the Great Hall, Manchester Town Hall*, illustrating the murals in colour, obtainable from the Information Office at the Town Hall.

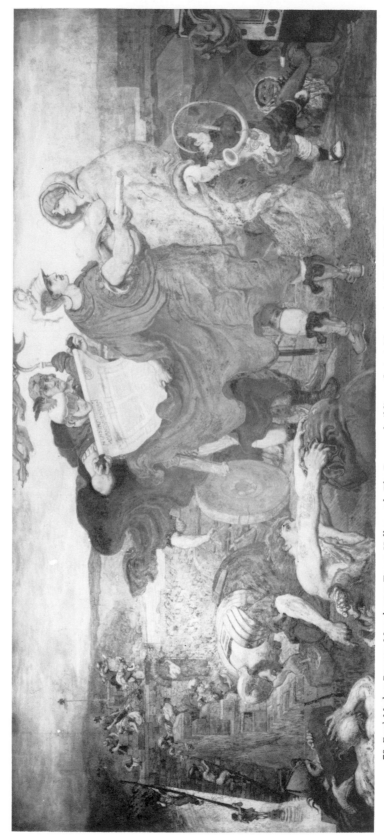

79 Ford Madox Brown: Manchester Town Hall mural. *The Romans building a fort at Mancenion A.D. 60,* 1879–80

The Romans building a fort at Mancenion, A.D. 60 **79**

A Roman general's wife is visiting the fort and being shown a map of the camp. The windswept red cloaks indicate the chilliness of the northern climate, 'making the work in hand more arduous to men of southern nationality'. The Romans are laying the stones, whilst the Britons are lifting and carrying. Further contrast between conquerors and slaves is shown by hints of the luxurious life of the Romans: the Nubian slaves bearing the lady's litter, the lady's son kicking them, her fur cloak, and her hair dyed yellow whilst her eyebrows remain black.

With Pre-Raphaelite literalness, Brown carried a bugle up to the top of the Town Hall tower in order to see it clear of reflections; a similarly precise naturalism is seen in the exact depiction of a November day, with grey skies, autumnal colours and the misty Peak hills across the Medlock. The gold helmets and dragon standard provide opportunities for interesting detail, and the sweeping curved lines of the cloaks, which form the dominant motif of the picture, make a decorative pattern which emphasises the flat surface of the mural in contrast with the spatial depths of the steeply foreshortened wall and camp.

The busy group of builders on the left, cut by the lower edge of the picture, occupies a lower level, and helps to lead the eye into the scene, up to the main figures. These stand the full height of the panel, and are raised up on a kind of stage overlooking the extensive landscape. The contrast between emphatically drawn tall foreground figures and tiny distant ones is a device used by Brown in his earliest mural design, *The body of Harold brought before William the Conqueror*, **74**. But another source for the composition is William Bell Scott's *The Roman wall*, **77**. Here a standard and a centurion wearing a windswept cloak are silhouetted against the sky and seen against a bird's eye view of figures building the wall stretching back into the distance.

This was the second of the murals to be painted. It was designed in autumn 1879, and painted on the wall from April to September 1880.

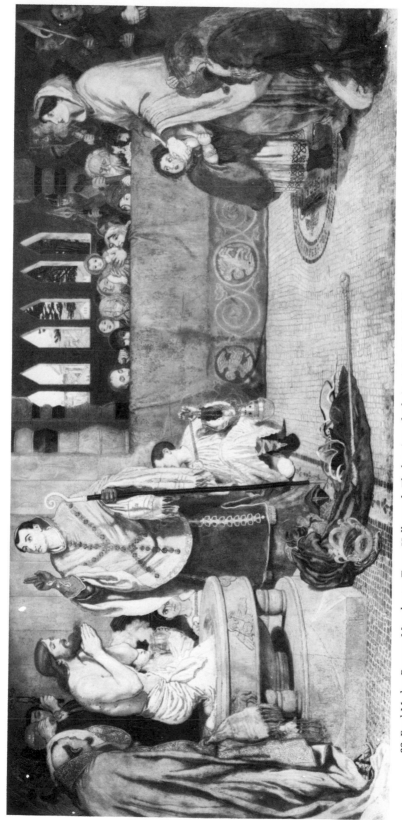

80 Ford Madox Brown: Manchester Town Hall mural. *The baptism of Edwin, A.D. 627, 1878–80*

The baptism of Edwin, A.D. 627 **80**

This subject was intended to show the introduction of Christianity to Manchester. Axon criticised it, as Edwin was baptised at York, but the pretext for including it was that Manchester formed part of Edwin's kingdom of Northumbria and Deira. A pagan, he was converted by his wife, Ethelberga of Kent, a Christian princess. Bede recorded that the ceremony took place in a small wooden church, but Brown has shown it as built on Roman foundations to give continuity with the first mural, hence the mosaic with the monogram *S.P.Q.R.* The baptism was performed by Bishop Paulinus, who is shown making the sign of the cross. In his text Brown quoted Wordsworth's sonnet *Paulinus*, which, following Bede, described him as 'of shoulders curved, and stature tall, Black hair, vivid eye and meagre cheek, His prominent feature like an eagle's beak'.

The composition, in which the flatness of the picture surface is emphasised by the straight lines and by the draped barrier parallel to the picture plane, is based on features taken from two of Dyce's murals in the House of Lords. *The baptism of St Ethelbert,* **76** has an identical kneeling figure being baptised, and a barrier in front of a row of spectators, whilst *The admission of Sir Tristram to the fellowship of the Round Table,* **75** has a similar clarity of modelling and grouping, and similar architecture, with an expanse of floor in the centre and a row of arcaded windows behind. Brown's font, on which he has painted his monogram as though carved in the stone, is an invented design, but recalls the round table of Dyce.

Brown has filled out his picture with subsidiary detail – the delightful faces of the spectators peering over the barrier, the acolytes pulling faces at each other, the view of ancient York through the window, and the embroidered vestments. Charles Rowley sat for Edwin, and the Queen, not looking at her husband but raising her eyes to heaven, is Mrs Madox Brown.

This was the first mural to be painted. Brown began the design in July 1878, transferred it to the wall in April 1880, and finished it in July that year.

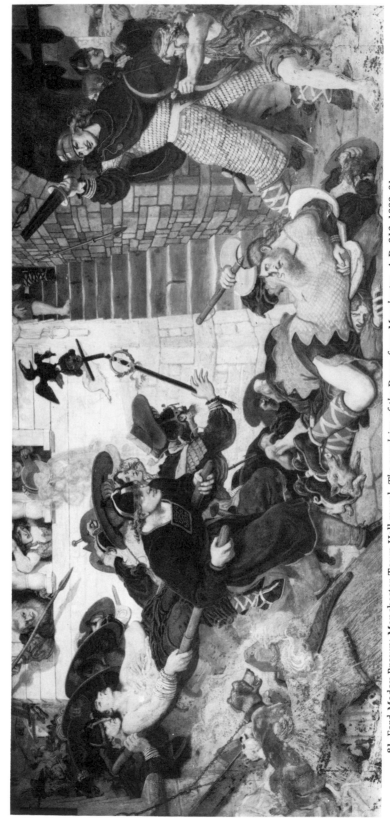

81 Ford Madox Brown: Manchester Town Hall mural. *The expulsion of the Danes from Manchester, A.D. 910*, 1880–81.

The expulsion of the Danes from Manchester, A.D. 910 **81**

A group of Danish raiders are escaping from the town. In a confused rush amidst smoke, animals and fallen bodies a wounded young chieftain is being carried out on an improvised stretcher. The Danes are shown as young men, in search of booty which 'they were wont to convert into gold bracelets which were worn on the right arm'. They hold up shields to protect them from the mounted English soldiers seen in the left background, and from the missiles thrown from the windows by Manchester townsfolk.

In contrast to the previous panel, the scene is full of movement and gesticulation. Brown harks back to his early training under Baron Wappers, a Belgian follower of Delacroix. Wappers specialised in sweeping, romantic crowd scenes, built up on the grand scale with many figures. But Brown's composition is ingenious, for an impression of depth is given by a shallow line of central figures and by the introduction of deep space at the edges of the panel, where little distant views are glimpsed. The sunlit wall behind the central figures emphasises the curved outlines of the shields and other details.

The scene is marred by some grotesque poses and grimaces. Charles Rowley sat for the contorted defeated warrior at the foot of the steps. By his feet is the pig from the burning sty, which caused the 'pigmentary predicament' by squealing during an organ recital in the Town Hall.

This was the third mural to be painted. Designing began in January 1880, painting on the wall in September, and it was finished in March 1881.

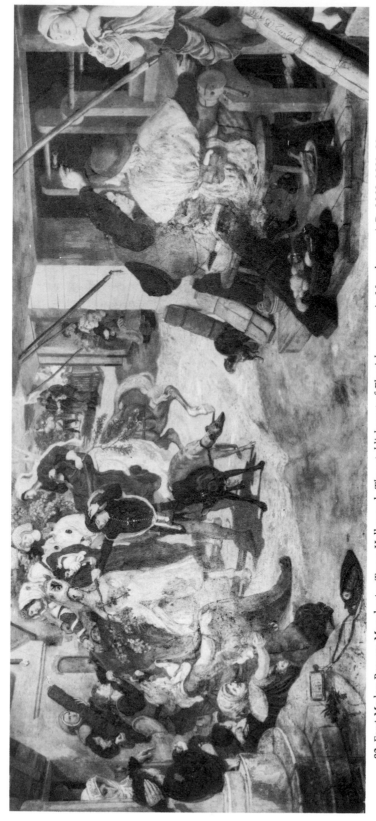

82 Ford Madox Brown: Manchester Town Hall mural. *The establishment of Flemish weavers in Manchester, A.D. 1363, 1881–82*

The establishment of Flemish weavers in Manchester, A.D. 1363 **82**

Queen Phillipa of Hainault, wife of Edward III, is supposed to have been responsible for the settlement of Flemish weavers in England. To show the early importance of textiles in Manchester, Brown imagines her visiting the town, over which her son, John of Gaunt, held sway. The time of year is indicated by the warm spring sunlight, and by the may-blossom borne by the Queen and her ladies. In their pretty Lincoln green costumes they make an attractive group with the elegantly clad page-boy and the gently restless movement of the horses.

The costume of the late fourteenth century was one of Brown's old loves, and the headdresses of the ladies recall, for instance, those in *Chaucer at the court of Edward III* (1845–51, Art Gallery of New South Wales). Realistic out-of-doors light was also an interest of Brown's, for example the hot July sunlight of *Work* (1852–65, City of Manchester Art Galleries). Like the contrast between sunlight and shade in *Work*, the sunlit court group are contrasted with the weavers in the reflected light beneath the canopy. The sleek court greyhounds sniffing at a hostile Manchester cat also provide an echo of *Work* in the use of animals to emphasise the story.

Like a novelist, Brown has filled the scene with interesting detail (bales of cloth, the schoolgirl's slate and lunch bag), and has given the characters parts to play. The Queen's page has been running on foot, and so mops his brow, hot from keeping up with the horses. A man and his wife hold out cloth for the Queen, aided by their child and a workman: a weaver stands ready with another roll of cloth. At the top of the steps of the cross a child is being bidden to join the others. One of these children at the foot is putting her tongue out at the girl on the extreme right of the picture. This girl's Flemish nationality is indicated by her wooden shoes, and the old weaver close by has his name, 'Jan van Brugge', on the bale of cloth in the corner. He pretends to work at his loom, but is really looking at the Queen. Meanwhile his apprentice is making eyes at the Flemish girl, who studiously avoids his gaze and toys with a kitten.

This most decorative and skilful composition was a subject which Brown had long wanted to paint. He began the cartoon in May 1881 and finished the panel, the fourth to be painted, in May 1882.

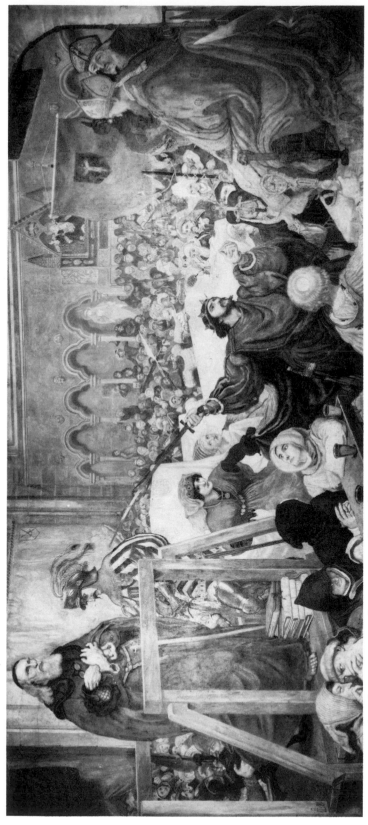

83 Ford Madox Brown: Manchester Town Hall mural. *The trial of Wycliffe, A.D. 1377*, 1885–86

The trial of Wycliffe, A.D. 1377 **83**

John Wycliffe, whose challenge to the authority of the Church foreshadowed the Reformation, is being tried before Convocation in old St Paul's. His defender is John of Gaunt, Earl Palatine of Lancaster, whose wife is trying to restrain him. At Wycliffe's side is Lord Percy, who points to Wycliffe's books, and asks for a seat for him, saying, 'An you must answer from all these books, Doctor, you will need a soft seat.' In the background Chaucer is taking notes. The bishops are Simon Courteney, Bishop of London (seated) and Simon Sudbury, Archbishop of Canterbury (whispering to him).

Axon criticised the subject's tenuous connection with Manchester, but it appealed to Lancashire independence, both religious and political. In date the subject is very close to that of the previous mural of the *Flemish weavers*. The architectural detail is conjectural, though some features are based on engraved views.

Shields, a passionate Non-conformist, posed for Wycliffe; Harold Rathbone, Brown's pupil and later founder of the Birkenhead della Robbia Pottery, sat for John of Gaunt; Kendrick Pyne, the Town Hall organist, sat for Courteney, whilst Sudbury was a self-portrait. Chaucer was based on engraved portraits.

Gaunt's broad gesture recalls figures in Bell Scott's Wallington murals of *The spur in the dish* and *Bernard Gilpin*. As in previous scenes, Brown's composition is carefully organised, with large foreground figures contrasted with a busy and crowded background. The sweeping composition is very different from the clarity and repose of his earlier painting in Pre-Raphaelite style, *Wycliffe reading his translation of the Bible to John of Gaunt* (1847–48, Bradford Art Gallery).

Though this is the fifth subject, Brown painted it seventh, probably because it was first assigned to Shields. It was designed in 1885, begun on the wall in June, but left during the winter and not finished until mid-1886.

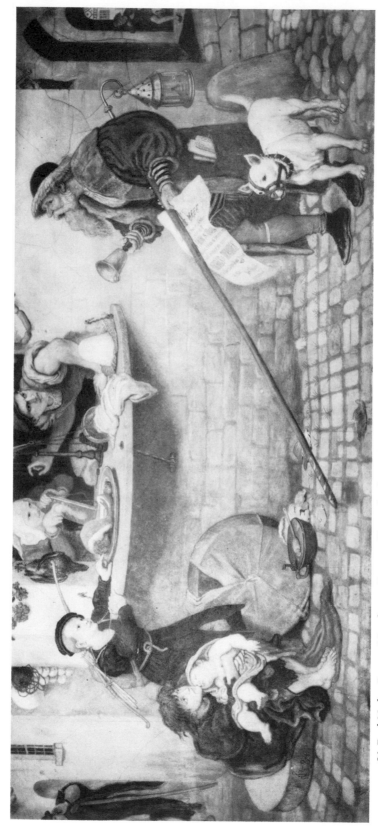

84 Ford Madox Brown: Manchester Town Hall mural. *The proclamation regarding weights and measures, A.D. 1556, 1881–84*

The proclamation regarding weights and measures, A.D. 1556 **84**

A bellman is crying the new edict of the Court Leet of the Barony of Manchester, ordering the testing of weights and measures. In the food shop the grocer is 'listening in anxious and undisguised indignation, whilst his wife removes some butter adhering to the bottom of her scales'. This is meant to show 'the foundation of commercial integrity in the town', and is based on Brown's own reading of the Court Leet records. Brown's text describes other quaint requirements of the law, such as the bow and arrow worn by the grocer's son, in the blue and yellow uniform of King Edward's Schools. Brown's researches revealed that Manchester had four dog muzzlers, hence the muzzle on the bellman's dog. At the sound of the bell, figures run to hear the proclamation. The beggar girl with child, porringer and spoon 'is exposing to the commiseration of the charitable, an exceedingly well-fed, but half-naked baby'.

After the last crowded scene this is a quiet, beautifully simple composition, depending on the elegance and interest of the figures, the chief of which seem to be based on Italian Mannerist sources. The schoolboy is like a cupid by Bronzino, the Florentine painter, and the grocer and his wife were possibly suggested by the type of picture common in the sixteenth century showing merchants or shopkeepers in their shops. The composition is articulated by the shallow concave movement of the wall, with glimpses into deep spaces at the sides.

This was the sixth mural to be painted. The design was started in November 1881, but work on the wall did not begin until July 1883. It was finished in April 1884.

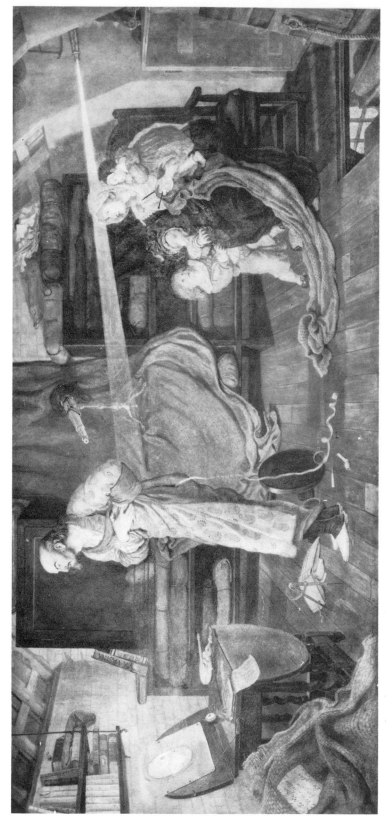

85 Ford Madox Brown: Manchester Town Hall mural. *Crabtree watching the transit of Venus, A.D. 1639, 1881–83*

Crabtree watching the transit of Venus, A.D. 1639 **85**

For scientific achievement, Brown shows the observation of the transit of Venus across the sun made by William Crabtree, a draper from Broughton, Salford. He is seen gazing at the image of the planet projected through a telescope in a darkened room. Crabtree had assisted his more learned friend Jeremiah Horrox of Hoole, Lancashire, in the preparatory calculations. When Crabtree made the observation he was so struck with amazement that he failed to use his instruments to record the exact path of the planet.

Brown has made much of this, showing him having leapt up from his seat in wonder, dropping his book, pipe and compasses. This engaging amateurism, and the fact that Crabtree was an honest artisan and not a learned man, doubtless appealed to Brown; Axon had complained that Crabtree's observation was insignificant compared with that of Horrox. But Horrox had no connection with Manchester and so was not relevant to the series.

Brown consulted astronomers for the technical detail, but the treatment is his own. He sets the scene above the draper's shop in an attic room filled with an appealing clutter of books and parcels of cloth. Crabtree wears a decoratively patterned silk robe. On the right, the trapdoor (with monogram and date) reveals that the room is on an upper floor, a device taken from an early Holman Hunt drawing of Lorenzo in his office above a warehouse. This provides a glimpse into a space beyond the clear perspective 'box' of the attic. The wintry season is indicated by the frost on the windows. The composition is further organised by the curved lines of the draperies and the straight lines of the floor, furniture and sunbeam.

The striking group of Mrs Crabtree and her children may derive from sixteenth-century Italian representations of Charity, traditionally a woman nursing two children, or from a Virgin and Child with St John. The models for this group were Brown's daughter Lucy (Mrs William Michael Rossetti) and her children. Brown's friend C. B. Cayley, the translator of Homer, sat for Crabtree.

This panel was the fifth to be painted. It was designed in July 1881, but not begun on the wall until May 1882. During the following winter work was interrupted through illness, and so it was not completed until September 1883.

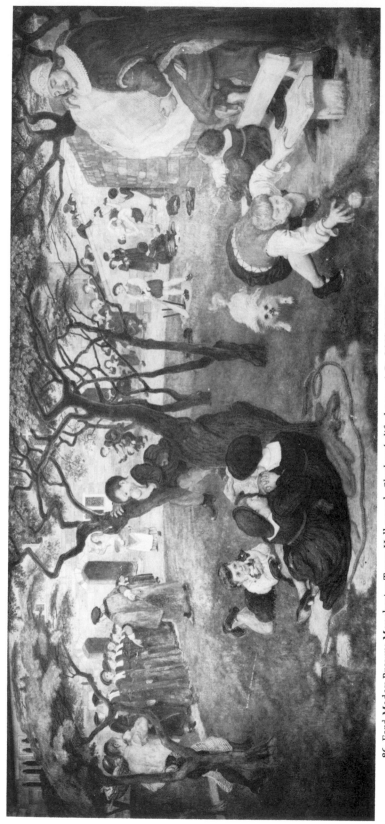

86 Ford Madox Brown: Manchester Town Hall mural. *Chetham's life dream, A.D. 1640, 1885–86*

Chetham's life dream, A.D. 1640 **86**

Humphrey Chetham, a cloth merchant and financier, founded and endowed a school in his will, and Brown shows him with the will, imagining the realisation of his dream. The scene represents the provision of education, and Bishop Hugh Oldham, founder of the Manchester Grammar School, was also considered for this subject. But as with Crabtree and Horrox, the layman was preferred to the learned.

The courtyard of the school was known to Brown, and he may also have consulted engraved views of it. Chetham's portrait depends on those at the school, supplemented by sittings from Harold Rathbone. The activities of the schoolboys are depicted with a sense of fun, particularly the boisterous games of leapfrog and wrestling, the cricket match and the boys reading 'Jack the giant-killer'. On the left, a master scolds his class, whilst the cook beckons to the butcher's boy.

It is possible that Breughel's *Children's games* and *Peasant and bird's nester* (both in Vienna) suggested the idea of the boys playing and the boy in the tree, but neither is an exact prototype. Brown could have known these from engravings. The decorative treatment of the trees, also a Breughel motif, recalls the fashion for Japonaiserie current in artistic circles in the 1870s and '80s, but the stylisation is somewhat weak and unconvincing, as is the drawing of the boy in clogs reaching for the ball, and the silly little dog bounding after him.

The hesitancy in the drawing is matched by a thin quality in the paint, the modelling being much less solid than in previous murals. The general lack of vigour may have come from the change of medium, for *Chetham* was the first of the series to be painted in oil on canvas. Possibly the different light in the studio also had an effect, for the green colour scheme is colder than in any of the previous scenes. The subject was designed in March 1885. Then *Wycliffe* was begun on the wall, but during the winter it was left unfinished whilst *Chetham* was completed in the studio.

H

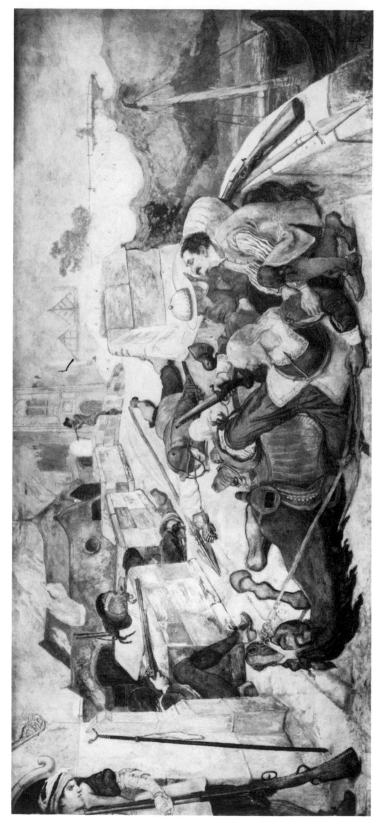

87 Ford madox Brown: Manchester Town Hall mural. *Bradshaw's defence of Manchester, A.D. 1642*, 1892–93

Bradshaw's defence of Manchester, A.D. 1642 **87**

This subject from the Civil War shows Parliamentarian Manchester defended by John Bradshaw, who, with a garrison of only forty musketeers successfully repelled a large Royalist force. In the background is Bradshaw firing a musket at the defeated Royalists on the bridge, who include Lord Montagu, one of the leaders, on the fallen horse. The action took place on the bridge between Manchester and Salford, by the collegiate church (later designated the cathedral). By Brown's time the bridge had been replaced and the cathedral restored.

This was the last of the murals to be painted. Finished in spring 1893, about six months before the artist's death, it shows considerable signs of failing powers. Whilst painting it, Brown suffered a stroke which temporarily deprived him of the use of his painting arm, so much of the mural was done with the left hand. The landscape on the right is not well handled and appears ill defined when compared to his previous fluency. The flames of the burning thatch, and the clouds of musket smoke, each with a bright explosion at its centre, are decoratively treated but fail to give a convincing illusion of space or atmosphere. The drawing of the figures, particularly of Montagu's head and the figure slumped in the bridge embrasure, is also weak.

Nevertheless, as a whole, the composition has extraordinary daring, with the boldly foreshortened bridge stretching straight back into the picture, and the fallen horse strongly outlined. Despite the failure in realisation, the conception is dramatic, adventurous and typical of Brown's unorthodox mind, even in his old age.

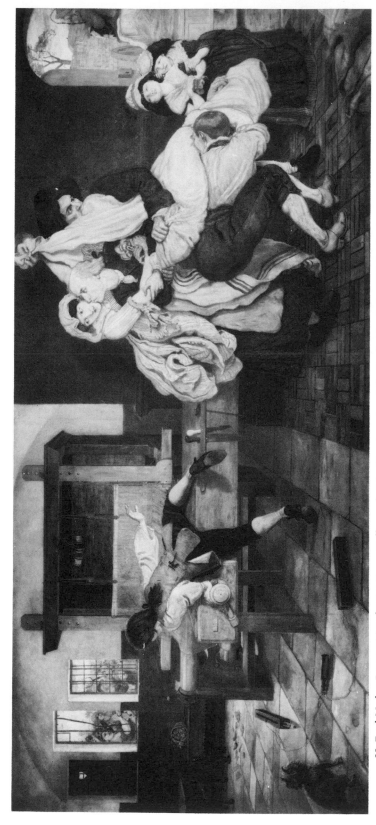

88 Ford Madox Brown: Manchester Town Hall mural. *John Kay, inventor of the fly shuttle, A.D. 1753, 1888–90*

John Kay, inventor of the fly shuttle, A.D. 1753 **88**

Kay is shown at his house in Bury with his invention, the flying shuttle, which caused riots among the weaving population, whose livelihood it threatened. Kay's wife, wearing a dress of cream, pink and green stripes, receives a parting kiss as he is bundled into a wool sheet and out of the door on to a waiting cart. His two little girls stand wailing as his son keeps watch for the machine-breakers. The fly shuttle itself lies on the floor in the foreground, in front of a workbench and the loom. The touches of humour are limited to the little dog, the smashed flower pot knocked from the window sill by the mob, and the grotesque faces of Mr and Mrs Kay.

This is typical of Brown's anecdotal approach to history. In his text, however, he stressed the wider significance of the subject. 'But for Kay's simple, yet epoch-fixing invention of the shuttle which, without hands, flies backwards and forwards across the loom, all the wonders and achievements of steam-weaving would never have been perfected.'

The lines of the loom, the bench and the floor paving in perspective define the composition with rectilinear clarity. In contrast, the agitated group of Kay in the sheet is all wriggling curves. The curious poses are an adaptation of the traditional scheme for a descent from the cross, with Kay in the position of Christ and his wife as the Virgin. The figure bent over to carry the body derives from a type such as that in Pontormo's *Deposition* (Sta Felicita, Florence). The boy leaning over the workbench is derived from Raphael's *Bathers*, engraved by Marcantonio Raimondi. Mrs Henry Boddington, wife of Brown's patron, and her children were models.

This was the tenth subject to be painted, and the third of the oils. It shows a much more assured touch in modelling and drawing. It was begun in 1888 and finished in 1890.

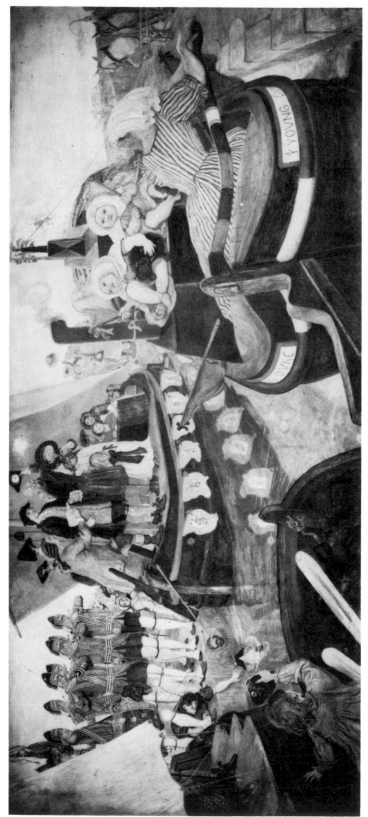

89 Ford Madox Brown: Manchester Town Hall mural. *The opening of the Bridgewater Canal, A.D. 1761, 1890–92*

The opening of the Bridgewater Canal, A.D. 1761 **89**

The first barge sets forth on the canal, drawn by two mules and steered by the bargee's wife accompanied by twin babies. On a nearby barge the Duke of Bridgewater looks on. His engineer, Brindley, pours him a drink as crowds cheer and the band plays.

In this splendidly colourful picture of display, Brown has made the most of the uniforms, flags, bright colours and details of costume such as the amusing glimpse of eighteenth-century shoes under the awning at the left. The workaday side of the canal, which might have appealed to the painter of *Work*, is less in evidence, though the boy in the coal barge was included because 'the Duke's orders were always to execute the smaller orders first'. The glass of brandy from Brindley's flask indicates that, in contrast to the engineer, the duke 'was not of a convivial turn' and had 'omitted providing refreshments'.

As before, Brown has filled out the formal events with humorous marginalia, such as the boy reaching between the soldiers' legs to rescue his dog from the water, the people throwing their hats into the air, and the twin babies, whose identical faces and white bonnets recall the Elizabethan formality of *The Cholmondeley sisters* (Tate Gallery). The babies were done from a single model, discovered at a baby show in Camden Town, and Brown's granddaughter Juliet posed for the girl reaching up for a sip of brandy.

The cartoon for this, the eleventh mural, occupied Brown from March 1890 to April 1891, and the canvas was completed in February 1892. When sent up to Manchester it was the cause of criticism by the more philistine members of the committee. Though some of the large areas of single colours are not particularly well painted, this fault is more than compensated for by the bright colour, extreme foreshortening and strong use of outline, which creates bold, flat areas out of the decorative shapes of the boats and sails. Perhaps it was this, and the prominence of the two fat babies, which caused offence. It is one of Brown's most original conceptions, and shows what the artist might have been able to do with the Bradshaw subject had it not been for his stroke.

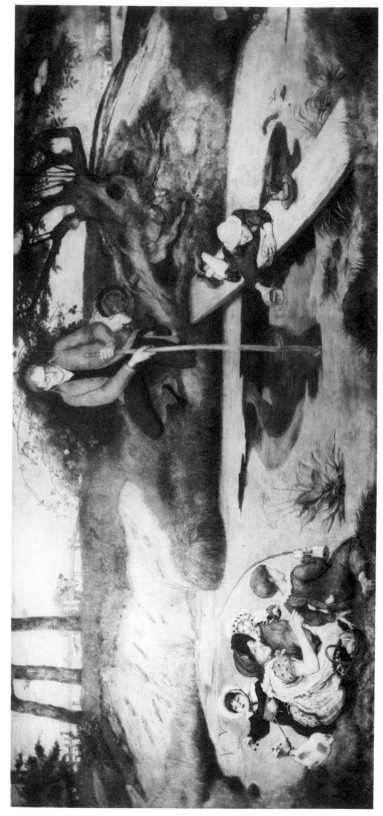

90 Ford Madox Brown: Manchester Town Hall mural. *Dalton collecting marsh–fire gas, 1886–87*

Dalton collecting marsh-fire gas **90**

Dalton represents invention, and is the only nineteenth-century subject of the series. He is shown not in a laboratory but in an oddly inappropriate pastoral setting, collecting bubbles of marsh-fire gas by stirring up mud in a stagnant pond. A farmer's boy is collecting the bubbles in a jar. Dalton's discovery of atomic theory began with his experiments on the composition of natural gas. According to Brown's text, the girl in the foreground is telling her friends that '"Mr Dalton is catching Jack o'Lanterns"—marsh-fire gas being, when on fire, the substance the Will o' the wisp is composed of'.

Brown had been scornful of the pictorial possibilities of the subject of a man thinking, but seems to have warmed to the idea. It is evident from his description of the mural that he liked the idea of an ordinary schoolmaster whose experiments made him a world-famous scientist. Dalton was born in Cumberland, and came to work in Manchester. The rural setting is perhaps meant to be Cumberland, though the pond was painted from one in Victoria Park, near where Brown lived.

It is one of the least crowded of the murals, and the landscape is treated with a decorative sense of line. But the curved lines of the pond lack the emphatic boldness of the similar shapes in the other murals, the figures are not big enough to possess the force they have in other panels, and their spatial relationships are unsatisfactory. Nevertheless, it is an unusual and refreshing end to the series.

It was the ninth mural to be painted, and the second in oils, coming between *Chetham*, **86** and *Kay*, **88**. The tentative handling shows that Brown was still not yet quite at ease with the return to oil. The predominance of landscape, as in *Chetham*, may also account for the lack of vigour. Studies were begun in November 1886, the canvas was started in May 1887, and it was finished in the autumn. It was the last to be painted in Manchester, for the move to London took place at the end of 1887.

The Whitworth Art Gallery

The death of Sir Joseph Whitworth at Monte Carlo on 2 January 1887 brought to a close a strenuous life of some sixty years dedicated to the improvement and manufacture of machinery and armaments, **91**. He was born at Stockport on 21 December 1803, the son of Charles Whitworth, the proprietor of a school in that town and later a Congregational minister. In 1817 the young Joseph entered his uncle's Derbyshire cotton-spinning mill and whilst there acquired a practical knowledge of machinery. It was in this particular direction that his interests quickly developed, and he gained invaluable training in London before returning to Manchester in 1833 to found his own tool-making workshop. Whitworth first established himself in a mill in Chorlton Street, where he produced lathes, planing machines, standard gauges and screw-cutting equipment. From the time of the Crimean war, 1854–56, his advice on rifle production was sought by the government and he also carried out a number of important tests on the use of steel in gun casting. In 1880 his company moved to a larger site at Openshaw. As Whitworth had no children, the firm was amalgamated with Armstrong's in 1897; Armstrong Whitworth and Co. later became part of the Vickers group.[1]

The Legion of Honour was conferred upon Whitworth in 1868 and he was created a baronet the following year. As his wealth increased he acquired a more impressive residence, The Firs in Fallowfield, commissioned from Edward Walters, and shortly before his second marriage, in 1871, he purchased an estate at Stancliffe, near Matlock in Derbyshire. As far as his private fortune is concerned, his will of 18 December 1884 indicated that after provision had been made for his wife and a few personal friends the residuary estate was to be administered for charitable and educational purposes by three legatees, who

[1] For further information on Sir Joseph Whitworth see 'Memoir of Sir Joseph Whitworth, excerpt Minute of *Proceedings of the Institution of Civil Engineers*, vol. 91, Part I, 1887–88; *Dictionary of National Biography*, vol. 61, 1900; F. C. Lea, *A pioneer of mechanical engineering. Sir Joseph Whitworth*, British Council, 1946; A. E. Musson, 'The life and engineering achievements of Sir Joseph Whitworth', *Whitworth Exhibition catalogue*, Institution of Mechanical Engineers, July–August 1966; *id.*, 'Sir Joseph Whitworth, engineer of today', *Vickers Magazine*, summer 1966; *id.*, 'Joseph Whitworth and the growth of mass-production engineering', *Business History*, vol. 17, no. 2, July 1975.

91 Sir Joseph Whitworth (1803–87)

were given 'the fullest powers in the management and disposition of [his] property and affairs'. A codicil emphasises that these legatees 'shall respectively have the absolute free and unfettered right and power of enjoyment and disposition for their own benefit of the property herinbefore expressed to be given to them for their own absolute benefit', and in a third codicil he again expressed his 'full confidence that the legatees will respectively desire to carry out [his] wishes to the utmost of their power'.[2]

The legatees were his widow, Mary Louisa (*née* Broadhurst), who endowed a hospital and institute at Darley Dale, Derbyshire; Richard Copley Christie, Chancellor of the Diocese of Manchester, who financed the building of the Whitworth Hall and Christie Library at Manchester University; and Robert Dukinfield Darbishire, a solicitor, who became the principal benefactor of the Whitworth Institute, which is now the Whitworth Art Gallery of the University of Manchester.

Robert Darbishire (1826–1908) was the son of Samuel Dukinfield Darbishire, a founder of the Manchester Athenaeum and of Manchester New College, and it was at his parents' house that he first met Joseph Whitworth around 1850. This led not only to a long personal friendship but also to a close business association, as Darbishire eventually became Whitworth's legal adviser.

On 21 November 1887 the legatees wrote to eleven highly respected men with local connections, including William Agnew (1825–1910), created a baronet in 1895 and the eldest son of the founder of the famous art-dealing firm of Thomas Agnew and Sons; Thomas Ashton (1818–98), a leading textile manufacturer, of Hyde, and father of the first Lord Ashton of Hyde; Sir Joseph Lee (1832–94), partner in the firm of textile manufacturers Tootal Broadhurst Lee and Co., and chairman of the committee of the Manchester Royal Jubilee Exhibition of 1887; William Mather (1838–1920), chairman of the large engineering firm of Mather and Platt, who was Member of Parliament at various times for local constituencies and was knighted in 1902; and C. P. Scott (1846–1932), editor of the *Manchester Guardian* from 1872 to 1929 and a cousin of its proprietor, John Edward Taylor. In this letter the legatees outlined their plans for founding an institution in memory of Sir Joseph:

> Desiring to establish in Manchester, some worthy memorial of the Deceased, we have thought of founding one in a form which shall secure at once a source of perpetual gratification to the people of Manchester, and at the same time, a permanent influence of the highest character in the directions of Commercial and Technical Instruction, and of the cultivation of taste and knowledge of the Fine Arts of Painting, Sculpture, and Architecture. With this view, we have purchased 20 acres of land in Oxford Road, lying between Denmark Road and Moss Lane, – the same plot as has lately been talked of as Potter's Park, – for £47,000. We propose to offer the whole of this fine Plot to the Corporation of Manchester.

[2] Copies in Whitworth Art Gallery archives.

The letter describes a scheme for building an Institute of Art, a Comprehensive Museum of Commercial Materials and Products, and a Technical School, and the citizens to whom it was addressed were invited to attend a meeting with the legatees on a date to be arranged by Darbishire. This took place in Manchester Town Hall on 29 November 1887, and a Whitworth Committee was appointed, with Sir Joseph Lee as chairman and Darbishire as honorary secretary. At the meeting William Mather gave his enthusiastic support to the legatees' proposals, his views being reported in some detail in the following day's *Manchester Guardian*. According to this report, he compared Manchester with similar manufacturing centres in other countries:

> When travelling abroad he had been struck with the magnificent institutions raised by Governments and by private munificence for the purpose of developing higher culture amongst even the lowest class of people, and he had reflected with some amount of shame and humiliation upon the fact that in Manchester, the very centre of the world's great enterprises, where the textiles industry had grown, where mechanical trades had developed so largely, and where nature had surrounded us with so many advantages on every side, those who had reaped the reward of these great natural advantages had not established in our midst institutions similar to those that existed elsewhere. Thanks to Lady Whitworth and her co-trustees this stigma would now be removed, and Manchester would set a good example to every other large centre of industry.

A formal approach for financial assistance was made to Manchester Corporation in a letter from Darbishire to the Mayor dated 24 March 1888, stating that:

> The Consultative Committee have found themselves so heartily encouraged by prominent Manchester men of various experience and interest, that they have readily seized the idea of at once taking in hand the completion of the Whitworth Park scheme, and the organisation of the Museum of Fine Art and of Commerce and Industry, with its connected Art and Technical Schools . . . without any loss of time. We therefore have decided . . . to ask the Corporation to render its assistance in the way of a moderate charge on the city rates, leaving the administration of the Park and Institute to the new body, in which, of course, the Corporation will be fully represented.[3]

In addition to the Potter's Park estate, endowments amounting to £225,000 were offered, including £50,000 to be supplied in carrying out the project for a Whitworth Institute and a further surplus of £40,000 from the guarantors of the Royal Jubilee Exhibition of 1887.

Whereas the Whitworth legatees and committee made considerable progress with their scheme over the next two and a half years, the Corporation dithered and delayed, perhaps because it was considering purchasing property on Deansgate in order to build a new art gallery. A proposal came before the

[3] Published in the *Manchester Guardian*, 1 June, 1888.

City Council on 2 January 1889, but without decision.

The Whitworth Committee's aims were not only to establish the Institute of Art and Industry in Whitworth Park, as Potter's Park had by now been renamed, but to enlarge the School of Art in Cavendish Street (now part of Manchester Polytechnic) and build a new Technical School on a site in Sackville Street (now part of the University of Manchester Institute of Science and Technology). However, the Corporation accepted responsibility for both schools in 1892 and at the same time, for the benefit of both institutions, the committee transferred over £23,000 from the funds donated by the Royal Jubilee Exhibition of 1887.[4]

Plans for laying out the grounds of Whitworth Park were published early in 1889, and they show an east-to-west carriage road dividing the pleasure grounds from a five-acre strip of land on the north side along Denmark Road, this being reserved for the Fine Arts Gallery and other museum buildings. Avenues of trees were proposed, meeting at a central point, and 'an abundance of seats' was promised. Grove House, **92**, which stood near the corner of Oxford Road and Denmark Road, was to be remodelled internally to provide exhibition rooms, offices and storage areas. On 4 September 1889 the *Times* gave a long account of the activities of the Whitworth Committee, taking the opportunity to comment on the Corporation's reticence about disclosing whether or not public money could be made available in the form of an annual subsidy, as requested by the legatees. The paper's Manchester correspondent concluded:

> If there is any reason to view the proffered benefactions as in any sense a white elephant, a frank explanation would have been better than the unintelligible picture that has so long presented itself, of the Whitworth Legatees and Committee continually holding out their hands full of golden blessings (so an appreciative town councillor has termed them), and the Manchester Corporation still unable to make up its mind whether to leave what is offered.

The Whitworth Institute scheme failed to get financial backing from the Corporation because of differences of opinion regarding the control of Whitworth funds and the authority of the legatees.

The Manchester Whitworth Institute's charter of incorporation was signed by Queen Victoria on 2 October 1889, and those who were named as Governors, in addition to the three legatees and the local dignitaries already mentioned, included Sir John James Harwood, Oliver Heywood and Edward Donner, all members of the original committee formed in November 1887. In describing the general objects of the Institute, emphasis was given to 'The Collection, Exhibition, and Illustration of Fine Art, and the study of and Instruction in Fine Arts, by means of Galleries, Libraries, Lectures, Classes and

[4] See *The Manchester Whitworth Institute. Minutes of Proceedings at a Special Meeting of the Governors, held in the Memorial Hall, Albert Square, Manchester, at 2.30pm, Thursday, October 8th, 1891*, copy in Whitworth Art Gallery Library.

92 Grove House, with the large South gallery behind it, c. 1898

other methods. . . .'[5] At that point, equal importance was attached to the formation of a similar department which would collect and exhibit 'Works of Mechanical and Industrial Arts, and of Science as applied to those Arts'. Another clause stressed the need to establish 'Galleries, Museums, Libraries, Lecture Rooms, Laboratories, Workshops and Class Rooms' as might be required for the purposes described above, but, whereas the Whitworth Institute soon became enriched with outstanding water-colour and textile collections, there was no development towards the establishment of a Technical Museum, and this idea seems to have been dropped completely after the Corporation had accepted control of the Technical School. It is questionable whether or not Sir Joseph would have entirely approved of this concentration on the fine arts, as his own personal interest appears to have been limited to collecting works by nineteenth century Royal Academicians, including Thomas Uwins, Frederick Pickersgill, Thomas Sidney Cooper and Frederick Goodall, all of which he bequeathed to the City Art Gallery.

Whitworth Park opened to the public in June 1890 and, according to the *Manchester Guardian* of 16 June, 'thousands of people visited the grounds between three and nine o'clock'. The broad walks and ample lawns had been completed by then, but there was still an elaborate fountain to be erected, and the small lake along the western boundary was still in course of construction. The article also referred to the various houses belonging to the park, and described how one of them, Grove House, had been converted to a gallery. 'The partitions of the rooms on the ground and first floors have been removed, and the whole place has been modified and internally reconstructed, so as to make a very effective temporary gallery. . . . When the new galleries are erected the art collection will be transferred from Grove House.'

The formal opening ceremony took place on 17 July 1890, following a meeting of the Governors in Grove House under the chairmanship of Sir Joseph Lee. Guests assembled in a marquee erected close to the house and speeches were made by Lord Hartington, later eighth Duke of Devonshire, Sir Frederick (later Lord) Leighton, President of the Royal Academy, Sir Charles Robinson, at that time Surveyor of the Queen's Pictures but formerly superintendent of the art collections in the South Kensington Museum, and the Mayor of Manchester, Alderman John Mark. According to the *Manchester Courier* (18 July 1890), a military band provided music, including pieces by Sullivan, Weber and Meyerbeer, and the day ended with a mayoral banquet in the Town Hall, at which Lord Hartington again spoke of the inauguration of the Whitworth Institute as an event of great importance to the whole area.

Describing the exhibits to be shown in Grove House at the opening, the *Manchester Guardian* commented on 17 July:

[5] Copy in Whitworth Art Gallery archives.

The rooms . . . have been transformed into a series of well-lighted galleries, in which are stored works of art already acquired by donation or purchase. Among the possessions of the Governors in these rooms are a fine collection of plaster casts from the Niobe group at Florence; three tapestries by Mr William Morris, woven from the designs of Mr Burne-Jones; Mr Watts's 'Love and Death'; a series of proof engravings and etchings of notable pictures at the Manchester Jubilee Exhibition; and a complete set of Turner's 'Liber Studiorum'. In addition to the permanent collection there will be an interesting exhibition of ancient textile fabrics and embroideries, which Sir Charles Robinson is at present engaged in arranging in the upper rooms of the Gallery.

The exhibits also included portraits by G. F. Watts, lent by the artist, a loan of five Turner water-colours from William Agnew, and paintings by Briton Rivière, H. W. B. Davis and Frank Topham. The next day the *Manchester Guardian*'s critic commented somewhat caustically:

The basis of the ordinary provincial art gallery is the collection of contemporary English oil paintings. The same ominous preference appears already in this small collection . . . There are no watercolours, and that though watercolour is the one art in which England holds, or has held, the primacy . . . The decorative arts would be absolutely unrepresented but for the textiles lent by Sir J. C. Robinson.

In time, however, the Whitworth Gallery was to become internationally renowned for its collection of British water-colours and its unique range of textiles. The three tapestry-woven hangings mentioned in the *Manchester Guardian*, *Flora*, **93**, *Pomona* and *Fox and pheasants*, all woven by Morris and Company from figure designs by Burne-Jones, appear to have been purchased about a year after the Whitworth Committee had been formed. As for G. F. Watts's painting of *Love and death*, **94**, it was shown at the Royal Jubilee Exhibition in 1887 (No. 253), and at the end of that same year the artist presented the picture to the new Institute to signify his support of the committee's aims.[6]

Sir Charles Robinson proved an invaluable help to the Whitworth Committee over the display and cataloguing of the collection which he lent for exhibition in Grove House.[7] An appreciation of his loan to the new gallery is expressed in a catalogue published on 11 August 1890, *Memoranda and lists of embroideries and woven stuffs, engravings, paintings, and casts, temporarily arranged and exhibited in Grove House, Whitworth Park*, which also describes the formation and contents of the collection in detail.

It contained upwards of 1,000 specimens, ranging from complete and important sets of Church vestments, copes, chasubles, dalmaticas, altar frontals, also wall

[6] See letters published in the *Manchester Guardian*, 24 December 1887.

[7] For further information on the collection see 'The Whitworth Institute: Sir Charles Robinson's collection', *Manchester Examiner and Times*, 9 August 1890, and Joan Allgrove, 'Vestments from the Robinson collection at the Whitworth Gallery, Manchester', *Costume*, no. 6, 1972.

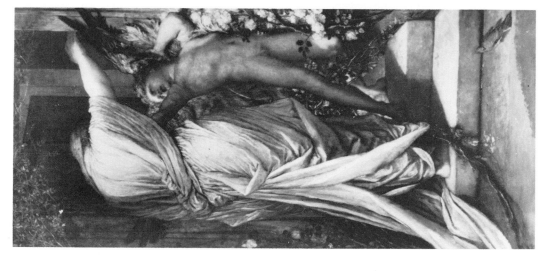

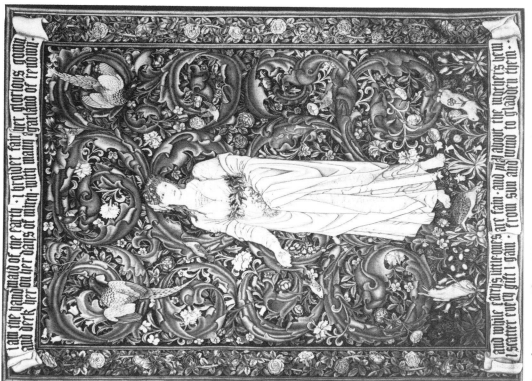

93 Morris and Company: *Flora*, 1885. A tapestry-woven hanging from a figure design by Edward Burne-Jones **94** G. F. Watts: *Love and death*, exhibited 1877. Presented by the artist to the newly formed Institute in 1887. Both *Whitworth Art Gallery, University of Manchester*

hangings, quilts, table-covers, rich guipure and point lace, fringes, tassels, etc., to single specimens of ancient gold and silver tissues, silk brocades and velvets . . . The dates range mainly from the first half of the 15th to the end of the 18th century.

The same publication draws attention to the fact that many of the pieces were purchased from the 'sacristies and treasuries of cathedrals and churches and suppressed monasteries', mostly in Italy and Spain. How this came about is also explained:

> In Italy, the suppression of monasteries and nunneries, ordered by the Government when Italy became united (1870), threw a considerable mass of rare treasures on to the art market. In Spain, much the same thing occurred on the deposition of Queen Isabella (1868), and the subsequent Republician and Carlist disturbances in that country.

This resulted in the enrichment of Sir Charles's collection, for he was a tireless explorer of Italy and Spain not only while he was in charge at South Kensington but more particularly during the 1870s and '80s.

Perhaps the most important single item in the Robinson collection is the late fifteenth century tapestry-woven German altar frontal, decorated with a figurative design of the Tree of Jesse, **95**. The collection also includes a magnificent sixteenth century Spanish crimson velvet hanging, with silk appliqué coats of arms, and richly ornamented Spanish and Italian ecclesiastical vestments of the seventeenth and eighteenth centuries. Another rare piece is a satin-embroidered casket completed by a twelve-year-old girl, Hannah Smith, in 1656, **96**.

The Robinson loan also included a series of ancient Egyptian textiles excavated in the cemetery at Akhmim in Upper Egypt, 1886–87. Perhaps it was the loan of this collection of tunics, caps and fragments that inspired the archaeologist William Flinders Petrie (1853–1942) to lend other Coptic fabrics in 1891 and, six years later, to present them to the Gallery, **97**. Petrie had excavated sites in the Faiyum region between 1889 and 1891, and was helped financially by Mr Jesse Haworth, a later benefactor. William Agnew was given the responsibility of approaching Robinson with an offer to purchase his collection for the Institute. By June 1891 an agreement had been reached whereby the Whitworth Committee were to pay £3,750 out of Royal Jubilee Exhibition funds for the whole of this magnificent collection, although Sir Charles confessed in a letter to Sir Joseph Lee, dated 3 December 1890, that he would be very reluctant to part with his most recent purchase, the fifteenth century German altar frontal.[8]

At the closing meeting of the executive committee of the Manchester Royal Jubilee Exhibition on 19 December 1889, with Sir Joseph Lee in the chair,

[8] Original letter in Whitworth Art Gallery archives.

95 Detail from a late fifteenth-century German altar frontal from Sir Charles Robinson's collection. *Whitworth Art Gallery, University of Manchester*

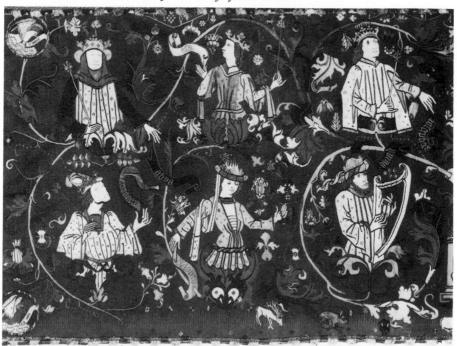

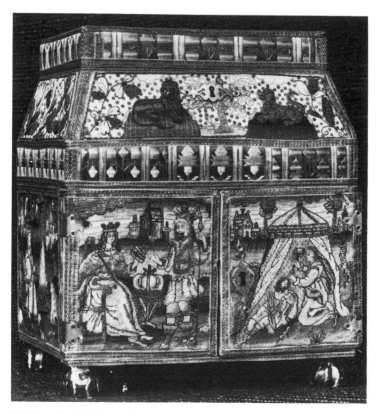

96 Hannah Smith's embroidered casket, 1654–56. From Sir Charles Robinson's collection. *Whitworth Art Gallery, University of Manchester*

97 Coptic fragment, *c.* fourth century A.D., from the Akhmim area, with roundels enclosing birds, animals and *putti*. Presented by Sir Flinders Petrie. *Whitworth Art Gallery, University of Manchester*

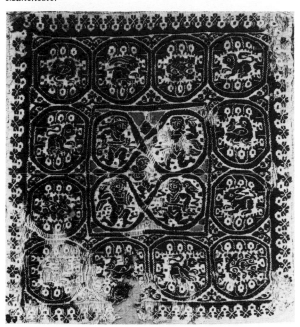

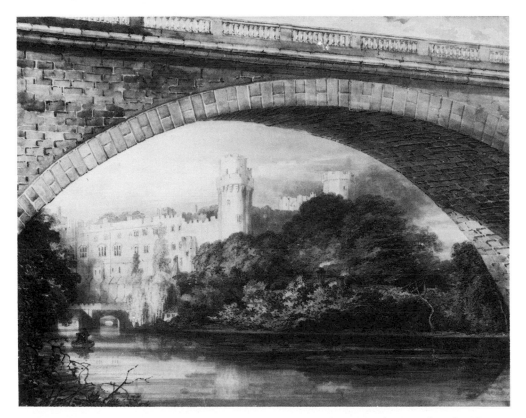

98 J. M. W. Turner: *Warwick Castle and Bridge, c.* 1794. An early water-colour purchased with funds from the guarantors of the Manchester Royal Jubilee Exhibition of 1887. *Whitworth Art Gallery, University of Manchester*

it had been formally agreed that surplus funds should be handed over to the Whitworth Institute by the Council of Guarantors.[9] It was with £20,000 of this money that the Whitworth Committee, around 1891–93, were able to purchase other works of art for the collection, including a number of outstanding British water-colours, selected on the expert advice of William Agnew. Among the drawings bought with these funds were *View from Mirabella in the Euganean Hills* by J. R. Cozens, *A Spanish fiesta*, by J. F. Lewis, several water-colours each by David Cox, Peter de Wint, William Henry Hunt, Samuel Prout and David Roberts, and a large group by Turner, including the early *Warwick Castle and Bridge*, **98** and the late *Lake of Lucerne*. Agnew himself presented a number of fine English drawings about the same time, the most important being Turner's *Interior of the Chapter House, Salisbury Cathedral*, exhibited at the Royal Academy in 1799.

In September 1891 an exhibition of water-colours was held in the Institute, the principal lenders being William Agnew, Charles Edward Lees, the Corporation of Oldham (from the collection already given to the corporation by Charles Lees), James Orrock and John Edward Taylor. As many as sixty-seven works were lent by Taylor, and the Whitworth Institute contributed almost fifty water-colours and drawings from its own collection.

John Edward Taylor (1830–1905) was the son of the John Edward Taylor who founded the *Manchester Guardian* in 1821.[10] At the time of the elder John Edward's death at the beginning of 1844 his two sons, Russell and the younger John Edward, were aged eighteen and thirteen respectively. When Russell died of typhoid in 1848 John Edward was completing his studies in Germany, and on returning to England he decided to read for the Bar. In 1852, however, he joined the *Manchester Guardian* and within a few years had become its sole proprietor. It was he who offered the editorship to C. P. Scott and was responsible for opening an office in London. Gradually Taylor began to spend more time in London, eventually moving to a grand residence in Kensington Palace Gardens, known as Millionaires' Row.

The collections in Taylor's London house were varied and extensive. He collected not only British water-colours but also Renaissance bronzes, Chinese porcelain, Limoges enamels, French eighteenth century furniture, nineteenth century English paintings, Greek and Roman antiquities and Persian rugs. Most of these objects were sold at Christie's after his widow's death in 1912.[11]

Taylor's collection of water-colours was one of the most distinguished ever to be formed, and his interest seems to date from about 1862, when his name first appeared in Agnew's stock books. He made frequent purchases from

[9] For a full report see the *Manchester Guardian*, 20 December 1889.

[10] For further information on John Edward Taylor, father and son, see David Ayerst, *Guardian. Biography of a newspaper*, 1971; J. L. Hammond, *C. P. Scott*, 1934; F. W. Hawcroft, *British watercolours from the John Edward Taylor Collection in the Whitworth Art Gallery*, 1973.

[11] See Christie's sale catalogues, 1–16 July 1912 and chapter three, p. 00.

99 William Blake: *The Ancient of Days*, 1824 or 1826. A water-colour presented by John Edward Taylor. *Whitworth Art Gallery, University of Manchester*

that firm throughout the 1860s and, as Sir Geoffrey Agnew notes in his history, *Agnew's, 1817–1967*, 'with a taste far in advance of his day' acquired a number of water-colours by Turner. Having already shown a large selection from his water-colour collection at the Whitworth, Taylor generously decided to make an outright gift of some of his finest possessions between 1891 and 1893. In the Institute's *Historical catalogue of the Collection of Water Colour Drawings* (1894) Richard Christie refers to Taylor's gift as 'a very valuable donation of 154 water-colour drawings and four oil paintings illustrating the history and growth of Water-Colour Painting in England', and it was later explained in the annual report for 1895 that the donor had allowed the drawings 'to be selected from his own collection with a special regard to the aim of the Institute at Developing the Exhibition of the History of the Art of Water-colour Painting in England'. John Edward Taylor was a Governor of the Institute from 1895 until his death in 1905.

The Taylor water-colours in the Whitworth are among its most prized possessions, though it should be remembered that they were only a part of his entire collection. He gave over sixty water-colours to the Victoria and Albert Museum in 1894, and many other examples were sent to Christie's sale in 1912, including Turner's unrivalled masterpiece *The blue Righi*, but the Whitworth Institute's stature as a public gallery was greatly enhanced by Taylor's important gift, which formed the nucleus of its now internationally known collection of British water-colours.

William Blake's *Ancient of Days*, **99**, undoubtedly the Gallery's most celebrated water-colour, was included in the Taylor gift, along with six others by the same artist, illustrating Milton's 'Hymn on the morning of Christ's nativity'. Other highlights from the Taylor collection include Paul Sandby's *Ludlow Castle*, John Robert Cozens's *Lake Nemi, looking towards Genzano* and *Rome from the Villa Madama*, Rowlandson's *High life* and *Low life*, Edward Dayes's *Greenwich Hospital* and Constable's *Feering Church and Parsonage*. The most remarkable section of the Taylor collection, however, is its wonderful range of water-colours by Thomas Girtin and Turner. *Durham Cathedral and Bridge*, **100**, and *The west front of Peterborough Cathedral* are included in the group of Girtin water-colours, while the gift of Turner drawings amounts to more than twenty examples, among them the *East end of Canterbury Cathedral* of 1794 and a lively impression of *Petworth Park*. Drawings by some of the less well known artists of the same period are also included, and in 1895 the donor made an additional gift of 127 drawings by William Mulready.

By this time it was obvious that a more spacious building than Grove House was badly needed. As Richard Christie wrote elsewhere in the 1894 catalogue:

> Grove House is . . . quite inadequate for the display of what has already been collected, and the Council has undertaken the erection of suitable Galleries. These

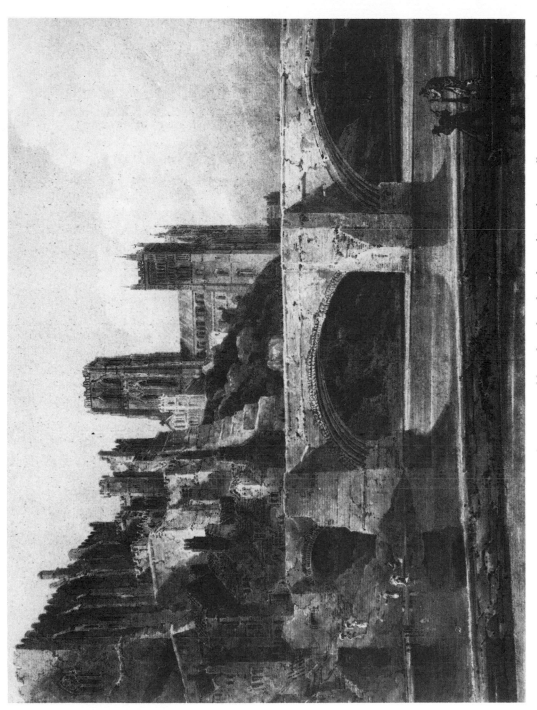

100 Thomas Girtin *Durham Cathedral and Bridge*, 1799. A water-colour presented by John Edward Taylor. *Whitworth Art Gallery, University of Manchester*

are intended in the first instance to be such as are immediately required, Grove House being retained for the offices of the Institute until required to give place at some future time to a characteristic and more completely architectural main building and facade.

In 1891, after an architectural competition with Alfred Waterhouse as assessor, J. W. Beaumont and Sons were appointed architects for the new galleries which were to be attached to the back of Grove House. Beaumont's final plans were accepted in 1894 and the firm was instructed to proceed immediately with the building of the North and Central galleries at a cost of over £10,000. The Building Sub-committee took a special interest in Beaumont's designs for the terracotta spandrils for the arched recesses in the wall facing Denmark Road and, after some modifications, these were finally approved in January 1895. In the early part of 1896 the same committee met to discuss the placing in the Central gallery of the plaster-cast copies from the Parthenon frieze, given by Sir William Agnew and in the North gallery, of other friezes presented by Mrs Crompton Potter.

The final part of this first phase of building, the South gallery, was started in the summer of 1897, and the room was handed over by the contractors in September 1898, having cost approximately £7,000, **101**.[12] The Institute at this stage, therefore, consisted of the remodelled interior of Grove House, from which corridors led to the three new large galleries behind it, **102**.

The second phase of building dates from 1904, when the Governors announced that plans had been prepared for an extension which would include a library, a lecture room, sculpture gallery, council room, offices, an entrance hall, further galleries at the back, and a new facade at the front. It was in October this same year that the park was transferred to the Corporation of Manchester at a nominal rent of £10 a year for a period of 1,000 years, thus saving the Institute almost £1,500 a year on the upkeep of the grounds.

Work was commenced in 1905 on three new exhibition galleries, added at the west side and leading out of the Central gallery. The president and council held a reception on the evening of 7 March 1906 to celebrate the opening of these rooms, which had been filled with exhibits normally shown in Grove House, so that demolition could proceed to make way for Beaumont's imposing new entrance front. The exhibition galleries, each measuring approximately 80 ft by 30 ft (24·384 m × 9·144 m), were simple in design, with plain walls and skylights along the curved ceilings. Although they remained physically unaltered until 1966–68, these rooms were put to a variety of uses, particularly during and after the 1939–45 war, when their tenants included the Manchester College of Art and the Unnamed Society, a well known amateur dramatic group.

It took more than another two years before work was finally completed on

[12] See accounts published in the Manchester Whitworth Institute's *Report of the Council*, 1897, 1898 and 1899.

101 A crowded display of British water-colours in the South gallery, *c.* 1898

102 The north corridor of Grove House, *c.* 1898

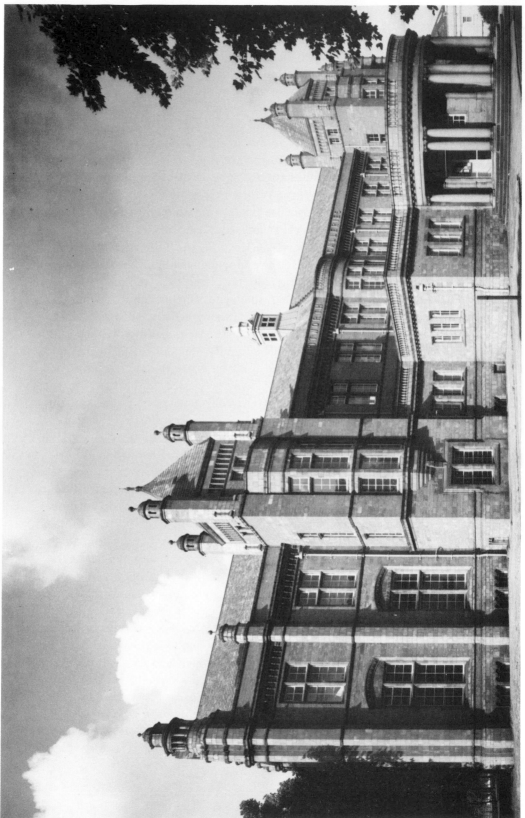

103 J. W. Beaumont and Sons: the front of the Whitworth Art Gallery, built on the site of Grove House and completed in 1908

the most ambitious and grandiose part of the whole memorial, the entrance front, **103**. The Gallery was opened on Wednesday 29 July 1908 by Sir Charles Holroyd, Director of the National Gallery, under the chairmanship of Sir Edward Donner, and in the presence of many of the Governors, including the only surviving Whitworth legatee, R. D. Darbishire. Lady Whitworth and R. C. Christie had died in 1896 and 1901 respectively.

Before Sir Charles Holroyd was invited to address the gathering, a special tribute was paid to the legatees, and Darbishire gave an interesting account of his own involvement in the foundation of the Institute.[13] He produced a statement of payments made out of the Whitworth estate which, in addition to expenses connected with the Institute amounting to more than £150,000, included financial aid to the Technical School, the School of Art, Owens College, the Manchester Museum, the Darley Dale Hospital and Educational Institute, and Openshaw public baths, and also the endowment of Whitworth Engineering Scholarships. Even after spending close on £1 million, well over £200,000 remained, and this money was also spent on further endowments and benefactions. Appreciation of Darbishire's untiring efforts, both as a legatee and as honorary secretary of the Institute since the first meeting, was shown in two ways: the new sculpture gallery, subsequently remodelled as a display area for textiles, was henceforth to be named the Darbishire Hall; and a portrait of Darbishire, as well as one of Whitworth, was presented to the Institute and unveiled immediately before Sir Charles Holroyd rose to speak. Darbishire died less than four months after this occasion, but his portrait still hangs today in the Gallery's entrance hall, across the room from that of Sir Joseph.

The 209 ft (63·703 m) long facade of the new building facing Oxford Road was built of red brick with terracotta ornamentation to correspond with the exterior of the galleries erected in the 1890s. Central steps, with a semi-circular porch carried on paired columns of grey granite, indicate the main entrance. From it a vestibule and handsome square hall lead to the wide Darbishire Hall, which was terminated at either end by an arcaded screen giving access to the two main staircases. The council chamber and library were situated on the first floor, and in between them and above the sculpture gallery ran a long exhibition room, reconstructed in 1976 to form a new Print Room and Textile Department with curatorial offices.

Although the building was scarcely altered from 1908 until the 1960s, the collections had continued to grow considerably from the 1890s onwards. In 1893 Charles Edward Lees (1840–94), whose industrial interests included coal, iron and spinning, presented thirteen water-colours, among them *Conway Castle* by Paul Sandby and *Salisbury Cathedral* by Edward Dayes, and in 1905 an important group of twenty-four water-colours, including ten works by Turner, was bequeathed by Mrs James Worthington. Furthermore, a number of

[13] A report of the proceedings was published by the *Manchester Guardian*, 30 July 1908.

water-colours illustrating places of beauty around Manchester had been purchased out of the £500 donated for the purpose by Thomas Horsfall in 1890. It is not surprising, therefore, that A. J. Finberg, writing in the *London Star* of 7 October 1905, selected the Whitworth as one of the three most important centres in the country where the work of the English water-colourists could be studied with advantage, the other two collections being those of the British Museum and the Victoria and Albert Museum. In addition to Turner's *Liber studiorum* there was a sizeable collection of prints, and as early as 1896 G. T. Clough had indicated in a letter to the committee that he intended to bequeath his outstanding collection of Dürer and other Renaissance prints to the Whitworth.[14] These were, in fact, presented to the Gallery in Clough's lifetime in 1921. The Gallery also possessed a good many oil paintings by this time, mostly of the nineteenth century British school, including works by Clarkson Stanfield, David Roberts, J. F. Lewis, Henry Liverseege, Thomas Webster and Briton Rivière. *Spring time* by James T. Linnell was offered as a gift by Miss Heaven of Victoria Park in November 1894 and, although its meticulously detailed branches and foliage were long out of fashion, it is one of the most popular exhibits today.

The sculpture acquisitions by this date could hardly be called a collection and, apart from an odd assortment of plaster casts, they included an 'Annunciation' tympanum of the Della Robbia school, presented by the Misses Gaskell, a marble *Head of Medusa* by G. F. Watts, presented by Charles Lees, and a gigantic Japanese bronze vase, decorated with twisting dragons and mischievous monkeys. Over the next fifty years, rather than attempting to enlarge the oil painting collection, the committee disposed of numerous works and added little in the way of sculpture, so that, when the Gallery was handed over to the University of Manchester in 1958, its reputation relied principally on three major collections—textiles, prints and British water-colours and drawings. There were also smaller collections of Old Master drawings and modern Continental works, the latter having been astutely acquired by G. P. Dudley Wallis during his term of curatorship, 1921–36.

Many benefactors helped to enlarge these collections in that fifty-year period between 1908 and 1958, but none deserves more credit as a generous patron than Miss Margaret Pilkington (1891–1974), honorary director from 1936 to 1959. Under her custodianship, important acquisitions were made in all fields, thanks also to the generosity of some notable private donors,[15] the War Artists' Advisory Committee and the Friends of the Whitworth, founded in 1933. Margaret Pilkington herself enriched the British drawings collection with numerous personal gifts, including works by Bonington, Barbara Hepworth, L.

[14] Manchester Whitworth Institute, Minutes of Council, 9 March 1897.
[15] E.g. Sir Thomas D. Barlow, Joseph Knight, Professor and Mrs P. E. Newberry, Denis F. Pilkington and Dr Percy Withers.

S. Lowry and Francis Towne. Another great benefactor of drawings was A. E. Anderson (1870–1938),[16] who as early as 1906 presented John Varley's *Harlech Castle* and for the next thirty years made many other gifts of the highest quality, including works by Tiepolo, Gainsborough and Picasso.

When the university accepted control of the Gallery it was obvious that the collections not only needed more space but also deserved a more sympathetic and attractive display area. The architect John Bickerdike (1924–81) was therefore invited to produce a scheme for modernising the interior. The time had come to replace the rows of dangling electric light bulbs with a more effective system, planned also to protect exhibits from daylight streaming through roof glazing in all the galleries. The design removed the cumbersome dark brown heating pipes from along the skirting of each room, reduced ceiling heights, simplified the wall surfaces by taking down the plaster friezes, improved environmental conditions and created an entirely new room in the centre of the Gallery. Funds were provided for this ambitious reconstruction by the university, the Calouste Gulbenkian Foundation and the University Grants Committee. The work was carried out in two phases, the central area in 1963–64 and the outer galleries between 1966 and 1968. Bickerdike's designs included many attractive features, in particular a mezzanine area above the North and Central galleries, large windows looking out on to Whitworth Park, alcove cases for exhibiting textiles in the Darbishire Hall, and the transformation of an area of awkward spaces into a new display area, named the Calouste Gulbenkian Room.

Since the modernisation scheme was completed in 1968 the collections have continued to grow, particularly in the fields of Near Eastern textiles and contemporary works of art.[17] Moreover, in 1967, Wall Paper Manufacturers Ltd donated its large and important collection of historic wallpapers, providing useful links with certain groups of prints and textiles.

Today it could be claimed with justification that at least some of the ideals which the three legatees had in mind when they decided to found a worthy memorial to Sir Joseph Whitworth have been successfully fulfilled, for the Whitworth Art Gallery is now serving the objects which they envisaged at the time of the royal charter of 1889, 'The Collection, Exhibition, and Illustration of Fine Works of Art, and the Study of and Instruction in Fine Arts, by means of Galleries, Libraries, Lectures, Classes, and other methods'.

[16] See article by M. Clarke in *French 19th century drawings in the Whitworth Art Gallery*, 1981.
[17] See *Guide to the Whitworth Art Gallery*, with contributions by members of the Gallery staff, 1979.

Basil Champneys and the John Rylands Library

When John Rylands died in 1888 his third wife and chief beneficiary, Enriqueta Augustina, was left to ponder how best to honour the memory of England's leading cotton trader, a devout Christian who had spent many of his leisure hours and much of his immense wealth in philanthropic activity and the promotion of evangelical education.[1] A commemorative building of some kind was the obvious solution, but the Rylandses' architectural patronage, though generous, had never been particularly discriminating. In 1887, however, the family had associated itself with a decidedly prestigious building project in subscribing to the establishment of Mansfield College, the new Congregational foundation at Oxford.[2] So when Mrs Rylands resolved to commemorate her husband's aspirations and achievements in a large, lavishly appointed ecumenical theological library, it was to the architect of Mansfield, Basil Champneys (1842–1935), **104**, that she entrusted the commission.

Mansfield is one of the most impressive and convincing of a large number of Gothic buildings designed by Champneys, whose early training and experience gave him a thorough grounding in medieval architecture.[3] Articled in 1864 to that serious-minded Goth John Prichard (1817–86), Champneys set up in practice in 1867, launching his career with the large and pugnacious brick church of St Luke, Kentish Town (1868–70). Its uncompromising prismatic forms and rugged French twelfth-century detail were derived from Bodley's churches at Brighton (1858–61) and Selsley (1862), but though good of its type

[1] After the death of his last surviving son in 1861, and of his only brother in 1863, John Rylands (1801–88) turned increasingly towards religion and good works. He built up a large private library of theological books, financed the publication of several evangelical editions of the Bible and made a collection of 50,000 hymns to establish the essential unity of the Christian Church. The Rylands Orphanage in Greenheys was set up in the year following his last son's death, and in 1880 Rylands was decorated by the King of Italy for founding an orphanage in Trastevere, on the outskirts of Rome. These and many other similar projects show him to have been a characteristic Victorian philanthropic industrialist. Enriqueta (1843–1908) survived her husband by twenty years. See D. A. Farnie, 'John Rylands of Manchester', *Bulletin of the John Rylands University Library of Manchester*, vol. 56, 1973, pp. 93–129. Dr Farnie includes an extensive list of biographical references.

[2] See C. Binfield, *So down to prayers. Studies in English Nonconformity, 1780–1920*, 1977, pp. 166–7.

[3] See his obituary in *RIBA Journal*, vol. 42, 1934–35, pp. 737–8, and Henry Stapleton's *The model working parson*, 1976, pp. 71–3 (a privately published account of the Champneys family, centred on the life of the architect's father, William Weldon Champneys, Dean of Lichfield).

this church was something of a false start for its architect and stylistically the antithesis of his later work. Few commissions followed this memorable if slightly old-fashioned début, and it was not until 1874 that Champneys was able to demonstrate, in St Luke's, Matfield (Kent), and St Peter le Bailey at Oxford, his abrupt and complete conversion to the English late Gothic manner which Bodley had embraced during the previous decade.[4] Over the next few years he experimented with medieval styles from late Decorated to Tudor, rearranging form and detail with the licence that is a characteristic of his more widely known Queen Anne work.[5]

With the one exception of St Luke's, Kentish Town, Champneys' Gothic buildings are never assertive but are more remarkable for the sensitive way in which they respond to their surroundings. Occasionally he was overtly symbolic in his manipulation of form and ornament, as in the church of St Mary, Star of the Sea, Hastings (1882–87), designed for Coventry Patmore, where a substantial cylindrical turret, built in bands of flint and dressed stone and crowned with a Tudor pepperpot, rises to become a metaphorical lighthouse appropriate to the dedication. Elsewhere Champneys upsets stylistic categoris-ation by combining the decorative vocabulary of one phase of the Gothic Revival with the form and structure of another. In St George's, Glascote, Staffs. (1876–80), for example, the tower is that of Butterfield's Middle-pointed St Alban's, Holborn (1862–63), disguised and tamed by late Decorated tracery. All these distinguishing characteristics are embodied to a greater or lesser degree in the Rylands Library, but its design also represents the culmination of the unusually strong historicist trend which dominates the Gothic works of the central part of Champneys' career and can be traced back to the buildings he erected in the Holywell district of Oxford during the period 1885–89.

The favourable impression made by the inventive classicism of his Indian Institute, Oxford (first phase 1883–90), probably assured Champneys of the commission for New College, his first Gothic collegiate work. This was for the building of a new range of sets to go alongside Gilbert Scott's Holywell Street frontage to New College in 1885. Champneys' lower wing, and the adjoining tutor's house, were executed in a delightful domestic Perpendicular which, though clearly inspired by Bodley and Garner's recent work at Magdalen (1880–84), is thoroughly characteristic of its architect in its thick-set but delicately detailed oriels and the expression of a well controlled instinct for the picturesque.

The special significance of the New College additions lies in the opportunity they afforded their architect to study the original late fourteenth-century college buildings, which were at that time wrongly construed as actual

[4] The architecture of G. F. Bodley (1827–1907) is well summarised in David Verey's chapter, 'George Frederick Bodley: climax of the Gothic Revival', in *Seven Victorian architects*, ed. Jane Fawcett, 1976, pp. 84–101.

[5] For a discussion of the latter see Mark Girouard's *Sweetness and light*, 1977, pp. 49–50, 59, 63.

104 Basil Champneys (1842–1935). 105 Basil Champneys: Mansfield College, Oxford, 1887–89. Chapel interior

Basil Champneys: Mansfield College, Oxford, 1887–89. **106** Library exterior. **107** Library interior

designs by the founder, William of Wykeham. The fortuitous publication in 1887 of George Moberley's life of this great English builder brought Champneys the thrilling revelation that Wykeham's only sister, Agnes, married a man who bore the unusual name of Champneys.[6] The following year two articles by Champneys on Wykeham's architecture appeared in the *Art Journal;*[7] in the first he proudly claimed collateral descent from the man whom he described as 'the greatest of English Gothic architects known to fame'.

In the meantime Champneys had won for himself a magnificent opportunity to follow in the footsteps of his fourteenth-century hero by securing the coveted task of designing a brand-new religious foundation, Mansfield College. Built with the donations of a number of wealthy northern Dissenters between 1887 and 1889, the college is the first building in which the architect's new-found interest in Wykeham is expressed; the Rylands Library is the second. The land bought for the college was a stone's throw from Holywell Street, and Champneys' Indian Institute and New College buildings, standing at either end, must have impressed upon the Congregationalists the notion that he was the coming man, for when Alfred Waterhouse, the grandest architect who worked for the northern Nonconformists, was invited to draw up a design it appears that Champneys also was asked for drawings. Waterhouse made the error of attempting a design in the Queen Anne style, which in the Oxford of 1887 was associated with the suburbs, whereas Champneys evolved his winning design from the Perpendicular Gothic of his New College buildings and produced a scheme that promised to give the Congregationalist presence in Oxford architectural parity with the more ancient academic institutions, **105–07**. Of those aspects of the college which express Champneys' almost adolescent reverence for Wykeham's architecture, the most easily recognisable is the gate tower, which in its upper storeys is obviously modelled on the austerely treated Muniment Tower and gatehouse at New College (1380),[8] while the college library may acknowledge a more obscure instance of the bishop's patronage. The cosy, timber first-floor reading room, **107**, which is said to have appealed so strongly to Mrs Rylands when newly completed in 1889, is one of the architect's best works and is not as well known as it deserves to be. The organisation of the space into a central aisle with lateral reading bays is accomplished by the spere-trusses of a great, open timber roof. Close precedents for this unusual structure are to be found in medieval barns. We can be fairly sure that Champneys had in mind the great tithe barn at Harmondsworth, **108**, that is traditionally associated with William of Wykeham, who acquired the manor in 1391,[9]

[6] G. Moberley, *Life of William of Wykeham*, 1887.

[7] 'William of Wykeham', *Art-Journal*, 1888, pp. 161–65, 257–62.

[8] The design of the Mansfield gatehouse was amplified in the Robinson tower at New College, with which Champneys linked his new sets to Gilbert Scott's buildings in 1896.

[9] Wykeham's connection with Harmondsworth was well known in the nineteenth century and Champneys could have learnt of it from James Thorne's *Handbook to the environs of London*, 1876, vol. 1, p. 320. I am grateful to Michael Robbins for this reference.

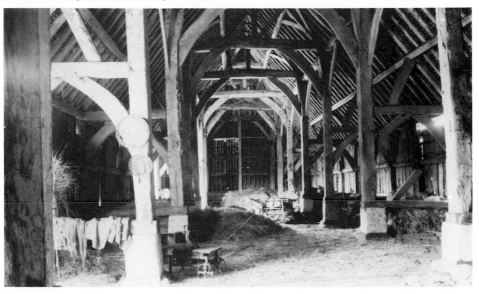

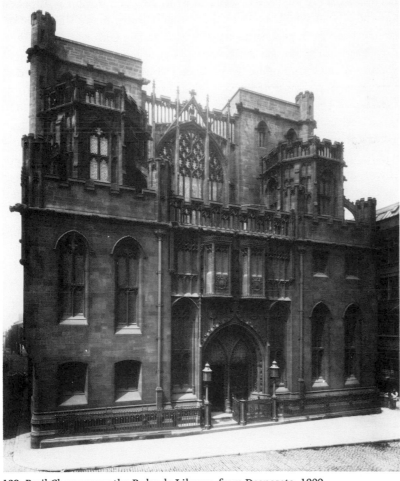

109 Basil Champneys: the Rylands Library, from Deansgate, 1900

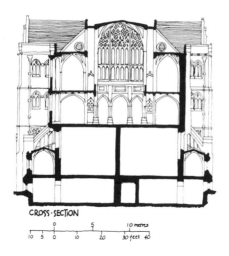

CROSS·SECTION

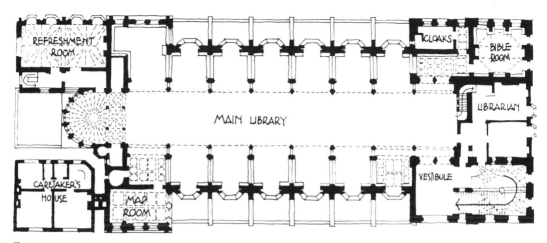

MAIN LIBRARY

REFRESHMENT ROOM

CLOAKS

BIBLE ROOM

LIBRARIAN

CARETAKER'S HOUSE

MAP ROOM

VESTIBULE

FIRST FLOOR

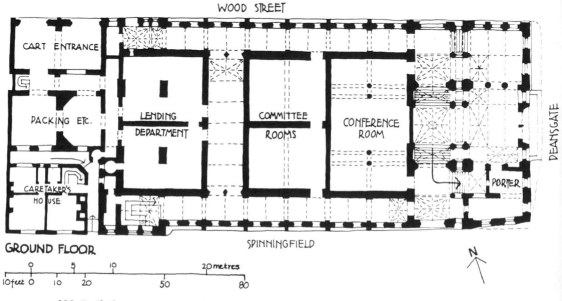

WOOD STREET

CART ENTRANCE

PACKING ETC.

LENDING DEPARTMENT

COMMITTEE ROOMS

CONFERENCE ROOM

CARETAKER'S HOUSE

PORTER

DEANSGATE

GROUND FLOOR

SPINNINGFIELD

20 metres

10feet 0 10 20 50 80

N

110 Basil Champneys: the Rylands Library, 1890–99. Plan and section

because the previous year he had installed a new rood screen in the parish church at Colnbrook, the neighbouring village.

The architect's interpretation of this structure was far from literal, and the princely brattishings and open tracery of the Mansfield roof indicate a different response to vernacular building from the more primitivist expression adopted by some Arts and Crafts architects. This is even more apparent in the translation of the pleasant timbered hall at Mansfield into the smooth, luxurious ashlar of the Rylands Library.

The Library was completed in October 1899, **109**, and a year later, in a lecture to the RIBA, Champneys recalled the brief from which the Rylands design had been developed ten years previously.[10] If 'the form and style suggested indicated a College Library in the later Gothic', Champneys remarked, 'the scope of the undertaking was obviously more extensive than any known example'. There were also special requirements; first, the very large number of books to be accommodated; second, loan and reference sections were to be provided, each with a totally separate entrance; and then other large rooms were needed, one for public meetings and two for committees. Further requirements were a suite of rooms for the librarians, refreshments rooms for the staff and public, and all the necessary spaces for unpacking and sorting. Part of the basement was to be reserved for muniments, and much of its area was devoted to services that as well as heating apparatus included engines and dynamos for electric lighting. A caretaker's house was to be detached from but in close connection with the Library, and, Champneys added, 'It was also urged on me that the vestibule should be of very considerable size and importance, and the main staircase or staircases ample and imposing.'[11]

The site of the Library was a narrow rectangle with a short side fronting Deansgate. To north and south it was bounded by Wood Street and Spinningfield, then both narrow thoroughfares between tall warehouses which shut out the light and posed a fire hazard. Several of the surrounding properties possessed ancient rights of light, which meant that at its boundaries the building had to be kept relatively low. The plans and sections, **110**, show how Champneys satisfied these demands. The main library was placed on the first floor over the committee rooms and the lending department. Low corridors running down the flanks, **116**, and the squat vestibule block at the Deansgate end, **109**, provided luxurious circulation routes which also insulated readers from street noise, allowed extra light to penetrate the central core over their roofs and filled the site without infringing ancient lights. It was ostensibly in the interests of fire-proofing that the architect decided on masonry construction, selecting a high-quality sandstone from Penrith; this consideration also justified the lavish use of vaulting and determined the independent expression

[10] 'The John Rylands Library, Manchester', *RIBA Journal*, vol. 8, 1900, p. 100.
[11] *Op. cit.*, p. 101.

of the caretaker's house and refreshment block. The drawings also show how at its edges a functional plan was squeezed into a symmetrical Gothic armature of turrets, towers and transepts. This design, completed in 1899, would have housed comfortably the original theological library, but in the course of construction other more precious collections were acquired. In 1892 Mrs Rylands bought the immensely valuable Althorp library of ancient manuscripts and early printed books, and while no change was made in the planning of the building to accommodate them, as an additional fire precaution the deep, tiled roof (externally similar to the library roof at Mansfield) was abandoned in favour of a concrete flat roof finished with macadam. But when the stock was further extended by the purchase of the Crawford collection in 1901 the burden proved too great and in 1913 Champneys, who had taken into partnership his eldest son Amian, built as one of his last works an extension adjoining the refreshment block on Wood Street.[12] Its character is rather more utilitarian than the rest of the building.

Champneys drew up the plans and elevations of the library within a week of receiving the commission from his client, but this initial speed contrasts ironically with the protracted process of construction, which extended over a decade and was bedevilled by misunderstandings and conflicts of personality. The story is unfolded in a nearly complete record of correspondence from which it is possible to identify all the designers and contractors with their respective contributions to the work, and also discover the cost, approximately £230,000 inclusive of fees, a sum apparently withheld from the technical press.[13] The builders were Morrison's of Wavertree, Liverpool. Joseph Bridgeman of Lichfield, who had worked with Champneys at Mansfield, was responsible for most of the timber panelling, complicated stone tabernacle work and most of the sculpture. However, John Cassidy (1860–1939), the fashionable Manchester sculptor, executed the group of *Theology directing the labours of Science and Art* for the vestibule and the statues of John and Enriqueta Rylands for the main library. Moulds for the plaster ceilings were made by George Frampton (1860–1928), and the whole building was glazed by C. E. Kempe (1834–1907), who painted the figures of the main gable windows. A certain amount of the metalwork, including the lending library galleries, was made by Crittall's to designs by Champneys, but the lavish Art Nouveau electroliers, switches, heating-coil cases and railings were designed and executed in bronze by Singer's of Frome, 115.[14] The electrical circuits were planned by Charles Hopkinson and installed by Bertram Thomas. The clerk of works, Stephen

[12] Amian Champneys was well equipped to tackle this, having already published a manual on the design of libraries, *Public libraries. A treatise on their design, construction and fittings*, 1907.

[13] Four volumes of letters are held at the Rylands Library (now the Deansgate Building, John Rylands University Library of Manchester). For details of the expenditure see vol. 4, pp. 191–200.

[14] See Chloë Bennett, 'The story of the metalwork in the John Rylands Library, Manchester, 1895–99, University of Manchester BA thesis, 1976.

Kemp, had held the same office at Mansfield and was Champneys' personal protégé, but his character seems to have deteriorated from the moment he became involved with the library. His pathological arrogance and lack of tact aggravated the poor relations between the various contractors, and the client and the architect. Suspicions of embezzlement and blackmail fell on him but were never proved, and Champneys' repeated attempts to secure his dismissal did not succeed. Kemp's conscientious supervision of the work did, however, ensure that the high standards of craftsmanship exhibited at Mansfield were excelled in Manchester. Working for an architect who rarely visited the site, and sometimes from inadequate drawings—he once complained of having to produce sixty sheets of extra working drawings for book cases alone—Kemp was vital to the successful outcome of the work.[15]

Mrs Rylands emerges from her letters as an enterprising but far from ideal client. Champneys remained polite but clearly found her interventions insufferable. Whereas she allowed him a good deal of freedom in the initial design of the building, she later instituted minor but highly expensive and time-consuming changes in parts that had already been constructed. Also she was determined to have absolute control over the selection of sculpture, stained glass, electrical fittings and furniture just as though she were decorating a house. Champneys cannot, therefore, be given any credit for most of the remarkable bronzework; neither can he be blamed for the pedestrian design of the Gothic tables and chairs, nor for the crassly designed clock cases of the committee rooms which, much to his indignation, were the handiwork of Kemp.[16] By stealth where possible, Mrs Rylands generally avoided discussion of these issues, but when they were debated, or when Champneys learned of some significant decision after it had been made, an argument generally ensued. The architect's 1896 spring holiday in Scotland was marred when he broke his journey north by his discovery of some stained glass which had been installed. Charles Kempe had introduced some coloured panels which Champneys disdainfully described as 'geometrical patterns of a crude type with sprays of fruit and foliage of a kind usually associated with villa residences pretending to be artistic' and 'expressive of the using up of odds and ends'.[17] The offending glass was removed on this occasion, but he had less success with the sculpture. If we find Bridgeman's historical figures in the main library rather dull, Champneys would have agreed, since he told his client in July 1893 that the sample figures were 'tame and inartistic' and 'likely to be very unfavourably criticized', commending instead rival designs submitted by George Frampton.[18]

Perhaps the most interesting single issue over which Champneys and his client were divided was the religious quality which suffused the design of the

[15] Letter Book, vol. 4, p. 140, letter dated 1 January 1900.
[16] *Ibid.*, vol. 3, p. 157.
[17] *Ibid.*, vol. 2, pp. 105–08, letter dated 13 April 1896.
[18] *Ibid.*, vol. 1, p. 139, letter dated 14 July 1893.

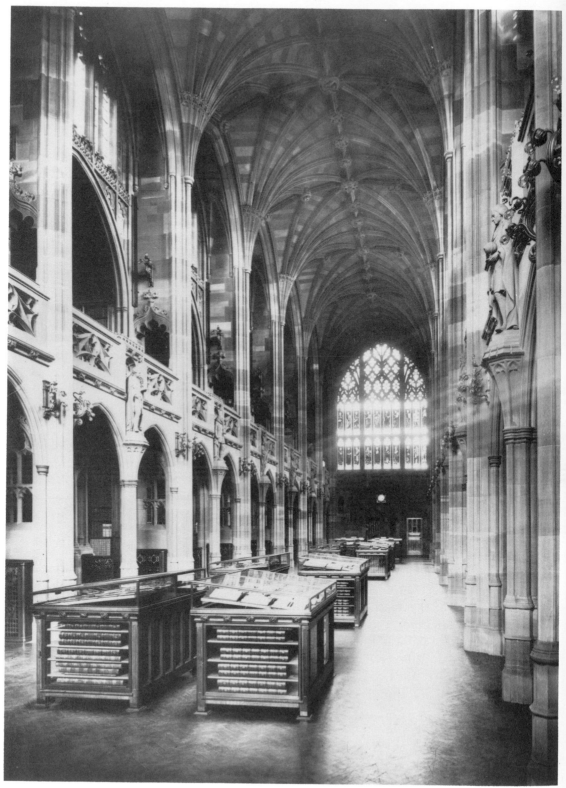

111 Basil Champneys: the Rylands Library. Interior of the main library, 1900

main library, **111**. While it is clear that the side oriels of the Mansfield College library, **106**, provided a ready-made solution for the external elevation, **116**, that there is a basic affinity between the plans of the two buildings and that the college gatehouse was in the architect's mind when he designed the two towers of the Deansgate end, it is obvious also that Champneys turned to the repertory of ecclesiastical architecture to endow the interior with greater monumentality. It has been observed recently that the library possesses the unique distinction of being the only Victorian building to adopt in its entirety the structural and spatial formula of St Augustine's, Kilburn (1870–80).[19] The organisation of the vaulting bays, the internal buttresses and the galleried walks which pierce them, as well as the side spaces perceived through this skeleton, are clearly derived from Pearson's design. Champneys admired Pearson's work even though its character was entirely different from his own, and in an article which he wrote in 1887 he illustrated Kilburn, singling it out as 'an important landmark in the history of the Revival', and praising its structural integrity.[20] The bipartite bay arcades which form the entrances of the lower reading recesses are derived unashamedly from Mansfield chapel, **105**, and, together with a wealth of late Decorated and Perpendicular ornament, they help to disguise the true structural ancestry of the design. The internal elevation of the main library, **111**, seems, by comparison with other buildings of the period, remarkably opulent, so it comes as a surprise to compare it with a preliminary sketch, **112**, which shows the executed design to be a considerable simplification of the original intention. The early drawing of one bay shows extra sculpture, more panelling and, most fascinating of all, screens of tracery cascading down before the openings of the reading bays.[21] Other drawings indicate that the dense tracery patterns of the gable windows were initially intended to be seen through a second and different internal trellis of geometric shapes. Champneys explained the tracery screens of the reading bays by referring to 'some old recesses in the Bodleian',[22] but they make more sense if the whole relevation is seen alongside a drawing by T. Raffles Davison, **113**, which illustrated Champneys' first article in the *Art Journal* on William of Wykeham's architecture and shows the bay of Winchester Cathedral nave that is filled up by the traceried walls of the bishop's chantry chapel. There is also, it must be admitted, a direct reference to the choir of Gloucester Cathedral. Champneys, who was well aware of the religious overtones of the library and referred to the side corridors as 'cloisters', was no doubt sensitive to the parallel between the readers who would have to study their theological texts behind tracery grills and the ancient chantry priests who once intoned masses for the

[19] A Quiney, *John Loughborough Pearson*, 1979, p. 114.
[20] 'The architecture of Queen Victoria's reign', *Art-Journal*, 1887, p. 207.
[21] A bound volume of plans and sketches for the Library is held in the planning office of Manchester University. The drawings for the Wood Street extension are included.
[22] Champneys, in *RIBA Journal*, vol. 8, 1900, p. 113.

112 Basil Champneys: the Rylands Library. Early sketch of one bay of the main library interior. 113 Winchester Cathedral, Wykeham's Chantry. (Drawing by T. Raffles Davison, *Art Journal*, 1888)

soul of Wykeham. This devotional quality is given meaning by the vaulted apse at the western end of the main library, which was initially conceived as the setting for a bust of John Rylands upon which the six small windows would have shed a mysterious and religious light.

As the building began to rise in the early 1890s the recognition of its overwhelming ecclesiastical aura began to dawn uncomfortably on a client who clearly had not properly understood the drawings. On 24 February 1893 Mrs Rylands wrote from the Hotel Metropole at Cannes, 'I think I have mentioned before that I am wishful to avoid anything that gives an ecclesiastical appearance to the building and for this reason in my statues and window figures am avoiding anything which has that tendency,'[23] a remark that explains Kempe's emphatically secular stained glass designs, and the little Renaissance semi-domes which Champneys substituted for the original Gothic tabernacles of Bridgeman's historical figures.[24] These last were introduced after Mrs Rylands had insisted that the central sections of each internal bay be taken down to floor level and rebuilt so that the statues might be treated with a boldness that cannot attach to figures cramped up in niches'.[25] The screens of tracery over the reading bays and gable windows were done away with and, in the final outcome, John Rylands was represented by a full-length standing figure in the central aisle. It was executed by Cassidy for £1,325.[26]

Today, while we may regret that Champneys was prevented from carrying out the full design in all its diaphanous complexity and sepulchral symbolism, we can also understand Mrs Rylands's misgivings. The most successful library interiors are calm rather than breathtaking, and conducive to study rather than religious emotion. Much of the freshness and intimacy of Mansfield library were lost, moreover, in this remarkable reinterpretation, and it is significant that the books are so conspicuously absent, tucked away behind plate glass in the reading bays. In fact it was only in the utilitarian interior of the lending department that Champneys unconsciously reproduced some of the pleasant qualities of the earlier work. In any case Mrs Rylands had her own idea of how the commemorative purpose of the library could best be expressed, for it was she who devised the comprehensive iconographic scheme with its sculpture and painted representations of great cultural figures from the past, its shields bearing heraldic devices or ancient printers' marks, and its scrolls with Latin mottoes.

There was, however, one area of the building in which Mrs Rylands scarcely interfered at all and with which she must have been well satisfied, and that was the entrance hall or vestibule, which, it will be remembered, was to be 'of very considerable size and importance', **114**. It was a challenge to which

[23] Letter Book, vol. 1, p. 110, letter dated 24 February 1893.
[24] Champneys deployed such semi-domes more effectively in the charming sedilia of St Luke's, Hampstead, 1898.
[25] Letter Book, vol. 1, p. 118, letter dated 24 February 1893.
[26] *Ibid.*, vol. 1, p. 130.

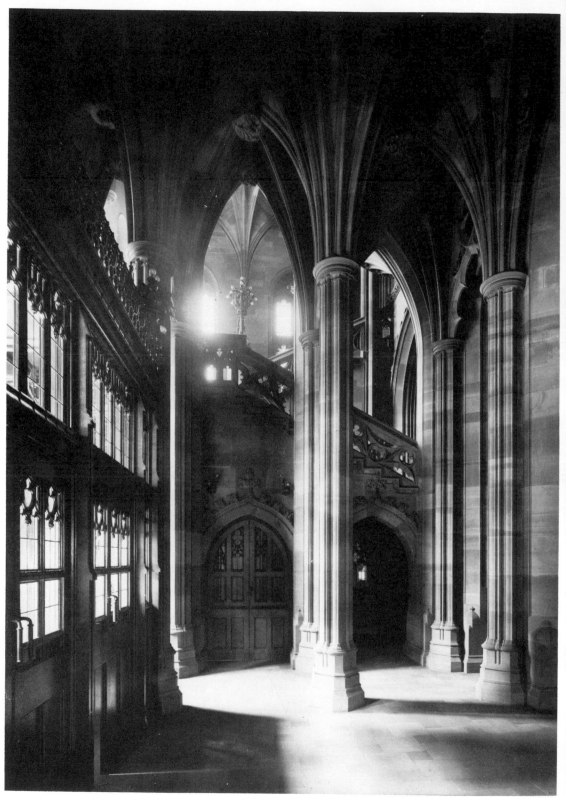

114 Basil Champneys: the Rylands Library. Vestibule interior, 1900

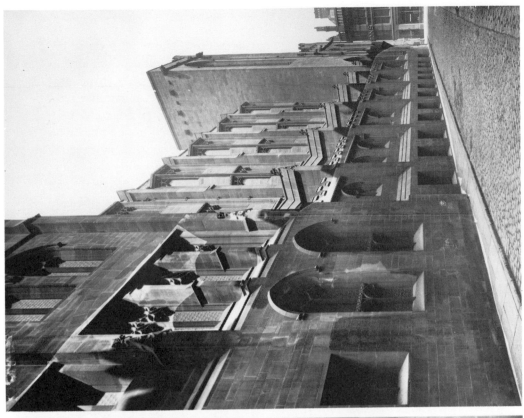

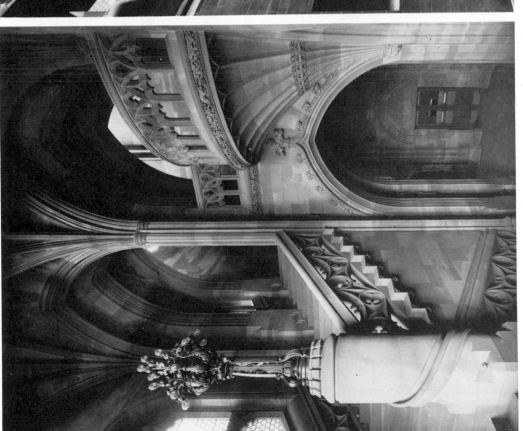

Basil Champneys: the Rylands Library. 115 Main staircase, 1900. The spectacular light fitting, and similar details in bronze, were designed and made by J. W. Singer and Sons, of Frome. 116 From Spinningfield, 1900

Champneys rose with great energy and imagination. Those who enter the building for the first time will momentarily forget any thought of study and, as their eyes become used to the subdued light, begin to explore one of the most interesting Gothic spaces of the nineteenth century. The forest of pillars and vaulting shafts is difficult to disentangle at first, but the design falls into three sections: a central lobby flanked on one side by a splendid staircase, 115, and on the other by a pillared hall of no fixed purpose whose minute vaulting bays are thickly ribbed and crowned by heavy bosses. The massive gable wall of the main library is supported above the vestibule by a series of double piers, and between each pair a thin stone membrane is fretted into tracery which, at either extremity, emerges on the outer walls in narrow windows. In the centre of the space shallow steps rise and then divide before Cassidy's group of *Theology directing the labours of Science and Art*, leading to the side corridors and, on the left, to the grand staircase.

The stairs, 115, are lit by tall windows and a lantern in the octagonal turret above, and on bright days shafts of light pour into the darkness of the entrance lobby. The open vault clearly owes something to the octagon at Ely, and its circular form is echoed below by a fan-vaulted quadrant balcony above the first flight. Doors at the top open into the antechamber to the main library, a tall spatial shaft which is the unencumbered volume of the south tower. There is a tenuous relationship between this elaborate design and the remarkable staircases of Waterhouse's Town Hall, where circular forms are also manipulated to great effect, but the comparison really points up the essential differences between their respective architects. Waterhouse's staircases combine dramatic effect with inexorable logical practicality, whereas there is no clear rationale behind Champneys' vestibule, for the impulses which brought it into being were purely artistic. It was designed to impress and unquestionably succeeds. Everywhere there is evidence of the architect's rigorous attention to historical detail in the profiles and other decorative devices, but the dogged insistence that every shaft should have both capital and base, and every chamfer its own stop, produces a congested effect at certain points. Also there are areas of the vestibule where forms collide unhappily, particularly at the junction between the staircase and the central lobby.

This expressive but rather undisciplined approach to architectural design is also revealed on the exterior of the building, which is really only seen to full advantage from the direction of Deansgate. The detailing of parts invisible from this direction was too obviously neglected. The fine mouldings of the vestibule plinth, for example, are unceremoniously cut off at the junction with the main block on the north side, and the 'backs' of the main towers are virtually devoid of articulation or ornament, 116. The same weakness is also found at Mansfield, where the long and blandly treated northern elevation of the college was clearly considered 'backstage'. In July 1893, moreoever, Champneys ascertained that

certain parts of the Library's upper works would not be seen from the close confines of the side streets and could therefore be built more cheaply in brick.[27] The exterior of the clerestory is thus no more than a brick box, and immediately below the original sight-lines on the back of the towers and turrets are diagonal patches of brickwork. The recent demolition of property on the Spinningfield side to create a civic square has unkindly revealed these economies and the vulnerability of a design that was intended to be viewed 'in very rapid perspective'.[28] This and other developments have dissolved the relationship which the vestibule block once enjoyed with the buildings on either side. It was admirably contrived to hold its own against its neighbours.

Champneys visited and studied a number of famous libraries in order to master their technicalities, but the Rylands itself does not seem to have made any really significant advances in the development of library design. The dust-proof cases, specifically devised to save the precious volumes from Manchester's airborne pollution, were remarked upon at the time, but most of the other impressive technical features—the superb electrical system, which is still in perfect order, and the sophisticated air conditioning and heating mechanisms—were more or less anticipated in other buildings.[29] The overall plan, a first-floor library with double-storey reading bays and a grand staircase, is traditional and could be compared with the Georgian library of Trinity College, Dublin (1712), a building which the architect may have known, since his younger brother Arthur was an authority on Irish architecture.[30] Champneys was clearly more concerned with the development of an expressive Gothic form, and it must be said that despite the clever planning his cellular ecclesiastical space and narrow, mullioned windows conspire to reduce light levels so that it is difficult to work without the aid of the remarkable electric lighting, though Kempe's green German glass, chosen by the client, is also to blame. The additional tracery rejected by Mrs Rylands would have exacerbated the problem, as would the original intention of admitting clerestory light indirectly from skylights in a great pitched roof.

It is quite clear in fact that the desire to achieve the monumental and the mysterious outweighed purely functional considerations. The same tendency is evident in the surprisingly overscaled twin-turreted western narthex which Champneys proposed to add to Manchester Cathedral. The design for this, published in 1895, was in its external appearance little more than a reworking of the Rylands vestibule block.[31] It was rightly rejected on the advice of Bodley,

[27] *Ibid.*, vol. 1, p. 138.

[28] Champneys, in *RIBA Journal*, vol. 8, p. 114.

[29] The decision to use electric light was not taken before 1894. Electric light had been used in England since about 1880, and Dr Hopkinson had already supervised an installation at Manchester Royal Infirmary. For further detail on the Rylands system see N. Wilkins, 'The lighting of the John Rylands Library', *Communication* (internal magazine of Manchester University), May 1974, pp. 9–10.

[30] A. C. Champneys, *Irish ecclesiastical architecture*, 1910.

[31] See the *Builder*, vol. 69, p. 258, 12 October 1895.

then the consultant architect, though the Victoria Porch and vestries, built in its place in 1898, salvaged the lower parts of the earlier scheme.

One aspect of the last phase of the Gothic Revival was a return to its origins, the English late Gothic that had been so convincingly practised by Pugin;[32] but few of the buildings designed by architects like the younger Gilbert Scott, Bodley or Sedding in the last three decades of the century actually look like works of the 1830s and '40s. Their churches and secular buildings were a genuine attempt to exploit the creative possibilities manifest and inherent in the architecture of *c.* 1400. The same cannot truthfully be said of the Rylands Library, where imagination and scholarship are not entirely integrated. Exciting spatial configurations are, by and large, accompanied by conventional and predictable Gothic details. Champneys' use of English late Gothic was old-fashioned, to the extent that one can almost discern the ghost of the Hardwicks' Lincoln's Inn Library (1842–43) hovering behind the towers of the eastern front, while the historical portraits, the coats of arms, the richly shafted and tabernacled elevations and the suites of linenfold panelled rooms are all powerfully redolent of the most richly ornamented secular works of Pugin. The reaction of the architectural establishment is attested by Beresford Pite (1861–1937), who in January 1900 attended Champneys' lecture on the newly completed building. For Pite the Library 'certainly removed the reproach that the Law Courts were the last word on the subject of English Gothic', and he found it

> interesting to note as he supposed their critical historian would in future that he had reverted to the style of Welby Pugin and Sir Charles Barry in the Houses of Parliament; but from that point of view, even in the adoption of a style that was manifestly and distinctly English Mr Champneys had moved backwards and his building could not be described as in any way such a modern building as the Houses of Parliament . . . they had gone a step further in a more thorough grasp of what was mediaeval in spirit and character . . .[33]

This back-handed compliment from a perceptive contemporary sounds a critical note that has not been heard since and indicates that by 1900 Champneys' aims were not shared by his compeers; nevertheless, like Pite and others of a significant minority, he thought of himself as an artist, an individualist, and always preferred to be disassociated from the architectural establishment, having firmly declined to join the institution to which he was lecturing. The concepts of progress and absolute originality did not appeal strongly to him, but he had the self-confidence to indulge in a combination of beguiling effects and an unusual vein of historicism that some more self-conscious designers would have eschewed.

[32] E.g. in the Houses of Parliament. Pugin urged the close study of English Gothic generally in *An apology for the revival of Christian architecture in England*, 1843, pp. 22–2.
[33] Basil Champneys, in *RIBA Journal*, vol. 8, p. 110.

The only other building in Champneys' *oeuvre* which can compare in scale and stature with the Rylands Library is Newnham College, Cambridge. It is a splendidly confident group in the Queen Anne style, built between 1874 and 1910, and is possibly the most successful accomplishment by any Victorian architect working in this mode. The buildings that were added to the college in the 1880s and 1890s, Clough Hall (1886–87) and the Pfeiffer Building (1892–93), show that facility of well judged theatricality that is so essential an ingredient in the Rylands Library. Unexpected oriels, improbable elaborate gables, costly terracotta swags and curious, painted casements are blended in an intoxicating mixture which invests the buildings with the quality of a dream. The Rylands Library, though very different in style, is possessed of the same fantastic quality in the freedom of its composition.

The stylistic currents of late Victorian and Edwardian architecture are indeed swift and inextricably intermingled. Pite's criticism suggests that in the Rylands Library he could discern the aspirations of his grandfather's generation, and it seems to have impaired his enjoyment of the building. His scruples need not hamper ours.

Acknowledgement. I am especially indebted to James Aulich in the preparation of this chapter. His 'The John Rylands Library, Manchester', University of Manchester BA thesis, 1975, is essential reading for anyone interested in the architecture of the library.

The Century Guild connection

The Century Guild of Artists flourished only briefly in the 1880s, yet it has attracted considerable attention, not least through the claims made for it by its chief protagonist, Arthur Heygate Mackmurdo (1851–1942), architect, designer, social, artistic and currency reformer.[1] Its work in the applied arts provided a vocabulary for many architects and designers in the 1890s and its influence was disseminated through the self-consciously artistic magazine *The Century Guild Hobby Horse*, first published in 1884, **117**.[2] Straddling as it did the Aesthetic and Arts and Crafts movements, and displaying characteristics of Art Nouveau a decade or more earlier than they manifested elsewhere, the Guild does not lend itself to neat classification and has been an obvious subject for speculation. Contemporary opinion upon both its aims and style was not always favourable. In 1885 the *Cabinet Maker* observed, caustically, that

> . . . some enterprising West-end architects and their friends are now trading under this imposing style and title, and, according to their manifesto, they essay to pose as reformers in the furnishing world . . . 'The Century Guild' has been formed by a firm of architects—Messrs. Mackmurdo and Horne—in order to bring about a more complete unity in architecture, decoration and furniture—an aim only to be realised by the mutual labour of chosen designers and workmen, *directed by the architect*. Capital idea! Here, then, is a panacea for all the ills that house-furnishers are heir to. Those who desire to furnish according to the axioms of true art need no longer be perplexed. Understand, once for all, ye baffled seekers after *safe* colouring and *correct* forms that such 'aims can only be realised' when 'directed by the architect'. The quintessence of that mystic and undefinable thing, 'complete unity' is, at last, obtainable.[3]

[1] No exact dates are known for either the commencement or the conclusion of the Guild. For information on Mackmurdo see John Doubleday, *The eccentric A. H. Mackmurdo*, Colchester, 1979, (catalogue); Malcolm Haslam, 'A pioneer of Art Nouveau', *Country Life*, vol. 157 (1975), pp. 504–6, 577–9; Nikolaus Pevsner, 'Arthur Heygate Mackmurdo', *Studies in art, architecture and design*, vol. 2, *Victorian and after*, 1968 (reprinted from the *Architectural Review*, vol. 83, 1938); Edward Pond, 'Mackmurdo gleanings', in J. M. Richards and N. Pevsner (eds.), *The anti-rationalists*, 1973 (reprinted from the *Architectural Review*, vol. 128, 1960); Aymer Vallance, 'Mr Arthur H. Mackmurdo and the Century Guild' *Studio*, vol. 16, (1899), pp. 183–92.

[2] See Ian Fletcher, 'Decadence and the little magazines', in Ian Fletcher (ed.), *Decadence and the 1890s*, 1979, pp. 173–202.

[3] *Cabinet Maker and Art Furnisher*, vol. 6, 1885, pp. 29 ff.

THE CENTURY GUILD

HOBBY HORSE

LONDON.
KEGAN PAUL, TRENCH AND CO:
1, PATERNOSTER SQUARE.

117 Selwyn Image: cover of *The Century Guild Hobby Horse*, 1884

The trade press had reason to carp: if original, the Guild's designs were outré and sometimes absurdly exaggerated and unpractical. Mackmurdo founded the Guild and was its physical and spiritual centre. His London house became home, workshop, office and showroom for the Guild as well as home or studio for some of his artist cronies—it was known as 'the Fitzroy Settlement'.[4] Mackmurdo and his partner, Herbert Horne (1864–1916), were the only two persons associated with the Guild to tag the letters 'MCG' (Member of the Century Guild) after their articles in the *Hobby Horse*, but a number of leading designers were actively involved with them. Selwyn Image (1849–1930) undertook stained glass work and decorative painting; Benjamin Creswick (?1854–1946), sculpture and modelling; Clement Heaton (1861–1940), enamelling. Others participating included William de Morgan, Heywood Sumner, Charles Winstanley and George Esling; all were artist craftsmen of a high order, some designing, some producing, and some engaging in both.

Although it had workrooms and agents to sell its wares, the Guild was no ordinary business venture. Rather it was an association of artists with a shared concern to sustain the highest qualities of design and execution. They were, Mackmurdo wrote, '. . . art workers . . . who deeply love their art, not as a means of living but as a fulfilment of life'.[5] An important influence on the formation of the Guild was John Ruskin (1819–1900) and his theories on art and society. Mackmurdo deeply admired him and claimed that as an architectural pupil in the 1870s he had come under Ruskin's spell through reading *Fors clavigera*, monthly letters addressed to 'the Workmen and Labourers of Great Britain'. Later he attended Ruskin's School of Drawing at Oxford, studied Gothic architecture under his direction and travelled with him to Italy. Undoubtedly it was Ruskin as much as the architects for whom he worked, first T. Chatfield Clarke (1825–95) and then James Brooks (1825–1901), the distinguished Gothicist, who led Mackmurdo to appreciate the arts and crafts both for their intrinsic beauty and for their social importance as a means by which craftsmen would regain their creativity and thus their individuality and dignity. This appreciation found practical expression when, for instance, Mackmurdo taught at the Working Men's College,[6] and throughout his life he was involved in idealistic ventures to alleviate the social, political and economic evils of the industrial age. Many had a basis in art, such as the Art for Schools Association, the Home Arts and Industries Association, and the National Association for the Advancement of art and its Application to Industry (founded respectively in 1883, 1884 and 1887). In later life Mackmurdo devoted himself principally to developing an elaborate scheme for reforming the

[4] Ian Fletcher, 'Herbert Horne: the earlier phase', in *English Miscellany*, Rome, 1970, pp. 140 f.

[5] A. H. Mackmurdo, 'History of the Arts and Crafts movement', unpublished typescript in the William Morris Gallery, Walthamstow, p. 215.

[6] Founded under the leadership of F. D. Maurice and opened in 1854 in Red Lion Square, Holborn. In Mackmurdo's time it was run at Queen's Square by the Rev. Stopford Brooke.

economic system.

Mackmurdo's connection with Manchester antedates the founding of the Guild and probably relates to the inauguration there in 1879 of the Ruskin Society, which he claimed was formed at his initiative.[7] Its aims were 'to promote the study and circulation of Mr Ruskin's writings: to exemplify his teachings; and to aid his practical efforts for social improvement'.[8] In 1879 Mackmurdo contributed a group of three lectures to the Manchester programme, **118**. His subject—'The three true causes of industrial depression'—derived from Ruskin's theories on political economy, but in the event the third lecture, on 'Our metallic currency', was given outside the Society's auspices. Ruskin's reaction to the lecture suggests that Mackmurdo had been quite right to dissociate himself from the Society. In a letter to the honorary secretary, F. W. Pullen, Ruskin wrote, '. . . the cause for vexation is great to my mind—greater than ever that any disciple of mine, or any thoughtful person who had ever read ten words of what I have written of the currency should have talked such a quantity of pestiferous nonsense . . .'.[9] Not discouraged, Mackmurdo involved himself with the Society in London and elsewhere but, in 1881, lectured twice more to the Manchester group. In February, on 'Art and its relation to life', a subject dear to him, he explained the moral and political influence that art could exert as well as its more obvious industrial and commercial application; in November his subject was 'Poet painters: or the relativity to art of things spectral and things substantial', in which he considered the distinction between painters who depicted the external world and those who painted from imagination, favouring the possible perfections of the ideal to the inevitable imperfections of represented reality.[10] Mackmurdo's design for the Society's emblem, a rose (Ruskin had suggested the subtitle 'Society of the Rose'), was chosen in a competition organised in April 1881, although the closing date had to be put back to July to enable entrants to work from nature. The emblem was engraved by Arthur Burgess, another Ruskin protégé.

Mackmurdo's activities introduced him to the circle of people who had

[7] Mackmurdo, *op. cit.* p. 221.

[8] R. B. Walker and F. W. Pullen (respectively, chairman and secretary), [*Preliminary Statement*] *The Ruskin Society* [*Society of the Rose*], Manchester, 1879, in the 'Ruskin Society (Manchester)' papers, Archives, MCL. An extract from this is quoted by Cook and Wedderburn (eds.), Ruskin, *Works*, vol. 38, p. 124.

[9] John Ruskin to F. W. Pullen, 27 September 1879, Ruskin Society archives, Archives, MCL.

[10] Mackmurdo's lectures for the Manchester group were: (1) 'The three true causes of industrial depression', given in the YMCA Hall, Peter Street, in 1879; (*a*) 'The land and the people', 22 September; (*b*) 'Usury', 23 September; (*c*) 'Our metallic currency', 24 September, '. . . delivered on Mr Mackmurdo's own responsibility, in order that the proposals contained in it, with which Mr Ruskin had not been made fully acquainted, might not be attributed to him . . .' (quoted from a review of the series by James Odgers in the *Co-operative News*, 4 October 1879, p. 645). (2) 'Art and its relation to life', given in the Royal Institution, Mosley Street, 9 February 1881; reported in the *Manchester Examiner and Times*, 10 February 1881. (3) 'Poet painters', given in the Old Town Hall, King Street, 14 November 1881; reported in the *Manchester Guardian*, 16 November 1881.

THE

Three True Causes of Industrial Depression!

THE RUSKIN SOCIETY.

A SERIES OF

LECTURES

BY

ARTHUR H. MACKMURDO, ESQ.,

WILL BE DELIVERED IN THE

Association Hall, 56, Peter St., Manchester,

ON THE

22nd, 23rd, and 24th SEPTEMBER.

LECTURE TO COMMENCE AT **7-30** ON EACH EVENING.

On Monday, the 22nd September.

THE LAND AND THE PEOPLE: Pointing out the national and individual loss consequent upon the divorce of the people from, and the disregard of their joint interest in, the soil; proposing also such a reform in the holding of the land as shall not permit a cultivation which is imperfect, or a tenure which is unjust.

On Tuesday, the 23rd September.

USURY: Which, by allowing an ever increasing number of persons to maintain themselves in idleness, imposes a heavy tax upon the workers, and increases the indebtedness of the people. Its demoralising influence upon character, and ruinous effect upon industry, specially pointed out.

On Wednesday, the 24th September.

OUR METALLIC CURRENCY: Which, being inexpansible, prevents any expansion of trade, except on a false and unsubstantial credit, and, therefore, by checking employment, arrests the natural development of our national resources, stifles industry, and hinders the proper cultivation of the soil.

Terms of Admission (to cover Expenses) *Front Seats, 1s.; Back Seats, 3d.*

Tickets for Front Seats may be had of Mr. NEWETT, at the Hall.

St. George's Cottage,
Bramhall, Cheshire.

F. W. PULLEN,

HON. SEC. RUSKIN SOCIETY.

118 Poster advertising three lectures given at the YMCA Hall, Manchester, by A. H. Mackmurdo in September 1879

fostered the Ruskin Society from within the Manchester Literary Club. They included W. E. A. Axon (1846–1913), compiler of a *Bibliographic biography of John Ruskin* and sometime editor of the *British Architect*; T. C. Horsfall (1841–1932), who promoted on Ruskinian lines the Manchester Art Museum and was later involved with housing reform, and Charles Rowley (1839–1933), friend to artists and socialists, who founded the Ancoats Brotherhood and claimed to have led the protest to the commissioning of the Belgian artists Guffens and Sweerts instead of native artists to paint the murals for the new Town Hall.[11] In 1884 Henry Boddington, brewer and patron of Ford Madox Brown, joined this group of earnest men who took their public and private duties seriously. Rowley, for instance, in 1875 was elected to the City Council on the cry of 'Baths and wash-houses and public rooms for Ancoats',[12] while in 1882 Boddington told the licensed victuallers that pubs should sell food and non-alcoholic drinks and be clean, pleasant and artistically designed.[13] All this group shared an interest in art and believed in its social value, and supported philanthropic schemes to improve the quality of life in Manchester.

Records of the Century Guild, its organisation and products, are sparse, and its activities are known mainly from reports in art and architectural journals of the time. It was instituted about 1882, offering to undertake commissions for complete buildings or for furnishings and decorating rooms. The 'Unity of the Arts' was the Guild's platform, and it aimed 'to render all branches of Art the sphere, no longer of the businessman, but of the artist'.[14] The lesser arts supported architecture, and the whole was to be directed by the architect—hence the *Cabinet Maker's* acerbic reaction, quoted earlier. Most of the Guild's designs and productions were in the main for the various minor arts to embellish the home. Stained glass, decorative metalwork, moulded plaster-work and painted decoration were executed, and textiles and wallpapers were manufactured to the Guild's designs, as were furniture and picture frames. Notices advertising the Guild generously recommended art-workers with similar aims, including Rhoda and Agnes Garrett for furniture and decoration, Morris and Company for wallpapers and textiles, de Morgan for ceramics, Powell's for glassware, and Charles Rowley of Manchester for picture frames. Their agents were Wilkinson and Son of 8 Old Bond Street, and Goodall and Co. of 13–17 King Street, Manchester, both of whom manufactured the Guild's furniture. It is not surprising that the Guild chose Manchester as an outlet. It was not only a wealthy city but enjoyed a reputation for patronage of the applied arts. In 1883 Morris and Company contemplated establishing a permanent showroom after their success at the Manchester Fine Art and

[11] C. Rowley, *Fifty years of work without wages*, n.d. [1911], pp. 51–2.

[12] Rowley, *op. cit.*, p. 50.

[13] See M. Jacobson, *200 years of beer*, Manchester, 1978, pp. 49–50.

[14] This date is given by Vallance, *op. cit.*, n.1. The aims of the Guild were printed inside the cover of each number of *Hobby Horse*.

Industrial Exhibition in 1882.[15] Goodall's were an old established firm, locally perhaps second only to James Lamb and Co., and in the 1880s were expanding to include furnishing and decoration for mansions, churches and public buildings. They held many agencies, including those for Liberty's and the Royal School of Art Needlework, as well as the Century Guild; they employed 'ateliers of artists and draughtsmen',[16] including Benjamin Creswick, whose services, it was reported in 1887, were entirely retained by Goodall's.[17] T. Raffles Davison of the *British Architect* illustrated their catalogue.

The Guild's work had its greatest impact when shown at a series of major exhibitions in the 1880s, the decade of exhibitions when manufacturers vied to produce eye-catching displays.[18] In this respect the Guild's work was outstandingly successful. It was the Guild's stand at the International Inventions Exhibition in London in 1885, its earliest known public appearance, that provoked the waspish comment from the *Cabinet Maker* quoted previously, yet that same display brought a different response from the *Building News*: 'The style of work is vigorous and fresh, and is what it aims at being—quite of this century.'[19] The following year the Guild showed at the International Navigation and Trades Exhibition, Liverpool, where Mackmurdo also was known. He had lectured there on a Corporation-sponsored course for working men and was friendly with the well known, artistic, Rathbone family. Two of its members, Robert Llewellyn and Edmund, later became associated with Guild.

Mackmurdo and the Guild were well represented at the Liverpool exhibition because in addition to providing a Century Guild display Mackmurdo designed a stand and a smokers' pavilion for Cope Bros, the tobacco firm. These were remarkably advanced works, and Nikolaus Pevsner has described the Guild's stand, **119**, as 'totally and in every detail independent'.[20] Its distinctive, slender, closely spaced pillars, broad cappings and yellow colour scheme with brown-stencilled flower motifs recall E. W. Godwin's work of the 1870s and anticipate that by C. F. A. Voysey and C. R. Mackintosh in the '90s. The content of the display, the furnishings and fittings for a dining room, **121**, was equally remarkable and the *Cabinet Maker* deemed it 'certainly the most original of all the furnishing studies of the year' before proceeding to a rollicking and quite justified criticism. The deep, flat cornices on the buffet and mantelpiece, it was pointed out, would leave the mouldings beneath obscured in shade; the broad cappings on the table leg would catch the knees, and the

[15] *Cabinet Maker and Art Furnisher*, vol. 3, 1883, p. 160.
[16] 'Our business places: Messrs. E. Goodall & Co.,', *Manchester Faces and Places*, vol. 2, 1891, pp. 15–16.
[17] *Cabinet Maker and Art Furnisher*, vol. 8, 1887, p. 6.
[18] John Allwood, *The great exhibitions*, 1977.
[19] Vol. 49, 1885, pp. 286, 288.
[20] Pevsner, *op. cit.*, p. 137.

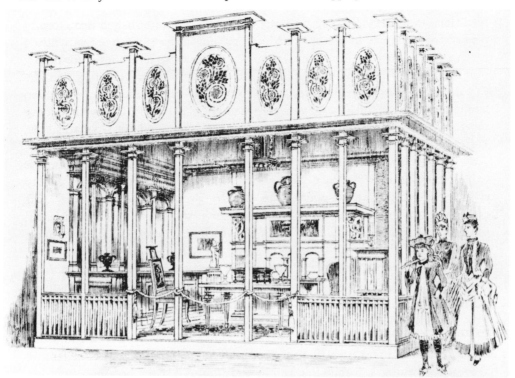

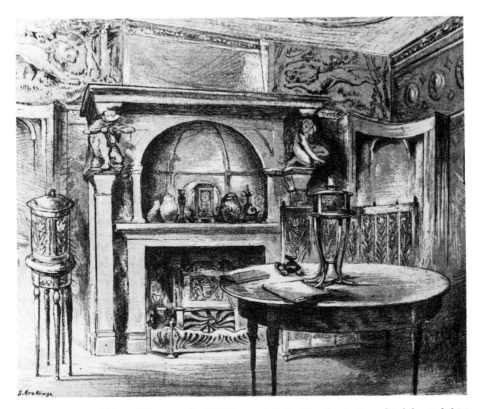

120 Century Guild furnishings on the Guild's stand at the Manchester Royal Jubilee Exhibition, 1887

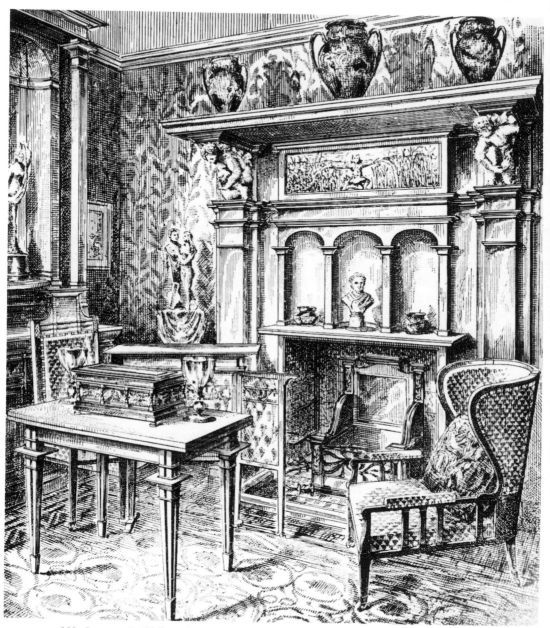

121 Century Guild furnishings on the Guild's stand at the Liverpool International Shipping Exhibition, 1886

shelf-like cappings on the chair-back the head: '. . . this shelving idea—I suppose they would call it "capping"—is quite a stock-in-trade notion with Messrs, Mackmurdo and Horne. It crops up in all sorts of odd corners. It caps the square posts of the stand itself – indeed it caps everything.'[21] Similar barbs have been directed at Mackintosh for his elongated chair-backs.

Yet the Guild's display had definite qualities, particularly when compared with the mish-mash of quaintness and craft work that constituted the contemporary run of show furnishings, usually of darkened oak in an Elizabethan or Jacobean style with flocked wallpaper, tapestry hangings, saddlebag upholstery, perhaps a stately lamp, some curious old weapons and a suit of armour for decoration. The Guild's dining-room display was quite different. It had a lightness of touch and a unity of effect. Conceived as a whole, it succeeded in balancing colour, form, structure and decoration, and integrated sculpture and painting, fine textiles and ceramics. The colouring was rich and striking: Horne's 'Bay Leaf' paper is greenish brown on orange-red hung on the walls, with a deep frieze depicting maidens playing musical instruments against a background of bay. The carpet was boldly patterned in blue, old gold, cerise and green. Against this was placed the dark mahogany furniture, not a suite but a group of pieces showing similarities of approach in design with variation of detail and enrichment: some with panels veneered in warm brown burr thuya, others with painted decoration by Selwyn Image. Sculpture was introduced in Creswick's boldly modelled and gilded figures supporting the mantelshelf. The fireplace tiles in claret and green, and the peacock blue vases on the shelf, were by de Morgan. Brasswork gleamed from the grate and lamps, the upholstery was in bluish grey and old gold chenille (shades of Whistler) and the pictures were framed in white with white mounts. Here the arts and crafts were irradiated with an aesthetic delicacy: the effect was neat, artistic and urbane.

The furniture and stand had been made for the Guild by Goodall's. The next year at the Royal Jubilee Exhibition in Manchester its work was shown again, in conjunction with Goodall's own much more extensive display. The Guild showed an entrance hall, **120**. The timber used was Australian abeille, the colour of old satinwood, which lined the walls and was used for a large bookcase, coved corner units and the fire surround. The fireplace was similar to the one shown at Liverpool but with a single coved niche in the overmantel, and Creswick this time provided apt supporting figures of miners winning coal. Above the panelling all was painted a dull buff stone colour. The ceiling and frieze were of moulded plaster, by Creswick, and included two rather incongruous panels depicting wild beasts. The loose furniture, also in abeille, was predominantly rounded in form and with the cappings mannerism omitted. The rather bland scheme of dull yellow and buff was relieved with Persian tiles in the fireplace, polished brasswork and painted and embroidered enrichment

[21] Vol. 7, 1886, pp. 85–9.

on the furniture. An embroidered screen appears similar to one now in the William Morris Gallery, Walthamstow.[22] The *Journal of Decorative Art* was flattering. 'One is immediately struck with the simplicity and largeness of the design . . . There is no frittering away of interest in a multitude of small spindles, recesses and shelves . . . and a nice sense of proportion evidences itself everywhere.' It concluded, 'Their exhibit displays *thought* from beginning to end.'[23] The *Cabinet Maker*, however, was qualified in its praise. 'The Century Guild excels both in colour and metal work . . . it would be difficult to speak too highly of the lamp on the table, the electrilier [sic] above, or the carpet beneath. A few lessons in shapely turning would cure the legs . . . of those gouty symptoms from which they suffer . . . [but] I prefer to pass over most of the chairs, for fear of being considered acrimonious.'[24] It found one chair to praise, **122**, a hybrid *fauteuil* upholstered in a Century Guild hand-loom silk. Certainly the display excited less comment than its predecessor, possibly because the organisers tricked out the stand frontages to suggest medieval streets, a device which can hardly have suited the Guild's emphatic modernity.

Henry Boddington, the brewer, came into his inheritance on the death of his father in 1886.[25] Until then he had lived 'over the shop' at the family brewery in Strangeways. From there he moved to Pownall Hall, Wilmslow, about ten miles south of Manchester. Wilmslow was then still mainly rural and Pownall an unpretentious Georgian house that had been gothicised in the 1830s. Boddington engaged a Manchester firm of architects, Ball and Elce, to alter and extend his house. He was then in his thirties, and Pownall Hall reveals that his tastes were as advanced as his social ideas. Behind the house he added a block to serve as a picture gallery, house his collection of curious old musical instruments and provide a space for family theatricals, and he commissioned the Guild to furnish his two principal reception rooms, the dining and drawing rooms, and to supply other special fittings and features such as the now famous metal furniture for the front door, **126**.[26]

The details of Boddington's association with the Guild remain conjectural, but as a member of the Manchester Literary Club he would have known the group with whom Mackmurdo associated in Manchester, and doubtless he saw the Guild's work displayed at the exhibitions in Liverpool and Manchester. Mackmurdo refers to Boddington in his unpublished 'History of the Arts and Crafts movement' and claims that it was at his suggestion that Boddington bought paintings by Ford Madox Brown.[27] Further, Boddington's interest in archaic musical instruments was shared by Arnold Dolmetsch, another of

[22] Catalogue No. G17.
[23] Vol. 7, 1887, pp. 172–3.
[24] Vol. 8, 1887, p. 5.
[25] The date is not certain. For Boddington's biography see Jacobson, *op. cit.*
[26] See also Gillian Naylor, *The Arts and Crafts movement*, 1971, plates 38 a–b.
[27] Pages 135–6.

122 Century Guild chair with hand-loomed silk upholstery

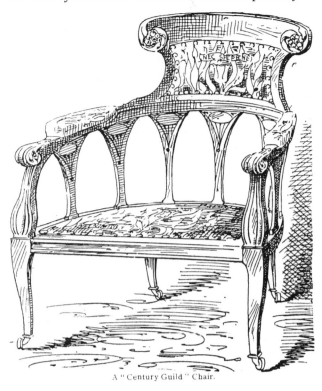

A " Century Guild " Chair.

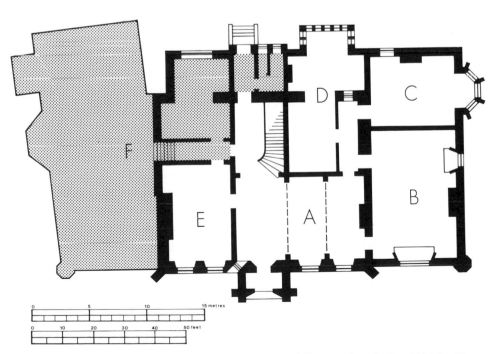

123 Pownall Hall, Wilmslow, Cheshire. Plan of ground floor as altered after 1886 for Henry Boddington by Ball and Elce, architects. *A* hall, *B* drawing room, *C* morning room, *D* library, *E* dining room, *F* service. The Century Guild were responsible for the decorations and furnishings of the drawing and dining rooms, and for metalwork elsewhere in the house

Mackmurdo's protégés. Boddington's patronage is significant because it produced the Guild's only known substantial commission. From what remains *in situ* and from contemporary articles on the house by T. Raffles Davison it is possible to reconstruct and assess this apparently unique work.[28]

Externally Pownall retains the appearance of a regular symmetrical house, but internally variety reigns. Boddington combined rooms and added ingles and bays to give the free, informal spatial arrangement that met contemporary taste, **123**. Wainscotting, half-timbering and the arts and crafts were introduced, with much carving and mottoes and inscriptions by Milson's of Manchester, stained glass by Shrigley and Hunt of Lancaster and the Gateshead Glass Company, and decorative painting by J. D. Watson (1832–92), a native of Manchester. Tiles by de Morgan enriched fireplaces and bathrooms, and the principal bedroom was furnished by Liberty's in the Moorish taste with fretwork screens and stencilling. The only rooms that retained their original proportions and a semblance of their Georgian character were those furnished by the Guild. The dining room, a tall, oblong room with windows in one end wall, was fitted and furnished with the contents of the Guild's stand from the Liverpool exhibition. The furniture has now been dispersed (one chair is in Manchester City Art Galleries), but architraves, mouldings and several major features survive, although generally incomplete in detail. Two notable features that had appeared at Liverpool are still in place, the buffet, which is on the wall facing the windows, and the chimney-piece with its gilded Atlantes, **124**. The original ceiling remains, with its delicate relief ornament in an oval panel, and below this is a plaster frieze decorated in relief with scrolls, leafage and a pack of standing hounds. The first impression is of the room's severity. The buffet, seen on the left in the illustration, **119**, in dark mahogany like the other surviving fittings in the room, is a ponderous piece. It is assertively architectural in character, with a heavy panelled base surmounted by three coved niches and topped by a massy cornice carried on slender columns. Its bulk is unrelieved by colour or other enrichment and, by reason of its position in the room, there is little modelling of its form by light and shade. As Davison commented, 'It is impossible to feel much exhilarated or impressed . . . for its massive weight and bulk of pedestal and cornice, contrasted with the thin detached pillars . . . do not come happily.'[29] The fireplace, **120**, is far livelier, with a more varied form and Creswick's gilded figures. Originally it had an elaborate grate and painted panel in the overmantel. In contrast, the loose furniture, although distinctly architectural in character, was quaint, over-delicate and reminiscent of Hepplewhite and Sheraton pieces, a point taken by the *Cabinet Maker*, which wondered whether it ought not to be attributed to the 'Eighteenth Century

[28] 'A modern country home', *Art Journal*, 1891, pp. 329–35, 354–7, and 'Pownall Hall, Cheshire', *British Architect*, vol. 36, 1891, pp. 454, 469, 471, 497–8.

[29] Davison, in *Art Journal*, 1891, p. 333.

Guild'.[30] Like the Garrett sisters, the Guild was an early proponent of the revival of this typically English style, which, although accepted by the furnishing trade in the 1880s, was not to find acceptance with the Arts and Crafts hard-liners until a decade later. The armchair and the dinner wagon illustrated, **124**, both have a version of the cabriole leg, but without the undercutting, and, like a quirky classical afterthought, a corniced panel rises from the chairback. The classicism of the Century Guild was always idiosyncratic.

Dark mahogany and deep, rich colours were the norm for Victorian dining rooms and were maintained in this room, where the walls were lined in dark-toned leather paper, but the solemnity of the convention was pointedly contrasted, even mocked, by the daring originality and lightness of the detail compared with the massive scale of the fittings and the relative plainness of the surface treatment.

The room exemplifies the Century Guild's declared ideal of reunifying the arts. Everything conforms to this aim, although the contents were drawn from different artists. The vases on the mantelshelf, for instance, **124**, appear to be those by de Morgan that were shown at Liverpool, **119**, and the painting in the overmantel was by Selwyn Image, whilst the clock, although unrecorded among the Guild's products, can be safely attributed to it on stylistic grounds. The Guild's success in achieving a rich complexity within a unified design was revolutionary only in a limited sense: historically it belongs to a classic tradition that stretches back from Victorians such as Alfred Stevens to Inigo Jones.

The second room furnished by the Guild, the drawing room, was described by Davison as 'a unique and pretty apartment', although he noted 'a formality and stiffness . . . which suggests neither luxuriousness nor ease'.[31] The room is now greatly altered, but from Davison's description it appears to have been much lighter and less earnest than the dining room and closer in mood and colouring to the sophisticated work of aesthetes such as Whistler and Godwin. Yellow predominated, and the fittings and furnishings were harmonious in yellowy satinwood. Around the room slim horizontal and vertical members formed a light but emphatic architectural framework. Against the broad horizontal bands delineated by skirting, dado, frieze and cornice, were juxtaposed tall, spare, capped pillars and pilasters arranged into canopied spaces enclosing windows and window seats, **125**. Narrow square pillars framed the windows and contained the softness of curtains and side hangings. Their decisive lines were echoed on a diminishing scale throughout the room. They occurred in a canopied settle that faced the fireplace and in the triple-shafted pilasters supporting the overmantel. Decorative detail added variety and richness to this airy concept. The cream-coloured dado was capped by a

[30] Vol. 6, 1885, p. 32.
[31] *Art Journal*, 1891, p. 334.

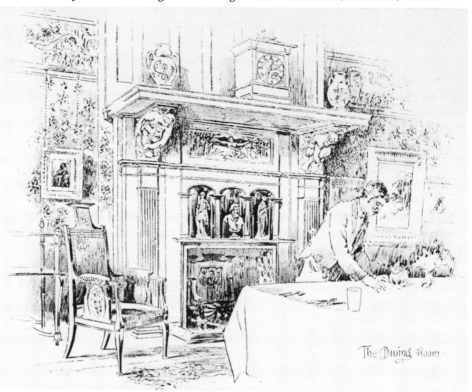

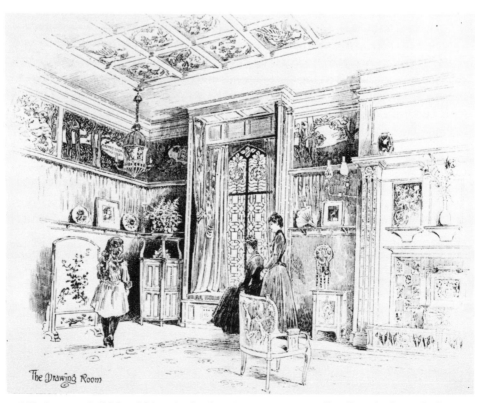

125 Century Guild furnishings in the drawing room at Pownall Hall, Wilmslow, Cheshire

shelf on which were displayed paintings, fans and china against a citron-coloured background of gathered cretonne in the Guild's 'Angel with trumpet' pattern, designed by Horne. The same fabric was used on the furniture. The frieze was outlined in flat gilt and painted in dull greens and reds with landscapes, figures and the inevitable inscriptions. Davison thought this 'too coarse in execution for its position', [32] a comment often made of the Guild's decorative painting by contemporary critics. The ceiling was coffered into squares filled with painted decoration, since removed, said, by the Boddington family, to have been executed by Frank Brangwyn (1867–1956), another of Mackmurdo's protégés, although apparently designed by Horne, and there were similar painted panels in the overmantel. [33] In each corner of the room hung a fretted brass chandelier suspended on a tasselled cord. Little of the scheme remains except the fireplace, which is without its panels and the grate, and some of the finely detailed joinery.

The decorations and some of this furniture would appear to have been commissioned specially for Pownall. In an article on the Century Guild H. P. Horne referred to '. . . the satin-wood drawing-room executed for Mr H. Boddington', [34] but little is known of the furniture beyond Davison's brief note suggesting a general lack of comfort. Some of the pieces may have appeared in the Guild's earlier displays. The brass chandeliers are similar to one illustrated in the *Journal of Decorative Art* in the review of the Guild's display at the Manchester exhibition, [35] and the cabinet shown standing in the corner, **125**, is identical to one shown in London at the Inventions exhibition. [36] Other pieces shown in Davison's sketch are obviously by the Guild but otherwise unrecorded. The chair in the foreground is of rather Frenchified, eighteenth-century appearance and is stylistically typical of the Guild, as are the fire-irons and coal box to the left of the mantelpiece. Both carry the flower motifs that are familiar elsewhere in the Guild's work. The fender and grate can be credited with certainty to the Guild. The settle, not shown, described by Davison as having 'a canopied seat with brass repoussé panels on the frieze' is almost certainly the one held by the Victoria and Albert Museum, [37] where its provenance is given as Pownall Hall, with Goodall and Co. as the manufacturer. The room as a whole appears to have been a strikingly successful interior, and if

[32] *Ibid*. The Frieze, now badly deteriorated, is in the William Morris Gallery, Walthamstow, Catalogue No. 0113–0124. A design, *Pictura*, by Selwyn Image, for a section of the frieze is in Manchester City art Galleries' collection.

[33] The thirty panels, depicting alternately a snipe and a hare counter-changed with panels of foliage, comprised lot 39, illustrated, in a sale of nineteenth-century European paintings and drawings held at Sotheby's, New Bond Street, London, on 21 June 1983. Two panels bear the monogram 'H.P.H.' (Herbert Percy Horne). A sketch for the panels with snipe, designed by Horne, is in the University of Michigan Museum of Art (1962/2.30).

[34] 'The Century Guild', *Art Journal*, 1887, pp. 295–8.

[35] Vol. 7, 1887, p. 172.

[36] *Cabinet Maker and Art Furnisher*, vol. 7, 1885, p. 32.

[37] Catalogue No. FH664.

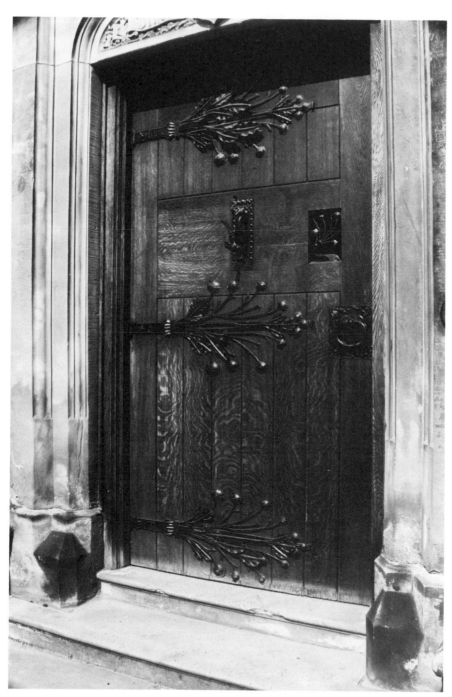

126 The Century Guild: Pownall Hall, Wilmslow, Cheshire. The main entrance door. Note the wrought iron door furniture

pieces were incorporated from stock their integration was notably harmonious. Some pieces may be individually quirky in design, but in the Pownall interiors illustrated by Davison the unity and harmony of effect that characterised the Guild's work give the dining and drawing room an air of stylishness and suavity, especially in comparison with the mawkish picturesqueness of the other rooms.

Metalwork by the Guild is particularly distinctive, and many pieces of ironmongery were supplied for Pownall, including those for the main entrance doors to the house and the new gallery building. The house door handle, knocker, peep-hole grill and hinges, all executed in wrought iron, have helped to establish the Guild's reputation in this field, **126**. They are not in the Puginian manner but are equally vital—swirling, organic forms even more expressive of the material's malleability. A curling stem comprises the grill; each hinge bursts out into a stiff spray of thistles; and the knocker is in the form of a winged dragon. Elsewhere in the house, chandeliers, sconces and other metalwork display the motifs which have come to be regarded as a hallmark of the Guild's work. Metal, whether cast, wrought, raised or fretted, lends itself to such natural forms.

The work of Mackmurdo and the Century Guild has often been regarded as 'proto-Art Nouveau', and the flowing lines in the design of the title page of Mackmurdo's book *Wren's City churches* (1883), or the cover of *Hobby Horse*, **117**, as well as other examples in his furniture and the Guild's textiles and metalwork, have been cited as evidence and frequently illustrated by historians.[38] Much of the work at Pownall shows this famous predilection for swirling organic forms, but, as has been pointed out—for instance, by Tschudi Madsen in *Sources of Art Nouveau*,[39]—there is a major distinction between this work and Continental Art Nouveau. Most of it is two-dimensional and strictly observes the Gothic Revival principle of 'truth to material'. Also, except in wrought ironwork, the sinuous decoration is always contained within a structural framework. This is demonstrated by the design of the basket grates at Pownall, **120**. In these the cast iron body is severe in form and the decoration consists of inset brass plaques of leaves and flowers. For the fret a flame-like pierced motif was used. The wrought iron rests for the fire-irons are curved, but the cast fireback had a rectangular relief panel by Creswick. The mahogany armchair in the illustration of the dining room, **124**, illustrates the same principle and is similarly severe. The frame is distinct and rectilinear, and the

[38] The term 'proto-Art Nouveau' is used by S. T. Madsen in *Sources of Art Nouveau*, New York, 1956, and *Art Nouveau*, 1967, to mean work, such as the Guild's, which immediately preceded the style's Continental manifestation. Robert Schmutzler, however, in his *Art Nouveau*, New York, 1962, uses it to describe certain works of art of *c*. 1800. Illustrations of the work of the Guild may be found in books referred to in these notes and the bibliography. See under S. T. Madsen, G. Naylor, N. Pevsner and R. Schmutzler.

[39] *Op. cit.* See his section 'English proto-Art Nouveau', pp. 148–63.

decoration is introduced in inlaid panels beneath the arm rests and in the low-relief carving of leaves on the ends of frame members. Aymer Vallance, writing on Mackmurdo and the Century Guild,[40] perceptively observed that Mackmurdo valued 'architectural severity of line in all structural features' and noted that proportion was to him 'the fundamental element of beauty'. Mackmurdo never introduced the curvilinear structural forms used towards the end of the century by later Continental designers such as Guimard, Horta or Van de Velde. In their hands the chair would have curved and twisted as though the timber had grown into the form of the frame, and the carving would have budded from the members.

The work of the Century Guild at Pownall reveals how its aims were realised and how the various artists and craftsmen contributed to the creation of a unified whole for which Mackmurdo must presumably be given the principal credit. It constitutes not only the one known major commission of the Guild but also, perhaps, the last concerted work of this group of associated artists. After Pownall the Guild does not appear to have entered major exhibitions, and with the formation of the Arts and Crafts Exhibition Society in 1888 its various associated artists displayed their work independently at the exhibitions held in 1888, 1889, 1890 and thereafter approximately triennially.[41] Mackmurdo seems not to have played a significant part in the new society and in the 1890s appears to have been more actively engaged in his architectural practice. In 1892 he relinquished the editorship of the *Century Guild Hobby Horse* to Horne and it is known that a bitter disagreement occurred between them.[42]

Mackmurdo's links with the North-west remained strong, and he executed work in Liverpool, Manchester and other places, including Nantwich, where the Brine Baths Hotel (started in 1892; demolished in 1956) appears to have been a major scheme incorporating Century Guild-style fittings, including two fireplaces identical to the one installed in the dining room at Pownall. Although this later work is of considerable architectural interest it cannot be compared with Pownall Hall and seems quite separate from the activities of the Guild.

The importance of the Century Guild and the rarity of its known commissions give Pownall Hall a special position in the history of the decorative arts in the nineteenth century. It has a curious aspect too in that the Guild's connection with Manchester occurred not simply as a response to the possibility of wealthy patronage but appears to have stemmed from the convergence of those who were seeking through art and social reform to alleviate the conditions of industrial life upon which was based so much of Manchester's wealth.

[40] Vallance, *op. cit.*
[41] For this information I am indebted to the editor.
[42] Fletcher, *Decadence and the 1890s, op. cit.*

BIBLIOGRAPHY

INTRODUCTION

1 Dictionaries and catalogues

(a) Dictionaries

Architectural Publication Society (ed. Wyatt Papworth). *The dictionary of architecture*, 8 vols, 1852 – 92.

Avery Architectural Library. *Avery obituary index of architects and artists*, Boston (Mass.), 1963; 2nd Ed. *Avery obituary index of architects*, 1890. [Note omission of artists.]

Baines, Edward. *History, directory, and gazeteer, of the county palatine of Lancaster*, two vols. (1824–25); rp. 1968 with introduction by Owen Ashmore.

Bryan, M. *Dictionary of painters and engravers* (2 vols., 1816); new ed. revised and enlarged under the supervision of George C. Williamson, 5 vols., 1903.

Colvin, H. M. *A biographical dictionary of British architects, 1600–1840*, 1978.

Dictionary of National Biography, 1885–

Fleming, John, and Honour, Hugh. *The Penguin dictionary of decorative arts* (1977), 1979.

Gunnis, Rupert. *Dictionary of British sculptors, 1660–1851* (1953), 1968.

Mallett, Daniel Trowbridge, *Mallet's index of artists*, 2 vols, New York (1935–40); rp. 1948.

Nodal, J. H. *Art in Lancashire and Cheshire*: a list of deceased artists. With brief biographical notes, 1884.

Stewart, Cecil. *The architecture of Manchester, an index . . . 1800–1900*, 1956.

Tracy, W. B. and Pike, W. Manchester and Salford at the close of the nineteenth century, 1899.

Ware, Dora. *A short dictionary of British architects*, 1967.

Wood, Christopher. *Dictionary of Victorian painting*, 1972.

(b) Catalogues

City of Manchester Art Gallery. *Catalogue of the permanent collection of pictures* (1894); 2nd ed. 1895.

City of Manchester Art Gallery. *Catalogue of loan exhibition of works by Ford Madox Brown and the Pre-Raphaelites*, 1911.

City of Manchester Art Gallery, *Descriptive catalogue of the permanent collection of pictures*, 1888, further eds. 1889, 1891.

Manchester City Art Gallery. *Catalogue of the Ruskin Exhibition*, 1904.

Manchester City Art Gallery, *Concise catalogue of British paintings*, 2 vols., 1976 and 1978.

Northern Art Workers' Guild, *Catalogue of work exhibited by members*, 1898.

Id., 1903.

Royal Institute of British Architects. *Catalogue of the drawings collection of the Royal Institute of British Architects*, 1969–

2 Contemporary sources

(a) Art and architecture

Barry, Alfred. *The life and works of Sir Charles Barry*, RA, FRS (1867); rp. New York, 1972.

Darbyshire, Alfred. *An architect's experiences*, 1897.

Eastlake, Charles L. *A history of the Gothic Revival* (1872); rp. 1970, edited with an introduction by J. Mordaunt Crook.

Fergusson, James. *History of the modern styles of architecture*, 2 vols. (1862), 3rd ed. 1891, revised by Robert Kerr.

Kerr, Robert. *The gentleman's house* (1864); 3rd ed. 1871, rp. New York, 1972, with an introduction by J. Mordaunt Crook.

Mills, Ernestine. *The life and letters of Frederic Shields*, 2 vols., 1912.
Murray's handbook to Lancashire, 1880 ed.
Rowley, Charles. *Fifty years of work without wages*, n.d. [1911].
Ruskin, John. *The complete works of John Ruskin*, ed. E. T. Cook and Alexander Wedderburn, 39 vols., 1903–12.
See particularly:
'A joy for ever' (*The political economy of art*, 1857), 1880; *Works*, vol. 16. *Lectures on architecture and painting*, 1854; *Works*, vol. 12. *The seven lamps of architecture*, 1849; *Works*, vol. 8. *The stones of Venice*, 3 vols, 1851–53; *Works*, vols. 9–11.

(b) **General references: works notably illustrated**

Aston, Joseph. *A picture of Manchester* (1st ed. 1816); 3rd ed., enlarged and illustrated, 1826.
Austin, S., *et al. Lancashire illustrated*, 1829.
Brothers, Alfred. *Manchester as it is*, 1878.
James, H. G. *Views of old halls, buildings, etc., in Manchester and the neighbourhood*, 1821–25.
Love and Barton, *Manchester as it is*, 1839.
Love, B. *The handbook of Manchester*, 1842. [The second and enlarged edition of Love and Barton, *Manchester as it is.*]
Ralston, J. *Views of the ancient buildings in Manchester*, 3 vols., 1823–25.
Rock and Co. *Views of Manchester*, 1850–54.

(c) **Social and general**

Axon, W. E. A. *The annals of Manchester*, 1886.
Diggle, John W. *The Lancashire life of Bishop Fraser*, 1889.
Engels, Friedrich. *The condition of the working class in England* (1845); trans. and ed. W. O. Henderson and W. H. Chaloner (1958), 1971.
Faucher, Léon. *Manchester in 1844* (1844); rp. 1969.
Hayes, Louis M. *Reminiscences of Manchester . . . from . . . 1840*, 1905.
Kay, J. P. *The moral and physical condition of the working classes employed in the cotton manufacture in Manchester* (1832); 2nd ed., enlarged, 1832; rp. 1969.
Prentice, Archibald. *Historical sketches and personal recollections of Manchester intended to illustrate the progress of public opinions, 1792–1832*, 1851.
Slugg, J. T. *Reminiscences of Manchester fifty years ago*, 1881.
Taylor, W. Cooke. *Notes of a tour in the manufacturing districts of Lancashire* (1st ed. 1842), 2nd ed. with additions, 1842; rp. with introduction by W. H. Chaloner, 1968.
Wheeler, James. *Manchester. Its political, social and commercial history, ancient and modern*, 1836.

(d) **Periodicals**

Academy Architecture, 1889–1932. *The Architect*, 1869–1918. *The Architectural Magazine*, 1834–38. *The Architectural Review*, 1896– , *Architecture*, 1896–97. *The Art Journal*, 1839–1912. *The British Architect*, 1874–1919. *The Builder*, 1842–1966, *The Building News*, 1855–1926. *The Cabinet Maker and Art Furnisher*, 1880– . *The Civil Engineer and Architect's Journal*, 1837–68. *The Ecclesiologist*, 1842–68. *The Illustrated London News*, 1842– . *The Magazine of Art*, 1878–1904, *Manchester Faces and Places*, 1890–1906. *Royal Institute of British Architects, Transactions*, 1835–93; *Proceedings*, 1878–93; *Journal*, 1893– . *The Studio*, 1893–1963. *The Transactions of the Lancashire and Cheshire Antiquarian Society*, 1883– .

3 Twentieth-century references

(a) Guides and gazetteers

Ashmore, Owen. *The industrial archaeology of Lancashire*, 1969.

Ashmore, Owen. *The industrial archaeology of north-west England*, 1982.

Atkins, Philip. *Guide across Manchester*, 1976.

City of Manchester Cultural Services, *A century of collecting, 1882–1982. A guide to Manchester City Art Galleries*, 1983.

Fleetwood–Hesketh, Peter. *Murray's Lancashire architectural guide*, 1955.

Pevsner, Nikolaus. *The buildings of England. Cheshire*, 1971.

Pevsner, Nikolaus. *The buildings of England. South Lancashire*, 1969.

Sharp, Dennis (ed.) *Manchester*, 1969.

Sharp, Dennis (ed.). *Manchester buildings*, 1966. [A commemorative issue of *Architecture North West*.]

Treuherz, Julian. *Pre-Raphaelite paintings from the Manchester City Art Gallery*, 1980.

(b) Art and architecture

Archer, J. H. G., 'Edgar Wood: a notable Manchester architect', *Transactions of the Lancashire and Cheshire antiquarian society*, vols., 73–4, 1963–64, pp. 153–87.

Aslin, Elizabeth. *The Aesthetic Movement*, 1969.

Boase, T. S. R. *English art, 1800–1870* (Oxford History of English Art, 10), 1959.

Bowness, Alan. 'The Victorians', in David Piper, (ed.), *The genius of British painting*, 1975.

Clarke, B. F. L. *Church builders of the nineteenth century* (1938), 1969.

Creese, Walter L. *The search for environment*, 1966.

Croft-Murray, Edward. *Decorative painting in England, 1537–1837*, 2 vols., 1970.

Cross, Michael. *F. W. Jackson, 1859–1918*. 1979. [Catalogue of an exhibition held at Rochdale Art Gallery.]

Cunningham, Colin. *Victorian and Edwardian town halls*, 1981.

Darcy, C. P. *The encouragement of the fine arts in Lancashire, 1760–1860* (Chetham Society, 24), 1976.

Davis, Frank. *Victorian patrons of the arts*, 1963.

Dellheim, Charles. *The face of the past*, 1982.

Dixon, Roger, and Muthesius, Stefan. *Victorian architecture*, 1978.

Farr, Dennis. *English art, 1870–1940* (Oxford History of English Art, 11), 1978.

Fawcett, Jane (ed.). *Seven Victorian architects*, 1976.

Fawcett, T. *The rise of English provincial art . . . , 1800–1830*, 1974.

Ferriday, P. (ed.). *Victorian architecture*, 1963.

Gaunt, William. *The restless century. Painting in Britain, 1800–1900*, 1972.

Girouard, Mark. *The Victorian country house* (1971), 1979.

Goodhart-Rendel, H. S. *English architecture since the Regency*, 1953.

Hardie, Martin. *Water-colour painting in Britain*, 3 vols., 1966–68.

Herrmann, F. *The English as collectors*, 1972.

Hersey George L. *High Victorian Gothic*, 1972.

Hilton, Timothy. *The Pre-Raphaelites*, 1970.

Hitchcock, Henry-Russell. *Architecture nineteenth and twentieth centuries* (1958), 3rd ed. 1969.

Hitchcock, Henry-Russell. *Early Victorian architecture in Britain*, 2 vols. 1954.

Jeremiah, D. *A hundred years and more*, 1980. [A history of the Manchester School of Art.]

Lockett, T. A. 'Architect and actor – Alfred Darbyshire (1839–1908)', in *Three lives. It happened round Manchester*, 1968.

Muthesius, Stefan. *The High Victorian movement*, 1971.

Naylor, Gillian. *The Arts and Crafts movement* (1971), 1980.

Pevsner, Nikolaus. *A history of building types*, 1976.

Port, M. H. *Six hundred new churches*, 1961.

Read, Benedict, and Ward-Jackson, P. (eds.). *Courtauld Institute Illustration Archives, 4. Late 18th & 19th century sculpture in the British Isles. Part 6: Greater Manchester*, 1978.
Read, Benedict. *Victorian sculpture*, 1982.
Reilly, C. H. *Some Manchester streets and their buildings*, 1924.
Reilly, C. H. 'The face of Manchester', in W. H. Brindley (ed.), *The soul of Manchester* (1929), rp. 1974.
Russell, Frank (ed.). *Art Nouveau architecture*, 1979.
Steegman, John. *Victorian taste*, 1970 (first published as *Consort of taste*, 1950).
Stewart, Cecil. *The architecture of Manchester*, 1956.
Stewart, Cecil. *The stones of Manchester*, 1956.
Summerson, John. *Architecture in Britain, 1530–1830* (1953); 7th ed. 1983.
Summerson, John, *Victorian architecture*, 1970.
Whinney, Margaret. *Sculpture in Britain, 1530–1830*, 1964.

(c) **General**

Ashton, T. S. *Economic and social investigations in Manchester, 1833–1933* (1934); rp. 1977.
Briggs, Asa. *Victorian cities*, 1963.
Broxap, Ernest. *Manchester a hundred years ago*, 1924. [An introduction to a reprinting of James's *Views*, etc.]
Cardwell, D. S. L. (ed.). *Artisan to graduate*, 1974. (see for M/cr. Mechanics' Institution).
Carter, C. F. (ed.). *Manchester and its region*, 1962.
Chaloner, W. H. 'Manchester in the latter half of the eighteenth century', *Bulletin of the John Rylands Library*, vol. 42, September 1959, pp. 40–60.
Dobb, Arthur J. *Like a mighty tortoise. A history of the diocese of Manchester*, 1978.
Dyos H. J., and Wolff, Michael (eds.). *The Victorian city*, 2 vols., 1973.
Frangopulo, N. J. *Rich inheritance*, 1962.
Hammond, J. L. and Barbara. *The town labourer*, 2 vols. (1917), 1925.
Kennedy, M. *Portrait of Manchester*, 1970.
Millward, Roy. *Lancashire. An illustrated essay on the history of the landscape*, 1955.
Redford, Arthur, and Russell, Ina S. *The history of local government in Manchester*, 3 vols., 1939–40.
Spiers, Maurice. *Victoria Park, Manchester. A nineteenth-century suburb in its social and administrative context* (Chetham Society, 23), 1976.
Swindells, T. *Manchester streets and Manchester men*, 5 vols. (1906–08); rp. n.d., c. 1978.
Taylor, A. J. P. 'Made in Manchester', *The Listener*, vol. 96 (16 September 1976), pp. 333–4.
Taylor, A. J. P. 'The world's cities. (I) Manchester', *Encounter*, vol. 8, (March 1957), pp. 3–13.
Thomson, W. H. *History of Manchester to 1852*, 1966.
The Victoria history of the counties of England. Lancashire, 8 vols. (1906–14), rp. 1966. See vol. 4.

CHAPTER ONE

Bell, Quentin. *The Schools of Design*, 1963.
Cleveland, S. D. 'The origin of the Royal Manchester Institute', *Transactions of the Lancashire and Cheshire Antiquarian Society*, vol. 47, 1930–31, pp. 258–9.
Cleveland, S. D. *The Royal Manchester Institution*, 1931.
Darcy, C. P. *The encouragement of the fine arts in Lancashire, 1760–1860* (Chetham Society, 24), 1976.
Fawcett, T. *The rise of English provincial art . . . , 1800–1830*, 1974.
Haydon, B. R. *The autobiography and memoirs of Benjamin Robert Haydon (1786–1846)*, edited from his journals by Tom Taylor, 2 vols. (1853), new ed. with an introduction by Aldous Huxley, 1926.
Jeremiah, D. *A hundred years and more*, 1980. [A history of Manchester School of Art.]

Macdonald, Stuart. *The history and philosophy of art education*, 1970.
Slugg, J. T. *Reminiscences of Manchester fifty years ago*, 1881.
Sutherland, W. G. *The R.M.I.*, 1945.
Swindells, T. *Manchester streets and Manchester men*, 5 vols. (1906–08), rp. n.d., *c*. 1978.
Yates, H. *A short history of the Academy* (1959), 1973.

CHAPTER TWO

Aitchison, George. 'Charles Barry', *D.N.B.*, vol. I, pp. 1230–3.
Barry, Alfred. *The life and works of Sir Charles Barry, RA, FRS* (1867); r.p. New York, 1972.
Binney, Marcus. 'The making of an architect', *Country Life*, vol. 146, 1969, pp. 494–8, 550–2, 622–4.
Builder, obit of Sir Charles Barry, vol. 18, 1860, pp. 305–7
Colvin, H. M. *A biographical dictionary of British architects, 1600–1840*, 1978, pp. 89–92.
Colvin, H. M. (ed.). *The history of the king's works*, vol. 6, 1973.
Part 3, M. H. Port, 'The new Houses of Parliament', pp. 573–626.
Dent, A. R. 'Barry and the Greek Revival', *Architecture*, 5th Series, iii, 1924–25, pp. 225, 320.
Fleetwood–Hesketh, Peter. 'Sir Charles Barry', *Victorian architecture*, ed. Peter Ferriday, 1963, pp. 125–35.
Fraser, P. 'The work of Sir Charles Barry', *RIBA Journal*, vol. 68 (1960), pp. 12–13. [Introduction to the catalogue of the Barry centenary exhibition at the RIBA, 1960.]
Girouard, Mark. 'Charles Barry: a centenary assessment', *Country Life*, vol. 128 (1960), pp. 796–7.
Girouard, Mark. *The Victorian country house* (1971), 1979.
Hitchcock, H.-R. *Early Victorian architecture in Britain*, 1954, vol. 1, chapters 6–7.
Port, M. H. *The Houses of Parliament*, 1976.
R.I.B.A., *Catalogue of the Drawings Collection of the Royal Institute of British Architects*, 'B', 1972, pp. 18–54.
Statham, H. H. 'The architectural genius of Sir Charles Barry', *Builder*, vol. 80 (1901), pp. 3–8.
Statham, H. H. 'Sir Charles Barry', *Architectural Association Notes*, vol. 17, July 1902.
Whiffen, Marcus. *The architecture of Sir Charles Barry in Manchester and neighbourhood*, 1950.
Whiffen, Marcus. 'Barry, Sir Charles', *Macmillan encyclopedia of architects*, 1982.
Whiffen, Marcus. 'The education of an eclectic: some notes on the travel diaries of Sir Charles Barry', *Architectural Review*, vol. 105 (1949), pp. 211–15.
Whiffen, Marcus. 'The Reform Club: a Barry triumph', *Country Life*, vol. 108 (1950), pp. 1498–1501.
Whiffen, Marcus. 'The Travellers' Club; its building history and the evolution of its design', *RIBA Journal*, vol. 59 (1952), pp. 417–19.
Wyatt, Matthew Digby. 'On the architectural career of the late Sir Charles Barry', *Transactions of the RIBA*, 1859–60, pp. 118–37.

CHAPTER THREE

Agnew, G. *Agnew's 1817–1967*, 1967.
Bronkhurst, J., 'Fruits of a connoisseur's friendship: Sir Thomas Fairbairn and William Holman Hunt', *Burlington Magazine*, vol. 125, 1983, pp. 586–97, plates 2–14.
Darcy, C. P. *The encouragement of the fine arts in Lancashire 1760–1860* (Chetham Society, 24), 1976.
Davis, F. *Victorian patrons of the arts*, 1963.

Gould, C. 'An early buyer of French Impressionists in England', *Burlington Magazine*, vol. 108 (1966), pp. 141–2.

Graves, A. *Art sales (from early in the eighteenth century to early in the twentieth century)*, 3 vols., 1918–21.

Herrmann, F. *The English as collectors*, 1972.

Hofstede de Groot, *A catalogue raisonné of the works of the most eminent Dutch painters of the seventeenth century*, 8 vols., 1908–27.

Hueffer, F. M. *Ford Madox Brown*, 1896.

Lugt, F. *Répertoire des catalogues ventes publiques, etc.*, 3 vols., La Haye, 1938–64.

Nicolson, B. *Joseph Wright of Derby*, 2 vols., 1968.

Smith, J. *A catalogue raisonné of the works of the most eminent Dutch, Flemish and French painters*, 8 vols. and supplement, 1829–42.

Swindells, T. *Manchester streets and Manchester men*, 5 vols. (1906–08); rp., n.d., c. 1978.

Waagen, G. F. *Treasure of art in Great Britain*, 3 vols., 1854, supplement, 1857.

Wood, Christopher. *Dictionary of Victorian painting*, 1972.

Catalogues

Exhibition catalogues

Catalogue of the Art Treasures of the United Kingdom collected at Manchester in 1857, Manchester, 1857.

Royal Jubilee Exhibition, Manchester, 1887.

Royal Manchester Institution, from 1827 to 1913.

William Holman–Hunt, 1969, Walker Art Gallery, Liverpool.

Permanent collection catalogues

The National Gallery, *Illustrated general catalogue*, 1973.

MacLaren, N. *National Gallery catalogues. The Dutch school*, 1960.

Manchester City Art Gallery, *Concise catalogue of British paintings*, 2 vols., 1976 and 1978.

Private collection catalogue

Galloway, C. J. *Catalogue of paintings and drawings at Thorneyholme, Cheshire, collected by Charles J. Galloway*, 1892.

Sale catalogues

Barlow, Samuel. *Catalogue of the valuable collection of oil paintings and water-colour drawings formed by the late Samuel Barlow, Esq., Stakehill, Middleton, which will be sold by auction by Capes, Dunn, & Pilcher. Tues. March 20, 1894, at the Gallery, Clarence St., Manchester.*

Mendel, Sam. *Manley Hall, Manchester. Catalogue of the magnificent contents of Manley Hall, the property of Sam Mendel, Esq., which will be sold by auction, by Messrs Christie, Manson & Woods, on the premises, Manley Hall, on Monday, March 15, 1875, and following days.*

CHAPTER FOUR

Ashton, T. S. *Economic and social investigations in Manchester, 1833–1933* (1934); rp. 1977.

Bayley, Stephen. *The Albert Memorial*, 1981.

Bellhouse, E. T. 'On baths and wash-houses for the people', *Transactions of the Manchester Statistical Society*, 1853–54, pp. 91–100.

Bowman, H. *Specimens of ecclesiastical architecture of Great Britain from the Norman Conquest to the Reformation*, 1846.

Bowman, H., and Crowther, J. S. *Churches of the Middle Ages. Plans, sections and details, etc.*, 2 vols., 1845–53.

Brockbank, W. *Portrait of a hospital, 1752–1948*, 1952.

Chorley, Katharine. *Manchester made them*, 1950.

Davies, Horton. *Worship and theology in England*, 5 vols., 1962. [See vol. 4, *From Newman to Martineau, 1850–1900*.]

Engels, Friedrich. *The condition of the working class in England*, 1845, trans. and ed. W. O. Henderson and W. H. Chaloner (1958), 1971.

Franklin, Jill. *The gentleman's country house and its plan, 1835–1914*, 1981.

Kay, J. P. *The moral and physical condition of the working classes employed in the cotton manufacture in Manchester* (1832), 2nd, enlarged ed. 1832; rp. 1969.

Manchester Corporation. *The restoration of Manchester's Albert Memorial, 1977–78*, 1979.

Nightingale, Florence. *Notes on hospitals* (1859), 3rd edn. 1863.

Pass, A. J. 'Thomas Worthington, practical idealist', *Architectural Review*, vol. 155 (1974). pp. 268–74.

Scott, G. G. *Personal and professional recollections*, 1879.

Stewart, Cecil. *The stones of Manchester*, 1956.

Woodham–Smith, C. *Florence Nightingale*, 1950.

CHAPTER FIVE

Contemporary publications

(a) Official

Catalogue of the Art Treasures of the United Kingdom collected at Manchester in 1857, 1857.

Exhibition of Art Treasures of the United Kingdom held at Manchester in 1857. Report of the Executive Committee, 1858.

(b) Critical and descriptive

The Art-Treasures Examiner, Manchester, 1857.

Blanc, Charles. *Les trésors de l'art à Manchester*, Paris, 1857.

Caldesi and Montecchi. *Gems of the Art Treasures Exhibition, Manchester*, 2 vols., *1857*, 1858.

Cassell, John. *John Cassell's Art Treasures Exhibition*, 1858.

Dorrington, George and Newman, William. *Punchinello's Art-Treasures Exhibition*, 1857.

Jerrold, W. B. *Guide to the exhibition. How to see the Art-Treasures Exhibition*, 1857.

Morris, Thomas. *An historical, descriptive, and biographical handbook to the Art Treasures Exhibition*, Manchester, 1857.

Robinson, J. C. *Catalogue of the Soulages collection*, 1857.

Scharf, G. *A handbook to the paintings by ancient masters in the Art Treasures Exhibition*, 1857.

Scharf, G. 'On the Manchester Art Treasures Exhibition, 1857', *Transactions of the Historic Society of Lancashire and Cheshire*, vol. 10, 1857–58, pp. 269–331.

Taylor, Tom. *A handbook to the British Portrait Gallery in the Art Treasures Exhibition*, Manchester, 1857.

Taylor, Tom. *A handbook to the modern paintings in the Art Treasures Exhibition*, 1857.

Taylor, Tom. *A handbook to the water colours, drawings, and engravings, in the Art Treasures Exhibition*, 1857.

Thoré, Théophile, E. J. (W. Bürger, pseud.). *Trésors d'art exposés à Manchester en 1857*, Paris, 1857, and *Art treasure exhibited at Manchester in 1857*, London, 1857.

Waagen, G. F. *A walk through the Art-Treasures Exhibition at Manchester*, 1857.

Waring, John B. (ed.). *Art of the United Kingdom. From the Art Treasures Exhibition, Manchester* (with essays by Owen Jones, Digby Wyatt, A. W. Franks, J. B. Waring, J. C. Robinson, and G. Scharf, jun.), 1858.

Waring, John B. (ed.). *Examples of metal work and jewellery, selected from the royal and other*

collections and forming part of the Museum of Ornamental Art in the Art-Treasures Exhibition, Manchester, 1857, 1857.

Waring, John B. *Examples of weaving and embroidery, selected from the royal and other collections . . . in the Art Treasures Exhibition, . . .* (with essays by Owen Jones and M. Digby Wyatt), 1857.

Waring, John B. *A handbook to the Museum of Ornamental Art in the Art Treasures Exhibition*, to which is added The Armoury, by J. R. Planché, 1857.

(c) **Publications in dialect**

Heywood, John. *A Yewud chap's trip to Manchisther to see Prince Halbert, th' Queen, an' th' Art Treasures Eggshibishur; by 'Oud John'*, 1857.

Rodgers, Charles. *Tom Treddlehoyle's peep at t'Manchister Art Treasures Exhebishan e 1857*, 1857.

Staton, James T. *Bobby Shuttle un his woife Sayroh's visit to Manchester un to th' greight Hert Treasures Eggshibishun, at Owd Traffort* (written for Bobby hissell by th' editor oth *Bowton Luminary*), 1857.

General

Bell, Clive, 'Art and socialism', *Vision and design* (1920); Phoenix ed. 1928.

Boase, T. S. R. *English art, 1800–1870* (Oxford History of English Art, 10), 1959).

Darbyshire, Alfred. *An architect's experiences*, 1897.

Darcy, C. P. *The encouragement of the fine arts in Lancashire, 1760–1860*, 1976.

Davis, Frank. *Victorian patrons of the arts*, 1963.

Finke, U. 'Waagen, Bürger-Thoré, Ruskin und die Art Treasures Exhibition in Manchester 1857', *Kunstchronik*, 1975, pp. 92–3.

Graves, Algernon. *The British Institution, 1806–1867* (1875); r.p. 1969.

Herrmann, F. *The English as collectors*, 1972.

Jowell, Frances S. *Thoré-Bürger and the art of the past*, New York, 1977.

Jowell, Frances S. 'Thoré-Bürger and the revival of Frans Hals', *Art Bulletin*, vol. 56 (1974), pp. 101–17.

Manchester City Art Gallery. *Art Treasures centenary. European Old Masters*, with an introduction by S. D. Cleveland, 1957.

Passavant, Johann D. *Tour of a German artist in England*, 2 vols., 1836.

Rebeyrol, Philippe. 'Art historians and art critics. I. Théophile Thoré', *Burlington Magzaine*, vol. 94 (1952), pp. 196–200.

Steegman, John, *Victorian taste*, 1970. [First published as *Consort of Taste*, 1950.]

CHAPTER SIX

Archer, J. H. G. 'A civic achievement: the building of Manchester Town Hall. I. The commissioning', *Transactions of the Lancashire and Cheshire Antiquarian Society*, vol. 81, 1982, pp. 3–41.

Axon, W. E. A. (ed.). *An architectural and general description of the Town Hall, Manchester* (1878); rp. 1977.

Brothers, Alfred. *Manchester as it is*, 1878.

Chadwick, E. *A description of the Hundred of Salford Assize Courts of the County of Lancaster*, n.d.

Cunningham, Colin. *Victorian and Edwardian town halls*, 1981.

Dellheim, Charles. *The face of the past*, 1982.

Dixon, Roger and Muthesius, Stefan. *Victorian architecture*, 1978.

Eastlake, Charles L. *A history of the Gothic Revival* (1872), rp. 1978, edited with an introduction by J. Mordaunt Crook.

Fergusson, James. *History of the modern styles of architecture*, 2 vols. (1862), 3rd ed. 1891, revised by Robert Kerr.

Girouard, Mark. *Alfred Waterhouse and the Natural History Museum*, 1981.

Goodhart-Rendel, H. S. *English architecture since the Regency*, 1953.

Jenkins, F. I. 'The making of a municipal palace', *Country Life*, 16 February 1967.

Maltby, Sally, MacDonald, Sally, and Cunningham, Colin. *Alfred Waterhouse, 1830–1905*, 1983.

McLeod, J. *Manchester Town Hall*, Manchester, n.d.

Pevsner, Nikolaus. *The buildings of England. South Lancashire*, 1969.

Redford, A., and Russell, I. S. *The history of local government in Manchester*, 3 vols., 1939–40.

Smith, Stuart. 'Alfred Waterhouse: civic grandeur', Jane Fawcett (ed.), *Seven Victorian architects*, 1976.

Statham, H. H. 'Plan as a basis of design', *British Architect*, vol. 5 (1876), p. 83.

Stewart, Cecil. *The stones of Manchester*, 1956.

Stewart, Cecil. *The architecture of Manchester*, 1956.

Summerson, John. *Victorian architecture*, 1970.

Waterhouse, Alfred. 'Architecture', Pitcairn, E. H. (ed.), *Unwritten laws and ideals of active careers*, 1899.

Waterhouse, Alfred. 'A description of the new Town Hall at Manchester', *RIBA Transactions*, 1876–77, pp. 117–36.

Waterhouse, Alfred. *Description of Manchester Town Hall* (pamphlet), Manchester, n.d.

Waterhouse, Alfred. 'Presidential address to the Manchester Society of Architects', *British Architect*, vol. 10 (1878) pp. 97–8.

CHAPTER SEVEN

Boase, T. S. R. 'The decoration of the New Palace of Westminster, 1841–1863', *Journal of the Warburg and Courtauld Institutes*, vol. 17 (1954), pp. 319–58.

Brown, Ford Madox. 'The Gambier Parry process', *R.I.B.A. Sessional Papers*, vol. 21 (1880–81), pp. 273–6.

Brown, Ford Madox. *Description of the mural paintings in the Great Hall, Manchester Town Hall*, n.d. [Modern reprint available.]

Brown, Ford Madox. 'Of mural painting', *Arts and Crafts essays*, Arts and Crafts Exhibition Society, 1893, pp. 149–60.

Fredeman, William E. *Pre-Raphaelitism. A biblio-critical study*, Yale (Conn.), 1965).

Hueffer, Ford Madox. *Ford Madox Brown*, 1896.

Ironside, Robin. 'Pre-Raphaelite paintings at Wallington', *Architectural Review*, vol. 92 (1942), pp. 147–9.

Liverpool, Walker Art Gallery. *Ford Madox Brown*, 1964. [Exhibition catalogue compiled by Mary Bennett.]

Mills, Ernestine. *The life and letters of Frederic Shields*, 2 vols., 1912.

Rabin, Lucy F. *Ford Madox Brown and the Pre-Raphaelite history picture*, New York, 1978.

Rowley, Charles, *Fifty years of work without wages*, n.d. (1911).

(Scott, William Bell). *Scenes from Northumbrian history. The mural paintings at Wallington Hall, Northumberland*, Newcastle upon Tyne, 1972.

Soskice, Juliet. *Chapters from childhood. Reminiscences of an artist's granddaughter*, 1921.

Strong, Roy. *'And when did you last see your father?' The Victorian painter and British history*, 1978.

Surtees, Virginia. *The diary of Ford Madox Brown*, 1981.

Watkinson, Ray. *Pre-Raphaelite art and design*, 1970.

CHAPTER EIGHT

Allgrove, Joan. 'Vestments from the Robinson collection at the Whitworth Art Gallery, Manchester', *Costume*, 1972.

Davis, Frank. *Victorian patrons of the arts*, 1963.

Hawcroft, F. W. *British watercolours from the John Edward Taylor collection in the Whitworth Art Gallery*, 1973.

Herrmann, F. *The English as collectors*, 1972.

Guide to the Whitworth Art Gallery, 1979.

Pilkington, Margaret. *A Victorian venture*, 1953.

Pilkington, Margaret. 'The Whitworth Art Gallery, past, present and future', *Memoirs & Proceedings of the Manchester Literary and Philosophical Society*, vol. 108, 1965–66, pp. 1–16.

For further information on Sir Joseph Whitworth see:
Dictionary of National Biography, vol. 61, 1900.

Lea, F. C. *A pioneer of mechanical engineering, Sir Joseph Whitworth*, 1946.

Musson, A. E. 'The life and engineering achievements of Sir Joseph Whitworth', Institution of Mechanical Engineers, *Whitworth Exhibition Catalogue*, 1966.

Musson, A. E. 'Joseph Whitworth and the growth of mass-production engineering', *Business History*, vol. 17, (1975), pp. 109–149.

Musson, A. E. 'Sir Joseph Whitworth, engineer of today', *Vickers Magazine*, 1966 (Summer).

CHAPTER NINE

Binfield, C. *So down to prayers*, 1977.

Champneys, B. 'The John Rylands Library, Manchester', *RIBA Journal*, 3rd Series, vol. 8, 1900, pp. 101–14.

Farnie, D. A. 'John Rylands of Manchester', *Bulletin of the John Rylands University Library of Manchester*, vol. 56, No. 1, (1973), pp. 93–129.

Green, S. G. *In memoriam John Rylands*, 1889.

Guppy, H. *The John Rylands Library, 1899–1924*, 1924.

Unpublished letters in the John Rylands Library 1889–1900, in four volumes.

CHAPTER TEN

Agius, Pauline. *British furniture, 1880–1915*, 1978.

Davey, Peter. *Art and Crafts architecture*, 1980.

Fletcher, Ian. 'Decadence and the Little Magazines', Ian Fletcher (ed.), *Decadence and the 1890s*, 1979.

Fletcher, Ian. 'Herbert Horne. The earlier phase', *English Miscellany*, Rome, 1970, pp. 140–56.

Haslam, Malcolm 'A pioneer of Art Nouveau', *Country Life*, vol. 157 (1975), pp. 504–6, 577–9.

Lambourne, Lionel. *Utopian craftsmen*, 1980.

Madsen, S. T. *Sources of Art Nouveau* (1956); rp. New York, 1975.

Madsen, S. T. *Art Nouveau*, 1967.

Naylor, Gillian. *The Arts and Crafts Movement* (1971), 1980.

Pevsner, Nikolaus. 'Arthur Heygate Mackmurdo', *Studies in art, architecture and design*, vol. II, *Victorian and after*, 1968. [Reprinted from *Architectural Review*, vol. 83, 1938.]

Pond, Edward. 'Mackmurdo gleanings', in J. M. Richards and N. Pevsner (eds.), *The anti-*

rationalists, 1973. [Reprinted from *Architectural Review*, vol. 128, 1960.]

Schmutzler, Robert. *Art Nouveau*, 1964.

Vallance, Aymer. 'Mr Arthur H. Mackmurdo and the Century Guild', *The Studio*, vol. 16 (1899), pp. 183–92.

Catalogues

Doubleday, John. *The eccentric A. H. Mackmurdo* (catalogue to an exhibition of the same name held at the Minories Gallery, Colchester), 1979.

Victoria and Albert Museum. *Exhibition of Victorian and Edwardian decorative arts*, 1952.

Victorian and Edwardian decorative art (the Handley-Read collection), Royal Academy, 1972.

William Morris Gallery. *Catalogue of A. H. Mackmurdo and the Century Guild collection*, Walthamstow, 1967.

INDEX

Buildings that are listed only by name or by name and street are located in Manchester or Salford. Numbers in bold type refer to plates.

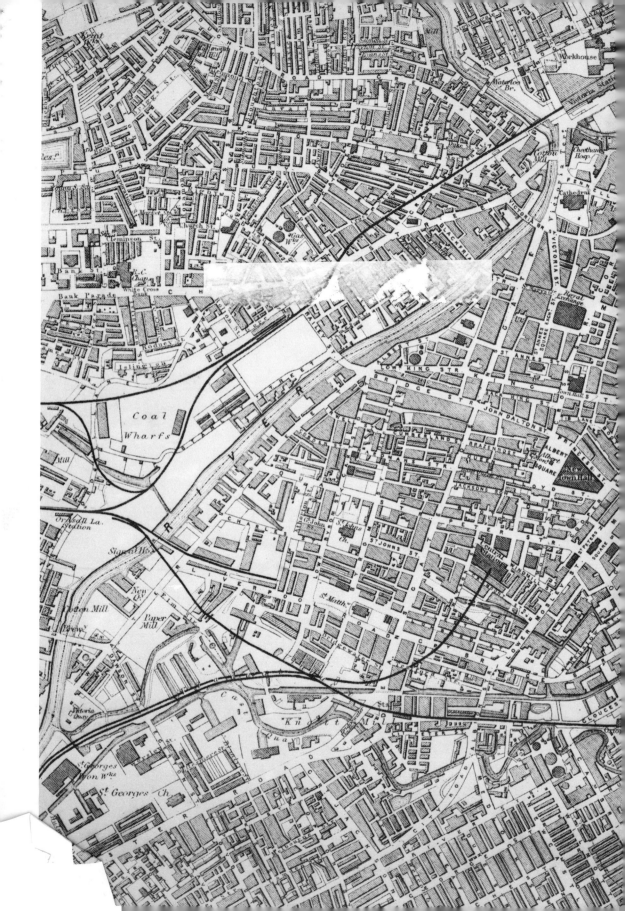